Art Education and Contemporary Culture:
Irish Experiences, International Perspectives

Edited by Gary Granville

intellect Bristol, UK / Chicago, USA

First published in the UK in 2012 by
Intellect, The Mill, Parnall Road, Fishponds, Bristol, BS16 3JG, UK

First published in the USA in 2012 by
Intellect, The University of Chicago Press, 1427 E. 60th Street,
Chicago, IL 60637, USA

A catalogue record for this book is available from the
British Library.

Cover designer: Holly Rose
Copy-editor: MPS Ltd.
Typesetting: John Teehan
Production Manager: Melanie Marshall

ISBN 978-1-84150-546-6

Printed and bound by Hobbs, UK.

For Mary,
and for Tríona, Muireann and Seona

Contents

Art and design education is at the confluence of many conflicting currents of discourse. Probably the most pertinent confluence is among the discourses of creativity, innovation and enterprise, which dominate 21st-century education policy debates in Ireland and elsewhere in the world and that of art and design education. The contemporary rhetoric of education policy is replete with references to established features of art and design education – problem-solving, divergent thinking, learning from and through failure, risk-taking, to mention but a few. Yet the connection between the 'new' rhetoric of education policy and the established language of art and design is rarely made. Art and design education remain relatively marginalised in Irish education as elsewhere, and the capacity of arts education in general or art and design education in particular to serve as a model for general education practice has not been recognised.

Perhaps the truth is that much of the rhetoric of education policy is presented in a deceptive discourse of criticality that masks an essentially different policy orientation, a 'command-economy' model of education. This is evident in the prevalence of highly structured models of education practice, as exemplified in curricula defined only by learning outcomes, in the modularisation of teaching and learning, in programmes defined by a hierarchy of levels and in frameworks of qualifications that equate credentials with learning. Educationists generally and art and design educationists in particular have been weak in challenging or at least questioning the new orthodoxies.

There is also a state of churn in the space where art and design practice meets art and design education. This churn is visible for example in the perceived gulf between contemporary art practice and the conventional art curriculum of schools, or in the limited range of qualities assessed in most school examinations compared to the qualities that designers value. Similarly, the 'disconnect' between school-art and art-school is a feature of internal disjunction perhaps unique to art and design as a disciplinary area. Thus, whereas higher education courses in most other disciplines accept entrants on the basis of their performance in cognate school subjects, art and design colleges in Ireland largely ignore such performance, insisting on separate, dedicated portfolios of work. Furthermore, the pedagogical turn in contemporary art practice has awoken an interest in radical education positions variously propounded by figures such as Freire and Illich nearly half a century ago (Bishop 2006; O'Neill and Wilson 2010). This repositioning or reinterpretation of the meaning of art making seems to be following an orbit tangential to that of formal education practice.

Contrasting currents of discourse can also be discerned between the conjoined disciplines of art and design themselves. There is a practice to link these two areas in education, yet we still tend to abbreviate our references to the singular term 'art education'. As a linguistic shortcut, this is acceptable but it is a matter of concern if there is a more significant elimination at work. The contribution that design education per se can make to general education is greatly undervalued and although current curriculum and assessment programmes in Irish schools incorporate art, craft and design, the potential of design in education should extend well beyond that single subject. Design awareness should be an integral part of teaching and learning across all subjects, especially in the domain of the technology subjects (McCarthy and Granville 1997).

This book is concerned with the current status of art and design in Irish education and with the relationship between art and design as fields of practice and education in art and design in the various contexts within which this can be experienced. There are three distinctive features to the book. Firstly, the focus on one national system, that of the Republic of Ireland, provides a lens through which to see the meanings, practices and orientations of art and design education policy and practice in operation. This helps to clarify and crystallise the parameters of the debate. As such, the focus of the book should be of interest not just to Irish readers but also to researchers in the international fields of art and design education. The book comprises reflections on the Irish experience as well as commentaries from an international perspective.[1] Thus, the national studies are complemented by external perspectives provided by international researchers based in the United States (Siegesmund), the United Kingdom (McGuirk) and Canada (D. O'Donoghue). A particular set of further connections between Northern Ireland and the Republic of Ireland is included through the participation of two art educators from Northern Ireland (Lambe and Herron).

Secondly, the treatment of art and design education on a comprehensive basis, inclusive of primary and secondary education, of higher education and of the community and cultural sectors is significant in highlighting the overlaps as well as the inconsistencies that can emerge across these divides, even within one small system. Education, in all disciplines and especially in art and design, extends beyond the confines of the formal school and college system. The relationships between formal and informal education, between statutory and popular education, between education in schools, in the cultural sector and in community settings are complex. The chapters of this book provide a number of windows through which to look at education operating in or across these various settings. The book should facilitate the development of further conversations and initiatives between these different fields of endeavour.

Finally, the common base of studies, carried out in or in association with the Faculty of Education of the National College of Art and Design (NCAD) in Dublin, provides a body of research, which is coherent but neither doctrinaire nor uniform. All the chapter authors have a close connection with the NCAD Faculty of Education. Many of the authors are PhD graduates of the Faculty (Donal O'Donoghue, Tom McGuirk,

Alastair Herron, John Mulloy, Michael Flannery and Hazel Stapleton) or are currently pursuing doctoral study (Glenn Loughran, Máire NíBhroin and Dervil Jordan). Some are or have been members of the academic staff of the Faculty (Jordan, McGuirk and Nuala Hunt), whereas others have been engaged with the Faculty as external examiners, associate staff or guests and valued friends (Ailbhe Murphy, Jacqueline Lambe, Helen O'Donoghue and Richard Siegesmund). The book will provide a benchmark for research in this field in Ireland, which has up to now been sporadic and incremental. It should help to establish a community of scholarship and collaborative research and teaching programmes with colleagues in art education in other Irish colleges. It will also provide a point of engagement between Irish scholars and those from other systems.

The book looks at art education in a rounded context. It provides a number of lenses, laid one upon the other through which to study a national experience in art education. That experience is viewed along three trajectories – one continuum within the formal education system links primary education, post-primary education and higher education; another continuum links the formal and informal education sectors; and a further continuum locates Ireland in the international context. The presentation of the chapters could have taken any of a number of different formats. The format adopted here has been chosen to be the most accessible to most readers: chapters for the most part are set out roughly reflecting the various settings for art and design education – the primary school, the post-primary school, the community, the cultural sector and the higher-education college. However, a chronological reading of chapters is not necessary and the thematic commonality across many chapters can provide many equally valid sequences of engagement.

The three international perspectives offered in the book are presented at the start, at the mid-point and at the end. The book opens with a philosophical reflection from Tom McGuirk, an Irish academic and artist, working in the United Kingdom. Roughly mid-point in the book, a provocative paper by the Irish art educator Donal O'Donoghue, currently working in Canada, is presented as a pivot between the largely school-related orientation of the preceding chapters and the post-school or informal education focus of the second set of chapters. Finally, a reflection on Irish art and design education as seen by a distinguished visiting American art educator, Richard Siegesmund, closes the book.

The question of what constitutes knowledge and how that relates to art and design is of fundamental philosophic importance. In Chapter 1, Tom McGuirk looks at drawing as knowledge generation and presents a cogent argument for art and design educationists to assert the epistemological validity of their discipline. His paper makes an important implicit statement about the primacy of drawing within the school curriculum. The strategic significance of McGuirk's paper is particularly important in terms of current debates in Ireland about the nature of research in art and design and in respect of the compensatory role of 'academic' studies within the Leaving Certificate art examination.

In Chapter 2, Gary Granville gives a brief overview of the relative marginalisation of art and design in Irish education as well as a critique of its treatment within the centrally important Leaving Certificate examination. The neglect of art and design education in

Irish education through the twentieth century is briefly charted, up to the contemporary period of curriculum renewal. The paper refers to the 'negative space' that art and design occupies at Leaving Certificate level, between the revived and coherent treatment of the visual arts in primary education, the innovative education projects in community arts initiatives and the evolving programmes of teaching and research at higher education.

In Chapter 3, Máire Ní Bhroin presents a valuable overview of the implementation of the visual arts component of the 1999 revised primary school curriculum. Her chapter constitutes a valuable statement of the current state of research in this field. It will serve as a standard point of entry for students interested in the current primary visual arts curriculum. She presents a positive picture of overall achievement but points out some important areas of concern: the challenges and opportunities presented by the integrated methodologies fostered in the primary curriculum and, in particular, the neglected role of assessment for learning within the visual arts curriculum.

Michael Flannery, in Chapter 4, gives us some of the findings and insights derived from his incisive and exciting research study, based upon the on-line continuing professional development courses that he designed and managed over an extended number of years with practising primary-school teachers. Flannery's research is innovative both in terms of its methodology and its insights into art teaching at primary level. His focus on 'looking and responding to art', as an inherent element of that curriculum, provides a strong platform for future policy in the area of initial and continuing teacher education.

A cross-border research study, linking art teacher education in Northern Ireland with the Republic of Ireland is presented in Chapter 5. Dervil Jordan was the national co-ordinator of an EU funded Comenius Project *Images and Identity*, involving six EU countries (Mason 2010). Arising from that project Dervil Jordan and Jacqueline Lambe designed a related initiative, working with student art teachers north and south of the border. This chapter gives an insight into one element of that study, a study of cultural nationalism informed by an important art exhibition of the work of John Lavery, which was shown in the Hugh Lane Gallery Dublin in autumn 2010. The findings reported here are potentially significant for education policy makers north and south of the border, at a time when a new generation of learners has grown up within the period of the peace process. The new meanings of Irish identity will be the context within which these student teachers will work, as they enter the teaching profession at post-primary level.

Assessment is perhaps the single most contentious issue in art and design education. The Irish education system, at post-primary level, is especially dominated by a public examination system, which at Leaving Certificate level is a very high-stakes examination. In Chapter 6, Hazel Stapleton provides an insight into the processes and challenges of assessing art in such a context. Her position as an insider to this process provides a unique, original and valuable chapter in looking at the issues of reliability, validity and utility in assessment of art and design. This chapter breaks new ground in engaging with the internal issues of assessing art within a high-stakes public examination system.

Chapter 7 acts as a central pivot to the book by providing a critique of the school curriculum in art – the focus of most of the previous chapters – and relating this to the contemporary world of art practice, which informs most of the chapters that follow. Donal O'Donoghue was an undergraduate student and the first PhD graduate of the NCAD Faculty of Education. He is currently Chair of Art Education in the University of British Columbia in Canada, an internationally recognised centre of excellence in art education. This chapter suggests that Irish art education remains distinctly out of touch with current understandings of art practice and to that extent is dysfunctional. Although O'Donoghue uses the primary-school art curriculum as a case for analysis, his critique has equal if not more application to the post-primary curriculum and resonates very much with later chapters in terms of contemporary art practice and education. His challenge to Irish art and design education in schools is to locate the school learning experience within the postmodern discourse of contemporary art practice.

As a parallel narrative to that of the formal school system, the next three chapters address the experiences of art education in other settings. In Chapter 8, Ailbhe Murphy, an eminent researcher and an experienced art practitioner in community settings, captures recent international debates on the pedagogic or social turn in art practice and locates this in the Irish context. In particular, she addresses the need for art education to address the needs of artists in formation. She points to the need for art colleges to provide a more appropriate programme of education for artists whose professional careers will increasingly involve work with diverse sets of interests and experiences in a variety of settings. Tellingly, she distinguishes between collaborative and participatory practices in community art settings and identifies the need for rigorous and critical evaluation of all such projects.

Chapter 9 provides us with an analysis of and reflection on the implications of a radical project in 'evental education'. Glenn Loughran's work is informed by Ranciere and especially by Badiou, and his research is based on an innovative art education project evoking the old Irish popular education phenomenon of the eighteenth-century *hedge school*. Loughran developed a series of art interventions with different communities, driven by a concept of education as empowerment. He tests the viability of a programme that manifests the 'axiom of equality' – that pedagogical practice should affirm that 'equality' exists at the *beginning* of a pedagogical process, rather than as a goal to be achieved *through* a pedagogical process. The chapter provides an important evaluation of an original application of theory in practice.

John Mulloy presents a challenge to community arts activists in Ireland in Chapter 10. The title of his chapter, 'Making a Show of Ourselves', evokes the sense of unease he feels at the colonisation of community activism by the forces of the establishment, as represented by the state and its agencies in the cultural sector. Mulloy's paper, written from the perspective of an activist, sounds a cautionary note and provides a critical view of the practice of community arts education. He suggests that community-based art, as it has developed and been colonised by agencies of the state, leads us to make a show of

ourselves, through a performance of community as 'engaged citizenship'. His chapter, trenchantly expressed, will serve as a valuable point of reference and evaluation for community developers, art practitioners and cultural activists.

The cultural sector is often cited as a partner with the education sector in terms of arts education. However, too often, the lines of engagement are tenuous, consisting of one-off engagements (visits from school to galleries, for instance) or parallel tracks (education programmes in museums that may refer to mainstream curriculum but do not engage with schools and teachers). Helen O'Donoghue in Chapter 11 gives a valuable overview of the innovative experience of the Irish Museum of Modern Art (IMMA). More especially, she explores the set of relationships that exist between learners, artists, teachers, youth workers and others in the field. The research base of the IMMA community and education programme provides a rich source of experience for this chapter, and a model for developing relationships between teachers and the cultural sector.

Holistic education is an overused term, often poorly understood or unpacked. In Chapter 12, Alastair Herron looks at the meaning of holistic education in art and design education in higher education. Suggesting that 'art aspires towards a condition of nature', Herron critiques established norms in education policy generally and provides a model of working with students in a holistic manner that transcends current systems of anticipated learning outcomes. His chapter explores the relationship between art, creativity and the environment and he proposes a new form of visual enquiry to facilitate students in a holistic experience of learning. He illustrates his theoretical position with an analysis of a specific intervention designed to integrate the dancer with the dance, the learner with the learning.

The continuum of education through lifelong learning remains a challenge for art and design education. The NCAD grew out of a traditional model of education, often referred to as the South Kensington system. This has always featured part-time education and that tradition of continuing education has been maintained throughout the twentieth century. However, the form of part-time education that evolved was found to be inadequate to the needs of twenty-first century. In Chapter 13, Nuala Hunt provides an analysis of the reform programme that NCAD has undergone over the past decade. In doing so, she raises specific issues in connection with the meaning of lifelong learning in art and design and proposes a policy that would provide for a seamless relationship between full-time and part-time provisions of higher education in art and design.

Finally, in Chapter 14, Richard Siegesmund from the USA, a Fulbright Scholar in NCAD in 2010, reflects on his experience in Ireland and provides a commentary that is supportive and constructive in its presentation. He provides an affirmation of much of what he observed in his placement here in Ireland, and perhaps most significantly, offers a rationale for qualitative reasoning through the visual arts that can inform policy and practice both in teaching and learning at all levels and in research in art and design. He compares the philosophical traditions and practices of art education in Ireland with those of North America. His 'three forms of the visual' provide a significant rationale for

8

research work in art and education and his view of aesthetics as a philosophy of care gives us a very constructive platform upon which to develop new practices in art education.

These chapters present a diverse set of views and reflections. They do not comprise a unified set of perspectives. There are constructive lines of dissent between many of the chapter contributors. Donal O'Donoghue's 'take' on the primary curriculum is quite deliberately different from those of Ní Bhroin and Flannery. Similarly, Mulloy's critique of community arts education may not sit entirely comfortably with that of Murphy, nor his view of holistic education with that of Herron. Granville's reservations about the second-level curriculum do not chime fully with the views of Stapleton or Siegesmund. It is precisely in such differences that we can learn most about our common concerns. Nevertheless, there is great complementarity across these papers. Most importantly, the work collectively presented in this book provides an important platform for new research in specific aspects of art education that have been unexplored or underdeveloped up to now.

If we view curriculum as a mind altering device, as Siegesmund says, then the art and design curriculum in all its guises – formal, informal and hidden – may offer us the most potential to liberate the minds of learners and to shift the mindset of policy makers. As Eisner (2004) suggests,

… shifting the paradigm of education reform and teaching from one modelled on the clockwork character of the assembly line into one closer to the studio or innovative science laboratory might provide us with a vision that better suits the capacities and the futures of the students we teach.

References

Bishop, C. (2006) The Social Turn: Collaboration and Its Discontents, *Artforum*, February 2006.

Eisner, Elliot (2004) Artistry in teaching, *Cultural Commons* http://www.culturalcommons.org/eisner.htm. Accessed March 10, 2009.

Mason, R. (2010*) Images and Identity: Improving Citizenship Education through Digital Art.* Comenius Report, European Commission, Brussels.

McCarthy, I. and Granville, G. (1997) *Design in Education: A Discussion Paper* Dublin: NCAD/NCCA.

O'Neill, P. and M. Wilson (Eds) (2010) *Curating and the Educational Turn* London/ Amsterdam: Open Editions/deAppel.

Sugrue, C. (Ed.) (2004) *Curriculum and Ideology: Irish Experiences and International Perspectives* Dublin: The Liffey Press.

Note

1. The sub-title of this book, *Irish Experiences and International Perspectives*, echoes and gratefully acknowledges that of Sugrue's *Curriculum and Ideology: Irish Experiences and International Perspectives* (2004).

Chapter 1

From *Disegno* to 'Epistemic Action': Drawing as Knowledge Generation

Tom McGuirk

Through oppositions like that between theory and practice, the whole social order is present in the very way that we think about that order.

(Bourdieu 2000, p. 83)

In the Renaissance and Baroque periods, drawing was understood as having an intellectual dimension – as an activity of the mind – and this sense has persisted. For more than four centuries drawing was at the core of education in art and design, its epistemic claim underwritten by theories of *disegno*. For at least the past half century however that writ has no longer run and consequently the status of drawing in the curriculum has waned. However, recent work at the interface of philosophy and cognitive science, specifically regarding theories of 'situated cognition', lends fresh credence to a renewed positive epistemological appraisal of drawing.

Within conceptions of *disegno* there persisted an obstinate distrust of the embodied and situated aspects of drawing. This is testimony to a remarkably deep-seated attitude in collective Western consciousness. Dewey diagnosed this as originating in an evolved Greek distrust of aspects of custom and practice. Practice, in terms of activity and 'experience', was associated with 'material interests', the needs and wants of the body and the unreliability of the senses (Dewey 1930, p. 307). All had negative connotations for the Greeks for whom Dewey points out 'practical life was in a condition of perpetual flux, while intellectual knowledge concerned perpetual truth' (Dewey 1930, p. 306).

Dewey saw this bias as rooted in a fundamental dualism of labour and leisure. The contemplative life was seen as the highest calling and mode of being, this was accompanied by a disparagement of embodied and situated practices and any truth claims that might be asserted on their behalf. Plato felt able to describe manual workers as 'lifeless things which act indeed, but act without knowing what they do, as a fire burns' (cited in Porter 1997, p. 100).

Dewey sees this phenomenon as responsible for 'the magnification in higher education of all the methods and topics, which involved the least use of sense-observation and

bodily activity' (Dewey 1930, p. 314). This tendency, later copper-fastened in Cartesian dualism, has continuing cultural ramifications, which are felt in higher education in art and design. In a recent analysis Pallasmaa suggests that little may have changed:

> Prevailing educational pedagogies and practices... continue to separate mental, intellectual and emotional capacities from the senses and the multifarious dimensions of human embodiment.... our embodied existence is rarely identified as the very basis of our interaction and integration with the world... the integral role of the hand in the evolution and different manifestations of human intelligence is not acknowledged (Pallasmaa 2009, p. 12).

It is in the context outlined by Pallasmaa that this chapter addresses the epistemic claims of drawing. Drawing is of course not the only work of the hands and is, to an extent, here a totem for other embodied and situated 'making' practices. However there are two points that make drawing particularly significant: firstly, its unique history and position in higher education in art and design; and secondly, the integral role that perception plays in the drawing process, which gives it a singular claim for consideration as a mode of thought and a path to knowledge.

A drawing academy

The founding of the *Accademia del Disegno* in Florence in 1563 was a historical moment that heralded a more positive assessment of the epistemological significance of embodied practices. This event owed much to the confluence of complex, often contradictory, social forces and equally conflicting insights and motives. As Goldstein explains, the primary motivation of the academy's founders was the social advancement of its members:

> That the academy viewed itself as an agent for professional advancement is made clear, then, by its name and deeds: the whole concept of an academy of *disegno* is inimical to a guild or workshop (Goldstein 1996, p. 19).

While the academy's founding marked the advent of a more progressive understanding of drawing's epistemic claims, this socio-political impetus should not be underestimated, because its ramifications sometimes counteracted these insights.

Bermingham references one of the most influential texts of the period, Baldassare Castiglione's handbook for courtiers of l518: *Il Libro del Cortegiano*. Castiglione argued that manual activities such as drawing and painting were, contrary to appearances, appropriate occupations for courtiers. Appealing to the authority of antiquity, Castiglione pointed out that in Greece painting had been taught to 'children of gentle birth', that it was 'ranked among the foremost of the liberal arts' and tellingly, that it

was forbidden to be taught to slaves (Bermingham 2000, p. 4). Bermingham suggests that this defensiveness

> goes directly to the heart of the problematic social status of the arts in the Renaissance. Stigmatised as handicrafts and institutionalised within the medieval guild system, they appeared as skills better suited to the artisan than to the courtier (Bermingham 2000, p. 4).

The academy's founders and subsequent theorists reconstituted the practice of drawing, elevating it to the status of an overarching principle. However, in their polemics they walked a precarious line. Their Neo-Platonic rhetoric founded *disegno's* epistemic claim on the notion that it 'paralleled the creative aspect of divinity', offering direct access to the Platonic forms – Christianised in terms of 'the Devine Intellect' (Langmuir and Lynton 2000, p. 200). In this guise *disegno* was presented as 'the intellectual component' of the plastic arts and this facilitated their promotion from the status of the crafts to that of the liberal arts.

There remained, however, an inherent tension at the core of this enterprise. Beyond the rhetoric, drawing remained an inescapably situated and embodied practice. This aspect needed to be downplayed. The price of drawings' newfound status was therefore a distancing of it, not merely from association with menial craft, but more significantly, a disassociation from its own embodied and situated aspects. The intellectual milieu of the period is one where, in Dewey's words, 'the aristocratic tradition which looked down upon material things and upon the senses and the hands was still mighty' (Dewey 1930, p. 329).

Disegno

Even recent commentators can seem at odds in their definition of *disegno*. Goldstein describes it as an 'ineluctably intellectualising activity different from, and *not to be confused* with descriptive drawing' (my emphasis) (Goldstein 1996: 14). Whereas Anne Bermingham suggests that *disegno* referred to drawing in two species in terms of '*both* the initial mental conception *and* to its linear execution in sketches and cartoons' (my emphasis) (Bermingham 2000, p. 5). Bermingham recognises the convenience of the room for manoeuvre this afforded:

> The slippage in the term allowed between conception and execution, or between design and drawing was essential in reorienting the visual arts away from craft and towards the more elevated and intellectual liberal arts (Bermingham 2000, p. 5).

The need for such 'slippage' is a testament to the embedded nature and reach of the dualism outlined earlier. A 'fudge' was necessary to facilitate the elevation of drawing as *disegno* in the face of its inconvenient associations, to the extent that in subsequent theorisation these discrepancies were internalised, becoming polarities within the concept

itself. Vasari's (1511–1574) conception of *disegno* attempted to sidestep these dilemmas through a holistic theory that integrated *disegnoís* intellectual *and* embodied aspects. However Federico Zuccaro (1542–1609) later criticised him for conflating *disegno internoódrawingís* conceptual aspect presented in idealist, Neo-Platonic termsówith *disegno esterno*. *Disegno esterno* included the cognitive aspects of drawing, which were also associated negatively with representation and mimesis, and the physical, practical, embodied and situated aspects of drawing. All of these elements were regarded by Zuccaro as 'secondary and necessarily inferior' (Goldstein 1996, pp. 31–32). For Zuccaro saw these different aspects of *disegno* represent entirely separate and independent intelligences, one universal and the other particular (Goldstein 1996, p. 32). In hindsight, Vasari's conflated view appears in a positive light, as integrated and holistic, when viewed, as we shall see, from the point of view of more recent understandings.

Rosand summarises these complexities and their legacy for art and design education:

> For all the philosophical rhetoric brought to the discussion by intellectually ambitious academics like Zuccaro… a basic truth remains; *disegno* is fraught with contradiction and ambivalence, located as it is at the very boundary between mind, hand, idea and form. This truth, a discovery of the Renaissance, has shaped the subsequent history of drawing, its practice and its critical appreciation (Rosand 2002, p. 60).

Ironically, this legacy is just as evident in the dualism that persists in contemporary academic attitudes to embodied and situated practices, as in the (sometimes grudging) recognition of drawing's epistemic significance. The persistence of such dualism is perhaps most evident in the contemporary context as a dualism of theory and practice. Carl Goldstein (1996) identifies this tension – already at play in Renaissance theories of *disegno* – as a persistent thread in the fabric of higher education in art and design. He suggests that from this period up to the Bauhaus there prevailed 'a problematising of the relationship between theory and practice, and… a "deconstruction" of theory in a resolutely dialectical engagement with it as something demonstrably different from practice' (Goldstein 1996, p. 24).

This phenomenon resurfaces periodically and is evident in relatively recent and contemporary debates and anxiety, particularly those surrounding the advent of the practice-based PhD in art and design. Fiona Candlin's (2000) critique of a report of the UK Council for Graduate Education (Frayling et al. 1997) is instructive. Candlin suggests that despite the report's assertion that 'doctoral characteristics of originality, mastery and contribution to the field are held to be demonstrated *through the original creative work*' (my emphasis) (Candlin 2000, p. 5), the authors insist that in practice an extensive accompanying text was essential to render the work 'precise, clear and accessible' and to demonstrate 'doctoral powers of *analysis* and *mastery* of contextual knowledge… *accessible to* and *auditable* by knowledgeable peers' (emphasis in the original) (Candlin 2000, p. 5). Candlin objects that the report thereby effectively privileges theory over

'artwork', 'since it is the theoretical component of the doctorate that [ultimately] gives the work PhD standing' (Candlin 2000, p. 6). She therefore interprets the report as presuming that

> art practice, no matter how cognitively sophisticated and theoretically rich... cannot be deemed research without the supporting apparatus of conventionally presented academic study (Candlin 2000, p. 6).

This, she suggests, is due to the 'relatively common' notion that 'images need words to explain or pin them down' (Candlin 2000, p. 5). In this regard, she criticises Margaret Iverson's stance that sees the image as 'set over against discourse. It is mute and in need of a voluble interpreter. It drifts and requires a linguistic anchor' (in Candlin 2000, p. 5). She suggests furthermore that rather than 'open[ing] out the boundaries of academia to acknowledge different ways of thinking and working', the report actually 'reduces art practice to the conventions of academia' (Candlin 2000, p. 12). She remarks (elsewhere) that the report

> draws a firm line between theory and practice, places academic research in opposition to practice generally and artwork specifically, [and] maintains the stereotype of art as *anti-intellectual*... (cited in MacLeod 2000, p. 6).

Candlin's argument foregrounds the persistence of dualism that underpins the problematic relationship between art making and 'university life' (Elkins 2009, p. 128).

Drawing and feedback

Mareis presents a contemporary account of the continuing significance of *disegno* that focuses on drawing as an epistemic process.

> [d]isegno means nothing less than a clear design and representation of the picture that one has in mind, which one imagines and creates as an idea. More specifically the sketches of the artist or plans of the architect bring complex conceptual ideas onto paper by means of simple, economic lines: they are, in a manner of speaking, materialised figurations of the idea. Drawing has more than just an executive function (as in the merely mechanical translation of a finished idea onto paper), for the act of sketching or drawing itself generates knowledge. In turn, this knowledge can influence our imagination and modify, modulate or reshape the design during the process of drawing itself. Accordingly, in the act of drawing, as well as in the finished drawing, the intellectual activity of designing and the manual execution of these ideas are inextricably linked and subject to a reciprocal influence (Mareis 2007, pp. 2–3).

Mareis' final point is opportune; it progresses our discussion in the direction of an understanding of drawing's knowledge generating powers and in emphasising the vital role of feedback it engages with contemporary theories of 'embodied' and 'situated' cognition.

Even in the Renaissance 'hey-day' of *disegno* the significance of feedback is evident. Ernst Gombrich (19841982) discusses this with regard to Leonardo's method. Gombrich poses an interesting question: 'why should the artist put something on paper only to reject it?' (Gombrich 1982, p. 227). As an answer, he cites Vassari's objection to Giorgione's direct and unmediated painting method, which dispensed with the need for drawing, particularly preparatory drawing. In Vasari's words, Giorgione foolishly

> failed to realise that it is necessary to anyone who wants to arrive at a good composition and to adjust his inventions, first to draw them on paper so as to see how it all goes together. The reason is that the mind can neither perceive nor perfectly imagine inventions within itself unless it opens up and shows its conceptions to corporal eyes which aid it to arrive at a good judgement (Gombrich 1982, p. 227).

The Italian word for sketches – *schizzi* – referred to preliminary drawings made, as Vasari puts it, 'to test the spirit or that which occurs to the artist' (Gombrich 1982, p. 227). Gombrich suggests that this method represents a mental attitude and spirit of experimentation, which was essential to the reinvigoration of art in the Renaissance:

> Here we have the idea of experimentation, of negative feedback applied to the artist himself. He is his own mental guinea pig submitting the invention of his mind to the critical judgment of his eyes. The more an artist ventures into the unknown by abandoning the well-tried methods of tradition the more vital is this procedure likely to be (Gombrich 1982, pp. 227–228).

This understanding of the role of 'feedback' in knowledge generation through drawing is something that is acknowledged by many artists, designers and theorists; witness the following from the theorist and draftsman John Berger:

> Every line I draw reforms the figure on the paper, and at the same time it redraws the image in my mind. And what is more, the drawn line redraws the model, because it changes my capacity to perceive (Berger in Pallasmaa 2009, p. 92).

This is the graphic equivalent of the idea of 'thinking out loud', the notion that our conception of thought need not, and indeed ought not, be constrained by confinement to entirely cerebral processes. Vasari's insight and his understanding of embodied perception appears strikingly modern in its nascent recognition of the inadequacy of the cerebral 'mind', and of the role the body plays in cognition.

This insight invites an expansion of our view of the mind, a view echoed, in recent work in 'situated cognition', the inheritor of two specific philosophical traditions: phenomenology and pragmatism (Gallagher 2009).

Situated cognition

Dewey, a philosophical antecedent of 'situated cognition' (Gallagher 2009, pp. 37–40), recognises that in most of nineteenth- and early-twentieth-century thought, a dualism of body and 'spirit' was 'replaced by that of the brain and the rest of the body' (Dewey 1930, p. 391; see also Bourdieu 2000, pp. 17–32 and Lakoff and Johnson 1999). As early as 1916, Dewey's observations regarding early developments in cognitive science set out what could be regarded as the basic tenets of situated cognition:

> The brain is essentially an organ for effecting the reciprocal adjustment to each other of the stimuli received from the environment and responses directed upon it. Note that the adjusting is reciprocal; the brain not only enables organic activity to be brought to bear upon any object of the environment in response to a sensory stimulation, but this response also determines what the next stimulus will be (Dewey 1930, p. 392).

Feedback is central to this analysis. Dewey cites such examples of 'consecutive activity' as a carpenter at work on a board and significantly 'an etcher at work [drawing] upon his plate' (Dewey 1930, p. 392). He describes these activities in terms of the 'motor response' adjusting to the particular situation or 'state of affairs' as appreciated through the senses. This in turn shapes the next 'sensory stimulus', which stimulates the next 'motor response' and so on and so forth (Dewey 1930, p. 392). He also instances the work of the carpenter:

> [T]he brain is the machinery for a constant reorganising of activity so as to maintain its continuity; that is to say, to make such modifications in future action as are required because of what has already been done. The continuity of the work of the carpenter distinguishes it from a routine repetition of identically the same motion, and from a random activity where there is nothing cumulative. What makes it continuous, consecutive, or concentrated is that each earlier act prepares the way for later acts, while these take account of or reckon with the results already attained – the basis of all responsibility (Dewey 1930, p. 392).

Dewey's argument here holds just as well for the processes of drawing. The holism of his understanding of the embodied, situated and interactive aspects of such activity is insightful. It recognises the embodied integration of the artist/artisan, through their brain

and nervous system, with the object of their attention and their environment. Dewey's thesis also amounts to a full frontal assault on the isolationism of epistemologies founded in Cartesian perspectivism:

> No one who has realised the full force of the facts of the connection of knowing with the nervous system and of the nervous system with the readjusting of activity continuously to meet new conditions, will doubt that knowing has to do with reorganising activity, instead of being something isolated from all activity, complete on its own account (Dewey 1930, p. 392).

It is clear that what is described here illustrates the type of 'knowing' achieved through drawing. The brain, the perceptual faculties, body and nervous system work in unison in the physical manipulation of material. The added dimension in the case of drawing is the achievement, through the process of feedback, of a heightened level of perception.

'Situated cognition' also presents a model of cognition as both active and inextricably situated within an environment. As Dewey put it 'in actual experience… an object or event is always a special part, phase, or aspect, of an environing experienced world – a situation' (Gallagher 2009, p. 37). In situated cognition the person/environment relationship is radically altered from the Cartesian epistemological model's emphasis on the separation of subject and object, to one of integration of the individual as embodied actor. They are *part of* the environment as opposed to being merely a passive occupant, in Dewey's phrase: 'like a cherry in a bowl' (Dewey in Bredo 1994). Bredo succinctly captures this idea: 'put simply the inside outside relationship between person and environment is replaced by a part/whole relationship' (Bredo 1994).

In Dewey's case, this is accompanied by an equally radical Pragmatist reinterpretation of knowledge itself. Knowledge is essentially active and produces change. Dewey makes the following forthright claim:

> Only that which has been organised into our disposition so as to enable us to adapt the environment to our needs and to adapt our aims and desires to the situation in which we live is really knowledge (Dewey 1930, p. 400).

This radical view inverts the Platonic–Cartesian epistemological order.

Situated cognition defined

Robbins and Aydede give a useful description of the three principal component theses of situated cognition:

First, cognition depends not just on the brain but also on the body (the embodiment thesis). Second, cognitive activity routinely exploits structure in the natural and social environment (the embedding thesis). Third, the boundaries of cognition extend beyond the boundaries of individual organisms (the extension thesis) (Robbins and Aydede 2009, p. 3).

All three theses are germane to our discussion regarding drawing. Those of us who have in the course of drawing become engrossed in the process to the point of complete absorption can testify to attaining a level of both mental and physical engagement that approximates a meditative state. In lending oneself to the process there is a sense of forgetting oneself, of ceasing to be a mere observer and becoming, in a holistic sense, part of an interaction.

Bredo chooses the activity of drawing to illustrate this model of knowledge as action. Just as in Dewey's analysis, feedback is highlighted:

Drawing for example, is a drawn out affair… one draws, responds to what one has drawn, draws more, and so on. The goals for the continuation of the drawing change as it evolves and different effects become possible. Acting with the environment in this way contrasts with acting on it, because it presupposes that it will turn round and alter oneself in return. The production of a well-coordinated performance then involves a kind of dance between person and environment rather than the one-way action of one on the other (Bredo 1994).

Gallagher points out that for Dewey cognition is a kind of 'action' and it is a mistake to regard it merely in terms of the 'relation between a thinking that goes on in the mind and a behaviour that goes on in the world' (Gallagher 2009, pp. 38–39). In 'situated cognition', thinking is not confined to an isolated entity called the 'mind' but is 'an activity or event in the world' (Gallagher 2009, pp. 38–39).

Drawing's epistemic significance might best be understood in the context of 'enactive cognition', the notion that 'perception and thinking are fully integrated with motor action' (Gallagher 2009, p. 39). This takes us a long way from the passivity of the relation of the Cartesian subject with her equally passive object. In this view, not only is perception active, but it is also indistinguishable from the sensory–motor action of which it is composed, and furthermore it is indistinguishable from thought.

This approach rehabilitates the claim of many embodied and situated making-activities for consideration as representing different ways of thinking. Indeed descriptive drawing, given its particular integration of perception with sensory–motor action, might in this view be regarded as a knowledge forging activity par excellence. As we shall see, this approach is promoted by a number of commentators notably Johnson (2007) and Noë (2004).

Enactive perception

The role of perception in knowledge generation is of course recognised as pivotal by many. Often, however, the kind of knowledge achieved through perception is regarded as somehow more primitive or lower than more abstract knowledge associated with conceptual/propositional thought. This latter coupling still represents the dominant epistemological paradigm within academia (Bourdieu 2000). Johnson objects to the tendency within Anglo-American philosophy in particular to 'retain an exclusive focus on the conceptual/propositional as the only meaning that mattered for our knowledge of the world' (Johnson 2007, p. 9). Indeed an objection to the privileging of conceptual and propositional knowledge over and above other ways of knowing (particularly those grounded in perception) is a feature of other alternative philosophical traditions from Schopenhauer to the phenomenology of Heidegger and Gadamer (McGuirk 2008).

Maurice Merleau-Ponty (2008, p. 34) tells us that, since Descartes, perception has been regarded as 'no more than the confused beginnings of scientific knowledge'. This is of course merely a rehearsal of the dualism we have already encountered. In Merleau-Ponty's ironic characterisation of this attitude we hear once more echoes of the Platonic distrust of the senses:

> The relationship between perception and scientific knowledge is one of appearance to reality. It befits our human dignity to entrust ourselves to the intellect, which alone can reveal to us the reality of the world (Merleau-Ponty, 2008, p. 34).

From a Pragmatist stance, Johnson attempts to overcome this bias, with reference to recent developments in cognitive science. He points to 'Dewey's continuity principle', which viewed the operations of 'mind' as having evolved through the development of increasingly complex 'sensorimotor' activity. He suggests that therefore 'there is no radical ontological or epistemological gap separating perceiving from thinking' (Johnson 2007, p. 228). Johnson references Arnheim's assertion that 'the cognitive operations called thinking are not the privilege of mental processes above and beyond perception but the essential ingredients of perception itself' (cited in Johnson 2007, pp. 227–228). Arnheim lists the cognitive operations that comprise thinking as 'active exploration, selection, grasping of essentials, simplification, abstraction, analysis and synthesis, completion, correction, comparison, problem solving, as well as combining, separating, [and] putting in context' (cited in Johnson 2007, pp. 227–228). What is striking about Arnheim's list is how closely it would parallel any list of the cognitive operations inherent within the act of descriptive drawing.

Noë's thesis emphasises the enactive nature of perception – indeed he insists that perception is indistinguishable from action at a fundamental level. In this view, perception is understood as not merely dependent on, but indeed 'constituted by' our possession of 'sensorimotor knowledge' (Noë 2004, p. 2). His theory presents vision as an explorative

interaction with the environment, more analogous to the active way a blind person uses their stick than to conventional understandings that appeal to '*internal representation*'; the 'pictures in the mind' paradigm. As he explains:

> According to this [enactive] approach to perceptual experience, the content of an experience is not given all at once, as is the content of a picture given all at once. Rather, the content is given only thanks to the perceiver's exercise of knowledge of sensorimotor contingencies. The content of experience isn't really given at all – it is enacted. Perceptual experience, according to this enactive approach, is itself a temporally extended activity, an activity of skill-based exploration of the environment (Noë 2008).

This approach is, as Noë recognises, highly amenable to accommodating the epistemic claims of the kind of embodied, situated and experiential knowledge native to art-making practices (Noë 2008). There is a correlation between perception and descriptive drawing; such drawing may be understood as 'a temporally extended activity... of skill-based exploration of the environment'. Such drawing demands the same kind of active searching, reaching, probing and testing that Noë recognises in ordinary looking. Drawing's epistemological status as a heightened mode of perceptually based thinking finds support in Noë's theory, particularly in the context of the pragmatist conflation of perception and thinking outlined by Johnson. Like Johnson, Noë holds that 'all perception is intrinsically thoughtful' and indeed that 'perception and perceptual consciousness are types of thoughtful, knowledgeable activity' (Noë 2004, p. 3).

Noë also stresses that 'perception and action may be related constitutively by dynamic patterns of circular input–output–input loopings' (Noë 2004, p. 235 n.20). So that if we understand observational drawing as a correlative of Noë's conception of 'enactive perception' then his analysis may be seen to echo insights regarding the feedback we encountered earlier from Vasari, Gombrich, Dewey and Bredo.

Drawing and 'active externalism'

A yet more radically 'situated' and 'enactive' understanding of cognition is presented in a controversial paper by Clark and Chalmers (1998), which presents a theory termed 'active externalism'. This is described by Noë as centred on the notion that 'the environment can drive and so partially constitute cognitive processes' (Noë 2006, p. 411). This is a radical take on the 'extension thesis' encountered earlier (Robbins and Aydede 2009, p. 3). As Robbins and Aydede explain:

> The Cartesian tradition is mistaken in supposing that the mind is an inner entity of any kind, whether mind-stuff, brain states, or whatever. Ontologically, mind is much more a matter of what we do within environmental and social possibilities and bounds.

Twentieth-century anti-Cartesianism thus draws much of mind out, and in particular outside the skull (Robbins and Aydede 2009, p. 8).

This has radical implications for our estimation of the epistemic status of drawing. Just as Noë insists that seeing 'is a dynamic probing process' (O'Regan and Noë 2001: 14), the idea of probing is also an essential part of drawing. Rosand reminds us that the 'movement of the draftsman's hand is a tracing on the surface and a probing of a world beyond' (Rosand 2002, p. 8).

But what of the probe? If we apply the concept of 'active externalism' (Clark and Chalmers 1998, p. 12) then when someone making a drawing uses something from the environment – something as basic as a piece of charcoal – the charcoal may be regarded as constituting, in a holistic sense, an *integral* element (as integral indeed as the hand or eyes) within a series of interactions that constitute a process of cognition. In this view the mind is extended beyond the skull, beyond the body out to where the charcoal tip meets the surface and beyond, to incorporate the paper's surface, the drawing and indeed the whole environment. The draftsman/woman is not merely 'thinking on paper' but is thinking *with* the environment, which includes the thing drawn, as part of a feedback loop.

Epistemic action

Clark and Chalmers adopt the phrase 'epistemic action' to describe the manipulation of diagrams on a computer screen as an aid in perceptual experiments involving the fitting of shapes into depicted 'sockets'. The coiners of the term define epistemic actions as 'actions performed to uncover information that is hidden or hard to compute mentally' (Kirsh and Maglio 1994, p. 513). Drawing may likewise be understood as 'epistemic action', whether descriptive drawing, to understand and reveal form, or more technical drawing – for example architectural drawings – used to analyse, explain, clarify and solve problems. Clark and Chalmers furthermore suggest that 'epistemic action… demands spread of epistemic credit', as they explain:

> If, as we confront some task, a part of the world functions as a process which, were it done in the head, we would have no hesitation in recognising as part of the cognitive process, then that part of the world is… part of the cognitive process…. In these cases, the human organism is linked with an external entity in a two-way interaction, creating a coupled system that can be seen as a cognitive system in its own right (Clark and Chalmers 1998, p. 11).

Note that feedback is an essential aspect in this analysis. Noë's description of this process whereby 'the mind reaches… beyond the limits of the body out into the world' (Noë 2006, p. 411) echoes Rosand's description of drawing. If we apply this model to drawing

we must accept that in the cognitive process represented by drawing, the body and the hand, the pencil and the page are all integral, indeed indispensable parts of that process – the thinking process.

Conclusion

Relatively recent developments in higher education in art and design internationally have brought the question of knowledge and knowledge generation to the fore. These developments include the absorption of art and design education into the universities, the emergence of 'research' in fields of art and design and the development of the PhD degree within these fields. With regard to the latter development, the normative expectation that PhD research ought to produce 'new knowledge' is foregrounded. James Elkins has critiqued this approach, suggesting that the application of terms like 'research' and 'new knowledge' to 'studio work' is both 'artificial' and 'problematic' (Elkins 2009, pp. 111–133). He also recognises that 'one way to defend the idea that the studio produces knowledge is to invest the materials of art with an intellectual or conceptual status'. He acknowledges that the phenomenological tradition from Husserl to Mark Johnson presents an alternative conception of knowledge more amenable to the field. However, he objects that all of these 'stretch the meaning of *knowledge*' (emphasis in the original) and thereby constitute 'special pleading' (Elkins 2009, p. 115).

Elkins suggests that securing the place of art production in the university presents an 'immensely difficult' 'problem' (Elkins 2009, p. 128). This is due to the disjuncture between the theorising and 'conceptualising' of the 'finished' products of art practice, and the more problematic 'experience of making – its exact pedagogy, its methods, knacks and skills' that 'is prior to any talk about art' (Elkins 2009, p. 128).

From Renaissance theories of *disegno* to our current debates, it would seem that the preferred solution to the problem of fitting embodied and situated 'making' practices into the academy continues to be the conferring of intellectual status through the filter of propositional and conceptual knowledge and through the media of academic language and methods. As Candlin recognises, such knowledge remains the epistemological gold standard for the academy. Pierre Bourdieu describes this tendency within the 'scholastic disposition' as 'a repression of the material determinations of symbolic practices' (Bourdieu 2000, p. 20). He sees this as singularly apparent in 'the early moments of the autonomisation of the artistic field' – the era of the *Accademia del Disegno*. Bourdieu's analysis of this phenomenon remains pertinent in terms of current debates:

The slow, painful process of sublimation through which pictorial practice asserted itself as a purely symbolic activity denying its material conditions of possibility has a clear affinity with the process of differentiation of productive labour and symbolic labour that proceeded at the same time (Bourdieu 2000, pp. 20ñ21).

Bourdieu sees this division of productive and symbolic labour as undiminished within contemporary academia. Like Dewey, he sees this as the product of an 'academic aristocratism' that promotes an exclusion from 'scholastic universes' of base means and métier (Bourdieu 2000, p. 25). The extent of this is reflected in the dearth of academic discussion (recognised by Elkins) of the practical, embodied and situated aspects of 'art production' (Elkins 2009, pp. 128–129).

It is in this context that the insights generated within the broader field of 'situated cognition' become relevant. This is particularly true with regard to the light that embodied, embedded and extended conceptions of cognition, including 'enactive perception' and 'active externalism', cast on the epistemological significance of artistic practice in general and drawing in particular.

It is doubtful that we can begin to tackle the 'problem' that Elkins diagnoses at the heart of the 'incommensurability of studio art production and university life' (Elkins 2009, p. 128) unless we are prepared to grasp the nettle by taking radically progressive steps to stretch the meaning of knowledge. If we fudge this issue as we have historically done and as we are culturally predisposed to doing, then not only do we fly in the face of recent lessons from the forefront of philosophy and cognitive science but we also miss a huge opportunity for a re-envisioning of the university itself. Noë suggests, for example, that 'art can make a needed contribution to the study of perceptual consciousness… [and] can be a tool for phenomenological investigation' (Noë 2000, p. 23).

As early as 1926 Martin Heidegger urged us to recognise that 'the kind of concern which manipulates things and puts them to use… has its own kind of "knowledge"' (Heidegger 1962, p. 95). We need to take radical if belated steps down that path.

Finally with regard to the broader university we need – to borrow a phrase encountered earlier – a 'spread of epistemic credit', and by reappraising drawing as a mode of 'epistemic action' not only do we begin to better understand drawings' potential as a mode of knowledge generation, but we also begin that vital process.

References

Bermingham, A. (2000) *Learning to Draw: Studies in the Cultural History of a Polite and Useful Art,* Newhaven and London: Yale University Press.

Bourdieu, P. (2000) *Pascalian Meditations,* London and Cambridge: Polity Press.

Bredo, E. (1994) Cognitivism, situated cognition and Deweyian pragmatism, *The Philosophy of Education Society Yearbook 1994*. Accessed July 26, 2008 – 13.20 GMT. http://www.ed.uiuc.edu/EPS/PES-Yearbook/94_docs/BREDO.HTM.

Candlin, F. (2000) Practice-based doctorates and questions of academic legitimacy, *London: Birkbeck ePrints.* Available at: http://eprints.bbk.ac.uk/737/. Originally published in the *International Journal of Art and Design Education* 19 (1): 96–101.

Clark, A. and Chalmers, D. (1998) The extended mind, *Analysis* 58: 10–23.

Dewey, J. (1930) *Democracy and Education: An Introduction to the Philosophy of Education,* New York: Macmillan (first published 1916).

Elkins, J. (2009) On Beyond Research and New Knowledge in Elkins J. (Ed.) *Artists with PhDs: On the New Doctoral Degree in Studio Art,* Washington DC: New Academy Publishing.

Frayling, C. et al. (1997) United Kingdom Council for Graduate Education, report: *Practice-Based Doctorates in the Creative and Performing Arts and Design.* Also available online, as accessed on June 4, 2010 – 2.40 pm: www.ukcge.ac.uk/Resources/.../PracticebaseddoctoratesArts%201997.pdf.

Gallagher, S. (2009) Philosophical antecedents to situated cognition, in P. Robbins and M. Aydede (Eds) (2009) *Cambridge Handbook of Situated Cognition,* Cambridge: Cambridge University Press.

Goldstein, C. (1996) *Teaching Art: Academies and Schools from Vasari to Albers,* Cambridge: Cambridge University Press.

Gombrich E.H. (1982) *The Image and the Eye: Further Studies in the Psychology of Pictorial Representation,* London: Phaidon Press.

Heidegger M. (1962) *Being and Time*, trans. J. Macguarrie & Robinson E. Oxford: Blackwell.

Johnson M. (2007) *The Meaning of the Body,* Chicago and London: Chicago University Press.

Kirsh, D. and Maglio, P. (1994) On distinguishing epistemic from pragmatic action, *Cognitive Science* 18: 513–549.

Lakoff, G. & Johnson, M. (1999) *Philosophy in the Flesh,* New York: Basic Books.

Langmuir, E. and Lynton, N. (2000) *The Yale Dictionary of Art and Artists,* New Haven and London: Yale Nota Bene – Yale University Press.

MacLeod, K. (2000) The functions of the written text in practice-based PhD submissions, *Working Papers in Art and Design,* Vol. 1. Retrieved December 28, 2010 12.35 pm. http://sitem.herts.ac.uk/artdes_research/papers/wpades/vol1/macleod2.html.

Mareis, C. (2007) The art of illustration, in R. Klanten & H. Hellige (Eds) *Illusive 2: Contemporary Illustration and Its Context,* Berlin: Die Gestalten Verlag.

McGuirk, T. (2008) Beyond prejudice: Method and interpretation in research in the visual arts. *Working Papers in Art and Design* Vol. 5. Retrieved December 28, 2010, 12.50 pm http://sitem.herts.ac.uk/artdes_research/papers/wpades/vol5/tmfull.html.

Merleau-Ponty, M. (2008) *The World of Perception,* New York and Abingdon, Oxon: Routledge (Originally published in French as *Causeries* 1948).

Noë, A. (2008) Art as enaction, in *Intredisciplines.* Online, accessed February 17, 2011 15.08 GMT: http://www.interdisciplines.org/medias/confs/archives/archive_1.pdf.

Noë, A. (2004) *Action in Perception,* Cambridge MA and London: The MIT Press.

Noë, A. (2006) Experience without the head, in T. Szabó Gendler and J. Hawthorne (Eds) *Perceptual Experience,* Oxford: Oxford University Press.

Noë, A. (2000). Experience and experiment in Art. *Journal of Consciousness Studies,* 7(8–9). 123–35.

O'Regan, K. J. and Noë A. (2001) A sensorimotor account of vision and visual consciousness, in *Behavioral and Brain Sciences* (2001) 24(5).

Pallasmaa, J. (2009) *The Thinking Hands: Existential and Embodied Wisdom in Architecture* Chichester: John Wiley and Sons.

Porter, J. I. (1997) Aristotle and specular regimes, in M.D. Levin (Ed.) *Sites of Vision: The Discursive Construction of Sight in the History of Philosophy* Cambridge MA and London: The MIT Press. (Plato *Statesman* 259e–260e).

Robbins, P. and Aydede, M. (Eds) (2009) *Cambridge Handbook of Situated Cognition,* Cambridge: Cambridge University Press.

Rosand, D. (2002) *Drawing Acts: Studies in Graphic Expression and Representation,* Cambridge: Cambridge University Press.

Chapter 2

Trajectory, Torque and Turn: Art and Design Education in Irish Post-Primary Schools

Gary Granville

The terms *trajectory* and *torque* have been used to describe how phenomena locate themselves within classification systems: people, institutions and systems, described and constructed within categories and classifications, each have trajectories that may pull or torque each other over time if they move in different directions or at different rates (Bowker and Star 2000, p. 195). The application of these terms to education seems very apt, especially in the light of the Irish education system's ever-increasing tendency towards classifications, frameworks and grids. The Celtic torque itself, as a defining feature of ancient Irish art, adds resonance to that term. The term *turn* is regularly used to capture a strategic shift in epistemological or philosophical position, notably in respect of the pedagogical turn in art and curatorial practice in recent years (O'Neill and Wilson 2010). This alliterative trilogy of trajectory, torque and turn is used as a frame and as a metaphor within which this chapter will address the evolution and current state of art and design education in Ireland, with particular reference to the post-primary curriculum.

This chapter addresses art and design education in Ireland in terms of the trajectory of its historical evolution on the margins of the formal education system, the torque of its attempts to find a secure place within that system and the turns of its confused relationships with art practice, design industry and educational policy. The chapter is concerned with the marginality of art and design education in relation to curriculum policy generally (*trajectory*), the conflicted values and practices involved when art and design education tries to assert itself in a wider education system increasingly expressed in terms of modular curricula, learning outcomes and performance criteria (*torque*) and the dilemmas art and design education faces as it looks on the one hand to art and design practice and on the other to education policy (*turn*).

Trajectory – art and design on the margins of policy

Art and design has been on the periphery of Irish education since the foundation of the state. Indeed, it could be said that the foundation of the independent Irish state secured that marginalisation. The stirrings of a child-centred and practical curriculum including 'drawing' as a central element in the education of all pupils had emerged in the *Revised Programme for National Schools* in 1900. This programme presented an insightful, integrated approach to learning, which valued the development of art and

craft education as a common and central element of the education of all young people. The orientation of the newly established Irish Free State in 1922, however, set cultural nationalism as the priority issue for schools. In this climate, 'drawing' – among other aspects of the curriculum perceived as less important – was sacrificed in order to include the teaching of Irish language and other such badges of the new orthodoxy (Brown 2004, p. 41; Coolahan 1981, p. 40).

The arts generally, including the visual arts, had been prominent in the cultural revival of the late-nineteenth and early-twentieth century, out of which grew the national identity emblematic of the new state. The hope that the new state accordingly would see an enlightened policy in art education was noted by one prominent art figure of the time, who wrote to the incoming minister of education advising on new directions, including the development of art education. He got the reply that 'your proposals are excellent and will be of immense assistance to us when this department is being put on a proper footing' (Bodkin 1949). Unfortunately, the writer learned that subsequently his memorandum had been adversely criticised by civil servants and his advice disregarded by the succeeding ministers. Reflecting on this and similar incidents relating to art education in the new state, one art historian notes that 'the important role of the visual arts in the cultural revival in the early years of the century had been little appreciated by the politicians and administrators of an independent Ireland' (Turpin 1995, p. 233).

Through the twentieth century, the status and esteem accorded to the visual arts remained at a low level. In a report published in 1949, Bodkin noted that

[i]n Irish schools, the subject of art, in either the historical or practical aspect, is neglected. Few of the principal schools and colleges, for either boys or girls, employ trained teachers to deal with it, or possess the requisite accommodation and equipment for the purpose (p. 31).

Support for the visual arts in education, usually interpreted as drawing and art, was apparent in some influential quarters however, including an internal committee within the Department of Education in 1947 whose work produced no official response. In 1944 the Commission on Vocational Organisation urged the inclusion of drawing and rural science in all national schools and the Irish National Teachers' Organisation (INTO) published a policy paper in 1947 proposing major educational reforms including a child-centred curriculum 'embracing literary, aesthetic, practical and physical education'. A Council of Education was established in 1950 and its report on primary education published in 1954, although not calling for any radical reform, did urge the re-introduction of drawing, nature study and physical education as compulsory subjects (Coolahan 1981, pp. 44–45).

In 1962, some 12 years after its establishment, the Council of Education published its report on the curriculum of the secondary school. Like its earlier report on the primary curriculum, this report for the most part supported the status quo, seeing no need for

significant reform of curriculum or structures. However, even this quite conservative document did attest to the neglected state of art and craft education, reiterating its earlier report's recommendation that

> drawing be re-introduced into the primary curriculum because of its aesthetic and practical values: it trains hand and eye, cultivates self-expression, stimulates intelligent interest, develops appreciation of form and colour and beauty, helps to form good taste (Council of Education 1962, p. 208).

It went on to note that in the secondary-school curriculum, two subjects – drawing and art – were offered for examination at Intermediate and Leaving Certificate (LC) levels. The two subjects overlapped in terms of syllabus content with drawing being taken by 2,353 LC candidates in 1957, out of a total cohort of 6,665, with some 648 candidates also or separately taking art in the examination: thus, approximately 45% of the LC cohort were sitting an examination in drawing or art.[1] Interestingly, about twice as many boys as girls took drawing, whereas almost ten times as many girls as boys took art (580 girls, 62 boys).

The commission recommended that the two subjects be combined and that the aim of art teaching in the secondary school should be 'the development of aesthetic sense and practice in the various techniques that will form a suitable foundation for further professional study' (p. 210). For higher level 'honours' students, it was recommended that history and appreciation of art be added, in order, among other things, to give students 'the facility to assess the quality of design in daily life as exemplified in interior decoration, furniture, pottery, carpets and other textiles, domestic utensils and pictures' (p. 212). Although this report did not recommend any major structural or curricular changes in secondary education, and although even the modest recommendations that it did offer were not acted upon, the years that followed its publication were to bring some radical changes in the discourse and practice of both education in general and the role and perception of art and design in education and society.

Art and design as a general field of endeavour and as an educational orientation came under intense scrutiny at this time. A specially commissioned review of the state of design in Ireland, conducted by a team of Scandinavian experts, concluded that 'the Irish schoolchild is visually and artistically among the most under-educated in Europe [and]… is exposed in a much lesser degree to drawings and the manipulation of materials than the Scandinavian counterpart' (Franck et al. 1961, p. 49). A design council, established on foot of that report, noted shortly afterwards that 'indifference to the importance of good design in every aspect of the school (often dictated by what is felt to be economy) has been part of an educational tradition in which art as a whole has been gravely undervalued (Council of Design 1965, p. 6). The impact of the *Design in Ireland* report was profound, not just in relation to the data it presented or the recommendations that it made, but, in the words of Turpin (1995, p. 259) 'in its exposure of Irish design to the shock of international comment. The report came like a bombshell into the provincial and

complacent atmosphere of Irish art and design education'. Some significant initiatives were undertaken in the wake of the report, including the establishment of the Kilkenny design workshops, the national design council and eventually, the incorporation of design into the title and mission of the restructured National College of Art and Design in the 1970s. Despite this, however, 30-odd years later the potential of design education remained untapped in the curriculum of Irish schools and it was suggested that a dedicated initiative was required in order to realise the rhetoric of curriculum reform (McCarthy and Granville 1997, p 23).

The latent discontent in art and design education manifested itself most dramatically in the turmoil experienced at the National College of Art in the late 1960s and early 1970s. Student and staff unrest directed mainly at the nature of the curriculum in the college and at the restrictive influence of the state Department of Education, which directly controlled the college, resulted in a number of confrontations, leading ultimately to the suspension of classes and the establishment of a new National College of Art and Design in 1974 (Turpin 1995). This was a time of international student unrest, of course, and one of the most influential international artist–educators was prominent in developments in Ireland. Joseph Beuys gave a series of public lectures in 1974, in conjunction with an exhibition of his own work, in Dublin, Cork, Limerick, Belfast and Derry (Tisdall 1975, Delap 2011). Beuys considered locating his newly founded Free International University for Creative and Interdisciplinary Research in Dublin; one of the venues under active consideration was the then disused Royal Hospital, Kilmainham, later to become the home for the new Irish Museum of Modern Art (IMMA). As events developed, Beuys adopted an alternative vision for his Free University, one of a nomadic nature, with no fixed base.[2] His engagement with Irish education and art was nevertheless a significant encounter, both in terms of his own experience and formation and that of Irish art and design education.

The 1960s were a significant moment of change in Irish life generally but especially so in education, with the publication in 1966 of the influential OECD *Investment in Education* report, the introduction of free second-level education in 1967 and the abolition of the old primary certificate examination to be replaced with an imaginative new primary curriculum. This new curriculum, introduced in 1971, provided for considered and comprehensive treatment of the visual arts, including crafts, as part of a developmental programme for all school children.

At the second level, a new syllabus for art in the LC was introduced in 1969. It reflected the essential tenor of the Council of Education's recommendations in respect of art education, including a substantial element of art history and appreciation. In a perceptive comment, Stapleton (2010, p. 115)) notes that 'the introduction of the art syllabus came at the end of one era but too early for the modernising influences of the 1970s'. The syllabus was to remain in place for more than 40 years.[3]

In 1979, after the first wave of euphoria regarding the new primary curriculum had waned and some ten years after the introduction of a new LC art syllabus, the Arts

Council of Ireland published a major report, *The Place of the Arts in Irish Education*. This report, referred to as the Benson report after its chief author, painted a damning portrait of the arts in education, despite the rhetoric of national curriculum policy. In respect of the visual arts, the report noted the inadequate implementation of the new primary curriculum and the continuing marginalisation of art at second level. The heavy weighting (37.5%) given to art history within the LC art syllabus was seen to be inappropriate, projecting a diminution of the educational value of art making as such. The report confirmed the recurring criticism of how art was valued in the education system, noting that the subject was disproportionately offered to academically lower-achieving students, that art was seen as more appropriate for girls than boys, that the standard of achievement in art was poor and that assessment modes and techniques were inadequate (p. 41). The report echoed the tone of the Bodkin report some 30 years earlier and stated that Irish schools had failed to achieve any significant advance in terms of the arts.

The trajectory of art and design education through the twentieth century was one of marginality, maintaining a tenuous connection with the mainstream of schooling – undervalued, under-resourced and under-provided. The series of scathing reviews in the 1960s and 1970s established a platform and impetus for reform. The extent to which change and development would occur remained to be seen.

Torque: art and design in curriculum context

The arts have never been central to the educational experience of Irish students. At various stages in the evolution of Irish education through the past hundred years or so, art and design has been cited as potentially significant but never placed at the centre of teaching and learning. This section addresses the relationship, at times tortured and at times inert, among art and design education, national education policy generally and the wider society.

Bowker and Star (2000), looking in particular at health system classifications, use the term *torque* to describe the bends or twists one phenomenon may experience in attempting to align itself within a more powerful system of classification. For the purposes of this chapter, we can apply this sense to the experience of art and design education attempting to locate itself within the wider education system of subject hierarchies, points systems and awards. 'When all are aligned, there is no sense of torque or stress; when they pull against each other over a long period, a nightmare texture emerges', suggest Bowker and Star (p. 27). The current state of art and design education in Ireland is addressed here to ascertain the extent of such alignment or torque.

At primary-school level, the established primary certificate curriculum, which dominated schooling for the first five decades of independence, emphasised the core subjects of Irish, English and arithmetic. In this context, the 'new curriculum' for primary

schools, introduced in 1971, was revolutionary in its child-centred orientation and its advocacy of integrated teaching methodologies. The role of the arts was encouraged but its realisation was unfulfilled (CEB 1985, p. 16). However, the revised primary curriculum of 1999 marked a significant landmark in foregrounding the role of the arts in Irish education, making an arts education a required element of learning for all primary school children (up to 12 years of age approximately). The presentation of that curriculum, incorporating visual arts, music, drama and dance was highly sophisticated. The status of Visual Art was further validated through its inclusion in the first round of subject areas to be implemented and supported in the revised curriculum.

However, recent research indicates a number of challenges in terms of teacher confidence and pupil experience of art at primary level (DES 2005a; NCCA 2005). The capacity – or more particularly the confidence – of teachers to teach art successfully as a subject in itself and as part of an integrated approach to the whole curriculum has always been problematic. Recent studies have highlighted the relatively low level of prior art education experience of primary-school teachers (Cleary 2010; Flannery 2010), while simultaneously noting their high regard for and positivity towards the potential of art in education. In respect of one cohort of student teachers taking an initial teacher education programme, Donnelly (2003, p. 98) found that about 85% did not study art to any significant extent after their own primary schooling; indeed, some 97% had not taken art at LC level. This presents a challenge to teacher educators and to art educators to devise strategies to break the vicious cycle of inadequacy in art education. Experiences in continuing professional development (Flannery 2010; NCCA 2005) offer positive signs of constructive engagement and progress in this regard.

At second level (aged roughly 12 to 18 years), the arts are present but not central or common to all students. The literary arts, experienced largely through poetry, fiction and plays as part of the English syllabus, have always been prominent but usually in a passive sense. For instance, drama is neither a subject nor an examinable element of any course within the national Junior Certificate or established LC programmes,[4] plays being encountered as text not performance. No discrete courses in drama or dance are provided, though dance is incorporated to a limited extent in the physical education syllabus. Only art and music are provided as stand-alone arts subjects.

Within the period of compulsory education (up to age 16 years) about 44% of students take Art, Craft, Design as a subject for the Junior Certificate at the end of lower secondary cycle, with some 23% taking Music (DES 2005b). In the post-compulsory upper secondary cycle, about 20% of the cohort takes Art for the LC examination, with only 4% studying Music. Art is a relatively popular subject, about 9th or 10th in the annual 'top ten' list of subject take-up (DES 2005b; McDonagh, 2010). Dissatisfaction with the current LC art syllabus is commonplace, however, and art teachers have been particularly vocal in criticism of its structure, which still retains great reliance on terminal examinations, including more than one-third of marks for history of art and design, assessed by discrete written examination. By contrast, the Junior Certificate Art,

Craft, Design syllabus incorporates project assignments and integrated support studies in its assessment modes. A revised LC course was prepared and approved in 2005 but its implementation has been deferred indefinitely; this delay has further alienated the art education constituency and increased the perception of marginalisation of art within the curriculum.

The LC examination is a very high-stakes rite of passage for school leavers in Ireland. Nearly 80% of the age cohort sits the exam and the examination is the dominant selection mechanism for entry into higher education and employment. Points for selection onto higher education courses are calculated on the basis of student performance in six subjects, with a competitive system of place allocation on the basis of demand for courses. However, there is a long-standing disjunction between 'school art' and higher education art and design in Ireland. Although most college selection is based on points calculated on LC performance, art colleges operate separate entry procedures, centred on portfolio presentation. Criteria for assessment of these portfolios bear little resemblance to those for assessment of the LC Art. As far back as 1976, a report on awards in art and design in higher education noted that 'the standard of art at second level is so mediocre that the results obtained in the subject at the Leaving Certificate examination are no indication of a student's potential' (NCEA, p. 2). This disjunction between school art and art school, of course, is not unique to Ireland. The observation of one art-school teacher in Germany that 'the first thing you have to do with students who are just beginning is destroy their expectations, this kitsch they enter art school with' (in El Dahab 2008, p. 137), perhaps overstates but still resonates with the conventional perception of Irish art college lecturers.

Art and design courses are offered in some seven colleges in Ireland, all but one within the Institutes of Technology sector. The National College of Art and Design (NCAD) is a recognised college of the National University of Ireland and currently operates within an Academic Alliance with University College Dublin (UCD). The profile of art and design students by and large has been one of social bias towards middle-class representation. One significant study has shown that students from professional, employer, managerial and salaried employee groups are over-represented in art and design colleges, by two and a half to three times relative to their representation in the national age cohort (O'Donoghue 2003, p. 117). The same study shows that students from a 'non-manual' background are more likely to enrol in fine art as distinct from design courses whereas students from a manual background are more likely to choose design courses than fine art, with students from a working-class background being most strongly represented in craft design courses, 'the most functional of all design disciplines' (p. 123).

Art and design education in post-primary schools exists in a constant torque between the push of art and design practice on the one hand and the pull of the school curriculum and examination system on the other. The tensions and conflicting demands of these different constituencies is well illustrated in the evolution of art as an LC subject within the context of the LC examination as a selection mechanism for entry to higher education.

The introduction of free post-primary education in 1967 led to a consequent rapid growth in the number of students applying for higher education. Matriculation requirements for entry to university, and later for entry to the newly established regional technical colleges, subsequently to become Institutes of Technology, were pegged against the national LC examination results. The introduction of the points system coincided with the phasing out of the separate matriculation examination for entry into Irish universities. The points system was designed as an objective process of allocation of places on university courses, based on the aggregate performance of students on six LC subjects. The system emerged from localised college or faculty procedures in the late 1960s and early 1970s to a national system of centralised application to higher education. The Central Applications Office (CAO) was established in 1976 to process all university applications and has since extended to almost all higher education courses in almost all colleges in Ireland (Commission on the Points System 1999pp. 12–15).

The role of the universities in recognising LC subject examinations as appropriate predictors of university performance was crucial. Two LC subjects in particular were subjected to some intensive assessment and sceptical university comment, in the late 1960s, as matriculation requirements for university selection began to be a contentious issue – Home Economics, or Domestic Science as it formerly had been known, and Art were both seen as perhaps inappropriate for university entry, lacking, it was alleged, the necessary academic rigour. A new Home Economics subject was introduced in 1969; Home Economics (Scientific and Social), as distinct from the traditional Home Economics general syllabus, which was almost entirely practical in content. By contrast, the 'social and scientific' syllabus as it came to be known, introduced aspects of social science and related studies, and was assessed through a terminal written examination (Rohan 2007). This new syllabus quickly overtook the older practical syllabus, as the new entity alone carried the valuable currency of university recognition (the two courses co-existed until 2002 when they were replaced by a unified course).

The then conventional academic understanding of 'practical' as distinct from 'intellectual' work discerned no significant distinction between the practical work of the Home Economics kitchen and that of the art and design studio. The same considerations of academic respectability were demanded of Art as of Home Economics. In that context, a new syllabus for LC Art was introduced also in 1969, containing a mandatory history of art element comprising 37.5% of total marks for the subject. The assessment of this element of the subject was, and remains, through a discrete, terminal, written examination. These new arrangements satisfied the requirement of the universities for an explicit 'academic' element in all subjects designated as calculable for points accumulation for entry purposes. The new syllabus thus served to establish Art as a subject equal in status to other LC subjects.

However, the new arrangement contained a number of negative aspects. Firstly, it revealed the very restricted perspective of university authorities on what constitutes academic learning and on the nature of intelligence. In essence, the requirements of the universities betokened an attitude that only the capacity to write essays in traditional

manner constituted evidence of the 'intelligence' required of university students. It indicated a distrust, if not an absolute ignorance, on the part of university authorities and education policy-makers in general, of the nature of intelligence that underpins art and design thinking, process and production. The fact, for instance, that 'practical' knowledge in Home Economics was seen as equivalent to practical knowledge in art and design displayed an ignorance of the epistemological processes of these disciplines, on the part of academics largely drawn from the classical liberal humanities or physical sciences. Subsequent developments in our understanding of what constitutes intelligence, including the influential multiple intelligence theories of Gardner and others have not resulted in any repositioning of this issue.

It also laid the basis for the divided practice in teaching and learning art in schools, where history of art and design is taught and experienced almost entirely separately from the making of art and design. This has the effect of restricting many students from high performance in art. Students whose practical work may be of the highest quality but whose written production may not be of the same standard have found it particularly difficult to achieve first-class awards (initially grade A or latterly, grades A1 or A2) in the subject, as some 37.5% of the available marks are allocated to history of art. By the same token, other students, who may be particularly high achieving in subjects such as English, History or Classical Studies may score disproportionately highly in Art, despite not being outstanding in the practical or studio-based elements of the course.

The need for a new syllabus in art for the LC has been noted for a long time. The new Junior Certificate *art, craft, design* syllabus, introduced in 1989, was greatly welcomed at the time. As its title indicated, the new syllabus was not dominated by the fine art tradition as had traditionally been the case, but instead presented a comprehensive and structured exposure to and engagement in art, craft and design. The syllabus set out to engage learners within a holistic experience linking head, heart and hand (DES 1988). All students were required to engage with the syllabus through a focus on drawing, on two-dimensional studies and on three-dimensional studies. It incorporated a project-driven component of learning, with students with undertaking tasks over an extended period, rather than performing under one-off examination conditions. It also included a support-studies component, where the work of artists and designers from contemporary practice and from historical contexts can be used as reference points in the ongoing project and within the material accompanying the finally submitted pieces.

The logical development of an appropriate follow-through from the Junior Certificate to the LC was recognized from an early stage, and a course committee was established to produce such a syllabus in 1995. A draft syllabus was prepared and issued for consultation in 1999 but a final text of the syllabus was not formally approved by the NCCA until 2005. Along with four other subjects, all within the 'technology' range, the new Art syllabus was submitted to the Minister for Education for approval. Approval was granted in 2006, but a stay on implementations was ordered, pending adequate resources. The syllabus remains unimplemented in 2011, with no immediate plans on the horizon.

Turn – pedagogy and practice in art, design and education

In an ironic counterpoint to the marginalised status of art education in Ireland, much of the current rhetoric in Irish education is presented in language that has long been the lingua franca of the arts. The development of creativity is expressed as an underpinning feature of all education policy (Ireland 1995), and the qualities of such an education are described in terms of an ability to experiment, to innovate, to seek appropriate solutions to given problems rather than the 'right answer' – in the words of the then Minister for Education and Skills:

> Our learners need to be flexible, adaptable, resilient and competent if they are to participate successfully in society and be enabled as independent learners throughout the whole of their lives. They need to develop critical thinking skills and move away from the trend towards rote learning. Curriculum reform must result in a more active learning experience for the individual, promote a real understanding within learning, and aim to embed a seed of creativity and innovation in the learner (Coughlan 2010).

The congruence between such general aspirations of education policy and the essential language of arts education has never been realised by policy-makers. Curriculum specifications increasingly dominated by defined learning outcomes and assessment procedures defined by external, terminal examinations, with prescribed formats, predictable questions and transparent marking schemes, all present a challenge to a subject like Art and Design in terms of its inherent orientation towards divergent thinking, intuitive processes of working and crucially, the educative values of failure as a process of learning and of resolving design issues and art processes.

The impossibility of teaching art has been a recurring theme among art educators. Elkins, referring specifically to assessment issues, notes the radical distinction between 'the crit' in art studio teaching and conventional examinations. Conventional tests, according to Elkins, are boring, telling little about the qualities of the person, only promoting the accumulation of systematic knowledge:

> Critiques are an entirely different matter. They are unbelievably difficult to understand and rich with possibilities. All kinds of meaning, all forms of understandings can be at issue.... But the price critiques pay for that richness is very high. Critiques are perilously close to total nonsense. They just barely make sense – they are nearly totally irrational (2001, p. 166).

Such a tenuous process of assessment practice does not lend itself easily to the requirements of high-stakes public examinations like the LC. The same issue caused Noel Sheridan, then director of NCAD, to ask – 'what is it about art?' as he pondered the dilemma of

the relationship between art education and the art world, the dilemma of 'that which cannot be taught':

> It is this unspecific mode of interaction that is coming under most pressure from the modular, time-and-motion, quality assessment managers who see this as lost time (Sheridan 1999: 29)

His concern was that the wave of globalised educational reform, emphasising concepts of transparency, accountability and modular curricula structured around learning outcomes, although laudable in many respects, did not sit easily with either the practice of artists and designers or the practice of art and design educators. The 'unspecific mode of interaction', which is the hallmark of the relationship between tutor and student in art college, is not easily amenable to incorporation within the current curriculum framework of the post-primary school.

Another experienced Irish art educator addressed the same vexed question, in the particular context of preparing primary-school teachers to incorporate appropriate methodologies in the teaching of art to young children. She proposed the development of 'the percipient eye' as the central focus of art education. This is 'an immersion process, somewhat analogous to osmosis....The ability to recognise art and to trust one's own judgement is a form of knowledge by acquaintance (Donnelly 2003, p. 100). Such an immersion process is not easily achieved within the curriculum structures, timetables and assessment demands of current education policy.

The development of discipline-based art education (DBAE) over recent decades has located art education firmly within the general discourse of education. Despite this, these sorts of statements about the 'unteachability' of art keep chipping away at the conventions of education policy, making the case for an essential difference between art education and other disciplines and forms of education. The more the current hegemony of learning outcomes, targets and performance indicators asserts itself in education policy, the more divergent art education appears. Attempts to capture art education within this new consensus may be counter-productive. Perhaps, the call that Elliot Eisner (2004) made some years ago is even more relevant today in respect of education policy, that

> shifting the paradigm of education reform and teaching from one modeled on the clockwork character of the assembly line into one closer to the studio or innovative science laboratory might provide us with a vision that better suits the capacities and the futures of the students we teach.

Unfortunately, the indications are that a contrary track is being pursued by Irish education policy-makers. There may be a watershed in art education policy visible in the relationship between two national publications in recent years. *Points of Alignment* (Arts Council 2008) was a report commissioned by the Arts Council, about 40 years

after the landmark Benson Report, again to address the role of the arts in education. The report proposed a partnership approach between the cultural sector and the education sector in the promotion of the arts in schools. The report met with no official response from the Department of Education and Skills (DES). Instead, a very significant recent DES strategy paper *Better Literacy and Numeracy for Children and Young People* (2010) may have signalled a new 'turn' in education policy. A renewed emphasis on literacy and numeracy is seen to require a more restricted curricular provision. Whereas a broad interpretation of literacy is presented in the opening paragraph, the document generally adopts a functional skills approach. The policy proposal is 'to give priority to the improvement of literacy and numeracy over other desirable, important but ultimately less vital issues' (p. 11). It goes on to refer (p. 25) to demands from 'organisations, interest groups and various educators' for the inclusion of such elements as 'social and life skills, environmental issues, arts and music education', which are seen by implication to be not among the priorities for the future. This rapid turn away from the consensus rhetoric of the previous two decades echoes similar shifts in England and Wales, with the same concerns for the status of an already marginalised arts education sector (Steers 2011).

In the context of this *turn* to a more functional view of literacy and a more restricted view of curriculum, the capacity of art education to contribute to general education, let alone to realise what Rogoff (2010) calls the processual nature of a creative enterprise, is under increased threat. The aspiration of arts educators, as articulated through the Arts Council's *Points of Alignment*, seems farther from achievement than ever. The negotiating strength of the arts within the school system, especially at second level, is weak. By contrast, developments within the informal education sector, at community level, have been perhaps the most imaginative and exploratory in Irish education. Between the retrenched rhetoric of basics, as enunciated by the DES and the radical investigations of education through art at the margins of the formal system, lies the negative space occupied by the formal curriculum of art.

The current educational turn in art practice, as documented for instance in O'Neill and Wilson (2010), is concerned not only with art *as* education, but also with the relationship between art practice and art education processes. Most, though by no means all, of that discussion has been concerned with art education in third-level art colleges, galleries and similar cultural institutions. Engagement with younger learners, adolescents in a formal or informal education setting is perhaps a more challenging issue. In the Irish context, there have been a number of innovative, ground-breaking initiatives in the domain of informal education in recent years[5]. Yet the scope within the formal school classroom for the incorporation of such approaches or insights is greatly restricted both by the curriculum and examination structures and by the limited support provided to teachers in their initial, induction and continuing professional development courses.

The long delay in introducing a new LC art syllabus indicates a certain lack of concern or priority in relation to art in the curriculum. The nature of curriculum design process in Ireland may also serve as a brake on real reform. There is a real danger of

institutionalised thinking within the structural process of curriculum design (Granville, 2004). Course committees for all subjects on the curriculum are constructed according to a designated representational composition. This composition includes significant teacher representation through union and subject association. This compositional formula was a significant breakthrough when first introduced in the 1980s, replacing the system whereby subject syllabi were drawn up by the department of education inspectorate, with varying levels of consultation with other interests. LC syllabuses were always heavily influenced by university advisors, and LC examination papers were given to such advisors annually for approval. In the case of art, the longevity of the current syllabus has meant that many generations of students have experienced the same syllabus and similarly, no teacher of art would have a memory of any other syllabus or exam structure other than the present one, which has been in operation for about 40 years. In this context, the generation of new ideas and new frames of conceiving possibilities may be eclipsed by the weight of custom and practice.

The draft LC syllabus still contains a discrete history of art element, though this is considerably altered in content, with a range of modules, including film, oriental culture and contemporary Irish art. It is weighted at 30% of total marks in the examination, a reduction in proportion but not in structure, as compared to its predecessor. One wonders how much consideration was given to radical reconceptualising of the role of history of art and design, of contemporary art practice and of visual culture. The option of two separate syllabuses might also be considered, revisiting the proposal to this effect in the Benson Report – a studio-based course that would incorporate support studies as an essential part of the studio practice, and separately, a visual culture course, which would deal in detail with socio-cultural aspects of contemporary and historical visual culture.

The revised draft of the LC syllabus may itself be out of date before it ever reaches implementation. To that extent, it may be appropriate for a root-and-branch re-examination of the syllabus rather than waiting for the opportune moment to implement it.

Conclusion

Art and design education was neglected in and literally excluded from the educational experience of young people for the first half century of Irish independence. Since the 1960s, official policy at primary and post-primary levels has been much more accommodating of arts education generally. However, this positive rhetoric has not been translated into practice. Indeed, there is a sad sense of *déjà vu* in reading the sequence of reports produced in intervals of 30 years – 1949 (Bodkin), 1979 (Arts Council [Benson]) and 2008 (Arts Council) – each of which tells a similar story of neglect and marginalisation.

Yet the tale is not entirely one of failure nor the future prospects entirely bleak. There has been significant improvement in the field of primary education, with a well-designed

curriculum and a teaching profession increasingly well disposed to continuing professional development in this domain. There has been a successful implementation of a junior cycle (lower secondary) art, craft and design programme. The single greatest challenge for art and design education in Ireland is to introduce an LC programme or programmes fit for the purpose. That purpose is essentially twofold: firstly, to provide learners with an engagement in art and design, which reflects the current practice of artists and designers in the real world, and secondly, to do so in such a manner that its assessment relates to the requirements of higher education in art and design. Such provision should include an appropriate exposure to visual culture, to art and design history and to aesthetics. The resolution of this challenge can remove the torque that has constantly bedevilled Irish art and design education and facilitate its alignment with the stated priorities of education policy generally, a decisive and welcome turn in its historical trajectory.

References

Arts Council Working Party [Benson report] (1979) *The Place of the Arts in Irish Education* Dublin: Arts Council.

Arts Council (2008) *Points of Alignment. The Report of the Special Committee on the Arts and Education* Dublin; the Arts Council.

Bodkin, T. (1949) *Report on the Arts in Ireland* Dublin: Stationery Office.

Bowker, G.C. and Susan Leigh Star (2000) *Sorting Things Out: Classification and Its Consequences* Cambridge Mass: MIT Press.

Brown, T. (2004) *Ireland: A Social and Cultural History* London: Harper Perennial.

CEB [Curriculum and Examinations Board] (1985) *Primary Education: A Curriculum and Examinations Board Position Paper* Dublin: CEB.

Cleary, A. (2010) Unpublished MLitt thesis, Faculty of Education, NCAD.

Commission on the Points System (1999) *Final Report and Recommendations* Dublin: The Stationery Office.

Coolahan, J. (1981) *Irish Education: History and Structure* Dublin: IPA.

Coughlan, M. (2010) Address by the Tánaiste and Minister for Education and Skills at the launch of the NCCA Junior Cycle consultation process, 21 April.

Council of Design (1965) *Report* Dublin: The Stationery Office.

Council of Education (1962) *Report on the Curriculum of the Secondary School* Dublin: The Stationery Office.

DES [Department of Education and Skills] (1988) *Junior Certificate Syllabus: Art, Craft, Design* Dublin: The Stationary Office.

DES (2005a) *An Evaluation of Curriculum Implementation in Primary Schools* Dublin: Stationery Office.

DES (2005b) *Statistical Report* Dublin: Stationery Office.

DES [Department of Education and Skills] (2010) *Better Literacy and Numeracy for Children and Young People* Dublin: DES.

Franck, K., Herlow, E., Huldt, A., Petersen, G. and Sorenson, E. (1961) *Design in Ireland* Dublin: Coras Tráchtála.

Delap, H. (2011) Joseph Beuys and the Proposal to Locate the Free International University of Creative and Interdisciplinary Research in Dublin, unpublished PGDip paper, Faculty of Education, NCAD.

Donnelly, N. (2003) Regarding art and regarding future teachers regarding art *Irish Educational Studies* Vol. 22, No. 1 pp.89 – 104.

Flannery, M. (2010) Unpublished Ph.D. thesis, Faculty of Education, NCAD.

Eisner, E. (2004) Artistry in Teaching, *Cultural Commons* http:// www. culturalcommons. org/eisner.htm Accessed March 10, 2009.

El Dahab, M.A. (2008) Kitsch, Destruction and Education – Interview with Tobias Rehberger, in H. Belzer, and B. Daniel (Eds) *Kunst Lehren/Teaching Art* Frankfurt: Stadelschule.

Elkins, J. (2001) *Why Art Cannot Be Taught* University of Illinois Press: Chicago.

Granville, G. (2004) Politics and Partnership in Curriculum Planning in Ireland, in C. Sugrue (Ed.) *Curriculum and Ideology: Irish Experiences, International Perspectives* Dublin: Liffey Press.

Ireland (1995) *Charting Our Education Future; White Paper on Education* Dublin: Government Publications.

McCarthy, I. and Granville, G. (1997) *Design in Education: A Discussion Paper* Dublin: NCAD/NCCA.

McDonagh, S. (2010) Higher Leaving Certificate 2009: A Study Presented to NUI for Discussion, Unpublished Paper.

NCCA (2005) *Primary Curriculum Review Phase I, Final Report.* Dublin: National Council for Curriculum and Assessment.

NCEA [National Council for Educational Awards] *Report on Recognition and Awards for Courses in Art and Design* Dublin: The Stationery Office.

O'Donoghue, D. (2003) Higher education in Art and Design: access, participation and opportunity *Irish Educational Studies* Vol. 21, No. 3 pp. 111 – 129.

O'Neill, P. and Wilson, M. (Eds) (2010) *Curating and the Educational Turn* London/ Amsterdam; Open Editions/deAppel.

Rogoff, I. (2010) Turning, in P. O'Neill and M. Wilson (2010) *Curating and the Educational Turn* London/Amsterdam; Open Editions/deAppel.

Rohan, M. (2007) Home Economics Education in Ireland today, in A. Moran (Ed.) *St Catherine's College of Education for Home Economics 1929–2007* Dublin: Linden Publishing.

Sheridan, N. (1999) What is it about Art? in *A Is for Art: A Supplement on Art Education* Circa 89, Autumn 1999.

Stapleton, H. (2010) Assessment of Visual Art in a High Stakes Setting: A Study of the Leaving Certificate Examination in Art, Unpublished Ph.D. thesis, Faculty of Education, NCAD.

Steers, J. (2011) Letter to Secretary of State for Education (UK) from NSEAD General Secretary http://www.nsead.org/downloads/Gove%20letter%20February%202011.pdf.

Tisdall, C. (1975) Report to the EEC on the Feasibility of Founding a Free International University for Creative and Interdisciplinary Research in Dublin, Unpublished Document, NIVAL, NCAD.

Turpin, J. (1995) *A School of Art in Dublin since the Eighteenth Century; A History of the National College of Art and Design* Dublin: Gill and Macmillan.

Notes

1. The syllabuses and examinations were such, however, that the practice of students sitting the examinations without having followed any structured course of study (sometimes with quite successful results) was common.
2. The advent of IMMA to the Royal Hospital site, some 15 years later, was a significant link in the chain, however, as a hallmark of the new museum was a vibrant, proactive and inclusive community and outreach education practice, in the tradition of Beuys.
3. ...and counting still in 2011!
4. The Leaving Certificate Applied programme, taken by fewer than 5% of the age cohort, does contain Arts Education as a required element: within this, modules can be chosen from visual arts, drama, dance or music.
5. Some of these are documented elsewhere in the present volume – see for instance the chapters by Murphy, Loughran and H. O'Donoghue.

Chapter 3

The Irish Primary School Visual Arts Curriculum – Emerging Issues

Máire Ní Bhroin

When asked what they liked doing most in school, children were unanimous in identifying art as one of their two favourite school subjects (DES 2005, p. 85).

Introduction

The Irish Primary School Revised Curriculum, launched in September 1999, was welcomed by teachers (INTO 2000, p. 36) as a significant development in education.[1] One curriculum component in it, Arts Education, comprises the visual arts, music and drama. The visual arts curriculum is outlined in two books, The *Visual Arts Curriculum Statement*[2] and the *Visual Arts Teacher Guidelines.*[3]

This chapter describes the visual arts component, locates it in the context of the international evolution of art education and considers the challenges and opportunities that arise from the initial decade of implementation, particularly in relation to integration and assessment. It considers the international literature and research in the fields of systemic review and of localised research projects.

Visual art education

Art has been taught as a discipline from the time of the ancient Greeks. 'Art is a way of making and communicating meaning through imagery', a discipline in its own right and 'a natural and enjoyable way of extending and enriching the child's experience of the world' (*Visual Arts Curriculum Statement* 1999, p. 5). It is a way of looking, seeing, making, knowing, expressing, representing, recording and analysing (Danvers 2006; Gnezda 2009). Read saw art as both a means of child centred self-expression and as a means of fostering a civil society (1947). He saw aesthetic education as 'fundamental to general education in nurturing individual growth' (Hickman 2005, p. 46). Steers maintains that Read understood the mission of art as 'having a revolutionary social purpose' (2007, p. 144). Other theorists emphasised the cognitive aspects of art education (Dorn 1999; Eisner 2002, Efland 2002; Lowenfeld 1947; Southworth 2009). Hickman describes the value of art education by outlining the individual benefits of practice and theory, which in turn combine to contribute to

social tolerance, awareness and sensitivity, creative solutions for different situations, informed habits of matching evidence and deduction, the means to learn for oneself and to apply considered values towards human culture and the natural environment (Hickman 2005, p. 18).

Hickman also sees a good art education programme as helping to develop improved standards of literacy, communication and problem solving. Improving visual literacy is surely a vehicle for improving literacy standards generally (Heise 2004). With increased access to digital media, this is now eminently possible (Gude 2007; Raney 1999).

The visual art curriculum, reflecting the views of Eisner (1972, p. 9), sees visual art as a vehicle for the child to make sense of the world as s/he experiences it through organising and expressing ideas, feelings and real or imagined events. Visual arts education provides opportunities for creative experiences through experimenting, investigating, inventing, designing and making in various media. Creating art, which is personally meaningful, can help foster self-confidence, self-esteem and create a sense of cultural awareness and empathy. Working in the visual arts helps develop observation and visual, spatial and tactile sensitivity. These qualities of perceptual awareness can help with learning in all areas of the curriculum (*VA Curriculum Statement*, p. 5). Finally, there is a sense of enjoyment associated with art making, amply illustrated at primary level by the children's responses in the report of the inspectorate (DES 2005) and by Cleary (2010, p. 190).

Different stages of a child's artistic development have been identified by among others, Lowenfeld (1947/1957), Gardner (1980) and Parsons (1987), which have influenced art teaching at primary level from the 1960s onwards. These developments, coupled with the child-centred and self-expressive educational movements inspired by Dewey (1934) and Freud, influenced curriculum policy in art in Ireland as elsewhere. Teachers encouraged self-expression through experimentation. In some cases, the emphasis put on self-expression was at the expense of structured curriculum development (Gruber and Hobbs 2002; Walling 2001).

There is much debate internationally on what an art curriculum should encompass (Duncum 2010; Eisner 1984; Gude 2007; Lanier 1984; Walling 2001). Central to discussion in most 'Anglophile nations' (Priestly 2002, p. 121) and reflecting the DBAE[4] approach, there is a general consensus that art education needs a structure, which includes creating art, acquiring technical skills, art appreciation and learning about the history and production of artworks. Recently, such issues as integration (Efland, 2002; Herberholz 2010; Luckawecky 2007), visual culture studies (Duncum 2010; Zwirn and Libresco 2010) and assessment (Collins and O'Leary 2010; Eisner 1966; Gruber and Hobbs 2002;), feature with increasing regularity in literature on visual arts education.

The Irish visual arts curriculum

The overriding principle of the Irish visual arts curriculum is that the 'child must be the designer' and have a personal input into any art created (*Visual Arts Teacher Guidelines* 1999, p.12). This philosophy, reflecting the beliefs of, among others, Gentle (1988), Morgan (1995) and Matthews (1999), underpins all proposed teaching and learning in art.

The curriculum is divided into six strands: drawing, paint and colour, print, fabric and fibre and construction and modelling with materials such as clay or papier mâché. Looking at and responding to the work of artists, craftspeople and fellow students are incorporated into each strand. It is understood that overlaps of the various strands can occur in the making of art. The *Visual Arts Curriculum Statement* states the aims and objectives in the six strands for each age group and gives a guided progression through the primary school years (see example in Appendix A). Although outlining at each stage what the child should be enabled to do, the curriculum is not prescriptive and allows the teacher to devise, within its framework, a creative art programme to suit his/her own pupils.

As for the 60% of pre-service primary teachers in Ireland, Britain and the US who do not study visual art at second level (Cleary 2010; Kevlihan 2007; Lanier 1984), it can be an onerous task to plan art programmes that encourage creativity, development of ideas and skills in the use of different media (Chapman 2005; DES 2005; Lanier 1984). The concept of providing practical teacher guidelines and teaching exemplars is quite rare. Most visual arts curricula simply state the attainment targets for each key stage (The National Curriculum for England Art and Design 1999[5]; The Georgia Core Quality Curriculum for the Fine Arts 2010).[6] The second book, the *Visual Arts Teacher Guidelines*, contains exemplars for lessons in each strand with plenty of good quality illustrations. These exemplars are designed for use in a non-prescriptive way by teachers as an optional guide for preparing art lessons.

Art was included as one of the first phase support subjects in the implementation of the revised curriculum. Teachers received two days in-service training in the visual arts. Research has shown that there was satisfaction among participants (Cleary 2010; DES 2005) in relation to the *quality* of instruction received. However, when questioned in more detail in one research survey, it emerged that the *quantity* of training was insufficient:

> Almost half of the teachers found their in-service inadequate in preparing them for the implementation of the revised curriculum. Further training, of the same high standard as that already received, is what these teachers felt was necessary (Gallagher 2006, p. 25).

In 2003–2004, the Inspectorate of the Department of Education and Science carried out a study to examine the implementation of the revised curriculum in Maths, English and the Visual Arts (DES 2005). Teachers felt most comfortable with the familiar paint and colour and drawing strands. Although they showed an awareness of the possibilities for

working in different media, they found the clay, fabric and fibre, construction and print strands in the curriculum less useful in their planning and teaching. Overall classroom organisation and support for curriculum implementation was recorded as good in 75% of classrooms surveyed by the inspectorate but in the 25% that were not considered to be supportive of pupils creativity, 'poor stimulus, insufficient display and ineffective use of resources hindered pupils' spontaneity, initiative and independence' (DES 2005, p. 38). Two areas in the visual arts curriculum were singled out for improvement by the inspectorate: that of looking at and responding to works of art and that of assessment.

The survey took place less than five years after the first implementation of the revised curriculum while teachers were coping with new curricula in eleven different subject areas. Many of those surveyed mentioned 'lack of confidence in their own art abilities, lack of adequate space, large class numbers and lack of resources' (DES 2005, pp. 122, 123). It is timely, therefore, to examine more recent research on how the visual arts curriculum has been implemented in Irish schools.

The six strands

Drawing

Drawing from imagination and observation is seen as an integral building block in the Irish primary schoolchild's development in art education. The curriculum recommends that drawing be used for creative expression, recording, representing, composing, design planning, preparatory work for projects in other media and appreciation of the art elements; line, space, texture, tone etc. Looking at and responding to the drawings of various artists increases appreciation and understanding of drawing as an artistic medium as well as acting as a stimulus for creative artwork.

The inspectorate found that the strand of drawing was 'implemented effectively in most classrooms' (DES 2005, p. 39). In a small-scale study, Gallagher (2006) also found that planning and implementation of the drawing strand were generally good. However, in researching the teaching of observational drawing to children from 8 to 12, Phelan (2007), found that it was being taught with varying degrees of success and that teachers required further pre-service and in-service training to develop a more stimulating, effective and systematic approach.

Paint and colour

The visual arts curriculum advises that Irish schoolchildren should be enabled to explore colour with a variety of media, make paintings based on real or imagined feelings or situations and enjoy colour combinations, texture and spatial effects. They should also paint subjects of their own choice from observation, perhaps using a viewfinder, attending to subtle colour differences and tonal variations.

Paint and colour was implemented effectively in almost all Irish classrooms surveyed (DES 2005). Teacher competence in planning and implementing this strand was high (Gallagher 2006). Teacher confidence, availability of resources, student enjoyment and relative ease of organisation may be factors in explaining this success. Striking a balance between teaching techniques of colour mixing, tonal variation, texture and composition through a mixture of discovery and instruction (Vygotsky, 1978) and Gude's emphasis on 'playing' with ideas and materials and on freedom to create art in an expressive way remains a challenge for curriculum designers and teachers (2007, p. 7).

Print

The visual arts curriculum recommends that by age 12, the child should be enabled to experiment with complex printmaking techniques, to make simple prints by overlapping and to create theme-based or non-representational prints by making a variety of relief prints, for example, to compose relief print blocks with attention to line, shape, texture and pattern. Pupils should be able to reinterpret observational drawings in relief prints, make monoprints, pictorial rubbings, silk screen prints, experiment with fabric printing techniques, make posters and design and print cards and logos.

In two-thirds of the classrooms observed by the inspectorate, the print strand was taught in a satisfactory manner. However, the remaining third showed evidence of weak practice in the teaching of print. In this third, there was 'little evidence of planning, limited opportunity to experiment with a variety of print making materials, tools and techniques and a lack of emphasis on developing continuity and progress throughout the school' (DES 2005, p. 39). Gallagher also noted that many teachers found planning for print difficult (2006).

Modelling with clay

The curriculum recommends a balance between the time allotted to two- and three-dimensional artwork (*VA Teacher Guidelines*, 1999, p. 13). Three-dimensional work suggested includes modelling with clay or papier mâché, construction and working with fabric and fibre.

Modelling with clay in which the child manipulates and changes the form of the clay in purposeful ways develops sensitivity to form in other artworks and in the environment. It also helps develop a sense of texture, shape and space. The Inspectorate Report found that in two-thirds of the classrooms, the clay strand was being covered adequately but poor planning and teaching was evident in the remaining third of classrooms. It is not revealed whether these are the same teachers who had difficulty with teaching the print strand. Gallagher's (2006) results replicated those of the inspectorate, but a year later, in a small-scale study, Kevlihan reported that all of the teachers surveyed demonstrated a positive attitude to teaching lessons using clay. However, she noted that they 'gave more consideration to the practicalities of working with clay than to the choice of topic or content of the lessons' (2007, p. 64).

Construction

Construction activities provide opportunities for children to make use of a large variety of materials in an imaginative way while building three-dimensional shapes and structures. Children as young as five can create constructions from large boxes and pieces of card, inventing imaginative worlds in which to play (Ní Bhroin 2007). Older children can design models with moving parts, hanging wire structures, imaginative buildings, monsters etc. as well as examining spatial arrangement, balance and outline in existing structures. This helps to develop an awareness of shape, space, line, balance and rhythm. It leads to an appreciation of structure in nature and the man-made environment with the work of artists, sculptors, architects, engineers and craftspeople.

According to the inspectorate (DES 2005), two-fifths of the classrooms rated poorly as regards the construction strand, with 'little evidence of the inclusion of construction in teacher's planning or practice' (DES 2005, p. 40). Kevlihan found that although over 66% of the respondents used three-dimensional media in the classroom, 'mostly construction', as reported earlier in relation to clay, teachers appeared to 'give practical matters precedence over the creative possibilities of the project' (2007, p. 84). These findings suggest that, when teaching art, more thought might be given to thematic planning, which would incorporate three-dimensional art making.

Fabric and fibre

Working with fabric and fibre offers wonderful possibilities for children to experiment with manipulating materials, creating form and structure, experimenting with colour, tone, line, space and texture. Fabric and fibre art can be two- or three-dimensional and the creative opportunities to make imaginative, abstract, figurative or functional pieces are myriad. The curriculum suggests that by the age of 12, the child should be enabled to explore and discover the possibilities of fabric and fibre, make small inventive pieces in two and three dimensions, make simple character toys and design and make costumes.

The inspectorate reported that three quarters of classrooms surveyed were dealing effectively with the fabric and fibre strand. Subsequent research by Cleary (2010) found that teachers in general had a positive attitude to fabric and fibre but spent less time working in this medium than in the other strands. Lack of knowledge and confidence regarding teaching using fabric and fibre, a shortage of ideas, lack of thematic planning, and difficulty in accessing and storing resources were cited as possible reasons. Cleary suggests that there is a case for reintroducing the age-old needle crafts into the classroom and fears that 'the crafts associated with fabric and fibre could be lost entirely' (2010, p. 179).

Challenges and opportunities

Five issues, in particular, pose challenges to the provision of good quality art education in Irish primary schools. They are looking at and responding to art, the issue of assessment,

ensuring that the visual arts are seen as an integral part of primary education, addressing the shortcomings in the implementation of the visual arts curriculum and the issue of integration of art with other subject areas. Many of the opportunities associated with implementing the visual arts curriculum emanate from these challenges, as will now be discussed.

Looking at and responding to art

The visual arts curriculum advises that when looking at and responding to art the child should have access to a variety of art styles from different times and cultures for the pleasure they give, as a stimulus for the child's own art activities and as a way of comparing how ideas and themes are represented. Access to original artworks should be provided whenever possible with well planned visits to art galleries, art and craft studios and places where open air sculpture, structures, interesting architecture and other artworks are to be seen (*Visual Arts Teacher Guidelines* 1999, p. 14). Exposure to a variety of artworks relating to each strand is recommended. Opening children's minds to significant artworks from world cultures offers opportunities for appreciation, artistic creativity and intercultural awareness.

According to the inspectorate, looking at and responding to art was not covered adequately in a majority of classes (DES 2005). However, in a small study in 2000, Cahill found that 55% of schools had access to prints of artworks and 66% had visited an art gallery, indicating perhaps that there is a disparity in practice across schools.

The child's response need not always be verbal. Making art that is personally creative and not a copy, inspired by looking at works by other artists is a perfectly valid response. The challenge for teachers is to use the work of artists as a stimulus for the child to make original creative art as well as encourage the child to understand and appreciate the work artistically. This element in art education is incorporated into visual arts education courses for pre-service teachers.

Assessment

Assessment in the visual arts curriculum has been regarded by teachers as 'being out of bounds' and an 'anathema to the philosophy of visual arts' (DES 2005, p. 125). Indeed the INTO Discussion document on Assessment in the Primary School 2008 does not mention the visual arts. This attitude reflects a strong tradition in art education as expressed by theorists such as Brittain (Lowenfeld and Brittain 1975, p. 108) that 'grading in art had no function' and McFee who stated that 'letter grades have little value in art' (1961, p. 209). Teachers did not want to involve themselves in summative assessment, namely, awarding grades for artwork. Some 40% of the teachers questioned the value of assessment in the visual arts. Despite such views on assessment in art education, others believe that developing suitable methods of assessment has the potential to improve the quality of teaching in visual arts (Eisner 1966; Gruber and Hobbs 2002).

Assessment has both summative and formative dimensions. Summative assessment usually involves testing and grading after instruction (Clarke 2009; Sutton 1992). It is described as assessment *of* learning and involves reporting information on children's progress to parents, teachers and relevant bodies and for future planning (INTO 2008, p. 17). Formative assessment described as assessment *for* learning or AfL is an ongoing process, which involves interaction between teacher and pupil in establishing learning intentions, in creating dialogue and feedback during and after the learning process and it also involves self and peer assessment (Black and Wiliam 1998; INTO 2008).

Assessment should inform, enhance and expand learning rather than encourage strict adherence to a prescriptive set of examinable outcomes (Black and Wiliam 1998; Clarke 2009; Eisner 1985; Shephard 2000). The question of assessing creativity was addressed by Lars Lindström (2006) in a study of the progression of young people's creativity in the visual arts from pre-school to senior secondary school in Sweden. He found that creativity could be assessed and furthermore that it could be fostered by promoting the building of a culture of learning in schools.

Assessment in the visual arts provides information about a child's artistic development and the effectiveness of the teaching programme. It 'contributes to the teaching–learning–assessing continuum' and helps the teacher to evaluate and revise lessons, programmes and teaching strategies (Visual Arts Curriculum p. 80). The curriculum has clear guidelines relating to assessment of the visual arts. It sees assessment as being an integral part of teaching and learning and recommends assessing the child's ability to make art, the child's ability to look with understanding at and respond to art and the quality of the child's engagement with art. This is to be done through a combination of teacher observation, teacher designed tasks, work samples, portfolios, projects and self-assessment.

Because much of the assessment in visual arts is based on teacher observation of work in progress and interaction with the pupil, it is an ongoing process and very much integrated into teaching. This enables the teacher to plan and cater for pupil's individual needs, seeing difficulties with expression or use of media as opportunities for scaffolding learning and development as advised by Vygotsky (1978). Lowenfeld, in his first edition of *Creative and Mental Growth* (1947), provided for a qualitative evaluation of a child's artistic development and today over 50 years later, the literature on assessment of visual art commends a formative approach (Collins and O'Leary 2010; Shephard 2000). There is scope for educational research and new methodologies to improve practice in this area.[7]

Visual arts as an integral and important part of primary education

The publication of the government's draft National Plan to improve Literacy and Numeracy in Schools (DES 2010) recommends that more time be spent on literacy and numeracy thereby reducing time spent on other curricular areas. The draft report advocates 'revising the required learning outcomes' in areas other than literacy, mathematics and science and providing 'guidance on the possibilities for cross-curricular teaching and learning in areas such as drama, music and visual arts' (DES 2010, p. 30). The outcome

internationally of measures such as these, which include the use of frequent standardized testing in 'core areas' has been to have visual art marginalised in schools (Chapman 2005; Hickman 2005; Mishook 2010; Walling 2001). For art educators, it is important that government policy promotes the visual arts in the child's education and recognises its value as a discipline in its own right as well as the possibilities for growth through art in many areas including both literacy and numeracy. The approach proposed in the literacy and numeracy strategy seems to be based on a reductive understanding of both literacy and art education.

Addressing the shortcomings in the visual arts curriculum

The challenge for art educators is to ensure that pre-service college art courses are designed and delivered to prepare non-specialist teachers teach art to a worthwhile standard in primary schools. Holt (1997) makes a case for the 'hidden strengths' of the generalist teacher of art but these will not compensate for a lack of basic knowledge and practical experience in the subject. Although high entry points are required, more than 60% of students on primary teacher education courses in Ireland have not studied art at second level (Cleary 2010; Kevlihan 2007). Similar trends are noted in primary-teacher education internationally with lack of basic skills and experience in art making resulting in low levels of confidence and competence in visual arts (Alter et al. 2009; Chapman 2005). A common theme throughout the research literature is the need for more art education courses for in-service teachers in order to improve knowledge, skills and confidence (Cleary 2010; Gallagher 2006, Phelan 2007). Increased opportunities for in-service and post-graduate research and practice in primary visual arts education, nationally and internationally, keep art education in focus and improve practice.

Integration

The integration of visual arts with other subject areas of the curriculum has been a recurring source of concern among art educators. A glance at the visual arts curricula website for ten US states shows an increasing trend to provide for integrating art with other subjects.[8] At it is most educationally beneficial, integration may be understood to involve teaching and learning in two or more subjects in a manner that achieves the objectives of each, not an easy task. Well-planned integration at primary level offers the potential of a holistic learning experience, which encourages the child to explore themes from a variety of angles through different disciplines (Knight 2010; Zwirn and Libresco 2010). When integrating art, it is best to use areas or skills related to art education such as looking with close observation at something in nature or at a historical artefact or designing something imaginative with a mathematical structure.

Much of the literature relating to integration in art education refers to integrating visual art with areas such as computer technology or visual culture studies involving history or social studies (Lanier 1984; Zwirn and Libresco 2010). These subjects naturally complement one another. Using a computer to create a piece of art (short

film, photographic manipulation of previously painted work etc.) or closely examining and observing an image of social or historical relevance overlaps with art education and creates learning bridges with literature, drama, social studies and history through exploration, invention, dialogue, discovery and reflection. Exemplary ideas incorporating constructivist teaching have been put forward by Walling (2001), Popovich (2006), Luckawecky (2007), Zwirn and Libresco (2010) and Knight (2010). In each of these cases, the art activity can be creative and meaningful for the student.

Not all proposals for integrating art have such possibilities, however. On a policy level, integration may be seen as a means of rationalizing resources. Within the teaching context, Eisner cautions against the danger of art being subsumed entirely in the service of other curricular areas (1985). The DES report found that 43.4% of teachers provided opportunities for children to 'experience the visual arts through theme based activities at least a few times a week' (2005, p. 97). The inspectorate took this to signify that teachers had made progress with integrated teaching. However, Gallagher (2006) noted in his survey that in half of the cases where integration took place, the lack of specific art objectives cast doubt on whether meaningful artistic learning occurred. This was echoed by the findings of Doonan (2006). Although there are some good examples of meaningful integration with art to be found in classrooms today, there are also instances where art is used as an addendum to the curricular area with which it is integrated and where the art activity has little or no artistic value (Moran 2009).

The rationale put forward by some for integration is that teachers have so much else to teach that they 'are not willing to include subjects that won't help them prepare students for (standardised) tests' (Herberholz 2010, p. 14).[9] Perceived lack of time to teach art in the US may be due to issues such as funding, the NCLB[10] project and its implications, diverse state art curricula, teacher aptitude for and attitude to the visual arts, parental opinion and educational policy (Chapman 2005; Mishook 2010). In the Irish context the DES draft paper (2010) has worrying implications for the teaching of art. The challenge here is to preserve the integrity of the visual arts as a discipline within primary education while including its potential as part of the overall learning experience.

Conclusion

Swift and Steers draw attention to the 'interconnectedness of teaching, learning, subject knowledge, assessment and the preparation and development of teachers' and stress that all of these issues must be addressed in order to provide a high quality, meaningful art education experience for teachers and students (2006, p. 24).

This chapter has examined and compared research on how the Irish visual arts curriculum has been implemented over the ten years since its introduction. Shortfalls in teaching skills, particularly in the areas of three-dimensional arts and looking and responding have been identified and suggestions made regarding pre-service and in-

service courses for teachers. A case has been made for incorporating *formative assessment* into the teaching of visual art at primary level. Challenges relating to integration of visual arts have been discussed and concerns expressed regarding the maintenance of the integrity of the teaching of art within an integrated context.

An openness to change can foster creativity and exploration. However, it is important to ensure that in the quest to raise standards in what are termed 'core skills' (DES 2010, p. 13) through, among other means, increased use of standardized testing in primary schools, children are not deprived of a solid foundation in visual arts education. Similarly, the issue of integration should be treated with caution to ensure that high standards in art education are achieved at primary level. The visual arts curriculum can be viewed as a flexible concept but with core values that are immutable, capable of being adapted to facilitate a solid grounding in art education for primary schoolchildren.

References

Alter, F., Hays, T. and O'Hara, R. (2009) Creative arts teaching and practice: critical reflections of primary school teachers in Australia *International Journal Of Education and the Arts,* Vol. 10, No. 9 pp. 1–21, http://www.ijea.org/.

Black, P. and Wiliam, D. (1998) *Inside the Black Box: Raising Standards Through Classroom Assessment* London: King's College.

Cahill, B. (2000) Art appreciation for primary school children. Unpublished M.Ed Thesis, St Patrick's College, DCU.

Chapman. L.H. (2005) Status of elementary art education: 1997–2004 *Studies in Art Education* Vol. 46, No. 2 pp. 118–137.

Clarke, S. (2009) *Active Learning Through Formative Assessment* UK: Hodder Education.

Cleary, A. (2010) Fabric and fibre in the visual art primary curriculum: an examination of teacher attitudes, education and experiences. Unpublished MLitt Thesis, NCAD.

Collins, B. & O'Leary, M. (2010) Integrating assessment with teaching and learning in the visual arts: a study in one classroom *Oideas 55,* Ireland: DES.

Danvers, J. (2006) The knowing body: art as an integrative system of knowledge in T. Hardy (Ed.) *Art Education in a Postmodern World: Collected Essays* Bristol: Intellect Books.

Department of Education and Science (2005) *An Evaluation of Curriculum Implementation in Primary Schools.* Dublin: The Stationary Office.

Department of Education and Skills (2010) Better literacy and numeracy for children and young people: a draft national plan to improve literacy and numeracy in schools http://www.education.ie/home/home.jsp?pcategory=27173&ecategory=27173&language=EN Accessed Dec 7, 2010.

Dewey, J. (1934) *Art as Experience* New York: Putman.

Doonan, M. (2006) The practicalities and benefits of art-based project work in the primary classroom, Diploma Dissertation, St. Patrick's College, DCU.

Dorn, C.M. (1999) *Mind in Art: Cognitive Foundations in Art Education.* Mahwah, NJ: Lawrence Erlbaum.

Duncum, P. (2010) Seven principles for visual culture education *Art Education* Vol. 63, No. 1 pp. 6–10.

Efland, A. (2002) *Art and Cognition—Integrating the Visual Arts in the Curriculum* New York: Teachers College Press.

Eisner E. W. (1966) Evaluating Children's Art in E. W. Eisner and D.W. Ecker (Eds) *Readings in Art Education* Waltham, MA: Blaisdell Publishing Co, pp. 384–338.

Eisner, E. (1972) *Educating Artistic Vision* London: Collier-Macmillan.

Eisner, E. (1984) Alternative approaches to curriculum development in art education *Studies in Art Education* Vol. 25, No. 4 pp. 259–264.

Eisner, E. (1985) *The Art of Educational Evaluation: A Private View* London: The Falmer Press.

Eisner, E. (2002) *The Arts and the Creation of Mind* London: Yale University Press.

Gallagher, D. (2006) How are teachers coping with the implementation of the revised visual arts curriculum? Diploma Dissertation: St Patrick's College, DCU.

Gardner, H. (1980) *Artful Scribbles The Significance of Children's Drawings* New York: Basic Books.

Gentle, K. (1988) *Children and Art Teaching* London: Routledge.

Gnezda, N.M. (2009) The potential for meaning in student art *Art Education* Vol. 62, No.4 pp. 48–52.

Government of Ireland (1999) *Primary School Curriculum: Visual Art Curriculum Statement,* Dublin: The Stationery Office.

Government of Ireland (1999) *Primary School Curriculum: Visual Art Teacher Guidelines,* Dublin: The Stationery Office.

Gruber, D.D. & Hobbs, J.A. (2002) Historical analysis of assessment in art education *Art Education* Vol. 55, No.6 pp. 12–17.

Gude, O. (2007) Principles of possibility: considerations for a 21st-century art and culture curriculum *Art Education* Vol. 60, No.1 pp. 6–17.

Heise, D. (2004) Is visual culture becoming our canon of art? *Art Education* Vol. 57, No.5 pp. 41–45.

Herberholz, B. (2010) Art works… when integrated in the curriculum *Arts and Activities* Vol.148, No. 4 p.14 www.aertandactivities Accessed on Dec 2, 2010.

Hickman, R. (2005) *Why We Make Art and Why It Is Taught* Bristol: Intellect Books.

Holt, D. (1997) Hidden strengths: the case for the generalist teacher of art in D. Holt (Ed.) Primary *Arts Education: Contemporary Issues* UK: Falmer Press.

INTO (2000) Challenging times Proceedings of Principals Consultative Conference, October 1999, Westport.

INTO (2008) Assessment in the primary school: Discussion Document and Proceedings of the Consultative Conference on Education 2008.

Kevlihan, N. (2007) The attitudes and approaches of teachers towards clay and construction in the primary school M.Ed. Thesis St Patrick's College, DCU.

Knight, L. (2010) Why a child needs a critical eye and why the art classroom is central in developing it *Journal of Art and Design Education* Vol. 29, No. 3 pp. 236–243.

Lanier, V. (1984) Eight guidelines for selecting art curriculum content *Studies in art Education* Vol. 25, No. 4 pp. 232–237.

Lindström, L. (2006) Creativity: what is it? Can you assess it? *International Journal of Art and Design Education* Vol. 251 pp. 53–66.

Lowenfeld, V. (1947, 1957) *Creative and Mental Growth: A Textbook on Art Education* New York: Macmillan.

Lowenfeld, V. and Brittain, W. L. (1975) *Creative and Mental Growth: A Textbook on Art Education* NY: MacMillan.

Luckawecky, K. (2007) CD design: integrating art, music and information technology *Arts and Activities* Vol. 142, No. 3 pp. 32–42 www.aertandactivities Accessed Dec 2, 2010.

Matthews, J. (1999) *Helping Children to Draw and Paint in Early Childhood* London: Hodder and Stoughton.

McFee, J.K. (1961, 1970) *Preparation for Art* Belmont, CA: Wadsworth Publishing Co. Inc.

Mishook, J. (2010) Mediating the impact of high stakes testing on arts education: the case in Virginia *Arts and Learning Research Journal* Vol. 26, No. 1 pp. 96–125.

Moran, G. (2009) The attitudes and approaches of primary school teachers to the integration of visual arts with other subject areas in the curriculum, Unpublished M.Ed. Thesis, St Patrick's College, DCU.

Morgan, M. (1995) Art 4-11, *Art in the Early Years of Schooling* Cheltenham: StanleyThornes.

Ní Bhroin, M. (2007) 'A slice of life': The interrelationship between art, play and the real life of the child *International Journal of Education and the Arts* Vol. 8, No. 16 http://www.ijea.org/v8n16/ Accessed Dec 4, 2010.

Parsons, M. (1987) *How We Understand Art: A Cognitive Development Account of Aesthetic Experience* New York: Cambridge University Press.

Phelan, E. (2007) Current practice in the teaching and learning of observational drawing in senior primary school, Unpublished M.Ed. Thesis, St Patrick's College, DCU.

Popovich, K. (2006) Designing and implementing exemplary content, curriculum and assessment in art education *Art Education* Vol. 59, No. 6 pp. 33–39.

Priestly, M. (2002) Global discourses and national reconstruction: The impact of globalisation on curriculum policy *Curriculum Journal* Vol. 13, No. 1 pp. 121–138.

Raney, K. (1999) Visual literacy and the art curriculum *Journal of Art and Design Education,* Vol. 99, No.18 pp. 41–47.

Read, H. (1947) *Education Through Art* London: Faber and Faber.

Shephard, L.A. (2000) The role of assessment in a learning culture *Educational Researcher,* Vol. 29, No. 7 pp. 4–14.

Southworth, G.W. (2009) Art in the primary school: towards first principles in S. Herne, S. Cox, and R. Watts (Eds) *Readings in Primary Art Education* Bristol: Intellect Books.

Steers, J. (2007) The ever-expanding art curriculum – is it teachable or sustainable? *International Journal of Education through Art* Vol. 3, No. 2 pp. 141–153.

Sutton, R. (1992) *Assessment: A Framework for Teachers* London: Routledge.

Swift, J. and Steers, J. (2006) A manifesto for art in schools in T. Hardy *Art Education in a Postmodern World: Collected Essays* Bristol: Intellect Books.

Walling, D.R. (2001) Rethinking visual arts education: a convergence of influences *Phi Delta Kappan* Vol. 82, No. 8 pp. 626–631.

Vygotsky, L.S. (1978) *Mind in Society. The Development of Higher Psychological Processes.* Cambridge, MA: Harvard University Press.

Zwirn, S. and Libresco, A. (2010) Art in social studies assessments: an untapped source for social justice education *Art Education* Vol. 63, No. 5 pp. 30–35.

Appendix A

STRAND UNIT: PAINTING
THIRD AND FOURTH CLASS

The child should be enabled to

explore colour with a variety of materials and media

paint, crayons, oil or chalk pastels, coloured pencils, felt-tipped pens and fibre-tipped pens

print, small-scale collage

using a computer art program to experiment with the effects of warm and cool colours

make paintings based on recalled feelings and experiences, exploring the spatial effects of colour and tone, using overlapping, and with some consideration of scale

recent and vividly recalled events from own life events he/she identifies with

everyday familiar locations

express his/her imaginative life and interpret imaginative themes using colour expressively

stories, poems, songs, music

what might happen next in an adventure story

making large-scale group paintings of characters or story features

paint from observation

looking closely for subtle colour combinations in natural and manufactured objects

making large-scale paintings that emphasize colour, tone, texture, shape, rhythm

the human figure showing action

portraits of classmates posing for different activities

discover colour in the visual environment and become sensitive to colour differences and tonal variations through colour mixing

mixing and reproducing as accurately as possible the colours of objects of visual interest

exploring the spatial effects of colour and tone through themes chosen for their colour possibilities

using colour and tone to create a background, middle ground and foreground in simple still life arrangements, landscapes and cityscapes

discover harmony and contrast in natural and manufactured objects and through themes chosen for their colour possibilities

working out a colour scheme for a three-dimensional model he/she may have made

playing colour-mixing games

discover pattern and rhythm in natural and manufactured objects and use them purposefully in his/her work

using repetition and variation of contrasting colours and varieties of line types and textures to add variety and unity to a piece of work

explore the relationship between how things feel and how they look

discovering texture in natural and manufactured objects

interpreting a variety of textures in colour and tone and with varied brush strokes

LOOKING AND RESPONDING

The child should be enabled to

look at and talk about his/her work, the work of other children and the work of artists

describing what is happening in the painting

the colours and tones chosen

how the shapes, textures, pattern and rhythm and contrasts combine in the composition

how materials and tools were used to create different effects and whether they might have been used differently

what he/she or the artist was trying to express

the work of other artists who have interpreted the theme in a similar or dissimilar way

what he/she feels about the painting

Notes

1. The curriculum of 1999 was a total revision of the earlier Curaclam na Bunscoile (1971). It embodied the recommendations of the Review Body on the Primary Curriculum (1990), The National Convention on Education, (1994), The White Paper on Education *Charting Our Education Future* (1995) and the Education Act (1998).
2. See http://www.ncca.ie/uploadfiles/Curriculum/VisArt_Curr.pdf.
3. See http://www.ncca.ie/uploadedfiles/Curriculum/VisArt_Gline.pdf.
4. DBAE Discipline Based Art Education developed in the US in the 1980s proposed that art education focus on four main disciplines: art history, art criticism, aesthetics and making art.
5. Downloadable from: http://curriculum.qcda.gov.uk/.
6. Downloadable from: http://www.fultonschools.org/dept/curriculum/art/Elementary_Curriculum/Kindergarten.pdf.
7. The author is currently working on a PhD on AfL in the visual arts.
8. See, for example, http://artswork.asu.edu/arts/teachers/curriculum/links.htm.
9. Herberholz makes several worthwhile suggestions for integrating art with other subjects in this article.
10. The No Child Left Behind Act of 2001 is a United States Act of Congress concerning the education of children in public schools.

Chapter 4

Defining, Redefining and De-Defining Art: Teachers Engaging
with the Work of Artists in Irish Primary Schools

Michael Flannery

Among the most important kinds of research needed in the field [of art education] are studies of teaching and learning. By studies of teaching and learning I mean studies that try to answer the questions 'What do teachers of the arts do when they teach and what are its consequences?' By what teachers do, I mean questions like the following: What kind of curriculum activities do teachers ask students to engage in?

(Eisner 2002, p. 215)

The key aim of this article is to present research findings that explain the kind of curriculum activities, which Irish primary children experience with respect to *looking at and talking about artworks by other artists*.[1] This chapter presents 'grounded' theory concerning Irish primary teacher's perspectives concerning awareness, appreciation and appraisal in art, which impinges on children's 'experienced curriculum' (Mc Neill 2009, p. 108). It highlights the perceived key impediments to its full implementation. It subsequently identifies how Irish primary teachers can be assisted in implementing *looking at and responding to artworks* (LAR) as outlined in the 1999 visual arts primary curriculum. In essence, it explores the relationship between curriculum intention, primary teachers' interpretations and the actual implementation of LAR in Irish primary classrooms as noted in national research.

The expression *looking at and talking about artworks by other artists* assumes an awareness, appreciation and appraisal of art (DES 1999a, p. 14; DES 1999b). This viewpoint aligns it more with art criticism than art appreciation. It implies that children ought to be taught to reflect critically upon what they experience and provide reasoned evaluations about quality. Therefore, looking at and responding to artworks (LAR) implies that teachers need to develop some sense of connoisseurship among children about the ever-expanding world of art. It demands an elemental learning of aesthetics, art history and critical theory. It implies that children acquire specific concepts, skills and subject language development in order to look at, engage with, reflect upon and express perspectives about what they experience. It entails equipping children with different ways of approaching diverse artworks, and inculcating in them an open, curious and discerning disposition towards art. Although the visual arts primary curriculum has in mind the primary teacher, whose expertise is that of children, child development and

teaching and learning (Holt 1997, p. 88), Swift and Steers (2006, p. 23) ask what 'specific subject knowledge is axiomatic if a teacher is to act as an effective subject mentor' of the visual arts?

Research context and approach

Clement (1993, p. 2) comments that 'good art education in schools operates within two modes: productive and critical'. The critical mode involves appraising and evaluating that which both informs and enhances production. Taylor (1986, p. 174) similarly notes that 'the teaching of art has two aspects: Janus-like – looking out towards the visual language evolved by the culture we share, and looking inwards towards the individual student's expressive needs'. Both their sentiments permeate the 1999 Irish primary curriculum with respect to a key emphasis on LAR (DES 1999b, p. 11) and within its actual structure and layout. This aligns well with those who emphasise that 'an understanding of how art in its various forms is produced in different historical and cultural contexts' is not to be considered as a 'bolted-on' addition to art education, or a separate curriculum area that is 'divorced' from children's art production (Green and Mitchell 1997, p. 34; Taylor 1996, p. 280). The visual arts primary curriculum is constructed around six strands – *Drawing, Paint and colour, Print, Clay, Fabric and fibre* and *Construction*. Each of the media-oriented strands has a LAR strand unit, which provides a balance to its art production oriented co-requisite (see Table 1). Each of the LAR strand units entails exposure to and experiences of interaction with artworks by other artists, which explore similar or related media (LAR). Irish primary teachers' perspectives on appreciation and appraisal of art at primary-school level can at least partly explain why the critical mode of *looking at and responding to artworks by other artists* is neglected in what otherwise has been considered a well-embraced curriculum (Crafts Council 2009; DES 2005; INTO 2009; NCCA 2005a).

Table 1. The strand structure of the Irish visual arts primary curriculum (1999)

Strand unit	Co-requisite strand unit
Developing Form in Clay	Looking and Responding
Making Drawings	Looking and Responding
Making Constructions	Looking and Responding
Painting	Looking and Responding
Making Prints	Looking and Responding
Creating in Fabric and Fibre	Looking and Responding

Hickman remarks that the key to the future of art education lies with 'new teachers and teachers in training' in terms of their perceptions of art as well as the aims of art education (Hickman 2006, p. 169). In that context, Irish primary teachers who completed an online summer course concerning LAR as part of their continuing professional development (CPD) form the subject base for this chapter.

In total 2,120 primary teachers volunteered their perspectives over four consecutive summer periods from 2006 to 2009.[1] They did so via online discourse or computer mediated communications (CMCs), within a virtual learning environment called *Moodle* while they engaged in an online continuing professional development summer course. Each online CPD (oCPD) summer course concerned LAR, and was of 25 hours duration. Each comprised five modules of five hours duration. Primary teacher participants could engage with online content at their discretion during their summer holidays. Although some course content was specific to a particular year for currency and thematic considerations, other generic topics concerning planning, delivery or assessment for LAR were repeated, or further developed with each year.

The CMCs consisted of volunteered reflective learning logs, end of module discussion fora postings, online survey responses and nested discussion contributions. All online discussions were asynchronous. Although anonymity was assured for research purposes, any contributions could be read by others within that virtual learning community. The 'nested' discussion contributions were different from other online discourses as they were participant initiated, more informal and between smaller sub-groupings of participants. The reflective learning logs were the core data source for this research whereas the other CMCs were explored for possible triangulation. Six hundred primary teachers volunteered viewpoints while they participated in the online CPD summer course in 2006 (oCPD 2006). Another 600 primary teachers did so while they completed oCPD 2007. A further 606 primary teachers did so while they participated in oCPD 2008. Three hundred and fourteen primary teachers volunteered their perspectives while they partook in oCPD 2009 (see Table 2).

Table 2: Initial systematic random sample groups of reflective learning logs taken from oCPD 2009 and oCPD 2008

Online CPD summer course	Number of oCPD participants	Systematic random samples
oCPD 2006	600 primary teachers	
oCPD 2007	600 primary teachers	
oCPD 2008	606 primary teachers	100 Reflective Learning Logs
oCPD 2009	314 primary teachers	50 Reflective learning Logs

The research adopted a grounded theoretical approach to discourse analysis whereby theory emerged from primary teachers' online discourse in an unforced manner (Cohen et al. 2007, p. 491). The initial discourse analysis began with open-coded discourse analysis of two systematic random sample groupings of 150 reflective learning logs – 50 logs (15%) from the online continuing professional development (oCPD) summer course of 2009 (oCPD 2009) and 100 logs (15%) from oCPD 2008. Participants from previous LAR online summer courses were not asked to complete reflective learning logs. Their online discourse was limited to end of module discussion fora and online survey only.

Open-coded discourse analysis involved identifying anything with respect to any discrete or shared perspectives among those primary teachers concerning LAR. The process entailed constant comparison, memoing and referencing for future raw data retrieval. It entailed repeated sampling in other systematic random sample groupings until the coding process reached saturation whereby no further analysis revealed other perspectives and all key LAR related perspectives, phenomena or issues were identified. Four open code categories were identified from teachers' reflective learning logs in relation to their perceived knowledge acquisition and assimilation with respect to LAR, good intentioned future classroom application and accommodation of such knowledge and any remaining critical questions concerning LAR. These categories concerned *LAR-Teaching, LAR-Resourcing, LAR-Content and LAR-Teacher*. Open-coded discourse analysis was also conducted on various end-of-module online discussion fora postings from oCPD 2009 and oCPD 2008 and end-of-module online surveys conducted in oCPD 2007 and oCPD 2006. These concerned participants' perspectives regarding their preferences in art, reactions to artworks addressed in oCPD course content, their most used practical starting points for art production, art teacher types, impediments to LAR facilitation, opinions of the curriculum documents and traits of professional practice with respect to LAR teaching.

The discourse analysis continued with *attentive looking* in the form of axial-coded discourse analysis. This entailed making connections in or between any of the emergent LAR phenomena or issues in relation to causal conditions and consequences as identified from the open-coded discourse analysis processes. The third stage of the grounded theoretical approach to discourse analysis was selective coding. It involved delimiting and integrating LAR storylines. The delimitation is necessary 'to avoid both researcher and reader being over whelmed' and the integration is needed for clarity and coherence (Dey 2007, p. 261). In this research, the key emergent LAR-based storylines were investigated and triangulated using available 'word search' tools in *Moodle* and Microsoft's *Word*. Selective coding was applied to all modes of primary teachers' online discourse including nested discussions. This final stage of triangulation culminated in grounded theory, which derived from the available data.

Emergent storylines

Four key storylines emerged from this research, which can explain at least in part the poor implementation of LAR in Irish primary schools.

Expressionistic epistemological leanings: The impact of primary teachers' expressionistic perceptions of art education on the frequency and quality of LAR

Integration: The impact of the practice of integration and thematic planning in primary teaching on the breath and range of artwork selected for LAR

Loco Parentis: The influence that a primary teacher's position of *loco parentis* has in terms of perpetuating conservatism in the primary school canon for LAR

Digital literacy: The importance of a primary teacher's own digital literacy in addition to their perceived visual and cultural literacies in enabling them conduct a more inclusive and relevant LAR practice.

Expressionism

One 'grounded' storyline concerns the expressionistic leanings that many of the systematic random sample groupings had and enacted in classroom practice in relation to teaching visual arts. The research indicates that a majority of the subjects over-used or over-relied upon the suggested practical starting point entitled *Experience and Imagination* (DES 1999b, pp. 30, 31) for art production in their classroom practice. Consequently, they tended to sideline the other suggested practical starting points *Materials and Tools, Observation and Curiosity* and most especially the practical starting point – *Using the work of another artist* (DES 1999b, pp. 30, 31). Some participants communicated that they used *Experience and Imagination* because children's art production results were more guaranteed and it was easier for them to organize such lessons. They perceived that no research or resources apart from the children's imaginings were required for such lessons. Other teachers indicated that they consistently used *Experience and Imagination* as a means of avoiding the practical starting point *Using the work of another artist*. They did so because of their perceived lack of subject knowledge. Subject knowledge entailed knowledge of the world of visual arts, artists and art criticism. It included teaching knowledge with respect to LAR questioning and LAR methodologies. It also concerned resourcing knowledge in terms of where to acquire secondary sources and contextual information for LAR. Therefore, the implementation of LAR in primary classrooms appeared to hinge at least in part upon their confidence and competence with respect to their sense of connoisseurship (Eisner 2009, p. 57; Heller 2002, p. 25; Hildred 1989, p. 49).

Smith (1980) has offered a classification model for teaching styles that provides further evidence of these primary teachers' expressionistic epistemological positions in relation to visual arts education. He has categorized art teachers into five different types. These are the *High Priest, the Technocrat, the Social Worker, the Pedagogue, the Semiologist* and the *Anomic*. Each type has a set of different values, which form the basis of a certain approach to teaching visual art (Hickman 2004, p. 4). *High Priests* are largely concerned with providing opportunities for individual personal expression. This parallels the curriculum's broad objective that children be enabled to 'express ideas, feelings and experiences in visual from and with imagination, enjoyment and a sense of fulfilment' (DES 1999c, p. 10). The curriculum's suggested practical starting point entitled 'Experience and imagination' (DES 1999b, p. 29) provides for their teaching approach. Technocrats are mainly concerned with presenting art as a problem-solving activity encouraging inventiveness and giving opportunities for exploration and understanding of materials. This resonates with the curriculum's suggested starting point labelled as 'Materials and tools' (DES 1999b, p. 30). *Social Workers* encourage growth of imaginative ideas and wish to provide opportunities for their students' social awareness. This resonates with the curriculum's practical starting point 'Experience and imagination' with respect to empathising and with integration and thematic linkage with subjects such as Social, Personal and Health Education; Social, Scientific and Environmental Education or Religious Education.

Pedagogues have a focus on developing the aesthetic response in learners, which ties with the practical starting point 'Observation and curiosity' (OC) (DES 1999b, p. 31) whereby children look using their artist's eye. *Semiologists* value visual literacy. This literacy competency entails having the ability to read and produce visual arts through opportunities of engagement involving active and purposeful observation combined with art making (Barnes 1996, p. 9). These art teacher types see the value in looking and responding to other works by other professional artists. The visual arts primary curriculum highlights that 'learning to "read" what an artwork is about, how it was made and what was intended, and having time to reflect on how they feel about it, can help to reinforce children's understanding and appreciation of their own work and the work of others' (DES 1999, p. 34). They would embrace the curriculum's practical starting point 'Using the work of another artist [craftsperson or designer]' (DES 1999c, p. 31) and perceive visual arts as 'another way of knowing' (DES 1999b, p. 2). Art as another way of knowing is a core belief underpinning the 1999 visual arts curriculum and is presented as a key rationale for the centrality of visual arts education in the primary school curriculum (DES 1999a, p. 2). Smith considered *Anomics* to be a composite of all his art teacher types, but underlined by what he describes as a 'fundamental conservatism' (Hickman 2004, p. 5).

Subjects in the oCPD course (2007) were asked to suggest to which if any of these categories they would assign themselves. A small majority of subjects identified themselves as a *Social Worker, High Priest* or a hybrid of both with respect to perceived art teacher type. *Social Workers* and *High Priests* as categorised by Smith (1980) value self-expression

and imaginative thinking. Notably, none of the systematic sample groupings categorised themselves as a *Semiologist*. This suggests that many of these primary teachers are not quite aligned with all curriculum emphases with respect to epistemological values and beliefs concerning visual arts education. This may explain why consecutive curriculum implementation reviews (DES 2005; NCCA 2005a) have found that the expressionistic aspects of the curriculum have been embraced enthusiastically by teachers while planning and assessing concepts and skills development – most especially in relation to visual literacy and LAR have been overlooked or neglected.

For those with expressionistic leanings, LAR was perceived as limiting or curtailing children's own natural creativity. The visual arts curriculum strongly advocates that children's art production be open and that children remain the designers of their own work (DES 1999a). These teachers perceived LAR as interfering with or infringing on children's own natural innate creativity. Some of them communicated a shared misconception – that the only follow-through art production response to LAR is replication. However, the visual arts primary curriculum does not stipulate a required 'copying' response to LAR. In contrast, LAR is considered to provide children with more ideas and to expand their production repertoire with respect to techniques, emphases and styles (DES 1999a, p. 31). Artists engage with other artworks to examine how they explore similar media or themes, just as writers read to improve their writing ability (Herz 2010, p. 51). These primary teachers did not appreciate LAR as an opportunity for children to learn how other accomplished artists addressed similar themes, exploited the properties of the same visual elements, explored similar media or changed fixed notions of what is and what is not considered 'art'.

Regarding sketching a work of art, the curriculum notes that an artwork should be used for children's 'imaginative activity and not as an excuse for imitation or pastiche' (DES 1999a, p. 31). It frowns on replication. However, Hughes (1989, p. 76) suggests that pastiche and parody are more fruitful alternatives to copying. He also paraphrases Berger that 'a copy is not simply a representation of the copied work but a visual record of the work of art being looked at' (Hughes 1989, p. 76). It can help extend the range of children's awareness of the visual elements (Clement 1986, cited in Thistlewood 1989, p. 75). Herz (2010, p. 29) comments that sketching artworks is a tool artists use to observe artworks more carefully or attentively. However, Barnes (1996, p. 4) warns that to 'deliberately teach children to copy would not fit any principle of individual learning or creativity'. Teachers' misconceived association of LAR with 'copying' might partly explain why LAR is avoided.

Other primary teachers admitted they over relied upon *Experience and Imagination* not so much from deeply held epistemological standpoints regarding the teaching of visual arts but more as an excuse for what Barnes might term their more *laissez faire* approaches to teaching visual arts (Hallam et al. 2007, p. 213). Critics of Rouseauian or Arnheimian 'free expression' art education philosophies feel that only the most creative students will succeed in such teaching and learning environments (Hallam et al. 2007,

p. 208). However, this sub-grouping of primary teachers was in effect acting out such philosophies. They had reduced their teaching role and relinquished planning supposedly to increase children's autonomy for self-expression and creativity. They limited their role to organising materials rather than orchestrating learning mainly due to perceived lack of confidence, competence and basic connoisseurship regarding the nature of art and art appreciation. They avoided LAR.

Integration

A second extracted story line concerns the impact of integrated and thematic approaches to teaching and learning. These practices are promoted in the primary curriculum. Both practices appeared to be skewing visual arts teaching in a manner that negatively impacted on the menu of artwork being addressed in primary classrooms. The resultant menu was not representative of the ever-increasing diversity within visual arts or children's own visual culture. The majority of oCPD participants indicated they were less likely to address artwork or use it as a stimulus for art production if it did not have a perceived potential for thematic integration with other subject areas. Online surveys indicate that teachers were more likely to address works of art that had perceived potential for language development or another way of knowing about other subject areas as opposed to art itself. There was little evidence of the subjects selecting art for art's sake. That was somewhat surprising considering the majority of them espoused or enacted an expressionistic visual arts practice with respect to art production. It indicated while they embraced expressionism for art production, they exploited LAR more for thematic integration than as a learning experience in its own right.

The primary curriculum emphasises that visual arts should not be subsumed through integration (DES 1999b, p. 19). The research upon which this chapter is based suggests that the focus and emphasis on thematic planning and integration that pervades primary teaching negatively impacts upon the breadth and type of artwork being addressed for LAR. Artwork, which is perceived as having more obvious potential for integration with other subjects or language development, is more likely to be used in LAR than more ambiguous artwork.

While the subjects were very welcoming of contemporary or more ambiguous artworks into their classrooms, they did so, provided the artworks were deemed appropriate from a child-centred perspective in terms of its content and form. Contemporary artworks were embraced more especially when teachers saw their integrative potential with other subject areas. Although oCPD may have demystified more ambiguous work such as monochrome painting, the subjects still communicated far greater enthusiasm about contemporary artwork, which they perceived had greater integrative potential. A work's thematic potential may relate to the subject matter addressed, the media used in its production, the creative process involved, the work's content, its form, provenance or its physical location. Artwork that did not appear to the subjects as having as much potential for integration with other subject areas or language development was most probably excluded. Both time

constraints and curriculum overload were the perceived impediments for implementing LAR. Therefore, it is not surprising that the inclusion or exclusion of artwork for LAR in Irish primary classrooms seems to be heavily dependent upon the work's perceived capacity to fit easily into a thematic or integrated weekly plan.

Part of this study explored oCPD participants' preferences in art from the repertoire addressed in the summer online courses. Subjects indicated their preference and greater comfort in addressing artworks in LAR, which were painterly in appearance, were created with obvious craftsmanship, had a noticeable visual narrative and were considered to be child-centred with respect to their content and form. Perceived imaginative and colourful works were also preferred. They favoured artworks that were created from the artists' own experiences and imaginations. This parallels the participants' most used starting point for art production – *Experience and Imagination*. Their familiarity with the artworks was also a variable in terms of whether they would address it in LAR. Readymade sculptures, monochrome paintings and pure abstract expressionistic artworks appeared to be the least preferred for LAR purposes because of their perceived limited potential for fruitful LAR discussion. They found ambiguity in artwork off-putting for LAR.

In loco parentis

The third uncovered story line concerns an underlying fundamental conservatism that pervades LAR-content selection. It relates to their position of *loco parentis* and their mindfulness of some children's parents' more conservative viewpoints or values because of their cultural or religious backgrounds. Online discourse from oCPD 2009 highlighted that although all primary schools are required and have a visual arts education school policy, the majority of the subjects' schools have not addressed the issue of censorship in art. School policies do not provide any guidance for teachers with respect to the kind of artwork that is appropriate or that might cause offence or contravene the school's ethos. Whereas many teachers felt their professional discretion should suffice, as it does to other subject content, others felt it would be fruitful to have a staff discussion regarding artwork selection and the issue of censorship in LAR.

Although appreciating that art and controversy can apply to process, media used, physical context of work, artist etc., any censorship issues as expressed by subjects relating to this study only concerned content and form of encountered artworks. The research did uncover some surprises. For example, the exploration of the theme 'Death' in LAR was well received by participants. However, loss and bereavement do affect primary children's lives. Teachers were welcoming of the artwork that addressed the theme of loss and bereavement because it was perceived as being child-centred and appropriate for children to comprehend. Nudity in art received mixed responses from primary teachers even when it was depicted in an abstracted and reduced form.

Interestingly, there emerged a shared perception that context is a variable when looking at and responding to works of art. Location of display emerged as a variable when there was nudity present. Some teachers indicated they would be more receptive to

addressing nudity in a gallery space with confirmed parental consent. Otherwise, there was reluctance among a large majority of these teachers to actively bring in nudity into the classroom in case it may be misconstrued or cause upset to certain parents or cultural groupings or cause embarrassment to some children in senior classes. Some mentioned that because there was such a wide range of other artwork available for primary teachers, that artwork which addressed or entailed nudity could be easily avoided. This story line suggests that attribution of Victorian sensibilities to art education, is overly simplistic and somewhat unfair. Primary teachers' key concern is that of children's safety, their general well-being and holistic development. They are in a special and privileged position of *loco parentis* and they are mindful of the perceived responsibilities and expectations, which that position implies and entails. They also have to adhere to their school's ethos and are obliged to be inclusive of all children – including those who might come from more conservative cultural and religious backgrounds. Therefore, it is understandable that primary teachers tread carefully in terms of addressing potentially more controversial or sensationalist artwork.

ICTs

The fourth emerged story line suggests that developments in ICT in primary-school classrooms can consequently develop LAR. Lilly Lu (2007, p. 48) writes that digital visual culture is now so pervasive that all art educators of the twenty-first century need to think about engaging and motivating their students into utilizing or modelling their favourite digital media as effective learning technologies. Many oCPD participants communicated an awakening to the Internet as a resource for LAR resourcing and tool for LAR teaching. They communicated enthusiasm and excitement about emerging new art forms, which use and can only be viewed using digital media. Although course participants needed basic computer skills to actually engage in online learning, many of them communicated perceived ICT knowledge acquisition with respect to using the World Wide Web as resource for LAR resourcing and LAR teaching. They communicated intent to utilise the Internet more in class for LAR and to investigate how their schools' Internet could provide access for teachers to *You Tube* (You Tube 2011) for LAR, while at the same time ensuring security blocks are in place to ensure children's safety when using the Internet.

Choi and Piro (2009, p. 29) comment that technology is fast becoming the new alpha competency – an indispensable skill for twenty-first century learning [and teaching]. They outline that using interactive features and tools on LAR oriented multimedia websites can facilitate an aesthetic scanning of art and aesthetic objects to disclose their sensory, formal, technical and expressive qualities of art. This study indicates that in order for LAR to be fully implemented in the manner the visual arts primary curriculum intended, primary teachers need to feel digitally literate as well as confident and competent in terms of their own visual and cultural literacies to undertake the roles of researcher, questioner, mediator and philosopher required for LAR.

Empowering primary teachers: conclusions and recommendations

In terms of theory generation, discourse analysis of practising primary teachers' online postings proposes that the prevalence of expressionistic held epistemologies and the promotion of the integrated and thematic classroom teaching have negatively impacted upon the successful implementation of LAR in Irish primary classrooms. They have also narrowed the spectrum of artwork being addressed in schools. The integrationist and thematic approaches advocated by the primary curriculum steers primary teachers towards addressing certain kinds of artwork to the exclusion of others. Artwork for LAR is selected not for art's sake but rather as another way of knowing *about* other subjects. It promotes learning *through* art to the neglect of learning *about* art. The artwork selection criteria for curriculum inclusion is based more so on a work's perceived potential for integration or general language development. The resultant LAR menu is limited to narrative artworks predominantly. There is little challenge provided in terms of semiotics or critical dialogue as more ambiguous work is avoided. An understandable conservatism regarding artwork selection also stems from *loco parentis* and a primary teachers' mindfulness of the different values and sensitivities within a class grouping.

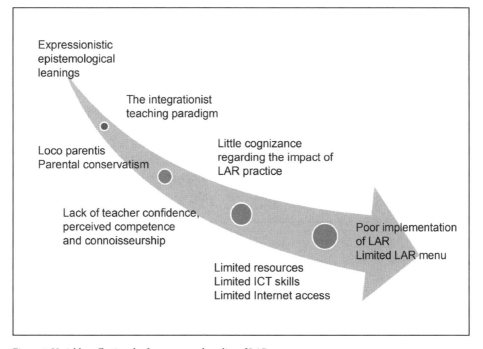

Figure 1. Variables affecting the frequency and quality of LAR

A lack of teacher confidence stemming from a poor sense of connoisseurship with respect to LAR has fuelled avoidance. Little cognisance regarding the importance of LAR in terms of children's artistic, linguistic and holistic development has resulted in it being perceived as non-priority curriculum component. Finally, although having no classroom access to the Internet means that a whole range of emerging digital art forms available for viewing online are excluded from LAR content, primary teachers are less likely to utilise the Internet as a LAR resource if they are not digitally literate. Each of these uncovered variables impedes the frequency and quality of LAR. They limit the breath and range of artwork addressed to a very narrow and skewed representation of what Searle (1999, p. 46) refers to as 'the definitions, redefinitions and de-definitions of art'.

While examining the limitations of the study, one needs to consider how representative the subjects are of the general population of Irish primary teachers. One could assume that on one hand they were all primary teachers who were already interested in and motivated about LAR. However, course evaluation surveys conducted each year using *surveymonkey* indicated that many opted for the course because it was available online (see Table 3). They selected it primarily because of its perceived advantages in terms of convenience, financial savings in relation to travel and child-care expenses and greater learner autonomy. Race (2005, p. 15) writes 'the three most common reasons learners themselves give for selecting for open learning pathways are to fit in with work commitment, accommodate family commitments and enable them to work at their own pace, and place, and at times of their choosing'.

Table 3. Course evaluation feedback

Surveymonkey course evaluation	oCPD 2006	oCPD 2008
Perceived greater convenience	70.6%	58.7%
Completed oCPD in their home	85.8%	84.8%
Have broadband at home	52.7%	85%
Would complete oCPD during school term	68.2%	59.9%
Perceived greater learner autonomy	47%	40%

The report of the DES Inspectorate on newly qualified teachers in primary schools (DES 2005) found that 'considerable percentages of primary teachers during their probationary period expressed that they had been poorly prepared to teach visual arts (27%)' (DES 2009, p. 15). The research upon which this chapter is based suggests that Irish primary teachers do need to be more informed about LAR with respect to awareness, appreciation and appraisal. They need to be more knowledgeable of the principles underpinning the visual arts primary curriculum other than those concerned with free

expression and imaginative thinking. They need to be and feel confident, competent and creative in helping children to look at and talk about artwork by other professional artists. This implies the acquisition of certain foundation subject knowledge pertaining to LAR and skills development with respect to visual, cultural and digital literacies. Although the visual arts primary curriculum is designed with the generalist teacher in mind, this study finds that primary teachers need to acquire certain connoisseurship with respect to art awareness, appreciation and appraisal. They need to develop a certain subject lexicon to implement this curriculum component effectively. They need to learn about specific LAR teaching methods and approaches, which will enable them to execute the roles of researcher, questioner, mediator and philosopher to facilitate rich LAR discussion.

This study outlines a number of recommendations for initial teacher education, curriculum development and enhancement and online LAR resourcing. The recommendation to increase the non-practical element of [visual] arts education in initial teacher education (Teaching Council 2009, p. 279) should be activated. Colleges of education should review and evaluate what they are doing to ensure their student primary teachers will feel informed, equipped and enthused about presenting and addressing diverse works of visual art in future classroom practice. Colleges should appraise how they apportion time for the analytical/critical and historical/cultural components of their visual arts initial teacher education courses in addition to the expressive productive and perceptual.

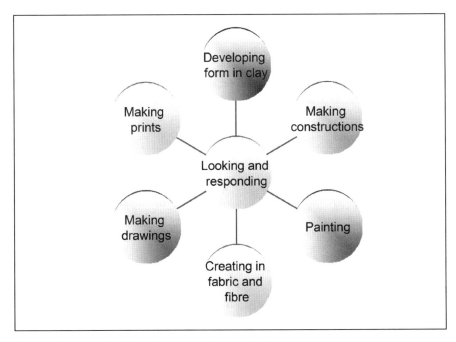

Figure 2. Presenting the LAR as a hub co-requisite strand unit

Regarding curriculum development and enhancement, the 1999 visual arts primary curriculum might be better re-presented so that the status of the six strand units *Looking and responding* is more evident for primary teachers (see Figure 2) A re-presentation exercise was completed by the NCCA (2005b) following confusions stemming from the original presentation of the English primary curriculum. A similar re-presentation of the six strand units with LAR as a single *hub* strand unit would clarify its presence and significance in the curriculum more clearly. It would not affect the curriculum's content objectives, curriculum emphases or demote other strand units. It would make more obvious the centrality and importance of LAR and illustrate how it interrelates with and benefits all six visual arts production strand units more effectively. A non-linear re-presentation of the six strands also removes any perceived hierarchies among the curriculum strands.

From a grounded theoretical perspective, four key story lines emerged, which explain at least in part why it is not so surprising that the LAR curriculum component is not being fully implemented in classrooms (Figure 3). Teachers' expressionistic and integrationist epistemologies, their sense of poor subject connoisseurship and loco parentis responsibilities emerged as key variables that impinge upon the frequency and

- Expressionistic epistemological leanings

- The practice of integration and thematic planning at primary level

- Loco parentis

- A teacher's own visual, cultural and digital literacy levels

Frequency and quality of LAR in the classroom practice

Figure 3. Four key variables affecting the frequency and quality of LAR

quality of effective LAR planning and facilitation. As teachers of the primary curriculum, they are advised to plan in an integrative and thematic manner. As professionals, any activity or experience that is perceived [or misconceived] to be limiting or infringes children's own imaginations is avoided. As generalist practitioners, they are not required to be, nor does the curriculum demand that they be, experts in each curriculum area. As caring professionals, they are expected to be and are ever mindful addressing child-centred content. However, each of these is an emergent variable, which can negatively impact upon the frequency and quality of LAR implementation. Conversely, this research also highlights when primary teachers are cognisant of and informed about the benefits of LAR, their role in orchestrating LAR and mediating works of art with children and of limited or skewed effects thematic integration can have on the LAR menu; they desire to improve classroom practice. They communicate intent to model a more open, positive and curious disposition towards art and to address a greater range of artworks. This research finds that primary teachers require greater and continual CPD support and appropriate resourcing such that LAR can be implemented more fully and in a manner that is more inclusive and representative of the ever-increasing range and ever-evolving nature of the visual arts.

References

Barnes, R. (2002) *Teaching Art to young children 4- 9.* New York, Routledge Falmer.

Choi, H. & Piro, J. M. (2009) Expanding Arts Education in a Digital Age, *Arts Education Policy Review* Vol. 110, No. 3, Spring. Heldref Publications.

Clement, R. (1990) The Art Teacher's Handbook.Cheltenham: Stanley Thorners.

Cohen, L., Manion, L. and Morrison, K (2007) *Research Methods in Education Sixth Edition.* London and New York, Routledge.

Crafts Council of Ireland (2009) *Creative Pathways: A Review of Craft Education and Training in Ireland,* Dublin: Crafts Council.

DES (1999a) *Primary School Curriculum Introduction,* Dublin, The Stationery Office.

DES (1999b) *Visual Arts: Arts Education: Teacher Guidelines,* Dublin: The Stationery Office.

DES (1999c) *Primary School Curriculum: Visual Arts: Arts Education,* Dublin: The Stationery Office.

DES (2005) *An Evaluation of Curriculum Implementation in Primary Schools.* Dublin: The Stationary Office.

Dey, I. (2007) *Grounding Grounded Theory. Guidelines for Qualitative Inquiry,* UK, Emerald Group Press.

Eisner, E. (2002) *The Arts and the Creation of Mind.* New Haven & London, Yale University Press.

Eisner, E. (2009) What Education can learn from the Arts, *Art Education,* Vol. 62 No. 2, pp. 6-9.

Green, L. & Mitchell, R. (1997) *Art 7 – 11 developing primary teaching skills.* New York, Routledge.

Hallam, J., Lee H. & Das Gupta, M. (2007) An Analysis of the Presentation of Art in the British Primary School Curriculum and its implications for Teaching, *JADE* 26 (2) pp. 206- 214.

Heller, G. (2002) *Why a painting is like a pizza.* New Jersey. Princeton University Press.

Herz, R. (2010). Looking at art in the classroom. New York: Teachers College Press.

Hickman, R. (Ed) (2004) *Art Education 11- 18. 2nd Edition.* New York, Continuum.

Hickman, R. (2006). Some Autobiographical Reflections on Becoming an Art Educator. In L. Beudert (ed.) *Work, Pedagogy and Change: Foundations for the Art Teacher Educator,* Reston, VA: NAEA.

Hildred, M. (1989) New Ways of Seeing. In: Thistlewood, D. eds. *Critical Studies in Art and Design Education,* UK, Longman Group Ltd.

Hughes, A. (1989) The Copy, the Parody and the Pastiche: Observations on practical Approaches to Critical Studies. In: Thistlewood, D. eds. *Critical Studies in Art and Design Education,* UK, Longman Group Ltd.

Holt D. (1997) *Primary Arts Education, Contemporary Issues,* London, Falmer Press.

INTO (2009) *Creativity and the Arts in the Primary school,* Dublin, Dublin: INTO.

Lilly Lu, L. (2008) Art café: A 3D Virtual Learning Environment for Art Education, In: *Art Education,* 61 (6), pp. 48-53.

NCCA (2005a) *Intercultural Education in the Primary School,* Dublin, The Stationary Office.

NCCA (2005b) Additional Support Material Structure of the English Curriculum, Dublin, Author.

Race, P (2005) *500 Tips for Open and flexible learning.* London & Sterling, USA, Kogan Page.

Searle, A. (1999) Art, *Guardian Weekend,* 16 January, p.46.

Smith, I. F. (1980) Art, In: R. Straughan & J. Wigley (Eds.) *Values and Evaluation in Education,* London, Warper & Row.

Swift, J. & Steers, J. (2006) A Manifesto for Art in Schools, In: Hardy, T. (Ed). *Art Education in a Postmodern World.* Bristol UK, Intellect .

Taylor, B. (1986) Art History in the Classroom: A Plea for Caution. In: Thistlewood, D. eds. *Critical Studies in Art and Design Education,* UK, Longman Group Ltd.

Taylor, R. (1996) *Educating for art: Critical Response and development,* Harlow: Longman.

Teaching Council (2009) *Learning to teach and its implications for the continuum of Teacher Education: A nine-country cross-national study,* Maynooth: Teaching Council of Ireland.

Thistlewood, D. (1989) *Critical studies in Art and Design Education* Longman.

Notes

1. Course participants were afforded the opportunity to refrain from participating in the re-search at any time by inserting the phrase 'Not for use' in their posting.

Chapter 5

'It's Easy to See which Side You Are On'[1]: Northern and Southern Irish Student Teachers' Reflections on Art and Identity

Dervil Jordan and Jackie Lambe

A rt and visual imagery have long been associated with concepts of national identity. Munro (1956, cited in Siegesmund, 1998)) suggests that there is no better avenue than art to the understanding of past and present culture. Eisner (1987), continuing the theme, concludes that to be able to understand culture 'one needs to understand its manifestations in art, and to understand art, one needs to understand how culture is expressed through its content and form' (p. 20).

This chapter examines the potential of art education to contribute to an exploration of national identity and citizenship across the island of Ireland. The chapter examines some recent research activities carried out with student teachers in the National College of Art and Design in Dublin and the University of Ulster and is structured as follows. Firstly, the context is described in terms of a recently completed EU Comenius project *Images and Identity: Improving Citizenship Education through Digital Art*. It then outlines the extension of this research in a national context, which is presented as the 'North South Exchange a Continuum: Images and Identity project'.[2] The research activities are described, and include student teachers' responses to 'Passion and Politics', an exhibition of the works of Sir John Lavery at the Hugh Lane Gallery in Dublin. Next, data drawn from a questionnaire examining the student teachers' responses to the exhibition and their perceptions of the role of the artist as a visual commentator of his times are presented. Finally, the chapter concludes by reflecting upon the potential for further research and practice.

Context

The EU Comenius project *Images and Identity: Improving Citizenship through Digital Art* was carried out with six education partners (UK, Ireland, Malta, Portugal, Germany and the Czech Republic) from 2008 to 2010. The project was primarily an art education initiative, co-ordinated from Roehampton University, London, designed to support and empower teachers to investigate citizenship themes and concepts through art education and digital media, with a specific focus on European Identity. Art education provides important opportunities to address emotional and symbolic aspects of human experience, integrate verbal and non-verbal forms of expression and promote intercultural communication between learners and teachers. Its potential contribution to teaching citizenship has not yet been explored in the European context (Mason 2010).

In defining the project's objectives Mason cites Kerr (2004) who states that 'Education for democratic citizenship (EDC) has been a Council of Europe priority since the mid 1990s. However Citizenship or Civic Education was established as a specific education aim very recently in many member states and there are shortfalls in resources and teacher training' (p. 6).

The findings drawn from the Irish aspect of the original study suggest that:

building discussion around citizenship issues related to Europe in art classes was challenging and it was perceived as difficult to achieve a satisfactory balance between art making and the discussion of citizenship and Europe (Jordan 2009).

At the same time the findings showed that within the setting of the art and design room, pupils were highly motivated to explore issues relating to personal identity within the context of their own national identity. The findings from this first phase of the research provided the impetus to expand the study and to explore the potential of the visual arts supporting the development of citizenship education across the island of Ireland (North and South) with particular reference to the pre-service stage of teacher education.

Image and identity: the North–South focus

Since the 1990s, there has been a renewed interest in citizenship education across the island of Ireland. In the Republic of Ireland, a programme of Civic Social and Political Education (CSPE) has been in place in post primary schools since 1997. Significant economic, political and social changes in Ireland during the final decades of the twentieth century were to have a profound effect on the development of curriculum and education policy in the Republic of Ireland (Kerr, McCarthy and Smith 2002, p. 183). The introduction of citizenship education into the Northern Ireland school curriculum, however, was potentially more contentious because of the difficulties of growing up in a society where loyalties are strongly divided in terms of national identity.

During 1970s and 1980s, when 'the troubles'[3] were at their height, schools in Northern Ireland often saw their role as providing what was for many young people a stable environment in otherwise hostile and turbulent surroundings. Teachers often saw their role as one of limiting discussion or simply avoiding controversial issues that might create dissension within the classroom or what Arlow (1999, p. 14) calls 'their oasis of peace'.

The signing of the Good Friday Agreement (GFA) on 10 April 1998 affirmed that Northern Ireland will remain part of the United Kingdom for so long as it is the wish of the majority of the people who live there while acknowledging the legitimate wish of a significant minority within Northern Ireland to be part of a united and independent Ireland. The potential contribution of education was seen as an important means in

helping to develop an overall culture of tolerance and the Department of Education (DENI 1999) recommended that the school curriculum should be developed to include citizenship and human rights education.

Defining citizenship and its relationship to national identity, however, remains problematic in spite of the fact that Northern Ireland may be viewed today as a relatively peaceful and functioning democratic society. The legacy of the past is still powerful and still deep enmities can remain, along with a perceived lack of cultural understanding and trust between communities. There also continue to be unresolved issues as to how historical events are perceived The two traditions tend to be portrayed in terms of identity and allegiance – either 'unionist/loyalist/protestant' or 'nationalist/republican/catholic' – and there continues to be a 90% religious segregation in schooling.

Strong family and community loyalties also tend to promote 'tribal' political interests, which often include a selective or partisan version of historical events that are often conveyed through folklore, pageantry, memorials and in various street paintings such as wall murals. In loyalist/protestant areas, banners or wall paintings will commemorate the 1916 Battle of the Somme during World War I where thousands of Northern Irish died in the cause of the British Empire. Alternatively, republican/catholic neighbourhood images might commemorate the Easter Rising (also in 1916) against British rule. Such visual images have been used extensively in Northern Ireland to draw selectively on the past.

Unlike other societies (including the Republic of Ireland), providing a universally accepted single model or even definition of citizenship in the context of Northern Ireland society can still be seen as elusive. More worryingly, Arlow (1999, p. 14) has suggested that 'Citizenship Education in the Northern Ireland curriculum has the potential to alienate not only teachers but pupils as well as the wider community'. There is, however, an expectation that it will be prioritised by schools, with learners given opportunities to discuss and examine key contemporary and often controversial issues relating to equality, diversity, democracy, human rights and identity.

Why art and citizenship?

Throughout history, human beings have looked to the arts to make sense of experience (Davis 2005, p. 12). This quality in the art process of *making discussing and reflecting on meaning* is one that is particular to an arts education. Art teachers and artists are familiar with processes of engaging with issues of identity, difference, justice, politics through image making and construction of meaning. As Jessica Hoffman Davis (2005) suggests in her paper Redefining Ratso Rizzo: Learning from the Arts about Process and Reflection, 'creating art gives students the opportunity to encounter and value different perspectives in their own thinking and action to integrate the learning they are doing in separate areas into a coherent artistic production' (p. 14).

Granville (2009) in his paper The Art is in the Tea: Educating against the Grain argues that the transformative power of art is one of the key features of an arts-based approach to exploring issues of identity. In the words of Mezirow (1999):

> The focus of the educator is on facilitating a continuing process of critical enquiry wherever it leads the learner. There are no 'anticipated learning outcomes' in transformative learning.

When exploring issue-based work that can be difficult and contentious, art making, discussion and analysis can go places where other more traditional educational methods cannot go. Often it is said that 'words fail you' or 'actions speak louder than words'. Human capacity for expression through the arts is relied upon to capture a mood or a profound sense of emotion when all else fails. Irish artists, from both north and south, such as Paul Seawright, John Kindness, Perry Ogden, Neil Jordan, Dorothy Cross, amongst many others have dealt with issues of national identity in ways that challenge us and create new meanings of what it means to be Irish. The work of these contemporary Irish artists formed the basis of discussion around national identity throughout the first phase of the Comenius *Images and Identity* project. As a result of the Comenius research project, it seemed a natural extension to focus more closely on what it meant to be 'Irish' across the whole island of Ireland. Given that we are dealing with art education in the North and South of Ireland, it was appropriate to examine the differing perceptions of what it means to be Irish on both sides of the border.

Link with art and design teachers North and South

Two groups of postgraduate students (from both campuses) embarked in September 2010 on a joint *Images and Identity: the North South Exchange* project, which involves exploring, making and discussing collectively images that represent their national identity. The aim of the project was to examine the potential for art education within the context of Initial Teacher Education to contribute to an exploration of national identity and citizenship across the island of Ireland. Art and Design student teachers have a common sense of purpose in this regard. Their stock in trade is image making and art education. Both these cohorts of student teachers are well positioned to reflect on their concept of national identity at this point in time.

Both groups of teachers share a similar process of formation, in that both courses are highly competitive, as many apply but few are chosen, and they are very intensive in nature. The northern group comprised 11 student teachers, 9 female and 2 male, aged from 22 to 35 years. The southern group was slightly more mature, with an age range from 23 to 44 years, and was larger in number with 15 females and 8 males.

The first phase[4] of the research collaboration was a joint visit to a significant art exhibition in Dublin, related to the theme of national identities: *'Passion and Politics'—Sir John Lavery: The Salon Revisited'* at the Hugh Lane Gallery in Dublin. They participated in a tour and drama workshop, which focused on exploring the work of Sir John Lavery, whose work chronicled the period from the 1916 Rising to the War of Independence through to the birth of the Irish Free State and the State of Northern Ireland. This exhibition was key to initiating discussions around identity. In the foreword to the catalogue, Lavery's portraits are described by Barbara Dawson, the gallery's director, as a non-erasable and vivid account of the two nascent states. Dawson highlights the significance of the exhibition in terms of the contemporary identity of Ireland.

> The approach to 2016, the centenary of the Easter Rising, one of the most significant events in modern Irish history, this must be seen as the most singular opportunity for a current appraisal of those events which culminated in the birth of modern Ireland as well as a critical evaluation of the consequences for Irish contemporary identity (Dawson 2010, p. 6).

This exhibition formed the backdrop for the conversations and image sharing that followed. Following the gallery visit and a period of reflection, a structured survey was completed by both cohorts.

Methodology

The study was qualitative in nature and used an open-ended questionnaire as the main data-gathering instrument (Appendix 1).

The aim was to be unobtrusive and not setting out to verify a predetermined idea, but instead to discover new insights. Responses to the nine open-ended questions were analysed qualitatively and the words of the students are presented as the findings of this study.

Qualitative content analysis: open-ended questions

The data were collected primarily through a questionnaire using open-ended questions. Having first read all the data thoroughly to get a sense of the whole (Tesch 1990) the material was read again, highlighting words in the text that appear to capture key thoughts or concepts and also to establish initial codes (Miles and Huberman 1984). The findings drawn from the student responses were analysed thematically following a qualitative approach as recommended by Vaughan et al. (1996) searching specifically for the following information:

- Key themes or common threads found by reading and re-reading the responses from the open-ended questions within the questionnaire

- Any commonality in phrases or sentences used by respondents.</Bullet List>

The responses to each question were transcribed and classified under each question. Notes were then made, reflecting on first impressions, and labels for codes emerged from this. To be able to use words drawn from the questionnaires, codes were also used to protect the anonymity of the respondents. All the pre-service teachers completed the same questionnaire and when returned were given a number and a code. The Northern Ireland students were numbered 1–11 and coded with an N, whereas the students from the Republic of Ireland, henceforth to be called Southern students, were numbered 1–22 and given an S code.

The process was continued so that key codes emerged that reflected the full range of thoughts and concepts found within the text of the open-ended questions. These codes were then sorted into categories that were linked or related (Patton 2002).

Findings: student responses to the Lavery exhibition

Almost all of the Southern students were familiar with the work of Sir John Lavery before touring the exhibition and were quite familiar with the events of the period before they went to the exhibition. This group did refer to their lack of knowledge of the Northern perspective despite having studied this period of history in secondary school. The detail of their political knowledge of events and people in Northern Ireland was very poor compared to their political awareness of people and historical events in the South.

When asked to nominate what they felt were Lavery's most important works, there was a mixed response across both groups. All the Northern students felt that Lavery's portraits of the main political figures of the time were his most important legacy both as artist and chronicler of history. For the Southern students the following emerge as important works: *Michael Collins, Love of Ireland; The Portraits of the Key Political Figures of the Day; High Treason, Court of Criminal Appeal: The Trial of Roger Casement, 1916* and the Portrait of Hazel Lavery, the artist's wife.

Almost half the Northern cohort cited *The Trial of Sir Roger Casement* as Lavery's single most significant painting. The fact that this painting is much larger than the portraits and that Lavery placed himself within the tableau (even though he was not present at the trial) suggested to the students that he was not altogether a neutral commentator and was sympathetic to Casement. Both cohorts felt that Lavery's motivation for tackling what would have been seen at the time as a highly controversial subject was not a purely objective one.

I think he was sympathetic to Casement. He did risk his own reputation with the British establishment but it didn't stop him (Student 7N).

The other painting cited by both groups as being most significant was the portrait of a dead Michael Collins lying in state and draped in the Irish flag. The responses of the students from a Northern Catholic background indicated that they were aware of the national significance of this image. '[T]his one is a very intimate and very tragic image with less grandeur attached to it unlike some of his other portraits' (Student 3N).

Figure 1. Michael Collins (*Love of Ireland*) 1922. Oil on Canvas, 63.8 x 76.8 cm.
Collection Dublin City Gallery The Hugh Lane. © By courtesy of Felix Rosenstiel's
Widow & Son Ltd., London on behalf of the Estate of Sir John Lavery.

Those from a Protestant background admitted they previously knew very little about Collins and his role in the negotiations and establishment of the Irish Free State. One commented:

I really haven't realised how important Collins was (is) to the Irish psyche and just what an important historic figure he was until I saw that painting.... I would not have seen him or his cause as in anyway relevant to me and my history (Student 2N).

Amongst the Southern students, the portrait of the dead Michael Collins who is portrayed lying in state, draped in the tricolour with a crucifix placed on top, showed the strong influence of the Catholic Church in the Republic of Ireland at the time:

It displayed quite powerfully the role of the church in the formation of the new state and the influence it would exert over the nation and particularly over the education system for decades to come (Student 5S).

Both student groups found the portraits of the key political figures of the day of great significance. These portraits, hung together on opposite walls, presented the viewer with the key figures on both sides of the divide. The importance of Lavery's role as a historical chronicler of the times is evident in these works and was noted by several students:

I think his portraits of key political figures are very important as they provide an opportunity for generations of Irish people to come face to face with the people who shaped this country (Student 8S).

All the respondents noted the portraits of Lord Carson and John Redmond as being specifically important as they represented opposing political opinion. There was some discussion as to Lavery's portrayal of these key figures in terms of what might be conjectured his less than sympathetic artistic portrayal of some of the British representatives. One Northern student articulated this saying:

... I did notice though that some of the portraits of English aristocrats didn't show much warmth or humour in their faces. I don't know if Lavery did this intentionally or whether they were just like that in life! (Student 8N).

The Southern cohort also recognized some disparity with one student summarizing as follows:

Their portraits were intended to hang side by side yet their differences led to speculation as to what side Lavery was on, as was pointed out by Carson (Student 2S).

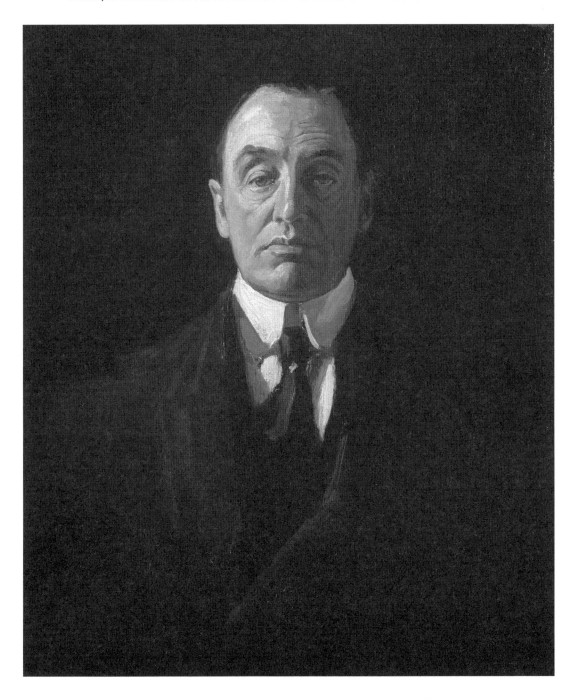

Figure 2. Sir Edward Carson MP. Collection Dublin City Gallery The Hugh Lane. © By courtesy of Felix Rosenstiel's Widow & Son Ltd., London on behalf of the Estate of Sir John Lavery.

Figure 3. John E. Redmond MP, 1916. Collection Dublin City Gallery The Hugh Lane. © By courtesy of Felix Rosenstiel's Widow & Son Ltd., London on behalf of the Estate of Sir John Lavery.

Students from both cohorts felt Lavery used the system to his advantage and there were mixed feelings about this. Some recognized that his social standing was an important aspect of his art. One respondent suggested that

> this exhibition highlighted the importance of the social standing and lifestyle of the artist as a tool for gaining the opportunities to really chronicle the times. I think that it says it all that during our tour of the exhibition the style of painting was never talked about, we were all purely focused on the political messages of the work (Student 5N).

All the students placed a high value on Lavery as a historical and political recorder of a key period in Irish history. Some felt, however, that his role as a society painter of the day curtailed his ability to be entirely objective.

> He was someone who could use the system and was in control of the identity he and his wife constructed for their own ends, most probably financial, in this regard, we have to consider his work with caution (Student 22S).

One student suggested that Lavery's attachment to social position was actually detrimental to him as an artist.

> I don't feel there was an obvious message in his work. I think he painted where the money was (Student 3N).

Most students felt that he was a painter of note at the time but was not exceptional and overall there were reservations about his motivation.

His style of painting was very much to the traditional and conservative taste of the Edwardian period. This irked some students. One commented that his work,

> did not appeal to me personally.… I could not find any sort of artistic idiom or indeed personal trademark in his work. Had I found one it would have helped me identify with the artist (Student 3N).

Although somewhat divided, the majority felt an artist should remain objective particularly when chronicling important historical events:

> If an artist is taking on the role of a visual/historical chronicler then they should try to remain objective (Student 2N).

Some respondents, however, felt that it would be very difficult to remain objective:

I think it is difficult to always remain impartial. I feel that all artists will always in some way present some of their own views somewhere in their work (Student 9N).

A minority felt that it was not the artist's role to remain impartial at all.

It is up to the artist to deliver his own opinion within his work even if he uses symbolism as a means of expressing his beliefs' (Student 3N).

When asked about key messages they had taken from the exhibition of Lavery's work and, in particular, how they felt it might be used in a classroom setting, responses were threefold. The main message was a recognition of the importance of the role of the artist as the visual chronicler of national history and events. One respondent suggested that for her the key message from the work

was to view Lavery as an historian, to look at how his work records key moments in Irish and British history and to realize that as an historical source it can be just as important as the written history of the time (Student 1N).

This view was reiterated consistently throughout the student responses (North and South) and was felt to be his main legacy. Despite some criticism of both his conservatism as a painter and his attraction to social status, all agreed that his work has left an important legacy from one of the most turbulent periods in British and Irish history. Crucially he was there to chronicle the creation of a new Irish state.

… for those of us who have heard the names but never seen the faces Lavery has helped us visualize the 'person' (Student 3N).

The notion of 'humanising' familiar names from this period was taken up by others whereas for some of the students Lavery's work visually contexualized historical events that previously they had heard of but were not overly familiar with. One respondent described this as offering an opportunity to 'open debate (within our group) to all the different viewpoints associated with each of the characters he painted' (Student 1N).

Lavery's continual use of the image of Hazel Lavery also drew comment, particularly with the realisation that it was her image that was commissioned and used in the Irish pound note.

I have to admit my ignorance and say that previous to the exhibition I was unaware that Lady Lavery was American nor did I know of her rather large celebrity status and influence in the country (Student 2S).

When asked to comment on whether there were important omissions of portraits amongst the gallery collection, both cohorts perceived their lack of knowledge of the period made it difficult to comment. Of the students who responded, some were very strong in their opinion that no prominent republican or anti-treaty figure had been included. They had also noted that with the exception of his wife Lavery created very little visual record of significant females of the period such as Maude Gonne or Countess Markevitz.

The Northern students felt less informed about the period but one student suggested she would prefer to see,

> a collection of gritty portraits that hinted as to how Lavery really felt when painting portraits from all angles of politics. I think artists should use their talent to express their view but Lavery is always sitting on the fence (Student 6N).

The Southern students felt that Lavery's work could be considered as a potentially important means of introducing content to classroom work... *by using art to say something important.* For some students the exhibition highlighted their lack of knowledge of the period especially from the Northern perspective, and so it was seen as a good opportunity for cross-curricular learning:

> personally it highlighted how little I knew about the history of a side of Northern politics; perhaps this could be discussed in the classroom. I think that this exhibition is definitely cross curricular, so classroom activities could be devised in conjunction with teachers of history, Irish, English and Religion (Student 2S).

In the words of one student, 'The past and present are inextricably linked, we are shaped by our past and it influences or should influence the decisions we make today' (Student 5S).

Analysis of findings: commonalities and differences

Commonalities

The responses to the exhibition had indicated that the Southern students were more familiar with Sir John Lavery's work and the events of the period, though less familiar with the events pertaining to Northern Ireland. In Ireland, this period of history covering political developments from the late nineteenth century to the twentieth century is part of the Junior Certificate history curriculum.

Recognising the importance of education for citizenship and of developing an understanding of contemporary life in Ireland, a substantial part of the syllabus deals with Irish history (NCCA 1996).

At senior level, history students cover the period of later modern Ireland as a topic on the Leaving Certificate syllabus and this includes 'Politics and Society in Northern Ireland from 1949 to 1993'. As the subject of History is an option at senior cycle, not all students would have studied it to this level.

In the subject History within the Northern Ireland Curriculum (NIC), there is a statutory guideline for pupils to[5] '(e)xplore how history has affected their personal identity, culture and lifestyle'. The NIC places the emphasis on developing pupils' transfer skills, therefore reducing the emphasis on content. In the History curriculum, for example, the only mention of content is the following. Pupils should

[i]nvestigate the long and short term causes and consequences of the partition of Ireland and how it has influenced Northern Ireland today including key events and turning points.

The teaching of the History and Appreciation of Art is pedagogically very different in the North than in the South of Ireland. The statutory requirements for Key Stage 3 (pupils ages 11–14) state that learners should be offered opportunities to:[6] Explore the diversity of various cultures that are expressed through Art & Design. Examples of how this might be approached include exploring 'symbols and artefacts that express the range of cultural traditions in Northern Ireland; explore styles of painting, design and sculpture that reflect other cultures etc'.

Teachers, however, are free to choose their own approach, depth of study and content, and in this probably lie both the NIC's biggest strength and its greatest weakness. In formal examinations such as Advanced level (comparable to the Leaving Certificate in the South), History of Art is offered as a separate subject and the study of the connection of History with the visual culture of Ireland is entirely optional. In the South of Ireland the History and Appreciation of Art is content driven (Irish and European Art from Neolithic times to the present) and accounts for some 37% of the Leaving Certificate Art examination marks..

The Southern students recognised the gaps in their knowledge in relation to Northern politics, and they could see the value of Lavery's work as a record of a significant period in Irish history. They agreed that his nationalist bias appeared in his portrayal of Michael Collins and in his depiction of the trial of Rodger Casement. Overall, however, there was consensus between both groups that both Sir John and Hazel Lavery were the celebrity couple of their time and they used their status to their own advantage. Nevertheless, the students felt that the legacy of his artwork was very important in capturing the social and political history of the time.

As beginning teachers of art and design, both cohorts saw the potential for developing cross-curricular links with History and English, Religion and CSPE or Citizenship Education. They recognized the rich potential of the exhibition to explore issue-based themes through the medium of art, issues such as race, class, national identity, discrimination and stereotypes.

In particular, they found the exchange of views from very different perspectives valuable

> it highlighted how little I knew about the history of a side of Northern politics, perhaps this could be discussed in the classroom (Student 19 S).

The commonalities and differences between the two groups of student teachers were clearly related to their lived experience in different communities in different parts of Ireland, with often different sets of values. Their shared values revolved around their identity as 'trainee art teachers' and their interest in 'art education'. Both groups concurred that the Lavery exhibition highlighted the role of the artist in documenting such an important time in Irish history and saw potential for developing an art curriculum of a cross-curricular nature, which could explore historical or rights-based themes.

Differences

The Southern students had a better knowledge of the history of the period than their Northern counterparts. This is a reflection of the nature of the teaching of Irish history in the south, which is clearly focused on the period of the foundation of the state. The Northern cohort admitted that they felt quite uninformed as to this period of Irish history and were aware of few of the characters in the portraits painted by Lavery. All acknowledged studying aspects of Irish history as part of their schooling but were vague as to the period in which Lavery was working. None felt they had sufficient knowledge to discuss historical events of the period leading up to and including partition in any informed way. Certainly, they did not feel they knew enough about Irish history to have really informed their feelings of national identity.

There was differentiation between the responses of Protestant and Catholic students in the North, whereas there was no religious distinction made between the Southern student responses. The Northern students were acutely aware of the religious distinctions and their responses tended to reflect this reality. The reality of segregated educational institutions – schools and teacher training institutions – in the North was part of their experience. Although no one student either north or south directly referred to 'The Troubles', the Southern students were less knowledgeable about the politics of the north than the politics of the south. Southern students were not as familiar with the nuances of the religious divide in the north and tended to reflect their knowledge of the Southern nationalist viewpoint.

Recommendations and conclusions

The research study raised questions as to how best to deal with national identity within a contested space in a divided society or whether it was relevant at all in this post conflict era. The Southern cohort felt that national identity was not as much a concern for their school pupils as for those of their Northern counterparts, and that personal identity was of greater interest. They also felt that there are more pressing global issues concerning young people today. Certainly, art was seen as a possible way of exploring issues in a contested space, where the teaching of controversial issues has been traditionally avoided. The Northern students were often uncomfortable using emblems such as flags and symbols in their classrooms. In the south, the subject of national identity within the art curriculum was not seen as a controversial subject, but one that is not seen as a high priority in a multicultural society.

The 'Lavery' exhibition was seen as an important initiation point for a conversation that developed over the year between two groups of student teachers. It provided a neutral platform to explore and share very different viewpoints and understandings of what national identity means to each group. An important finding of the research study was the acknowledgement of the potential for using art and design within a cross-curricular framework to explore a range of citizenship-based issues, not specifically national identity.

It also highlighted the difference in levels of content knowledge of 'the history of the foundation of the Irish state' of student teachers from both sides, north and south. 'Given the history of conflict on the island of Ireland and its present-day geographical, political, social and economic impact, it might be particularly important to incorporate the Northern Ireland conflict and peace process into citizenship education North and South' (Niens and McIlrath 2005, p. 22). In a postmodern society 'where capital is no longer restricted by the imperatives of nationalism' and 'where traditions are not valued for their claims to truth or authority but for the ways in which they serve to liberate and enlarge human possibilities' (Aronowitz and Giroux 1991) notions of national identity are open to a range of reinterpretations. It was clear from the research that the students' perceptions of their national identity were no longer determined by flags and emblems or religious divisions. In fact, the students were keen to be inclusive of religious and cultural differences, and despite the differences and contradictions they were keen to engage with each other and form new alliances through their subject. To further elaborate on Aronowitz and Giroux's theory of 'Border Pedagogy' where they suggest

> that remembrance is a form of counter-memory which might allow students to open up the past not as nostalgia but as the invention of stories, some of which deserve retelling, and which speak of a very different future – one in which a democratic community makes room for a politics of both difference and solidarity (Aronowitz and Giroux, 1991).

In an art and design context where 'difference, representation and identity are conceptual tools for exploring practice in relation to culture and tradition (Atkinson 1999) and equally where this rationale can also provide the basis for exploring aspects of citizenship based on multicultural identities or 'multiple forms of community' difference becomes a basis for solidarity rather than division. The potential for art and design teachers to excavate and explore these issues with their students, using the visual arts as a means of reinterpreting meanings and identities of our past, present and future is very potent.

References

Arlow, M. (1999) Citizenship education in a contested society *The Development Education Journal* Vol. 6, No. 1. pp 14-15.

Aronowitz, S. and Giroux, H.A. (1991) *Postmodern Education: Politics, Culture and Social Criticism* Minneapolis: University of Minnesota Press.

Atkinson, D. (1999) A critical reading of the national curriculum for art in the light of contemporary theories of subjectivity *Journal of Art and Design Education* Vol. 18 No. 1. pp. 137-45.

Dawson, B. (2010) *The Cold Heaven* in S. Mc Coole (Ed.) *Passion and Politics, Sir John Lavery: The Salon Revisited* Dublin City Gallery, Dublin: Hugh Lane Gallery, p. 11.

DENI (1999) *Towards a Culture of Tolerance: Education for Diversity* Report of the Working Group on the Strategic Promotion of Education for Mutual Understanding Bangor: DENI.

Eisner, E. (1987) The role of discipline based art education in America's schools. California: The Getty Centre for Education in the Arts.

Granville, G. (2009) *The Art Is in the Tea; Educating against the Grain.* Address to National Association of Youthreach Co-ordinators, Annual Conference, Athlone, 25 February 2009 http://www.youthreach.ie/index.htm.

Hoffmann Davis, J. (2005) Redefining Ratso Rizzo: learning from the arts about process and reflection *The Phi Delta Kappan,* Vol. 87, No. 1, September, pp. 11–17. Phi Delta Kappa International. http://www.jstor.org/stable/20441921.

Jordan, D. (2009) *Images and Identity: Exploring Citizenship through Digital Art, Ireland.* Action Research Report (Unpublished) National College of Art and Design, Dublin. 2009–2009. Executive summary report of Action Research in Ireland at www.roehampton.ac.uk/images-and-identity.

Kerr, D., Mc Carthy, S. and Smith, A. (2002) Citizenship education in England, Ireland and Northern Ireland *European Journal of Education* Vol. 37, No. 2, pp. 179-91.

Kerr, D. (2004). 'Changing the political culture: current developments and common challenges in citizenship education in Europe and the UK.' Presentation at the British Council International Seminar 'Socius Colombia 2004: Citizenship and Civic Education', Hotel Casa Dann Carlton, Bogota, Colombia, 25 November.

Mason, R. (2010*) Images and Identity: Improving Citizenship Education through Digital Art.* Comenius Report, European Commission, Brussels http://www.image-identity.eu Accessed February 2011.

Mezirow, J. (1999) Transformation theory – post-modern issues *Adult Education Research Conference* http://www.edst.educ.ubc.ca/aerc/1999/99mezirow.htm.

Miles, M.B. and Huberman, A.M. (1984) *Qualitative Data Analysis* Beverly Hills, CA: Sage.

Munro, T. (1956) *Towards science in aesthetics*, Indianapolis: Bobs-Merrill.

Niens, U.and McIlrath, L. (2005). Understandings of Citizenship Education: Northern Ireland and Republic of Ireland. Galway: Community Knowledge Initiative.

NCCA (1996) http://www.curriculumonline.ie/en/Post Primary Curriculum/ Junior_Cycle_Curriculum/Junior_Certificate_Subjects/History/History_Syllabus/History_Syllabus.pdf Accessed January 2011.

Siegesmund, R. (1998) 'Why do we teach Art today? Conceptions of Art Education and their Justification'. in *Studies in Art Education* Vol. 39, No. 3 1998 pp. 197-214.

Appendix 1

North South Student Teacher Exchange Group 'Images and Identity' October 2010.

Feedback Questionnaire. Please take time to answer all questions fully.

Please indicate what teacher education course you are currently attending: PGCE Coleraine or PGDipADE NCAD

'Passion and Politics' by Sir John Lavery

Knowledge of the background to the period.

1. How well did you know about the life and work of Sir John Lavery before you toured the exhibition?

Not at all well/Quite well/Very well

2. How familiar were you with the events of period documented by Sir John Lavery before you went to the exhibition?

Not at all familiar/Quite familiar/Very familiar

The role of the artist

Having viewed the exhibition, what (in your opinion) do you think was (were) Lavery's most important work(s) and why?

1. Could you sum up what you feel about Lavery as an artist having viewed the exhibition?

2. Amongst other things, Lavery provided a visual chronicle of important Anglo-Irish events and images of key players prior to, during and after partition. Do you feel there was an obvious message in his work? If so, can you identify what that message was? If not, how do you feel he maintained artistic objectivity? (Examples?)

3. Did you feel there were key players who were not included in his gallery of portraits? Can you suggest any names that you would have liked to see included and explain why?

Education

1. What were the key messages from the exhibition and the work of Lavery that could be used in a classroom setting (explain your thoughts and suggest ideas and possibilities for classroom activities).

2. What do the exhibition and the work of Lavery say to you about the role of the artist as a chronicler of his times?

3. Should the artist in the role of a visual/historical chronicler aim to be objective at all times or is it acceptable for the artist to present his or her own beliefs within his art?

Thank you for your time in answering the questionnaire.

Notes

1. Sir Edward Carson's comment on the paintings of Sir John Lavery.
2. As a cross-border initiative, this aspect of the research was funded by the Standing Conference for Teacher Education: North and South (SCoTENS).
3. 'The troubles' is the term often used to describe the period of turmoil and violence in Northern Ireland in the last three decades of the twentieth century.
4. The subsequent phases of the research involved the participants in the creation of their own images on the theme of identity. Further publications will address these findings.
5. See http://www.nicurriculum.org.uk/.
6. See http://www.nicurriculum.org.uk/.

Chapter 6

Examining Visual Art in a High-Stakes Examination –
Dilemmas and Possibilities

Hazel Stapleton

Introduction

The Leaving Certificate (LC) examination is perhaps the most significant rite of passage in Ireland. It is a high-stakes examination taken by in excess of 50,000 of the age cohort at age 18 years and is seen as the gateway to higher education, employment and social advancement. Art is one of 36 subjects examined at LC, taken by about 20% of those sitting the examination. Over the past 30 years or so, student performance in the examination is frequently reported in terms of total points accumulated across subjects, rather than differentiated grades in each subject.

In this context, art as an examination subject is treated in the same way as all other subjects. Criteria for assessment are uniform across the subjects and the traditional values of validity and reliability are seen as paramount. This chapter addresses the role of rt in this very high-stakes examination. It is especially concerned with the vexed question of reliability – how judgements made in so contested a domain as art can satisfy the public demand for reliability and confidence in a public examination.

This chapter does not set out to present a critique of the LC examination in art but to use it as a touchstone for a wider discussion on assessment of visual art. The first part addresses some generic issues in relation to assessment. The second part points to some of the particular challenges of the LC art examination. In the third part, findings in relation to empirical research on the process of examining art are discussed, leading, finally, to some general observations, conclusions and recommendations.

Art in high-stakes public examinations

In the Irish LC examination a common framework underpins all subjects and test formats: namely, that the model chosen must comprehensively cover the syllabus, that it must be a reliable discriminator between levels of attainment and that it must be fair to all candidates. The State Examinations Commission (SEC), the agency that runs the public examinations under the authority of the Minister for Education and Skills, states that '(a)ny compromise of these principles, either real or perceived, has the potential to undermine the integrity of the examination system and thereby undermine the high level of public confidence in the system' (SEC 2007a).

However, a complex situation emerges as a clear consensus regarding testing of visual art in terminal post-primary state examinations is far from settled. In some instances it is argued that art is no different from other subjects; that what is taught is prescribed by the syllabus and is, therefore, what should be examined; that there are issues about reliability of scores when techniques such as coursework are used. Nevertheless, discussion in the context of Discipline Based Art Education and the arts PROPEL project in particular, has served to force an engagement with the issues and problems (Eisner 1985, 2002; Gardner 1993, 2006; Ross et al. 1993). As a result, a considerable body of research has been published on assessment of the visual arts, but mainly as an adjunct to formative assessment for learning in classroom settings. Much of this work has resulted in strategies with the potential to be modified to suit the testing process in high-stakes settings and so provide a fertile ground for devising initiatives and practice-based advances (Black et al. 2003; Broadfoot 1979; Perrone 1991; Satterly 1981; Sefton-Green and Sinker 2000).

The American Educational Research Association (AERA), a highly influential body in the field of educational research, has proposed specific criteria for design of appropriate mechanisms for testing a syllabus in an examination setting. AERA underlines the considerable challenge for examination bodies to produce valid and reliable tests. According to AERA, the validity of the interpretation of a test score relies upon the technical quality of the testing system in question and should include evidence of careful test construction, adequate score reliability, appropriate test administration, accurate standard setting and careful attention to fairness (1999, p. 17). The Irish State Examination Commission (SEC) reiterates these principles by citing trustworthiness, impartiality, consistency and fairness as fundamental principles.

In order to create appropriate assessment techniques, 'test development is guided by the stated purposes of the test and the intended inferences to be made from the test scores' (AERA 1999, p. 37). This statement is supported by Dorn (2003) who states that purposes must be clearly identified, which opens a discussion of fitness for purpose and consideration of validity. The employment of performance testing in the form of coursework/portfolios has been promulgated as the most commonly used and promising method for the visual arts. Castiglione (1996) encapsulates the essence of such models as examination instruments: 'information from portfolios fleshes out the bare bones of more precise, controlled means-of-measurement programs'. However, there is no easy approach to employing performance testing techniques in art – any such techniques must also unequivocally operate under the same exacting set of operating principles as do standardised tests, as asserted by AERA.

A coursework/portfolio model of testing in art must deal with issues particular to the arts as well as general issues in relation to assessment in high-stakes examinations. Some of the common attributes of performance testing are outlined by Castiglione (1996) and consist of a number of dimensions: the use of open-ended tasks focusing on higher-order and complex skills; complex problems requiring several types of response and significant student time; and individual or group performance. Evidence presented may

be 'soft', which is qualitative in nature, or 'hard', which can be quantified (Broadfoot 2007, p. 58). However, the more standardised, or 'hard', the contents and procedures of administration, the easier it is to establish comparability and reliability of scores. The main challenge is that testing of specific instructional objectives may increase reliability but at a cost to creativity and the candidate's intuitive responses: 'the more unstructured the production task is, the more likely that scoring unreliability will further jeopardise the meaning of the score… the score is clearly influenced by the inability to extract a consistent index from the response' (Hoepfner 1984, p. 254).

By widening the range of assessment techniques used, challenges are intensified and new dilemmas are introduced, thereby increasing the demand for confirmation of reliability (Klenowski 2002). In short, the more performance tests, which include portfolios, become modelled to mirror authentic classroom practice, the more they become prone to issues about reliability in relation to 'a negative effect on the construct validity and curricular impact of the test since only some material and certain tasks are amenable to this type of testing' (AERA 1999, p. 5). An unequivocal assertion is also made by AERA that standardisation and technical excellence are essential: 'Where candidates are to be compared or placed in rank order there must be certainties that the test was administered in the same way for all and marked in the same way' (p. 5). Therefore, the greater the consequences associated with a given test use, the more important it is that the test in question is underpinned by the strongest possible reassurance about its technical quality.

Steers (2003) takes a somewhat less than enthusiastic line, arguing that a pervasive orthodoxy can creep in to damage creativity when the visual arts are externally examined and that there is an inherent danger that creativity can be endangered by over prescription, by standardised objectives and by marking scheme criteria (p. 25). This point resonates with that of Ross et al. (1993): 'Teachers recognise the limitations of an assessment model that appears to overvalue the outcome of the expressive act and observed practice and undervalue the aesthetic qualities, the personal expressive sensibilities that inspire the pupils to artistic creativity' (p. 9). On the other hand, Day (1985), in his discussion of assessment of visual arts production aspect of Discipline Based Art Education (DBAE), promotes the view that as in other subjects, students soon realise that specific things can be taught and learned and if one can learn and practice, one can make progress towards clearly delineated goals and so link the syllabus with tuition and with testing (p. 235).

It is clear that where high-stakes examinations are concerned, argument sways towards the position that the same rigours should apply to art as to other subjects and other types of tests: 'Establishing comparability requires portfolios to be constructed according to test specifications and standards and the development of objective procedures to judge their quality' (AERA p. 139). In general, expansive briefs (AQA 2007; NZQA 2007) are used for coursework/portfolios whereby the candidate, the teacher or both parties working together are involved in the process of producing the artwork and in selecting the portfolio contents. The particular responsibilities of each party are delineated in the specifications

regarding the range and balance of contents. Content selection is an important cornerstone as 'material is included that will permit inferences to be made concerning students' individual skills in making judgments in complex types of problem solving' (Castiglione 1996, p. 2). On balance, perhaps Gardner's view provides one example of how to anchor assessment within the realm of best pedagogical standards: 'the solution… is to devise instruments that are intelligence-fair, that peer directly at the intelligence-in-operation rather than proceed via the detour of language and logical faculties' (1993, p. 176).

General principles for the design of test briefs are common to all subjects and test types. In general, there are two distinct types of test: selected-response tests and constructed-response tests. Selected-response tests present the candidate with a number of options from which to select an answer. These can include multiple-choice, true/false or item-matching tasks. Although widely used in large populations of candidates, they do not come without their own set of challenges. Higher-order competencies can be diminished in importance and guessing and score-boosting through teaching for the test can undermine validity. Constructed-response testing, on the other hand, can include essays and essay-type answering as well as performance tests, which include coursework and portfolios. In addition, performance tests often comprise a number of stages over time and require candidates to demonstrate procedural knowledge as well as specific practical skills and problem-solving abilities. The main disadvantage of constructed-response testing relates to questions about the reliability of examiner scoring and practical issues such as ensuring that the protocols in place guarantee the authenticity of work presented in the case of portfolios and coursework.

Within the constructed-response matrix, Hoepfner (1984) identifies three types of tests for visual art, each of which can be identified in the LC examination in art. Firstly, unstructured tests, whereby there are no restrictions placed upon what the candidate can do, are the easiest to construct and have high validity but invite maximum unreliability in scoring. Secondly, verbally structured tests provide verbal instruction to support the standardisation of procedures across the entire candidature and so increase reliability. Verbal structuring improves reliability in a number of ways: firstly, administrative requirements can be generalised across all schools; secondly, common stimulus/briefs ensure that, at least, all candidates start at the same point, which allows the examiner to see the procedures and processes employed; thirdly, because of the generalising specification, the issues of inter-rater reliability becomes less of a challenge. The third type of test format for art is the object-structured test where candidates make a representation of a physical subject/object from direct observation. Life sketching in the LC falls into this category. Object-structured tests in art can be considered to be limiting as they constrain the scope and opportunity for candidates to display unbridled individualism. However, they can, on the other hand, have exacting marking schemes. Nevertheless, such an approach might fly in the face of good practice: 'Achieving accurate standardisation presents a considerable challenge to the awarding body, but ever-tighter drafting of assessment criteria and rigid application may not be the answer' (Mason and Steers 2006, p. 15).

The nub of the problem for visual arts assessment is insightfully identified by Witkin (1974), who states that when attempting to make rank-ordered qualitative judgements, the examiner is attempting to judge which candidate is 'more himself than another' (p. 52). In effect, the onus is placed on the examiner to benchmark each individual candidate's level of personal engagement and creativity against a standard.

The format used has a bearing on the validity and reliability of the test in question, be it a holistic approach, a connoisseurship model, or an analytical approach to evaluating a visual art product. Norm-referenced and/or criterion-referenced scaling can be applied to both holistic and analytical formats. Norm-referenced scores are based on qualitative judgements and are dispersed across a scale, thus allowing for differentiation between candidates. In essence, norm-referencing implies competition where candidates are compared (Broadfoot 2007, p. 14). On the other hand, criterion-referenced tests in art, as in all other disciplines, are linked to the specific learning objective and can be judged quantitatively – if every candidate has mastered the syllabus objective, then all scores will be the same and will indicate mastery only. Criterion referencing verifies that the candidate has mastered the construct in question and norm referencing ascertains the quality of that mastery. In reality, most test-scoring consists of a combination of both criterion and norm referencing requiring both quantitative and qualitative judgements. However, one is reminded by Sadler (1987) that criteria and standards should not be so tightly explicit as to breed a stifling conformity or so loosely ambiguous as to jeopardise achievement of comparability. There is a need to seek a middle course. Discrimination between candidates can be arrived at through the use of a marking scheme, which ensures that marks allocated are commensurate with the intended objective, adjudicates on how different responses are to be valued and confirms that the intended assessment objectives are being assessed (SEC 2007a).

Steers (2009) states that objectivity in art and design judgements is based upon the 'comparative and experiential knowledge of the assessor, on connoisseurship, rather than limited verbal descriptions'. Moreover, Stake and Munsen (2008) argue that 'qualitative assessment is fundamentally personal, rooted in the comprehensive experience of the person or persons evaluating'. However, they concede that qualitative judgement in art can invoke descriptive constructs through using a vocabulary of quantification, such as reference to specific elements of an artwork, but that it is primarily experiential, 'rooted in the lives of the beholders' (2008, p. 14). In short, when it comes to qualitative judgement, such judgements are dependent on the ability of an examiner to make an objective decision on the quality of the personal engagement of the candidate. All such judgements are fundamentally problematic as the personal perspective of the examiner cannot be removed from the transaction. AERA also cautions: 'Measurements derived from observations are especially sensitive to evaluation bias, idiosyncrasies, scoring subjectivity and inter examiner factors'.

Historically, connoisseurship has been the model for marking the visual arts in various examination settings, including the LC examination in art where the examiner's

intuition informs judgement underpinned by a professional knowledge of the subject. Connoisseurship is not an analytical, fragmented or reductionist approach where particular elements, principles and techniques are identified and evaluated along criterion and norm-referencing avenues. Rather, it draws upon the accumulated and all-encompassing experience and professional insights of an expert in the field who can evaluate the integration of all the aspects as a whole.

Eisner developed his solution for assessment of the visual arts by leaning towards the processes employed in art making: 'My desire is for a wider, more inclusive, view of what constitutes art making and a form of assessment which will allow for "the little narrative"' (1997, p. 210). Hardy's view expands the concept, arguing that when students are allowed to work on personal paths of research under a system that genuinely values any approach if appropriate to intentions, all these objectives will follow naturally in the wake of the student's enthusiasm and self-esteem 'if they have experienced a full grounding and safe experimental haven in the art room' (Hardy 2006, p. 273).

Gardner (2006) takes a similar line, that assessment of certain aspects of art making can be achieved with validity and reliability. His approach clearly looks to both the process undertaken by the candidate and an evaluation of the artefact itself. He sees the possibility of assessing 'processfolios' (a type of portfolio) on a number of dimensions, some being very straightforward, such as technical aspects of production as well as regularity of work/entries. The final artefact/s is also examinable on technical grounds and on the quality of the imaginative approach in his view. More controversial and subjective areas are also included, but he argues that students' meta-cognition, awareness of their own strengths and weaknesses, their ability to build on critiques, and using lessons from domain projects productively to find and solve problems can be identified and evaluated (p. 149). He outlines the basis of a taxonomy that was devised by the arts PROPEL team, under the headings of production, perception, reflection and approach to work.

The issue of the reliability of examiner scoring is one of the critical benchmarks for test quality. Castiglione (1996) contends that portfolios are less reliable and more likely to misclassify than other means of measuring students' attainment. Some possible reasons are worthy of consideration in respect of visual art because of the similar challenges involved in attempting to evaluate creative responses.

It is clear from these research projects that the considerable variations in what is valued point to the possibility of serious issues in relation to inter-rater reliability and to the development of training strategies to reconcile these differences. Sabol (2004) refers to research, which shows that teachers include many extraneous attributes to assessment of student work, such as 'effort' and 'behaviour'. They also indicate an increasing focus on the 'process' of making art and the thinking that accompanies it – not only the physical and cognitive processes involved in problem identification, creative thinking, critical thinking, problem solving, synthesis of knowledge, evaluation and so on. However, Mason and Steers (2006) take a pragmatic line by supporting the value of marking schemes and point out that common criteria have value in helping to draw the 'assessor's attention

on particular concerns but they do not provide absolute measurement standards – assessment of the arts in schools still require aesthetic judgement and connoisseurship based on experience of what pupils of a particular age can achieve'.

Leaving certificate art—assessing divergence in a high-stakes examination

The current Irish LC art syllabus was introduced over 40 years ago[1]. It is built on a creative self-expression syllabus model reflecting the dominant philosophical approach to art education of that time. Modifications have taken place to it during its lifetime, mainly through wash-back from changes to its assessment instruments introduced following the Price Waterhouse Report of 1997, which was commissioned because of system failures on a number of fronts during the 1995 state examinations. Additional ongoing nuances to the assessment practice have also propelled it in some direction towards embracing current pedagogies and assessment techniques. However, those modifications that have been introduced are not all embracing and could be considered not to have altered the overriding thrust of the syllabus or the pedagogy supporting it. Rather, they could be considered accommodations acting as a bridge between a syllabus built on a particular model and contemporary curricular philosophies that embrace such approaches as DBAE. Notwithstanding this point, the unchanged assessment framework for the syllabus ensures that teaching and learning remain constrained within four specific components, three concerned with arts production and one with the history and appreciation of art. A case could be made that the LC art syllabus, where specificity of learning outcomes is absent, passes control over the curriculum to the examining body (Madaus 1988).

The Irish LC Examination in art can be described as a constructed response test model, where diverse candidate solutions to a particular brief are valued. Such diversity provides particular challenges in an examination setting. Assessment consists of a total of up to 11 hours of examinations (depending on options taken) across 4 separate components. Candidates produce artworks within a defined timeframe under standardised conditions: Imaginative Composition or Still Life, Design or Craftwork and Life Sketching, all of which are invigilated, constructed-response tests. The History and Appreciation of art comprises a separate component consisting of a constructed-response, written paper. Consensus among examiners on the application of an agreed standard is a core imperative in ensuring reliability and inter-candidate equity in this examination.

The practical art examination papers, in effect, provide the stimulus for the candidates to go on to produce works that allow them to demonstrate the ability to interpret, edit, resolve problems, and be expressive and inventive. In fact, they could be considered to represent three separate modes of assessment as follows: the Imaginative Composition/ Still Life component, a verbally structured test relies on the translation of a passage of text to a visual work whereas the Life Sketching component is an object-structured test

and addressed from the point of view of drawing from direct observation. Both the Design and Craftwork components could be considered as 'micro' projects/coursework (albeit within a restricted timescale) where the candidate works his/her way through the process of designing in the case of the Design component, or designing and making in the case of the Craftwork component, leaving a footprint of the steps taken. Therefore, the practical components could be considered to represent the testing of three distinct constructs. In the case of Imaginative Composition/Still Life, the examiner is presented with an art product, which must stand on its merits without any supporting information in relation the process undertaken apart from a short candidate statement. In the case of the Life Sketching component, candidates are tested on their skill to observe from life and produce a representation, which values such aspects as scale, proportion and the representation of form; in fact, it is quite technical in its requirement. In the case of the Design or Craftwork components, the examiner is presented with the candidate's footprint of the process of designing, or designing and making, and the resulting solution. In the case of the Art History and Appreciation component, the course is divided into three sections: Irish Art, European Art and the Appreciation of Art. Candidates answer one question from each section from a large choice.

Marking is structured on a pyramid hierarchical format consisting of a team of Assistant Examiners, Advising Examiners and a Chief Advising Examiner, all of whom typically are experienced classroom teachers. The Chief Examiner, who directs the entire project, is usually the subject specialist Examinations and Assessment Manager of the SEC. A combination of criterion and norm marking is used. The marking schemes for all of the practical components change little from year to year. As a consequence, the criteria for marking each individual component are familiar to teachers and candidates. The Art History and Appreciation requires a separate marking scheme each year. The marking schemes used for the practical components in LC art include an allocation of marks for various attributes of the artefact being examined and include an assumption that evidence is available for all aspects of the production process, including the affective domain. Examiners firstly get an impression of the grade they think will be the final grade. This is not formally recorded but is used as a marker to which to return when the marking scheme has been applied. The purpose is to form a point of reflection and to further focus on the application of the marking scheme. A general descriptor of the standard for each grade is also provided for examiners to further support the application of the marking scheme, in effect triangulating the result.

Consistency of marking as between examiners is referred to in the literature as 'inter-rater-reliability'. A number of well-documented situations can impact on the reliability of examiners' scores and, therefore, on the overall reliability of the examination. Two specific dimensions to such inter-rater reliability are of interest: consensus inter-rater reliability and consistency inter-rater reliability. Consensus reliability is based on the assumption that, when trained, examiners 'should be able to come to exact agreement about how to apply the various levels of a scoring rubric to the observed behaviours'

(Stemler 2004). One strategy in devising methods for ensuring such reliability is to develop unambiguous marking schemes and grade descriptors. However, considerable challenges apply to ensuring consensus reliability in the marking of the visual arts as outlined earlier, not least, the value system of examiners themselves and the ability to achieve agreement in relation to the evaluation of any work of art.

Consistency of inter-rater reliability involves a number of issues central to quality assurance approaches: 'examiners need to confront their own parochial attitudes, personal preferences, and biases and to recognise that they are to be avoided when evaluating student work' (Myford and Misleavy 1995, p.17). The challenges include such interpretations of the marking scheme as 'halo effect', stereotyping, leniency/stringency, scale shrinking, contrast effect, as well as examiner fatigue and lack of experience. Halo effect occurs when the view taken by an examiner of perhaps one component colours that examiner's view of the rest of the candidate's submissions. This may have the effect of either inflating or decreasing candidate scores. Stereotyping occurs when the impression formed by the examiner about the entire cohort from a particular centre acts a blinker in his/her judgement. In such an instance, individual candidate work is viewed in the light of the overall standard of the entire centre, in effect creating a norm-referenced outcome for this centre. Leniency/stringency error occurs when an examiner has poor subject knowledge and poor judgement skills and therefore is not in a position to make objective judgements, or in the case where an examiner 'gives the benefit of the doubt' by pushing the candidate over the border to the next grade-band. Scale-shrinking is a phenomenon, which indicates an examiner's reluctance to award scores across the entire marking scale, usually bunching scores in the middle without awarding grades at the highest level or at the lowest. Sound quality assurance is critical to the reliability of the marking process and has a consequent bearing on the reputation of the examination itself and indeed, public confidence in a state examination. To this end, a robust system of monitoring is necessary.

Inter-rater reliability is an integral component of the quality assurance process and is of fundamental importance in a high-stakes examination (AERA 1999; Gipps 1994). At one level, the absence of such reliability can impact systematically should a consensus approach to procedures and marking judgements not be internalised by examiners (consensus inter-rater reliability). At another level, the performance of individual examiners also presents challenges, not least how to ensure that they apply the marking scheme consistently to all the individual scripts assigned to them (consistency inter-rater reliability) (Stemler 2004). It is, therefore, of critical importance for the good standing of an examination to develop marking strategies to minimise such potentialities.

Consensus among examiners on the application of an agreed standard is a core imperative when the goal is to ensure reliability. One could consider that a lack of such consensus reliability has the potential to have a more wide-reaching effect than a lack of consistency reliability: for example, should an Advising Examiner introduce a personal perspective, or a nuanced approach outside that agreed by the Chief Examiner, the potential to affect the results of a large number of results is present.

Examining the examination: empirical research on the process of examining art

Against the backdrop of issues outlined earlier, the work of examiners involved in the authentic examination of LC art was studied, with a view to levels of examiner consensus when marking three different types of visual art submission using three separate techniques for marking, namely, (a) connoisseurship, (b) the use of a holistic gradeband descriptor and (c) the use of an analytical marking scheme (Stapleton 2010). Firstly, the Imaginative Composition/Still Life component comprises a stand-alone artefact, which, by its conception and visualisation, relies for its meaning solely on the interaction with the viewer, in this case, the examiner. It moves directly from the stimulus to the finished artefact, thereby relying solely on the examiner's ability to engage with this visual language. There are no preparatory or preliminary sheets to provide way-marks for the examiner. Secondly, the Life Sketching component is an object-structured test and relies on an approach to visual language that is descriptive but that can also describe with skill, eloquence and flair. Thirdly, the Design component captures some of the elements of the design process, though not comprehensively. Nevertheless, it could be considered a 'mini' coursework/project, and has resonances of the techniques in use in other countries and with those put forward by major theorists on contemporary art education like Eisner and Gardner, where the process the candidate undertakes is way-marked for the examiner. This process consists of definable steps where ideas are 'discovered', stabilised, edited and published in the form of finished artwork. Establishing percentage agreement between examiners and an agreed correct score for three sets of samples of candidate submissions establishes the relative reliability of each marking technique. This study analyses the recorded deliberations of three examiners as they mark two sample candidate submissions, thereby allowing insights into strategies they employ while applying the Standard Marking Scheme.

It could not be considered that this research has found a definitive model for the assessment of the visual arts in a high-stakes setting. The optimum way forward is to take the positive aspects of the research results as well as the guidance that can be gained from other models and theoretical stances in order to find ways that protect the validity of the subject and the reliability of the examining process. The work of Eisner and Gardner on portfolios offers convincing and promising avenues to explore while some examination models, including those of New Zealand (NZQA 2000) and of the International Baccalaureate (IB 2007) show how some of the dilemmas identified can be addressed.

Student performance in the LC is assessed within subgrades, each typically of five percentage points. Irrespective of whether a connoisseurship approach, a descriptor or an analytical marking scheme is used, examiner consensus within a very narrow band is an untenable objective. Consensus within a three-subgrade band is a more realistic and achievable aim. However, this is not to say that the LC subgrade structure should be replaced. The three-subgrade band crosses grade boundaries and thereby misclassification

would impact less than if the scale were shortened. There is no clear-cut indisputable approach that should be recommended but rather different approaches are more reliable for different components. For both the Imaginative Composition/Still Life and Life Sketching components, there is little difference between the three techniques but where the Design component is concerned, the Standard Marking scheme is indisputably the most reliable option.

The original assessment matrix for the LC art syllabus follows a connoisseurship model, yet it is now found to be the least reliable. It takes a leap in faith by relying solely on an assumption that all examiners share a common aesthetic awareness. The descriptor technique has a number of positive aspects: it is a matching process where the work viewed matches a descriptive statement of standard and could provide a viable option for both Imaginative Composition/Still Life and Life Sketching. It is easy to administer and straightforward to apply and does not deconstruct the work to such an extent that marking becomes a series of independent, though related, decisions. The marking scheme technique is analytical and is indisputably the most reliable approach for the Design component, where two aspects are tested – the process of designing itself and the product that contains specific identifiable characteristics. Moreover, the marking scheme relies on the same type of qualitative judgement a number of times, in contrast with a connoisseurship model where examiners make one qualitative judgement only.

Although it is important to achieve the highest possible consensus among examiners, it is also important to keep those scores that are in the extreme range, either extremely harsh or extremely lenient, to a minimum, as the greatest challenge to inter-candidate equity occurs here. A particular model should not be regarded as the optimum until these areas are considered. Some widely inaccurate marking, both extremely lenient for lower achieving candidates and extremely harsh for higher achieving candidates is a feature of all three techniques of marking. However, the appeals system provides one means of identifying this problem where harsh marking is concerned but such an approach should be regarded only as a 'safety net' and not as an acceptable operational standard. Extremely lenient marking also presents a difficulty on equity grounds and as a contributor to grade inflation if widespread.

Insights from the recorded deliberations of a sample consisting of three examiners at work show that judgemental differences underscore the fundamental fact that artistic endeavour, by its very nature, can have multiple meanings and that the aesthetic sensibilities of examiners can be displayed as individualistic viewpoints. To say that all examiners can be trained to look at an artwork the same way is not a feasible position. It is a matter of living with this fact of life, but not an indication to narrow the curriculum or introduce a tighter specification as to do so would damage the learning experience for students. These examiners in the study show that differing perspectives on an artwork do not necessarily result in a lack of consensus in relation to the application of a marking scheme. These examiners demonstrate that different analyses and personal dispositions towards a particular work do not necessarily bring different results. There is scope to

accommodate personal aesthetic nuances; it is a matter of understanding, accepting and applying an agreed standard.

Lack of consensus inter-rater reliability is the result of two principal conditions. Firstly, examiners' perception of the creative aspects of the work in question and, secondly, where technical and procedural aspects of design, or identification of art elements are judged. Although an in-depth marking scheme is used, in effect, it requires examiners to make a connoisseur/personal judgement under a number of heading: the constituent elements of the work are treated as having their own internal validity and integrity and are thereby decoupled from the whole. On the other hand, the use of the grade-band descriptor considers the work in question as a full entity without the distraction of the compartmentalised and disassembled elements.

Through its triangulation aspect, the marking scheme consists of an internal questioning mechanism, yet this triangular interrogation of the way one arrives at the final decision as an examiner does not ameliorate the tendency towards lenient decisions for the less able and harsher decision for the more able candidate. One possible explanation might be that, as seen in the examiner recordings, when the examiners triangulate the marking scheme takes precedence. They do not alter the marks they have awarded when they review their scores by means of their impression of the work and the descriptor – rather than change their minds, they justify the marks awarded by finding points of agreement.

Although the examiners in the study came from diverse arts practitioner backgrounds, it did not have marked effect on their examining. These examiners' work is characterised by giving due consideration of all aspect of the work in question, whether it is the initial overview, applying the marking scheme or triangulating their results. The system should have confidence that when examiners are proficient there is no need to suppress their personal perspectives provided they reach a point where they adopt the standards made explicit in their training. It is a matter of examiners understanding the standards in question, and the examining board having confidence in their professionalism in agreeing to adopt them.

Conclusions

There is no easy solution to the many dilemmas associated with examining visual art in a high-stakes setting. The challenges are great and more important than the imperative to guard the integrity of the learning experience for students. However, a number of way-marks can be identified to support the predominant importance of consensus among examiners when applying a marking matrix. A concerted focus on the training of examiners should underpin the examining process where such phenomena as scale shrinking, halo effect, contrast effect, examiner fatigue and inexperience can be addressed. Some positives can also be taken from the above research, which shows, most notably, that when examiners are well trained, professional in their approach and where

they 'buy into' the examining process, high levels of consensus can be achieved. In terms of test instruments, a 'one-size-fits-all' approach should not be used but rather different approaches may be desirable for different learning outcomes being examined.

When visual art is an examination subject, like other subjects, carrying high-stakes life chances for candidates, the system must show fidelity on two fronts: firstly to art education and secondly to the examination itself. On the art front, the process should not be constricting of creativity, should reward independence of thought and should avoid the encouragement of orthodoxy. On the examination front, it must adhere to the core principles of validity and reliability. Only when these two imperatives are accommodated can an examination such as that for LC art discriminate between candidates efficiently and acceptably.

References

American Educational Research Association (AERA) (1999) *Standards for Educational and Psychological Testing* Washington: American Educational Research Association.

Assessment and Qualifications Alliance (AQA) (2010) *A Basic Guide to Standard Setting* http://web.aqa.org.uk.

Black, P., Harrison. C., Lee, C., Marshall, B. and Wiliam, D. (2003) *Assessment for Learning* Maidenhead: Open University Press.

Broadfoot, P. (1979) *Assessment, Schools and Society* London: Methuen.

Broadfoot, P. (2007) *An Introduction to Assessment* New York: Continuum.

Castiglione, L. (1996) Portfolio assessment in art and education *Arts Education Policy Review* Vol. 97, pp. 2–9.

Day, M. (1985) Evaluating student achievement in discipline-based art programs *Studies in Art Education* Vol. 26, pp. 232–240.

Dorn, C. (2003) Models for Assessing Art Performance (MAAP) A K-12 Project *Studies in Art Education* Vol. 44, pp. 350–370.

Eisner, E. (1985) *The Art of Educational Evaluation: A Personal View* Philadelphia: The Falmer Press.

Eisner, E. (1997) *The Enlightened Eye: Qualitative Inquiry and the Enhancement of Educational Practice* New York: Merrill Publishing Company

Eisner, E. (2002) *The Arts and the Creation of Mind* New Haven and London: Yale University Press.

Gardner, H. (1993) *Multiple Intelligences* USA: Basic Books.

Gardner, H. (2006) *Multiple Intelligences New Horizons* USA: Basic Books.

Gipps, C. (1994) *Beyond Testing* London: The Falmer Press.

Hardy, T. (2006) Domain poisoning: the redundancy of current models of assessment through art *Journal of Art and Design Education* Vol. 25, pp. 268–274.

Hoepfner. R. (1984) Measuring student achievement in art *Studies in Art Education* Vol. 25, pp. 251–258.

International Baccalaureate Organisation (IB) (2007) *Diploma Programme Visual Arts Guide* Chippenham: Anthony Rowe Ltd.

Klenowski, V. (2002) *Developing Portfolios for Learning and Assessment: Processes and Principles* London: Routledge Falmer.

Madaus, G. (1988) The distortion of teaching and testing: high-stakes testing and instruction *Peabody Journal of Education* Vol. 65, pp. 29–46.

Mason, R. and Steers, J. (2006) Impact of formal assessment procedures on teaching and learning in art and design in secondary schools *Journal of Art and Design Education* Vol. 25, pp. 119–133.

Myford, C. and Mislevy, R. (1995) *Monitoring and Improving a Portfolio Assessment System* Los Angeles: University of California National Centre for Research on Evaluation, Standards, and Student Testing (CRESST).

New Zealand Ministry of Education (NZQA) (2000) *The Arts in the New Zealand Curriculum* Wellington: Learning Media Limited.

Perrone, V. (Ed). (1991) *Expanding Student Assessment* Alexandria, VA: Association for Supervision and Curriculum Development.

Ross. M., Radnor, H., Mitchell, S., and Bierton, C. (1993) *Assessing Achievement in the Arts.* Buckingham: Open University Press.

Sabol, R. (2004) The assessment context *Arts Education Policy Review* Vol. 105, No. 4 pp. 3–9.

Sadler, D. (1987) Specifying and promulgating achievement standards *Oxford Review of Education* Vol. 13, pp.191–209.

Satterly, D. (1981) *Assessment in Schools* New York: Blackwell.

Sefton-Green, J. and Sinker, R. (2000) *Evaluating Creativity* London: Routledge.

Stake, R. and Munson, A. (2008) Qualitative assessment of arts education *Arts Education Policy Review* Vol. 109, pp.13–21.

State Examinations Commission (SEC) (2007a) *A Manual for Drafters, Setters, and Assistant Setters* Athlone: SEC.

State Examinations Commission (SEC) (2007b) *Instructions to Appeal Examiners* Athlone: SEC.

Steers, J. (2009) Creativity, delusions, reality, opportunity and challenges *Journal of Art and Design Education* Vol. 28, pp. 126–137.

Steers, J. (2003) Art and design in the UK: the theory gap in *Art Education in a Postmodern World* Addison, N. and Burgess, L. (Eds) Bristol: Intellect Books.

Stemler, S. (2004) A comparison of consensus, consistency, and measurement approaches to estimating interrater reliability *Practical Assessment, Research and Evaluation* Vol. 9, pp.1–24.

Stapleton, M. (2010) Assessment of visual art in a high-stakes setting, Unpublished Ph.D. Thesis, NCAD Dublin.

Witkin, R. (1974) *The Intelligence of Feeling* London: Heinemann Educational.

Note

1 A new syllabus, drafted by the National Council for Curriculum and Assessment, awaits implementation.

Chapter 7

Questions That Never Get Asked About Irish Art Education Curriculum Theory and Practice

Donal O'Donoghue

Introduction

What does it mean to teach art in our time and in a society that is increasingly diverse, fluid, complex, unstable, depersonalised, globalised and media-saturated? In this chapter, I consider the manner in which the Irish Visual Arts Primary School Curriculum responds to the needs of contemporary art learners and prepares them to access, engage with and critique art forms, artworks and visual cultural practices of our time, especially new art forms such as installation art, performance art and socially engaged art. Introducing children to ways of engaging with, and making sense of these new art and cultural practices not only contributes to their ability to participate in the visual arts, but also supports their right to participate in cultural life as enshrined in the UN Convention on the Rights of the Child and the UN Covenant on Social, Economic and Cultural Rights.[1]

Since it was first introduced in 1999, the Irish Visual Arts Primary School Curriculum has been subject to two reviews: one conducted by the National Council for Curriculum and Assessment and the other by the Department of Education and Science. Although both reviews evaluated the nature and success of the implementation of the curriculum; identified pedagogical and assessment approaches most commonly used by teachers; and solicited children's experience of the curriculum, neither addressed the relevance and appropriateness of the curriculum for the twenty-first century. In an effort to render visible ways in which the Irish Visual Arts Primary School Curriculum responds to the needs of contemporary art learners and prepares them (or not) to access and engage with visual cultural and aesthetic practices of their time, in this chapter, I inquire into the language of the 1999 Visual Art Primary Curriculum. In *Understanding Curriculum* (1995), William F. Pinar, William Reynolds, Patrick Slattery and Peter Taubman argue that 'to understand [a] field means that we need to attend closely to the language scholars working in [that] field use' (p. 7). Similarly, in his inquiry into the language and discourse of contemporary Irish educational policy, debate and theory, Aidan Seery (2008) reminds us, 'language is central (some claim determining) in the mediation and formation of self and others' (p. 133). He claims that the manner in which 'we speak of things in the world, of our inner world as well as the worlds of social and physical reality, reflects (or perhaps is identical with) how we think about these worlds' (p. 133).

I am not suggesting that the work of curriculum developers and designers is necessarily scholarly work. Rather, I am making the argument that to attend to the language of their

work, and specifically to the language of the Revised Visual Art Primary Curriculum, is to question common-sense notions of what art education is, and what it currently does in schools in Ireland. To attend to the language of the Revised Visual Art Primary Curriculum will likely enable us to identify and discuss several of the curriculum's conceptual, philosophical and ideological underpinnings. As Ronald Neperud (1995) reminds us, 'How art should be taught ranging from the elementary classroom to the university studio, has always been, and probably always will be, an area of contestation, marked by tensions arising from the dynamic interplay of contrasting views of what constitutes art, its values, and how best to know' (p. 2). As suggested by Neperud (1995) and stated by Philip Meeson (1991), art teaching and its accompanying curriculum is 'a combination of ideological commitment together with practical application in the use of appropriate forms, materials and implements' (p. 109). I have structured the chapter around a series of questions. Informed by Mieke Bal's theory of cultural analysis, which she describes as a critical practice 'based on a keen awareness of the critic's situatedness in the present, the social and culture present from which we look, and look back, at the objects that are always already of the past, objects that we take to define our present culture' (Bal 1999, p. 1), these questions invite a different type of engagement with a curriculum that I worked closely with during my time as an art teacher educator in one of the largest primary-teacher education programmes in Ireland in the early 2000s. Before I consider the nature of the Irish Visual Arts Primary School Curriculum, especially its potential to prepare students to live knowledgeably and creatively in the visual world of the twenty-first century, I first wish to address what is understood as curriculum, and how it will be taken up in this chapter. Following this, I will consider briefly the focus of the 1999 Irish Primary School Curriculum, from which the Revised Visual Arts Curriculum emerged.

Understanding curriculum

The term *curriculum* has more than one meaning. Elliot Eisner and Elizabeth Vallance (1974) explain that a curriculum is 'a program that is intentionally designed to engage students in activities or events that will have educational benefits for them' (p. 40). In this chapter, my focus is on what Eisner calls the 'intended curriculum'. According to Eisner, the 'intended curriculum' is the curriculum that is usually devised by a school board or state body, rather than by an individual school, for the purpose of guiding, controlling and monitoring the focus and content of teaching and learning. In Ireland, the intended curriculum is the curriculum devised by the National Council for Curriculum and Assessment in collaboration with the Department of Education and Science, and other partners in education. As Eisner (1990) reminds us, 'The intended curriculum is written; it has aims and objectives; it usually prescribes or suggests a sequence of activities and is often subject to external examination' (p. 63). It is, Eisner argues, 'the formal and public course study for which students, teachers, and schools, in one way or another, are

held accountable' (p. 63). The 'intended curriculum' outlines that which is important to teach, to preserve and to promote. It informs the decisions that teachers make about content, how they sequence their lessons, select resources and determine assessment methods in their art lessons. The 'intended curriculum' impacts on how they evaluate and assess student progress and how they measure student attainment, and report student achievement. Although it can limit a teacher's power to determine the course of study, it can also expand and extend what the teacher might have thought of as possible. In short, the 'intended curriculum' frames the types of learning experience students are likely to have in school. Framing, Robert Entman (2003) explains, 'entails selecting and highlighting some facets of events or issues, and making connections among them so as to promote a particular interpretation, evaluation, and/or solution' (p. 417). This, I argue, is what an art education curriculum does to, and for art.

Of course, the 'intended curriculum' gets taken up, altered, changed and mediated by those who encounter it, use it, claim it, classify it, decode it, reproduce it, critique it and know it (Bourdieu 1996). That being said, the 'intended curriculum' that is considered in this chapter – the Revised Visual Arts Primary School Curriculum – names art forms, creative practices and experiences and activities that are deemed to be artistic. In doing so, these activities, experiences and processes acquire particular value and meaning. The Revised Visual Arts Primary School Curriculum suggests and oftentimes prescribes teaching practices and subject content. In doing so, it sets certain parameters of what art can be, and what it can do in schools. In short, it defines what is possible, legitimate and worth pursuing.

The revised primary school curriculum and the visual arts curriculum

The introduction of the 1999 Revised Primary School Curriculum followed a long period of curriculum planning and preparation led primarily by the National Council for Curriculum and Assessment (NCCA), through committees that represented the major stakeholders in Irish primary education. Informed by the recommendations of the Review Body on the Primary Curriculum (1990), the revised syllabus sought to do a number of things. It stressed the importance of the individuality and autonomy of the child and promoted the idea of learning as active, independent, collaborative, integrated and developmental. Promoted as 'an exciting opportunity for change and renewal in primary schools' (Martin 1999, p. vi), it was presented as a 'relevant', 'broad' and 'balanced' curriculum. As a commitment to nurturing the child in all aspects of his or her life, including the aesthetic, a revised and expanded visual arts curriculum was introduced.

Comprising six strands (three of which relate to artistic processes and three of which referred to art-making materials), the Revised Visual Arts Primary Curriculum promotes an understanding of the visual arts from an elements and principles perspective. By that, I mean, it advances the idea that all art-making processes involve working in and with visual

elements and principles of design.[2] From this perspective, ideas are communicated and meaning made through the appropriate selection and combination of visual elements and principles of design. In addition, this perspective promotes the notion that all artworks can be interpreted, understood and described by using a visual elements informed analytical framework and language. For example, referring to practices of looking at artworks, the curriculum states, 'It is through talking about these artworks that the child develops sensitivity to the visual elements, and begins to use them purposefully in his/her own art-making'.[2] Seven visual elements and design principles comprise the conceptual underpinnings of the entire Revised Visual Arts Primary Curriculum, from infant to senior level. These are line, shape, form, colour and tone, pattern and rhythm, texture and spatial organisation. These elements underpin all activities undertaken in, and across, the six strands. They are described as the 'concepts and skills the child should develop as he/she engages in visual arts activities'. The six strands, which are viewed as 'a medium for visual expression' and as providing 'the context for learning in art', are: Drawing, Paint and Colour, Print, Clay, Construction, Fabric and Fibre. Comparable in some respects to the underlying commitments and philosophies of Discipline Based Art Education, which first emerged and was promoted in the United States in the 1960s, the Revised Visual Arts Primary Curriculum argues for a balance to be maintained between art production and art reception. Each strand comprises two units: (i) 'making' and (ii) 'looking and responding'. The Revised Visual Arts Primary Curriculum is divided into four class levels: Infant, First and Second Class, Third and Fourth Class and Fifth and Sixth Class.

Are the visual elements a good foundation for the Revised Visual Arts Primary School Curriculum?

As suggested by Tom Anderson and Sally McRorie (1997), a commitment to the visual elements in art production and reception has its roots in modernism. In his essay, 'The influence of modernism on Art Education', Meeson (1991) explains that an art education curriculum informed and shaped by modernism is one that emphasises individualism, self-expression, innovation, progress and novelty. Such a curriculum, Meeson maintains, promotes a visual grammar based on visual elements, and offers a set of prescribed activities to be conducted in a range of different media. These are, indeed, the qualities and commitments of the Revised Visual Arts Primary School Curriculum. An art education curriculum based on modernism, Meeson (1991) argues, is one that actively distances itself from the past because it has 'little use for the past'. Because it promotes individual expression and celebrates the unique and personal voice of the creator, there is little need to refer or defer to the 'old masters'. Meeson (1991) further argues that referring to the 'old masters' and preserving traditions of the past is believed to limit the space for free expression, although it aids and supports aims such as the following: 'to enable the child to develop the skills and techniques necessary for expression, inventiveness and

individuality' (p. 9). That being said, the theoretical alliances that the Revised Visual Arts Primary School Curriculum makes are never clear cut as suggested by the following objective: 'begin to appreciate the context in which great art and artefacts are created and the culture from which they grow'. Apart from raising an objection to the continuation of an implicit value system that ranks art products as great and not so great, clearly, this curricular objective suggests a commitment to the promotion of cultural understanding from a contextual perspective. So, if we are to strictly apply the characteristics of modernism to the Visual Arts Primary Curriculum, we would notice that the curriculum promotes ways of thinking and acting that are not only modernist in nature, but also encompass elements of postmodernism. As Suzi Gablik (1984) reminds us, 'Those who defend modernism claim that art need not serve any purpose but should create its own reality' and that 'aesthetic experience is an end in itself, worth having on its own account' (p. 20). Although the Revised Visual Arts Primary Curriculum promotes the idea that art 'is a discipline with its own particular demands and core of learning' (p. 2), it too advances the notion that 'Visual arts education channels the child's natural curiosity for educational ends' (p. 5). As Eisner (2004) reminds us and as we see played out here, there is likely to be a mix of different and competing versions and visions of art education at play in any given curriculum.

Using the visual elements as a foundation of and for art learning is an approach to art education that can be traced back to Arthur Wesley Dow's principles of art teaching, which were first advanced in the opening decades of the twentieth century in the United States (Efland 1990). Dow sought to provide a structure for making and engaging with art that was based on principles of composition, which was developed from his study of Japanese art. As Hurwitz and Madeja (1977) explain, 'his basic principle of pictorial structure were line; notan, or value; and a regard for the full spectrum of color' (pp. 22–24). According to the art education historian, Mary Ann Stankiewicz (1997, 2000), evidence of the use of the elements and principles of art in art teaching can be found as early as 1908. As Stankiewicz (2000) explains, they were used 'as means to improve expression and guide response' (pp. 307–308). Does this not sound familiar? This is precisely the role that the Revised Visual Arts Primary School Curriculum envisions for the elements and principles of design. Olivia Gude (2000) argues that while 'it made sense in the early twentieth century to concentrate on exercises that explored the formal properties of artmaking because this was one of the important ways in which those artists and critics conceived of their work'[3], it no longer makes sense when artists of our time, and especially those who are shaping the artworld, no longer use visual elements as 'the language of artistic communication'. Rather, as will be explained shortly, they are engaging with other representation and meaning making modes and strategies. Interestingly, at the time of the launch of the new and revised curriculum, the then Minister for Education, Micheal Martin (1999), wrote, 'The curriculum incorporates current educational thinking and the most effective pedagogical practices' (p. vi). Expanding on this perspective, the curriculum document states, 'The curriculum is based on a philosophy and psychology of teaching and learning

that incorporates the most advanced educational theory and practice' (Department of Education and Science 1999, p. 10). In light of the discussion so far, can we say that this is the case for all subject areas included in the 1999 Revised Primary School Curriculum?

Similar to the Australian experience[4], Irish art education has adopted and absorbed many ideologies and models of art education from abroad, especially from the United Kingdom and North America. Although an analysis of current or past Irish art education curricula reveals ways in which these curricula mimic, correspond to or deviate from dominant international paradigms of art education, it also suggests that there has been a significant time lag between the circulation and implementation of new ideas internationally and subsequent take up in Ireland.[6] For example, during the past ten years, visual culture theory has significantly influenced and shaped art education practice and policy in North America, and yet we find no reference to visual culture theory in Irish art education curriculum to date. Similarly, although multicultural art education played an important role in shaping art education pedagogical and assessment practices in the United States, Canada and elsewhere in the 1990s, it neither informs nor features in the revised Irish Visual Arts Primary School Curriculum launched during that period. At the time when the Revised Visual Art Primary School Curriculum was being designed, internationally, especially in North America, there was a commitment to seeking connections between the field of art education and other areas of knowledge. Feminist, psychoanalytical and sociopolitical theories and discourses of seeing and understanding the world were being introduced to the field of art education in an effort to provide a language that would speak to the complexities of art in schools. Such discourses did not find their way into the language and focus of the Revised Visual Arts Primary School Curriculum.

Notwithstanding the outdated nature of the elements and principles approach to art teaching, one of the greatest criticisms levelled against visual elements pedagogy is that 'these elements are applicable [only] in specific contexts such as abstract and non objective paintings in the Western world' (Efland et al. 1996, p. 56). Applying the visual elements as a means of analysing or understanding a performance artwork, for example, would not tell one much about the significance of that work. Neither would the elements provide any meaningful access to the work. Deploying the visual elements as a means to describe a visual phenomenon leads only to a decontextualised understanding of what is being seen and understood. It provides opportunities to appreciate the visual qualities of work, when applicable, but little else (Gude 2007). For example, in what ways might a visual elements analytical approach help us to understand the significance of the following recent work by the Irish artist Seamus Mc Guinness? In 2004, McGuinness produced an installation titled *21 Grams*. It was produced as a response to the high rate of male suicide in Ireland. Comprising 92 fragments of men's white shirts (mainly collars) that hang at shoulder height with each fragment weighing 21 grams (21 grams is said to be the weight of the human soul as the body decreases in weight by 21 grams immediately after death), the installation serves to remember the 92 young men's lives lost to suicide in Ireland in 2003. McGuinness creates a work that invites discussion and debate about a growing

phenomenon in Ireland, and requires an interpretative framework that considers how the work functions in ways that do not rely on visual properties alone. The work cannot be reduced to a form of representation. Spectator participation is essential for this work to function as intended. While the ability to recognise signifiers in the work (the white shirts, shirt collar hanging, etc.) assists in the interpretation of the work, more importantly, the ability to understand how the act of looking constitutes the subject of the installation, and understanding wider social and historical contexts, enables the viewer/participant to make connections between that which is represented, imagined and known. Although McGuinness has produced a material work, it is in the relations that the work suggests and generates (which in turn give rise to other relations) that meaning resides and is activated. Given that the work activates an immediate reaction and experience, in what ways might it be felt rather than merely perceived? How might an analytical framework that prioritises the relational potential of the work over the purely visual quality of the work aid more meaningful understandings? As becomes clear in considering McGuinness' work, promoting the idea that all art making and reception processes can be understood with reference to visual elements significantly reduces opportunities to engage in affective looking. Jill Bennett (2005 p. 41) asks, 'How is "seeing feeling" achieved', and goes on to argue that traditional and 'conventional theories of expression are inadequate… insofar as they regard the artwork as the transcription or deposit of a prior mental state' to be accessed by an understanding of visual elements (p. 24).

Using the visual elements as a foundation of, and for learning in the Visual Arts Primary Curriculum significantly reduces opportunities for art to be taught or experienced as a political, social or activist pursuit. Outside of schooling, art has been, and continues to be, used as a means of rendering visible issues of social and cultural importance. It serves as a space in which artists can work as public intellectuals. A public intellectual, Said (1994 p. 9) explains, is 'someone whose place is to raise embarrassing questions, to confront orthodoxy and dogma, to be someone who cannot easily be co-opted by governments or corporations'. There are countless examples of artists who have taken on this role in, and through, their work. In addition to the example already provided, consider the following work by the Canadian First Nations artist, Rebecca Belmore. Created in collaboration with her husband Osvaldo Yero, *Freeze* is a three-dimensional work that comprised 11 large ice blocks pushed together after she and Yero had carved one letter of the alphabet onto each block. When put together the ice blocks read S-T-O-N-E-C-H-I-L-D. Placed on a concrete floor in the middle of a car wash on Queen Street West in downtown Toronto for 24 hours, *Freeze* melted through the night changing from hard blocks of ice to a transparent and collapsed mass, as people encountered it, touched it, leant against it in an attempt to understand the meaning of it. A small piece of poetic prose accompanied the piece that gave it some context. It read, 'Last seen alive in police custody/under the influence/found 5 days later frozen to death in a field/wearing one shoe/marks on his body likely caused by handcuff/aboriginal teenage boy/dropped off and walking to where/In memory of Neil Stonechild (1973–1990) (Belmore 2006).

Although *Freeze* is about remembrance, and the preservation of memory, it invites the viewer to imagine what those final days and hours of this aboriginal teenage boy from Saskatoon, Canada, must have been like. This work is a profound form of political work that cannot be explained by reference only to the elements and principles of art.

Is looking an innocent act?

Underpinning the Revised Visual Arts Primary School Curriculum is the notion that looking is indeed an innocent act, although as Bourdieu and others remind us, ways of seeing are learnt, and looking always takes place from a particular position (a knowledge position, a subject position and so on). As Bourdieu (1993) argues in his essay 'Outline of a sociological theory of art perception', all art perception involves, 'a conscious or unconscious deciphering operation' (p. 215). In other words, the perception of an art object (or an art process) by a subject involves acts of decoding, undoing, seeking connections, placing or positioning it within representational possibilities and possibilities of representation and the history of such possibilities, identifying similarities or differences in relation to and with another object or set of objects (or practices) on a conscious or unconscious level, and oftentimes from a place of difference. There are, as Irit Rogoff (1998 p. 18) remarks, 'viewing apparatuses that we have at our disposal' that direct our looking and help to make sense of what we see, and how we see, and 'there are the subjectivities of identification or desire or abjection from which we view and by which we inform what we view'. In short, as Suzi Gablik (1984) suggests, perception relies on more than merely looking.

In the Revised Visual Arts Primary School Curriculum, no effort is made to trouble the positional dimension of looking. No effort is made to trouble, in Rogoff's (1998) words, 'who we see and who we do not see; who is privileged within the regime of specularity; which aspects of the historical past actually has circulating visual representations and which do not' (p. 25). Rather, teachers are to encourage students to look and respond without any understanding of the fact that looking and responding are political acts in and of themselves. Specifically, teachers are encouraged to attend to the meaning within the frame, rather than explore how meaning gets made in an encounter with a work, or through processes of circulation, practices of display and so on. Without providing adequate and appropriate guidelines to address how this aspect of the curriculum might be conceptualised and operationalised by teachers, one can rightly assume that the ideology of the innocent eye will persist in most cases. It is of little surprise to learn from the recent reviews of the Visual Art Primary School Curriculum, therefore, that teachers do not pay the same attention to the 'Looking and Responding' component of the curriculum as they do to the 'making' component. Specifically, teachers reported that they found the 'Looking and Responding' element of the curriculum in the following three strands, Fabric and Fibre, Clay and Print to be the least useful. Might a reason for this be the fact

that printmaking, clay work and textile work do not usually feature strongly in primary teachers' prior knowledge of, and experience with, art. Interestingly, and not surprisingly perhaps, teachers reported a higher level of engagement with two-dimensional processes and art forms than with three-dimensional processes and art forms. In short, although the curriculum promotes, 'observation and ways of seeing and helps the child to acquire sensitivity to the visual, spatial and tactile world and to aesthetic experience', it does not require teachers to problematise ways of seeing, who is seeing and from what position they are seeing.

Is art 'a way of making and communicating meaning through imagery'?

The curriculum opens with the statement, 'Art is a way of making and communicating meaning through imagery'. This statement and position, having had some currency in the past, is not sustainable in the present and unlikely to be tenable in the future. A statement such as this does not take into account that there are different sites of meaning making. Not only is meaning made in the process of producing a work, but meaning too gets made in the encounter with an artwork. Although the artist can set conditions for a particular meaning making process to occur, meaning is always fluid, context specific and contingent on a host of competing factors. The very notion that 'Art is a way of making and communicating meaning through imagery' is problematic for a whole range of reasons. Firstly, although it is true that meaning is made in the production of an artwork by its creator, meaning too is made in the encounter with the work. As Pierre Bourdieu (1996) reminds us, meaning is made not once but a thousand times over by all those who come in contact with the artwork 'who find a material or symbolic profit in reading it, classifying it, decoding it, commenting on it, reproducing it, criticising it, combating it, knowing it, possessing it' (Bourdieu 1996, p. 171). Furthermore, like any other encounter, reading and making sense of an artwork is, as Griselda Pollock (2006) reminds us, 'framed by the curators, by existing knowledges, by repressed knowledges, by questions that were not possible to frame and pose before but which are now not only possible but necessary' (p. 17).

This brings me to another point: that of equating art with imagery. Equating art with imagery as the Visual Arts Primary School Curriculum does, is misleading insofar as it does not speak to, or include the multiplicity of art practices and art forms that are being practised and circulated in our time that do not rely on imagery, and imagery alone. Consider soundscapes, for example. Since the 1990s, there has been a noticeable shift away from object-based art production to relations-based and situation-based art production (Spector 2008). Increasingly, artists, as Claire Bishop (2007) reminds us, are 'using social situations to produce dematerialised, anti-market, politically engaged projects' (p. 60). Nicholas Bourriaud (2002) theorises this move and the art practices associated with it as Relational Aesthetics. Grant Kester (2004) describes it as Dialogical

Practice, Homi Bhabha refers to it as Conversational Art, and Tom Finkelpearl terms it 'dialogue-based public art' (O'Neill 2010). Regardless of what we name it, it is one of the most noticeable and documented shifts in art practice since the 1990s. Although it is by no means the only one, Irit Rogoff (2010) maintains that 'the notion of conversation' has been 'the most significant shift within the art world over the past decade' (p. 43).

Artists who engage in relational aesthetic-based art practices rarely produce individual aesthetic objects. Rather, underpinned by the principles of collaboration, participation and interaction, their art practice is concerned with the activation and production of new relations between individuals, groups and communities, or the reconfiguration of existing ones. As Stewart Martin (2007) explains: 'Art's "sociability" is the principal "object" or "work"' of relational art practices (p. 370); 'and art's "objects" are subordinate to the social or relational dimension" (p. 370). In other words, relational artists propose and stage scenarios, events and happenings where people come into contact with each other and relate to each other in new and different ways, and this becomes the focus and form of the work. As Bourriaud (2002) explains, 'the possibility of a relational art (an art taking as its theoretical horizon the realm of human interactions and its social context, rather than the assertion of an independent and private symbolic space), points to a radical upheaval of the aesthetic, cultural and political goals introduced by Modern art'. (p. 14). Consider the following examples. In his 'Letter Writing Project', the Taiwanese-born New York-based artist, Lee Mingwei, invited viewers to communicate with absent friends, family or loved ones by writing a letter in one of three letter-writing booths he installed in the gallery. Never anticipating the public's emotional and physical response to the work and the role it would play as a 'public healing ceremony' Mingwei 'was overwhelmed by many participants' willingness to share their vulnerabilities: openly weeping in the installation, sharing intimate accounts through conversations with others in the exhibition, and displaying envelopes for strangers to read that were addressed with painfully personal headings such as, "To my father which I will never see" or "in memory of Jamal"' (Gross 2000, p. 8). These works undermine the notion promoted in the curriculum, that ' [Art] is a unique symbolic domain'. These works demonstrate how art can no longer be thought of in purely optical terms.

Does art offer opportunities to make sense of and express the world in visual, tangible form?

According to the Revised Visual Arts Primary School Curriculum, art education offers opportunities for children to 'make sense of and express [their] world in visual, tangible form' (p. 52). Artists have always been curious about and inquired into aspects of their worlds and the worlds of others in an effort to make sense of these worlds and/or to render visible issues of social, cultural, political or personal importance and significance. A recent travelling exhibition at the Vancouver Art Gallery, Vancouver, Canada, titled

Wack! Art and the Feminist Revolution demonstrated how art was used to articulate, and raise consciousness about, women's positions and roles in society in The United States, Central and Eastern Europe, Latin America, Asia, Canada, Australia and New Zealand between 1965 and 1980.

However, artists have not always expressed their world or the worlds of others in 'tangible form'. Consider, for example, the recent art performance by the Serbian-born New York-based artist, Marina Abramović, at the Museum of Modern Art New York. In a live art performance titled 'The Artist is Present', Abramović sat motionless on a wooden chair at a wooden table in the Donald B. and Catherine C. Marron Atrium of the Museum, wearing a long dress that pooled at her feet. She looked into the eyes of audience members who sat on the chair opposite her about six feet away. Abramović's performance was not concerned with the production of a tangible, physical object or a representational form; rather, the performance was concerned with the production of relations and/or the reconfiguration of existing ones. Her performance dealt with the interhuman sphere – with a relationship with oneself and the space of relationships between individuals (Bourriaud 2005). In a city where people learn to avoid eye contact with strangers, Abramović's performance forced individuals to stare back, to engage her through their eyes and to search for connection and participate in meaning making process in that moment. Through her performance, Abramović created conditions for members of the public to encounter each other, move beyond boundaries of 'normal communication', be uncomfortable in the company of others and find connections in unexpected places. She created a place of learning that is characterised by its unfinished nature and its resistance to closure. Similarly, the UK born artist, Liam Gillick, following an invitation to produce work for specific urban context in Brussels, used his budget to renovate and improve the foyers of the oldest public housing unit in the city.

Conclusion

The manner in which the Irish Visual Arts Primary School Curriculum responds to the needs of contemporary art learners and prepares them to access, engage with and critique art forms, artworks and visual cultural practices of our time, especially new art forms such as installation art, performance art and socially engaged art is a key concern in this chapter. Although this chapter addresses the Visual Arts Primary School Curriculum, as it is arguably the best articulated manifestation of visual art curriculum design in Irish education, the arguments advanced in this chapter apply equally to art education curriculum at the second level. Similar in several respects to their UK colleagues who, as Robert Watts (2005) reminds us, 'believe that the purpose of teaching art and design is to develop skills associated with creativity, communication and expression' (p 243), primary teachers in Ireland continue to promote traditional forms of art making, rather than seeking opportunities to introduce students to new art forms and practices. The recent

review of the visual arts implementation and teaching practices conducted by the NCCA suggests that drawing and painting still feature as the most prominent art processes in schools today. The report suggests that opportunities for students to work together, to generate ideas and solve problems together or to produce artworks collaboratively are neither frequent nor regular. To make a commitment to teach about and through art practices of our time means to be prepared to move away from traditional ways of making, showing and talking about art objects. It requires an openness to other communicative and representational means, as many of the examples that I have presented demonstrate. Oftentimes, this will require stepping away from traditional modes of making art, especially working with traditional media such as paint, clay, collage, printing inks, etc. It is also likely to lead to the development of different skills such as conversational skills, reflective skills, communicative skills, inventive skills and so on. There is no doubt that curiosity, openness and dialogue are important habits of minds and practices guided by an inquiry-based approach for engaging with the work of contemporary artists and their practices – a 'conception of arts practice that is coterminous with research and pedagogy' as Schnapp and Shanks put it (2009 p. 143).

The language of the Revised Visual Arts Primary Curriculum speaks of activities, 'drawing, painting, inventing and constructing' (p. 52), and ways of engaging in the world, 'enables a child to express ideas, feelings, and imaginative insights' (p. 52). It encourages students to 'explore and investigate the visual elements of the environment' (p. 52). The visual arts are viewed as having an ability to help the child to 'appreciate the nature of things' (p. 52). Underpinning these suggested activities is a commitment to the elements of arts – line, shape, texture, tone, form, etc. It is expected that by making artworks and looking and responding to the artworks of others (including artifacts produced by craft workers), children 'will develop sensitivity to visual elements and will begin to use them purposefully in their own two-dimensional and three-dimensional creations' (p. 53). The curriculum promotes the idea that knowledge about art is derived from engaging in art-making processes as well as from 'looking [at] and responding' to works of art. 'Process', it is argued, is as important as 'product'. Šuvakovic's (2008) idea that 'art is authentic inscription of a human action into an art work, namely, a trace of existence' (p. 15) can be found in several position statements throughout the curriculum. As Anderson and McRorie (1997) explain, a commitment to the visual elements is a commitment to aesthetic formalism, and this is precisely what the Revised Visual Arts Primary School Curriculum is committed to. Anderson and McRorie (1997) tell us that aesthetic formalism is as an approach to art teaching that emphasises '(1) use of the elements and principles of design, (2) manipulation of materials with focus on mastery of particular media, and (3) originality, all leading to production of objects that have "significant form" or that look good, look well crafted, are not copies of other work, that in short, look like art with a capital "A"' (p. 7).

Missing from the Revised Visual Arts Primary School Curriculum is any reference or a commitment to principles other than visual principles. As demonstrated in the artworks

introduced in this chapter, artists today are interested in issues of social democracy, activism, ecology, diversity, equality, etc., whereas the Revised Visual Arts Primary School Curriculum stresses the following: First, teachers ought to develop children's understanding of the qualities, characteristics and possibilities of a range of media. It is assumed that such an understanding will facilitate and bring about an ability to use media with skill, confidence and sensitivity and will develop technical skills in specific artmaking processes (painting, printmaking, modelling, carving and constructing, etc.) for the purpose of communicating ideas, feelings and emotions. Second, teachers ought to develop children's expressive, perceptual, inventive, critical and reflective skills. Emphasising the importance of developing children's ability to generate ideas and solutions to visual arts problems (decision making and problem solving), the curriculum stresses the creative process and promotes opportunities that lead to understanding of how subject matter, symbols and ideas are used to communicate meaning. Third, teachers ought to develop children's understanding of the value of understanding the visual arts from a cultural and historical perspective, although the conception of culture that is advanced is limited. The curriculum recommends that children develop viewing and analytical abilities that will enable them to not only describe how specific works are created but also to be able to place them in historical and cultural context. Paying attention to artwork, through 'looking and responding' will supposedly enable students to understand how meaning is constructed and conveyed visually (be they works created by children themselves and/or the work of other artists, designers and craftspeople). Although these beliefs and values afford children many opportunities to engage with art works and art practices as participants and viewers, they too limit opportunities for deep, meaningful and engagement with contemporary art forms and art processes. So, we can say with some confidence that the needs of contemporary art learners are not particularly well met by the Revised Visual Arts Primary School Curriculum. It does not appear to be very well equipped to prepare children to access, engage with and critique art forms, artworks and visual cultural practices of our time, especially new art forms such as installation art, performance art and socially engaged art.

Yet, our students grow up in the contemporary artworld. Artists are producing work that deals with issues that are important to students. Students are using and interacting with 'globalising technologies', media and thought processes that contemporary artists are using in the production and dissemination of their artworks. Artists and cultural workers in the twenty-first century are not making art about line, shape, texture, tone, balance, etc. Rather, they are engaging in questions and issues about living, life and the world. Through their practice and works, artists have drawn attention to social and culture issues and inequalities that have not always found their way into the public consciousness through more mainstream means. The students that we encounter in our classrooms on a daily basis have the right to explore, understand and engage with the art forms and art practices of their time.

References

Anderson, T. and McRorie, S. (1997) A role for aesthetics in centering the K-12 art curriculum *Art Education* Vol 50, No. 3, pp. 6–14.

Bal, M. (Ed.) (1999) *The Practice of Cultural Analysis: Exposing Interdisciplinary Interpretation* California: Stanford University Press.

Belmore, R. and Yero, O. *Freeze:* public artwork http://plepuc.org/en/artwork/freeze accessed 10 June 2011.

Bishop, C. (2007) The social turn: Collaboration and its discontents in M. Schavemaker and M. Rakier (Eds) *Right About Now: Art and Theory since 1990s* Amsterdam: Valiz Publishers pp. 58–68.

Bennett, J. (2005) *Empathic Vision: Affect, Trauma and Contemporary Art* Stanford: Stanford University Press, 2005.

Bourdieu, P. (1993) *The Field of Cultural Production: Essays on Art and Literature.* (R. Johnson, Intro & Ed.) Cambridge: Polity Press.

Bourdieu, P. (1996) *The Rules of Art: Genesis and Structure of the Literary Field* (Translated by Susan Emanuel) Cambridge: Polity Press.

Bourriaud, N. (2002) *Relational Aesthetics.* Paris: Les Presses du Réel.

Bourriaud, N. (2005) *Postproduction.* New York: Lukas and Steinberg.

Department of Education and Science (1999) *Primary School Curriculum* Dublin: The Stationery Office.

Efland, A. (1990) *A History of Art Education: Intellectual and Social Currents in Teaching the Visual Arts.* New York: Teachers College Press.

Efland, A., Freedman, K. and Stuhr, P. (1996) *Postmodern Art Education.* Virginia: The National Art Education Association.

Eisner, E. W. (1990) Creative curriculum development and practice. *Journal of Curriculum and Supervision* Vol. 6, No. 1 pp. 62–73.

Eisner, E. (2004) *The Arts and the Creation of Mind.* New Haven: Yale University Press.

Eisner, E. W. and Vallance, E. (1974) *Conflicting Conceptions of Curriculum* Berkeley, California: McCutchan Publishing Corporation.

Entman, R. (2003) Cascading activation: Contesting the White House's frame after 9/11. *Political Communication* Vol. 20, No. 4 pp. 415–432.

Gablik, S. (1984) *Has Modernism Failed?* New York: Thames and Hudson.

Gross, J. R. (2000) Osmosis in Gross, J.R. and Hyde, L. (eds) *Lee Mingwei, The Living Room* Boston, MA: Isabella Stewart Gardner Museum pp. 1–13.

Gude, O. (2000) Investigating the culture of curriculum in Fehr, D.E., Fehr, K. and Keifer-Boyd, K. (eds) *Real-World Readings in Art Education: Things Your Professor Never Told You* New York, NY: Falmer Press.

Gude, O. (2007) Principles of possibility: Considerations for a 21st-century art and culture curriculum *Art Education* Vol. 60, No. 1 pp. 6–17.

Hurwitz, A. and Madeja, S.S. (1977) *The Joyous Vision: A Source Book for Elementary Art Appreciation* Englewood Cliffs, NJ: Prentice-Hall.

Kester, G.H. (2004) *Conversation Pieces: Community and Communication in Modern Art* California: The University of California Press.

Martin, M. (1999) Minister's foreword in *Primary School Curriculum, Introduction* Dublin: The Stationery Office.

Martin, S. (2007) Critique of relational aesthetics *Third Text* Vol. 21, No. 4 pp. 369–386.

Meeson, P (1991) The influence of modernism on Art Education *British Journal of Aesthetics* Vol.31, No.2 pp. 103–110.

Neperud, R. W. (1995) Transitions in Art Education: A search for meaning in R. W. Neperud (Ed.), *Context, Context and Community in Art Education* New York: Teachers College Press.

O'Neill, P (2010) Three stages in the art of public participation: the relational, social and durational *dérive 39* http://www.eurozine.com/pdf/2010-08-12-oneill-en.pdf accessed 10 June 2011.

Pinar, W.F., Reynolds, W.M., Slattery, P. and Taubman, P.M. (1995). *Understanding Curriculum: An Introduction to the Study of Historical and Contemporary Curriculum Discourse*. New York: Peter Lang.

Pollock, G. (2006) Encountering encounter: An introduction in G. Pollock and V. Corby (Eds) *Encountering Eva Hesse* London: Prestel Publishing pp. 13–21.

Rogoff, I (1998). "Studying Visual Culture." *Visual Culture Reader*. Ed. By Nicholas Mirzoeff. London & New York: Routledge.

Rogoff, I. (2010) Turning, in O'Neill and Wilson (eds) *Curating and the Educational Turn* Amsterdam: Open Books.

Said, E.W. (1994). *Representations of the intellectual*. New York: Vintage Books.

Schnapp, J. T. and Shanks, M. (2009) Artereality (Rethinking craft in a knowledge economy) in S. H. Madoff (Ed.) *Art School: Propositions for the 21st Century* Boston, MA: MIT Press pp. 141–158.

Seery, A (2008) Slavoj Žižek's dialectics of ideology and the discourses of Irish education *Irish Educational Studies* Vol. 27, No. 2, pp 133–146 .

Spector, N. (2008) Theanyspacewhatever: an exhibition in ten parts in N. Spector (Ed.) *Theanyspacewhatever* New York: The Guggenheim Museum pp.13–29.

Stankiewicz, M.A. (1997) Perennial promises and pitfalls in arts education reform *Arts Education Policy Review*,Vol. 99, No. 2 pp 8–14.

Stankiewicz, M. A. (2000, Summer). Discipline and the future of art education. [Electronic version]. *Studies in Art Education,* Vol. 41, No. 4 pp. 301-313.

Šuvakovic, M. (2008) *Epistemology of Art: Critical Design for Procedures and Platforms of Contemporary Art Education* Belgrade: Standard 2 Publishing House.

Watts, R. (2005) Attitudes to making art in the primary school *International Journal of Art and Design Education* Vol. 24, No. 3 pp. 243–253.

Notes

1. At the local level, in Ireland, this right is embedded in National Children's Strategy: Our Children, Their Lives (2000).
2. Retrieved January 21 from http://www.curriculumonline.ie/en/Primary_School_Curriculum/Arts_Education/Visual_Arts/.
3. Retrieved January 22 from http://www.uic.edu/classes/ad/ad382/sites/AEA/AEA_01/AAEA01a.html.
4. See Boughton, D. (1989). The changing face of Australian art education: new horizons or sub-colonial politics? *Studies in Art Education* Vol. 30, No. 4, pp. 197–211.

Chapter 8

Artistic Formation for Collaborative Art Practice

Ailbhe Murphy

In the changing landscape of contemporary visual arts practice, artists are increasingly engaging in a range of situated social and institutionally specific contexts. In this chapter, I wish to discuss some of the navigational challenges that arise for artists working in the field of collaborative practice. I wish to explore the implications of those challenges in relation to the question of art education, specifically third-level provision for emerging artists interested in socially engaged practice. More particularly, the chapter examines how the endeavours of those artists who choose to enter into the complex territory of cross-sectoral collaboration in a range of community contexts are met with certain disorientating challenges in the form of aesthetic, ethical and social modes of accountability. Drawing on my own artistic practice, an interdisciplinary turn is described where questions of epistemology and knowledge production from within the social sciences encounter those negotiated practices and critical references from within socially engaged arts practice. The interface between art, education and community presents rich territory for considering the question of pedagogical coordinates. Examples of interdisciplinary practice and modes of inquiry operating at national and international levels are presented, which specifically set out to respond to this question of arts-based pedagogy in collaborative practice.

In recent times in Ireland the significant increase in artists and arts organisations interfacing with community, in the broadest sense, mirrors the movement in contemporary art in general towards engaging with varied publics and/or communities constituted in the development, realisation and distribution of arts practice. Increasingly, there are forms of practice that have been identified (or self-identify) as socially engaged, as art-in-context, as community-based, as participatory, as collaborative and so on. This connective impulse is being progressively incorporated into the discourse and practice of art and at the same time organised and disciplined within the institutional field of arts practice and within the art academy. In Dublin, in 2002, the Faculty of Education in the National College of Art and Design (NCAD) established a Postgraduate Diploma in Community Arts. This course is open to art and design graduates as well as those working in related fields such as the humanities and the community and voluntary sectors. The NCAD Faculty of Fine Art, in partnership with Create, the national agency for the development of collaborative arts, run a training and placement programme for fine art students in third year who wish to engage in a community context. In recent years the NCAD/Create *Learning and Development Programme* has expanded to include a number of other art colleges in Dublin including the Institute of Art, Design and Technology, Dun Laoghaire

and the Dublin Institute of Technology with international links to the Tisch School of Performing Arts, New York.[1] The MA Art in Public at the University of Ulster Belfast concentrates on developing and testing dialogic, interventionist or collaborative modes of public practice and most recently Limerick School of Art and Design has initiated an MA in Art and Design: Social Practice and the Creative Environment. Mirroring the interdisciplinary nature of the field of engaged arts practice, both these latter courses are also open to art and design graduates as well as those from related disciplines.[2]

This evolving field of practice and accompanying educational armature faces a distinct situational challenge. The dominant system of codification within contemporary art secures the artist as producer and validates the ensuing artwork through well-established and understood systems for the ascription of cultural and economic value. Those systems of ascription are also coded into the institutional networks and their modes of cultural (re) production such as independent spaces, galleries, public museums, private collections, art journals, art fairs and more traditional forms of public art commissioning. Socially engaged and/or collaborative projects have tended to operate largely outside that dominant market system and therefore do not come to the attention of those accompanying systems of codification and attribution of value within the promotional apparatus and distribution mechanisms of the established art world.[3] They operate instead in a permanently contested arena where there is no one clear authorial relationship between artist and artwork, certainly fewer traditional linear relationships between artist, artwork and audience. In its place, a more fragile but evolving framework for the ascription of value comes into play, which has to take account of a whole other set of registers. Artists emerging into this field come to recognise that there is an inherent tension in retaining the space for an open-ended dialogical process. As a prerequisite for establishing a project, this need to keep the space of creative possibilities open is not easily assimilated into the discourse and promotional endeavour of various sponsoring bodies.

Navigational challenges in the field

Particular navigational challenges arise for visual artists entering the field of collaborative arts. More specifically, the endeavours of emerging artists who enter into the complex territory of cross-sectoral collaborations in community contexts are met with defining challenges in the form of aesthetic, ethical and social modes of accountability. For artists engaged in collaborative projects the challenge to locate and describe their practice in relation to the path from embodied knowledge to social explication is embedded with certain conceptual and linguistic limitations. These conceptual and linguistic limitations are delineated by tensions between, on the one hand, the vocational–social model and, on the other, the traditional art historical model. The art historical model tends to apply a set of largely self-referential measurements to a collaborative process, which by its nature is actively engaged in a wider sociocultural field than contemporary visual arts practice

alone. The tensions that arise when those discursive fields encounter each other set up certain problematic dichotomies between the aesthetic and the social, between process and product, between artist and audience, between social value and market value and between artistic privilege and social responsibility.

Critical challenges in the field

Art historian and critic Grant Kester (2004) rejects those polarisations and focuses instead on the political and cultural agency of collaborative relations and their authorial challenges and responsibilities. Within the shifting landscape of contemporary visual arts practice, he addresses how the durability of the avant-garde tradition as the dominant frame of reference presents significant challenges to formulating a critique of long-term collaborative practice. Kester explores this clash of dispositions specifically in the context of the: '… long established resistance in the modern and postmodern avant-garde to any concept of shared discourse' (Kester 2004, p. 85) He characterises this counterpoint to the solidarity of the social movement as a

> gradual consolidation in modern and postmodern art theory of a consensus that the work of art must question and undermine shared discursive conventions (2004, p. 88).

How does one address that critical challenge for the collective work in collaborative projects when, as Kester points out, the avant-garde tradition is based on

> … the essentially solitary interaction between a viewer and the physical art object, providing no way to comprehend the creative dimension of communal or collective processes (Kester 2004, p. 89).

In the context of long-term inter-organisational and cross-sectoral projects, the avant-garde's restriction of the 'definition of aesthetic experience to moments of visceral insight' (Kester 2004, p. 89) cannot adequately address the breadth and diversity of the different elements that come into play over a longer-term collaborative arts process. Without abandoning the impulse towards social solidarity or retreating into the revelatory posture of the avant-garde disposition, a critically reflective process needs to be equipped to recognise and articulate the limits to advancing complex organisational platforms for collaborative projects among artists, arts organisations, community development projects and communities of place. These complex organisational platforms form the focus of *Transducers*, an interdisciplinary pedagogical project, which I describe later in this chapter. In his presentation of dialogical aesthetics as a critical frame, Kester crucially examines specific projects and collaborative practice in general in relation to the broader sociopolitical economy they inhabit.

More particularly, although processes of negotiation are core to collaborative work, there are insufficient critical mechanisms available to account for that intersubjective, experiential domain of the practice. As Kester (2005, p. 84) notes, there is '… no aesthetic language to describe this intensely somatic form of knowledge'. Neither are there widely available critical readings that could help alleviate the anxiety of the artist about their fluctuating visibility in long-term collaborative projects and that could in turn illuminate their occasional appearances in the field as a series of positive sightings rather than proof of the inevitability of their disappearance from the 'official' art world.

In the contemporary field, this anxiety about the position of the artist within collaborative, engaged practice is reflected in the art sector's pre-occupation with autonomy. In her article *The Social Turn: Collaboration and Its Discontents*, (2009) art critic Claire Bishop gives a number of examples of artists who have a closer relationship to the avant-garde tradition and who do not position themselves within an activist frame where '… art is marshalled to effect social change' (Bishop 2009, p. 25). As a consequence, she argues they '… attempt to think the social/political together rather than subsuming both within the ethical' (Bishop 2009, p. 25). She continues:

The best collaborative practices of the last ten years address the contradictory pull between autonomy and social intervention and reflect on this antinomy both in the structure of the work and in the conditions of its reception (Bishop 2009, p. 27).

In response, Kester (2009, p. 28) brings into question Bishop's 'deep suspicion of art practices that surrender some autonomy to collaborators'. For Bishop that 'righteous aversion to authorship' can only lead to the end of provocative art and thinking. In other words, any move away from the disruptive function of the avant-garde either in art practice or in art criticism is a move towards intellectual stasis. In Bishop's opposition between autonomy and intersubjective exchange, the extent of an artist's capacity to negotiate is less a sophisticated navigation of a set of complex inter-institutional and cross-sectoral realities and more the direct measure of the extent to which they are prepared to relinquish any authorial status and by extension, the critical agency of the work.

Bishop's neutralising of the critical agency and disruptive possibilities of engaged practice forms part of her misgivings about the rhetoric of socially engaged art being almost identical to New Labour's rhetoric of social inclusion and their prioritising of 'social effect over considerations of artistic quality' (Bishop 2009, p. 23) in their enthusiastic support for culture in the service of social inclusion. There is a notable absence of interdisciplinary models of arts evaluation, which promote a reading of community as *shaping* a process of self-actualisation through collaborative practice. In this absence the existing diagnostic arena will continue to appropriate community participation as evidence of the transformative, ameliorating effect of exposure to contemporary arts practices and to artists, or reduce it to an empirical measurement in order to underline a wider sociopolitical argument for cultural inclusion. This is particularly true of some of

the evaluative models that are emerging in the United Kingdom where there is increased expectation that the outcomes of arts programmes in receipt of state funding are linked to social gains vis à vis evidence of '… improved performance on indicators of health, crime, employment and education' (Newman et al. 2003, p. 310).

In her critique of the federal government's intrusion into educational research in the United States, educational policy and qualitative inquiry theorist Patti Lather (2004) draws attention to how the United Kingdom has experienced an extremely interventionist regulatory climate for the last decade (Lather 2004, p. 15). Drawing on an examination of mainly health care policy in *Evidence-Based Practice: A Critical Appraisal* (Trinder and Reynolds 2000) Lather characterises evidence-based practice as essentially a way for post traditional societies to manage risk in the face of both a dependency on and a mistrust of experts and expert knowledge (Lather 2004, p. 20). She offers the following view:

> Combined with the push to value for money, the rise of managerialism, consumerism and political discourses of accountability and performance, neoliberal ideologies of the neutrality via proceduralism of such practices prevail in an 'explosion of auditable management control systems' (Trinder 2000, cited in Lather 2004).

> Here, at last, is a way to manage quality issues by displacing professional judgement with promised effectiveness via the procedural production of evidence (Lather 2004, p. 20).

Lather's focus is on education and in that context she argues for the importance of 'contextual judgement' rather than the imposition of evidence-based practice (Lather 2004, p. 20).[4] In their review of evaluation frameworks for community-based arts projects in the United Kingdom Newman et al. (2003, p. 312) draw attention to how applying principles of evaluation 'which are widely accepted in the field of health and social care' to the arts is problematic. They note that although empirical approaches are common in the field of education and the arts, the complexity of community-based programmes with large numbers of participants, stakeholders and possible outcomes makes this difficult.

The problem of definition

Following on from the challenge of finding viable critical and evaluative frameworks is the problem of definition. Within this growing field of practice, the terms of reference for the request and sometimes demand for social engagement have yet to be clearly formulated. Degrees of conceptual and terminological confusion are borne out by the sheer constellation of potential approaches to engaged practice. Such a proliferation of approaches presents certain challenges for the preparation of those students who wish

to engage in this field. The diversity of possible approaches is reflected in the attendant frameworks of legitimisation, which include participatory practice, relational aesthetics, new genre public art, collaborative practice, activist art, connective aesthetics and dialogical practice among others. The expanding nature of the field of engaged practice and its formation into constituent groups is reflected in funding structures for emerging artists who seek financial support for their work. That expansion and accompanying formulation has further organised the field of practice into specific arenas such as Arts and Health, Arts and Disability, Artist in Schools, Artist in Prisons, Artist in the Community among others. In addition, requests for evaluation and for artist mentoring form another regulatory layer, which intersects with those sources of financial support. In such an entangled conceptual landscape, what are the criteria for measuring the success or otherwise of this work?

It may be useful here to start with a basic distinction between collaboration and participation. In his article *Working on Community, Models of Participatory Practice*, the art historian and critic Christian Kravanga (1998, p. 1) identifies four distinct arenas of practice. They are 'working with others', 'interactive activities', 'collective action' and 'participatory practice'. I'd like to move to the fourth of Kravanga's distinctions, participatory practice, which is initially based on an important differentiation between producers and recipients. According to Kravanga (1998), participatory practice is interested in the recipients, wishing to turn over a significant portion of the work to them in either its conception or in its realisation. Although the artist Dave Beech's (2009) more recent characterisations of engaged practice and more specifically his examination of participation and cooperation generally concur with Kravanga's, Beech's introduction of collaboration as distinct from participation is very useful. Beech says 'it is the shortfall between participation and collaboration that leads to perennial questions about the degrees of choice, control and agency of the participant' (Beech 2009, p. 7). He points to the fundamental difference between the two:

> [c]ollaborators are distinct from participants insofar as they share authorial rights over the artwork that permits them, among other things, to make fundamental decisions about the key structural features of the work. That is collaborators have rights that are withheld from participants (Beech 2009, p. 7).

This key distinction introduced by Beech is also the precise difference between negotiated practice and the more 'convivial' participation of relational aesthetics. Beech characterises relational art as 'an art of the generic social encounter, the programmatically unspecified event, the boundlessly open exchange' (Beech 2009, p. 3). Thus defined, participation has an authorial limit: an invitation to participate in an artist's project in order to realise an already well-defined idea and bring it to completion whereas collaborative engagement through negotiation creates the conditions for further shared conceptualisation of an idea and its subsequent development into a project. At a recent discussion entitled 'The

Ethics of Collaboration' organised by the Firestation Artist's Studios, Dublin Dave Beech returned to the distinctions between participation and collaboration.[5] He described his preference for talking about participation, noting how collaboration can too easily connote equality, whereas participation implies a distribution of unequal parts. In this sense, for Beech, collaboration is more like ideology. Beech's assertion draws attention to modes of description, which fail to make explicit the power relations that come into play in a collaborative network. This descriptive gap presents a pedagogical challenge in relation to the preparation of artists to negotiate and interrogate the structures of power that operate cross-sectorally as well as inter-institutionally within the field of collaborative practice.

Collaboration as distinct from participation is in my view a move towards co-authorship. To acknowledge this difference between participation and collaboration is also to allow for either the possibilities or the impossibilities of realising a project with others, to allow for the unpredictability (and often fractured nature) of collaborative practice. For artists wishing to engage in art as a social practice it is this very unpredictability, the contingent nature of collaboration, that does not always sit easily within the more formal commissioning frames, no matter how long a timeframe is on offer. Project proposals that present a less ambiguous authorial relationship among the artist, the idea and proposed work (as many participatory projects do) can offer a more reassuring degree of resolution before they even begin. When pitted against each other in this context, the open-ended possibilities of a genuine collaborative process will often lose out to the more technocratically over-specified needs of an institutional commissioning discourse and practice.

The mediation challenge

The curator Maria Lind has considered the current mediation challenge for institutions in the face of art practices where increasingly the process is as important as the product. She wonders what new forms of mediation can emerge from art which 'willingly relates to its surroundings and which therefore automatically shares many common interests with those that are not specialists' (Lind 2007 p. 22). She argues that the established forms of mediation are still useable but they are not enough. In the complex matrix of inter-organisational and cross-sectoral cooperations, how do we build a rigorous analysis, which can mediate the work and account for the intricacies and indeed the problematics of negotiating collective work over time? How do we account for the real and inevitable conflicts that can and do occur in collaborative practice? In the absence of such a framework, the tendency in the field is to uncritically accentuate the positive in accounts of collaborative practice. This is a discursive self-limitation that has serious implications for the continuous flow of learning and for the sustainability of the field of practice generally.

Artists can discover a significant lacuna in the critical armature for describing the kinds of institutional complexities and the particular kinds of attendant problems they give rise to. And because the effects of those institutional encounters remain largely outside of project accounts, they constitute a domain of experience resting outside the domain of social explication. The resultant channelling of the effects of those institutional and interpersonal tensions into the level of subjective experience can constitute a de-politicisation of what I would term the micro-political economy of a project. By micro-political economy, I mean the structural frameworks that evolve through negotiation at the level of the inter-organisational, cross-sectoral relations of collaborative practice. Barcelona-based educator and researcher Aida Sánchez de Serdio Martín (2009) draws our attention to the self-depoliticising, which can occur in artist collectives. For Sánchez de Serdio Martín, this occurs because of the tendency within arts collectives to present conflict or antagonism as something projected outwards towards whatever issue they are working against, when as she states there is 'an evidently impossible convergence of wills which is proposed towards the inside of the movement' (Sánchez de Serdio Martín 2009, p. 231). She notes the contradiction that despite operating within a referential framework where 'conflict constitutes the political condition for action', those internal conflicts and divergence can be 'tactically invisibilised by those involved' (Sánchez de Serdio Martín 2009, p. 231).

Interdisciplinary possibilities

Sánchez de Serdio Martín was writing about artists' collectives in the context of the *Transducers, Collective Pedagogies and Spatial Politics* project. *Transducers* as both a research project and a cultural initiative brought together artistic practices, political intervention and education on the basis of a range of project-based work initiated by collectives and interdisciplinary groups.[6] *Transducers* is coordinated by Barcelona-based independent researcher and educator Javier Rodrigo and a working group from Aulabierta, which is a self-managed student learning platform located in the University of Granada. The project arose out of an invitation from the José Guerrero Art Centre in Granada to Aulabierta to collaborate on a pedagogical and relational project working with local networks to help extend the museum's actions throughout the province of Granada. The project consists of a pedagogical strand that is based on a series of seminars and workshops aimed at different audiences and local organisations, such as schools and museums. The focal point of the project is an exhibition that offers 13 case studies of artists' collectives and collaborative practices. These practices propose integrated, participative and interdisciplinary approaches to the use of spaces through the collaboration of town-planning and architecture with other fields of knowledge, such as, for example, art, pedagogy, sociology, ethnography, ecology and community work (Rodrigo and Collados, 2009). The projects exhibited include the Centre for Urban Pedagogy (CUP) New York, Area Chicago, Platform London, CityArts and

Fatima Groups United, Dublin and Docklands Community Poster Project London and Aulabierta. Presented as case studies, *Transducers* explicitly set out to map the inter-organisational, cross-sectoral platforms, which were formed to deliver and sustain these arts-based projects. In addition, the complex inter-institutional matrices that make up the organisational platform for these collaborative projects were carefully researched and are displayed as a series of maps. The *Transducers* team have developed a relational archive, which houses documentation of how these interdisciplinary groups and artists' collectives advance and experience their work.[7] The *Transducers* project continues to act as a pedagogical platform prompting workshop based exchange and cross-sectoral dialogue.[8] In this way, the project sets out to explore the pedagogical possibilities that lie in the interface between different arenas of knowledge production. For the project coordinators

> The most interesting practices of political action, educational intervention and cultural work occur at present in these areas of interdisciplinary crossroads, in fractures or intermediate zones between disciplines and institutions – spaces that experiment and give rise to alternative ways of building new spheres of action and of learning collaboratively between institutions, organisations, individuals and knowledges that are very different one from the other. It is precisely at these junctures where we locate the collective pedagogies and spatial politics chosen and studied in *Transducers* (Rodrigo and Collados 2009).

In my own practice I have been exploring this question of critical alliances at the interface of different forms of knowledge production through *Vagabond Reviews*.[9] As an interdisciplinary platform, *Vagabond Reviews* combines my experience as an artist in the field of socially engaged arts practice with independent researcher Ciaran Smyth's background in constructivist psychology and sociology. In developing an interdisciplinary approach to arts-based research, *Vagabond Reviews* has combined modes of inquiry and representational strategies from socially engaged art practice with methodological strategies borrowed from the repertoire of social scientific inquiry. Those interdisciplinary research strategies have been structured as a series of collaborative inquiries in a range of artistic and cultural arenas including research on public art practice internationally, community-based processes of *cultural archaeology* and arts-based review processes within youth and community development contexts.[10]

With its focus on the many different areas of expertise and experience activated in collaborative arts processes, *Transducers* provides a compelling illustration of how multidimensional collaborative networks might be facilitated to construct meaning and shape learning together through interdisciplinary critical frameworks. *Vagabond Reviews* brings with it the opportunity to combine my own experience of formulating critical review processes in the context of collaborative practice with some methodological and epistemological pre-occupations from within the human sciences. Earlier, I outlined

some of the critical challenges for the field of socially engaged practice. In an effort to broaden and traverse those limits to sense making, *Vagabond Reviews* has been exploring how different fields of knowledge can be activated and combined towards developing a more layered series of critical registers that can take into account the aesthetic, political, social and inter-subjective faultlines within collaborative work. I will conclude by considering some of the implications of adopting that multidimensional critical register for the question of artistic formation.

Artistic formation for collaborative practice

The first pedagogical implication for artistic formation for collaborative practice is that the art historical model alone cannot provide all the necessary tools to navigate the field of socially engaged arts practice. Additional navigational tools are required. Advancing cross-sectoral, inter-organisational projects requires time and different degrees of strategic investment. Moving from the macro to the micro, I would characterise those strategic investments by the artist and their co-collaborators as taking place across a number of arenas that correspond to four levels of description. Each of those arenas must be critically engaged with in order to fully understand the structural and positional complexities that come into play within the collaborative process. More particularly, I suggest they may serve as a useful framework for signalling where interdisciplinary contributions can help formulate viable pedagogical coordinates for this area of practice.

Starting at the level of the macro, what pedagogical tools are available to assist artists to understand the political, economic and cultural conditions that together make up the historical trajectory of a particular collaborative encounter? Elsewhere I have referred to this level of description as the macro political economy of practice.[11] For example, collaborative projects advanced through percentage for art programmes have a distinct macro political economy connected to processes of urban regeneration. Descriptive investments and analytical tools are therefore necessary for understanding macro political economy as a particular set of (changing) economic conditions and sociopolitical contexts for urban regeneration and community-based cultural production. In this complex matrix, navigational coordinates would be drawn from such diverse disciplines as urban planning, social housing policy, public culture, community development practice and youth work with additional informational registers drawn from the spatial politics of urban regeneration to include the historical trajectory of private–public partnerships and so on. The work of San Diego/Tijuana architect and educator Teddy Cruz provides a key example of collaborative engagement that is self-consciously attendant to the level of the macro political economy. His work is articulated at the intersection of the economic and cultural conditions of the San Diego/Tijuana border region, which forms a complex social, economic and political context for his form of engaged design practice.

A different set of navigational tools is also required to enable the artist negotiate what I have referred to in my recent research as the micro-political economy of practice.[12] By micro-political economy, I mean to draw attention to the structural frameworks that evolve through negotiation at the level of the inter-organisational, cross-sectoral relations of collaborative practice. This level can form a very complex matrix, which expands or contracts in order to intersect with different fields of practice at various points in a collaborative process. As I noted earlier, these complex inter-institutional matrices, which make up the organisational platform for many collaborative projects, are both under-interrogated and often under-described as pedagogical subjects, with the notable exception of the *Transducers Collective Pedagogies and Spatial Politics* project. The *Transducers* project therefore offers a promising model for both mapping the micro-political arena of practice and for formulating viable pedagogical coordinates.

The third arena of practice with intriguing pedagogical possibilities concerns the capacity of the artist to navigate the social and cultural ecologies of really existing communities as particular networks of conversations. Apart from 'sudden immersion', what pedagogical responses can be formulated around that inter-subjective engagement between the artist and community? Collaborative processes reside at the level of those inter-subjective human exchanges, like a series of performed, project-bound social relations. As discussed earlier, the critical repertoire of art criticism offers few satisfactory models for properly understanding and critiquing that central experiential or embodied aspect of collaborative processes and practices. What systems of exposure, what pedagogical method would make practice at this level of inter-subjective exchange less Darwinian, less a question of the survival of the fittest (or the survival of those who can make the best fit)? Within the social sciences there is a repertoire of research practices, which explicitly sets out to capture, represent and interrogate those more experiential aspects of social relations. Through *Vagabond Reviews* I have precisely explored ways of capturing and examining that arena of the 'performed social relations' using forms of conversational inquiry derived from qualitative research methodologies combined with theoretical frameworks borrowed from constructivist psychology.[13]

I will conclude by considering the fourth arena of practice and its attendant implications for artistic formation and pedagogy. Further to developing an understanding of critical systems for interrogating macro and micro-political economies of practice and how to navigate the relational networks of engaged practice, there is a need also for the artist to constructively form a critical relation to *themselves*. This domain of the intra-subjective, what might be called the level of individual experience, needs also to find a relation to the wider field of socially engaged practice rather than remain as privatised, unarticulated experience. If this level of the individual experience of the artist is to constitute the fourth level of critical reflexivity, it too requires a language and a critical register to take it out of the realm of the subjective and (re)instate it into the political economy of practice. How then does a pedagogical process participate in the work of helping artists to find ways of bringing the level of embodied individual experience into the domain of social

explication and legitimate description? Art historian and educator Miwon Kwon has described the various acts of negotiation and persuasion that an artist engages in. She observes (2002, p. 136) that sometimes the artist will 'function as a translator, between the cultural realms of the art world and the local community group, shuttling back and forth between the two'. In considering this negotiation of a sense of identity Kwon (2002, p. 136) goes on to note that it 'does not foreclose the possibility of generative discussions' and in fact 'this instability of identity and subjectivity can be the most productive source of such explorations' (Kwon 2002, p. 136). The shifting roles and unstable identities of the artists and of their co-collaborators is a defining feature of collaborative projects; therefore the persona of the unified artist with a secure identity as sole author and producer of the work is not the pedagogical model for this kind of creative investment.

In my research I have examined in much greater detail this function of the artist as translator.[14] The work of transcultural studies theorist Encarnación Gutiérrez Rodríguez (2006) presents a complex and compelling analysis of cultural translation and positionality, which offers a very useful analytical frame for understanding the multiple positions of the artists as they negotiate a whole set of collaborative registers. Rodríguez (2006, p. 2) introduces the idea of a cultural translation 'as an attempt to create spaces of transversal understanding'. This notion of transversal understanding offers the potential to move critically through the field, rather than having to situate oneself on one or other side of polarising debates. Although it is beyond the scope of this chapter to go into further detail, these concepts of cultural translation and positionality offer a set of analytical tools, a method of description that allows us to venture into the murky inter-subjective experience of collaborative arts without reducing those complex experiences to a set of binary oppositions.[15] This seems to me to be the precise level of description that typically has remained outside the critical registers of the field. Concepts of cultural translation and positionality offer a more subtle, more nuanced and ultimately more promising conceptual and pedagogical register for thinking about how the artists and their collaborators could both navigate and interrogate the field of socially engaged practice.

Conclusion

In this chapter, I have explored a number of the navigational and critical challenges that await artists who choose to enter into the field of socially engaged arts practice. I have identified some of the descriptive challenges and gaps, which, in turn, present certain pedagogical challenges with regard to the question of artistic formation. I have invoked the work of art critic Grant Kester as a key reference point for considering the political and cultural agency of those collaborative networks along with their authorial challenges and responsibilities. I have briefly described some examples of interdisciplinary modes of research and practice that have widened the critical coordinates, thus facilitating a broader and richer analytical register for collaborative practice. I have argued that they

also offer the potential for a multidimensional critical register for the question of artistic formation. Finally, I have proposed the analysis of cultural translation and positionality (Gutiérrez Rodríguez 2006) as a promising analytical frame for understanding the strategic investments made by artists and their co-collaborators. Moving from the macro to the micro, those investments have been considered at four levels of description. In conclusion, I have used that layered framework for signalling where interdisciplinary contributions can help formulate viable pedagogical coordinates for this area of practice.

References

Beech, D. (2009) Don't look now! in *Art in the Social Sphere* 29th January 2009, Loughborough University, Business School http://www.arts.lboro.ac.uk/document. php?o=23.

Bishop, C. (2009) The social turn: collaboration and its discontents in P. Gorschlüter (Ed.) *The Fifth Floor, Ideas Taking Space* Liverpool: Liverpool University Press pp. 22–27.

Bishop, C. (2009) The social turn: Claire Bishop responds In P. Gorschlüter (Ed.) *The Fifth Floor, Ideas Taking Space* Liverpool University Press p. 30.

Downey, Anthony (2009) 'An Ethics of Engagement: Collaborative Art Practices and the Return of the Ethnographer', Third Text, 23: 5, 593–603.

Kester, G.H. (2004) *Conversation Pieces: Community and Communication in Modern Art* Berkley and Los Angeles California: University of California Press.

Kester, G.H. (2005) Aesthetic enactment: Loraine Leeson's reparative practice in *Art for Change: Loraine Leeson, 1975–2005* Berlin: Neuen Gesellschaft fur Bildende Kunst pp. 70–84.

Kester, G.H. (2009) The social turn: another turn in *The Fifth Floor, Ideas Taking Space* Liverpool University Press pp. 28–29.

Kravanga, C. (1998) *Working on Community, Models of Participatory Art.* (Re) publicart. net/European Institute for Progressive Cultural Policies Http://www.republicart. net/disc/aap/kravagna01_en.htm.

Kwon, M. (2002) *One Place After Another: Site Specific Art and Locational Identity.* Cambridge Massachusetts: MIT Press.

Lather, P. (2004) This IS your father's paradigm: governmental intrusion and the case of qualitative research in education *Qualitative Inquiry* Vol. 10, No. 1 pp. 15–34.

Lind, M. (2007) When water is gushing in *I Can't Work Like This.* Printed Project Issue 06 pp. 18–22.

Martín Serdio de Sánchez, A. (2009) Politics of the specific: collaborative cultural production and modes of organisation in *Transducers Collective Pedagogies and Spatial Politics* Granada: Centro Jose Guerrero pp. 229–242.

Murphy, A. (2010) *Tower Songs: Critical Coordinates for Collaborative Practice.* Ph.D. Thesis University of Ulster.

Newman, T. Curtis, K. and Stephens (2003) Do community arts-based projects result in social gain? *Community Development Journal* Vol. 38, No. 4 pp. 310–322.

Rodrigo, J. and Callados, A. (2009) *Transducers, Collective Pedagogies and Spatial Practices: An English Introduction* http://transductores.net/?q=es/content/english-info-transducers-collective-pedagogies-and-spatial-politics.

Rodríguez, G.E. (2006) *Translating Positionality: On Post-Colonial Conjunctures and Transversal Understanding* http://translate.eipcp.net/transversal/0606/gutierrez-rodrigouez/en/print.

Trinder L, and Reynolds S, eds.(2000) *Evidence-Based Practice: a Critical Appraisal.* Oxford: Blackwell.

Notes

1. The LAB, home of Dublin City Council's Arts Office and exhibition space for emerging artists, is also a partner in the Learning and Development Programme.
2. Drawn from the United Kingdom and North America, indicative examples of third-level provision for artists interested in socially engaged arts practice include the MFA Art and Social practice in Portland State University, Oregan, the Graduate Programme in Public Practice Otis College California College of the Arts, MFA in Fine Arts Social Practice Workshop, the MA/Postgraduate Diploma/PG Certificate in Cross-Sectoral & Community Arts; Goldsmiths, London, Colchester Institute: Dept of Art, Design and Media, MA Arts in a Social Context and the University of Cumbria: Community Arts MA among others.
3. I would make a distinction here between those collaborative practices that would be more closely aligned with activist practice and/or critical pedagogy and the notable increase in institutional support for those forms of participatory practices that re-inscribe the artist as

producer and that come to rely on what London-based educator and critic Anthony Downey (2009, p. 603) describes as '... more often than not vaguely defined field of social engagement that is in turn underwritten by a series of performative spectacles and pseudo-ethnographic encounters'.

4. The question of sustaining a critical pedagogy in the face of the influence of neo-liberal ideology on education in general and its impacts on art education in particular formed the focus of a two-day conference jointly organised by the Serpentine Gallery and Southbank Centre's Hayward Gallery. Held over two days at Southbank Centre's Purcell Room in April 2010, *Deschooling Society* brought together writers, artists and curators to discuss the changing relationship between art and education. Many of the presentations are available as podcasts from http://thehayward.southbankcentre.co.uk/category/deschooling-society/.

5. The discussion, held in NCAD in March 2011, occurred in the context of a project by the Firestation with Polish artist Artur Żmijewski and is available as a podcast from http://soundcloud.com/fire-station-studios/the-ethics-of-collaboration/s-ZDmje.

6. See http://transductores.net/?q=es/content/english-info-transducers-collective-pedagogies-and-spatial-politics.

7. Additional project elements include an international conference, which was held in December 2009, a web-based platform for ongoing discussion and project work and a publication.

8. Since its initial exhibition and conference in Granada in 2009, *Transducers* has been presented at *ACVIC* Centre d'Arts Contemporànies in Vic and in May 2011 will be presented as TRANS LAB at the Amarika Gallery in Votoria/Gasteitz a non-hierarchical arts space run collectively by artists and cultural workers. In both cases *Transducers* works with local groups and initiatives to establish dialogue, exchange and learning with and between various social, cultural and educational networks in the area.

9. *Vagabond Reviews* interdisciplinary practice meets in the territory where art and social science encounter each other as particular forms of inquiry. *Vagabond Reviews* seeks to develop creative and collaborative models of knowledge production, representation and distribution through a combination of art practice, research strategies and critical review. See www.vagabondrreviews.ie.

10. In 2008, *Vagabond Reviews* began working with the community development organisation Fatima Groups United towards formulating a critically reflective process focused on reviewing the rich history of arts and cultural practice in Fatima/Rialto. Entitled *The Cultural Review*, the research programme was organised into three strands of inquiry, loosely corresponding to preoccupations with the past (*Cultural Archaeology*), the present (*Cultural Audit*) and the future (*Cultural Anticipations*). Broadly described, within those three lines of inquiry, *The Cultural Archaeology* set out to examine arts and cultural practice in Fatima as a set of strategic responses within the spatial politics of regeneration over the last decade and into the future.

11. In my doctoral dissertation, *Tower Songs: Critical Coordinates for Collaborative Practice*, I have presented and explored four levels of description related to the strategic investments made by artists and their collaborators. The first of these is the macro political economy of practice.

12. Ibid.

13. In 2008, *Vagabond Reviews* was invited by Fatima Groups United to conduct a review of a major community-led project, which they had developed from May to October 2008. This project took the form of a community-wide Halloween street spectacle called *The Night of the Dark Angel*. The methodology developed by *Vagabond Reviews* for the review of the *Night*

of the Dark Angel was influenced by ideas drawn from the personal construct psychology of American psychologist George Kelly. For Kelly, people are active, co-constructers of reality. Furthermore, like scientists, they continually test out their personal constructs by engaging with life through action and then critically reviewing the outcomes. With Kelly in mind, we adopted a constructivist approach to our qualitative inquiry.

14. In my PhD thesis I have employed the notion of the *positionality* of the artist to examine more closely the multiple positions of both the artists and their collaborators in a negotiated network.

15. These binary oppositions include polarisations between signature practice and participatory practice, collaboration and autonomy, community and individual, artist and non-artist, ethics and aesthetics and so on. Additional registers, which I listed earlier such as relational, participatory, community-based, dialogic and socially engaged indicate that meaning in this field is also permanently deferred across spatial and temporal axes.

Chapter 9

Evental Education: The hedgeschoolproject

Glenn Loughran

There is no heaven of truths.

(Badiou 2001, p. 43)

The word 'evental' does not exist in the English language; it is a word taken from the philosophical system of the French philosopher Alain Badiou, and it is a word that he uses to describe a formal relationship between the construction of the 'new' and the production of a 'subject'. For Badiou, this relationship happens at a type of *site* called an 'evental site', and the enquiries that take place in these 'evental sites' are called 'truth procedures'. In the contemporary world, we cannot help but feel strange and slightly agitated when we say these words 'new' and 'truth'; they do not sit comfortably in any field. In a historical sense, the caution is a response to the traumas and perversions that have historically resulted in any concrete manifestation of these concepts. In a more ideological sense, there is a palpable fear of anachronistic regression; these concepts are out of time, redundant.

So why should we consider the emergence of practices that attempt to re-configure a concept of 'truth' for the fields of art and education? What are the conditions that would frame a logical return to the discourses of 'truth' and the 'new'? What would they bring to the fields of art and education that is not already there?

There are two occurrences in each of these fields that provide a context for us to begin our consideration, they emerged almost simultaneously and they highlight the minimal differences at play in these discourses between 'the new' as 'truth' and 'the creative' as 'novelty'. The first is the recent turn (Podevsa 2007) towards *education* as *art,* or *education* as *form,* which explores new spaces and new processes that reconsider arts potential for imagining a non-state, non-institutional knot between pedagogy and artistic practice.

Secondly, the turn towards *education* as *art* can be read alongside the ongoing reforms in higher education towards *education* as *innovation,* education as *creative.* These developments in education are the result of a long and complex shift in the values of education from a social institution to a business institution. These changes have largely been instituted through the theory of human capital formation, eventually replacing the ideology of the state, with the ideology of the economy.

This chapter will explore the critical value of these differences with reference to a pedagogical engagement through the hedgeschoolproject. The hedgeschoolproject is a multi-stranded series of experiments that enquire into the conditions and possibilities of an *evental education*. Evental education is an exploration of how evental thought might provide a new theoretical framework through which to engage with the emancipatory traditions of radical education in a time of creative capitalism.

Let me begin by highlighting two initial challenges in this investigation. Firstly, when the research began, it relied heavily on the *evental thought* of Alain Badiou, (rather than other evental thinkers such as Whitehead or Deleuze), yet Alain Badiou has never written anything specific on the practice of education. In fact, there is an uncanny lack of engagement in Badiou's writing with the field of education, given that he is a student of Louis Althusser whose writings on education and the State remain seminal, and secondly Badiou has been a teacher for most of his adult life. In his own language, we might say that education for Badiou is an *empty set* that *includes* elements of all of his other *sets/concerns*, but somehow does not *belong*. Similarly, and until very recently (Cho 2009; DenHeyer 2010), there has been very little written in the field of educational theory regarding the value of Badiou's work for education; what has been written is nevertheless invaluable.

The obvious challenge then to such contradictions would be, why turn to the work of Alain Badiou for support in the fields of visual art and education? There are a number of reasons for this. To begin simply, Badiou's entire philosophical system is hinged upon the relation between knowledge and truth; even a cursory glance at the title of his most regarded work *Being and Event* displays this. Being in this sense is *what is* (knowledge), and an event produces *that-which-is-not-yet* (truth). Truth then, for Badiou, is the *new*, and like most evental philosophers, the *new* is a process, rather than an object. This process of the *new* is founded upon something that happens (event) within the normative registers of situations to transform that situation from a situation of *what-is* to a situation of *what-for*. In the fields of visual art and radical education, Badiou's provocative pronouncement (ontology = mathematics) translates into a conception of knowledge production that is hostile to romanticism (Clemens 2008). For Badiou the contemporary romantic/formal paradigm circulates fundamentally around the concept of infinity, the unknown, which, in the visual arts is referred to as the *sublime*, and in the tradition of critical pedagogy, is called *the other*. Through a complex re-introduction of Plato to contemporary philosophy, and an ontologisation of set theory mathematics, evental thought articulates a concept of infinity that is neither mysterious nor unthinkable, but mathematical and banal. The banality of infinity in this shift allows for thinking the unthought through the primacy of practice.

Any exploration of the relation between event and education must then also begin with the 'primacy of practice' so as to already inscribe the investigation with the necessary risks that form evental processes. The most obvious risk in utilising such theoretical models of analysis and interpretation is how they can lead us to model certain events upon

those frameworks (in this case Badiou's philosophy) as exemplifications of practice. The danger here is in the well-worn tension between theory and practice, whereby applying a dominant theory to practice runs the risk of turning the practice into a scholastic illustration of a conceptual apparatus.

In this sense, it is important to understand that informal pedagogical experiments do not need evental philosophy to begin; the value of evental thought for these practices is in how they might be already inscribed in such acts, and how this theoretical support might motivate the continuation of practice by identifying and working through key problems such as rupture, sustainability, practice and theory. The tension between abstract theory and concrete practice is addressed in Badiou's work through the concept of the *evental site*. The *evental site* names the multiplicity of enquiries that an event produces through the process of subjectification; it names the interventions that link the originary event to the consequences of that event, for the possibility of *new* events. It was Gilles Deleuze, who, in an early correspondence, highlighted the significance of the *evental site* in the work of Badiou

> even before our correspondence, at the time when *Being and Event* was about to appear, he told me that the heart of my philosophy was the theory of the site of the event. It was this theory, he told me, that explained why one is not in immanence, which he regretted a lot, but neither is one in transcendence (Clemens 2008).

The *evental site* then is both *of* the situation and *extra* to the situation, mundane and transmundane. It is the articulation of those local processes that define an enquiry into how the 'state of the situation', as it is presented to us today, could be otherwise. The 'state' in this sense combines both the modern state of parliamentary democracy functioning through the politics of consensus, and the localised laws that normalise that consensus. What is maintained in both situations is a limitation of the possible; by presenting the limitations of the possible, the modern state pacifies political initiative, presenting both the past and the present as void of *new possibilities*.

In Badiou's systematic thought, it is the *evental site*, which produces a series of interventions into the name of *new possibilities*, and the consequences of these interventions provide a consistency to the chance elements of the event; this consistency is called a *truth procedure*.

> An intervention is a gamble that saves the 'event' from oblivion by pinning a signifier on it. The intervention orients the 'event' towards the situation, and by naming it draws it into linguistic circulation [...] The direct consequence of the illegality of this nomination is that the intervention does not quell the undecideabilty of the 'event' once and for all; each time that someone explores the consequences of the intervention they will have to decide again that it, and the 'event', took place within the situation, and that their efficacy requires further evaluation (Feltham 2008).

Through this dual relationship between the *site* and the *procedure*, evental philosophy provides a substantial theoretical and ethical support for those art and pedagogical explorations that lie on the edge of common practice. One small example of such a practice is the *hedgeschoolproject.*

The brief anthropology of a name

Hedge schools first emerged in Ireland during the Cromwellian regime, 1649 to 1653, and then as a response to the Penal laws from 1723 to 1782, which were laws prohibiting Irish Catholics from taking part in the commercial or intellectual life of their country. Often described as people's schools, hedge schools were subversively organised by priests and rural workers in barns and behind hedges throughout Ireland.

Although they were nomadic and temporal out of necessity, the hedge schools were nevertheless sophisticated in the delivery of a wide-ranging education from the humanities to classical studies and business studies to Irish history. A Commission of Inquiry report in 1826 showed that of the 550,000 pupils enrolled in all schools in Ireland, 403,000 were in hedge schools and recent research (Fernández-Suárez 2006) has shown that hedge schools were in operation until 1892. This is a significant development given that it was originally reported that these nomadic schools died out when the Penal Laws were legally abolished in 1782, and with the introduction of a nationalised state school system in 1831. Marx and Engel's 1881 text 'The Irish Question' draws attention to the radical nature and enormous significance of the Irish hedge schools in the history and development of popular education.

> There are 4,600 such Hedge Schools in Ireland, and that years report of the Commissioner says that such education the people are gaining for themselves and cannot be impeded (Marx and Engels 1971).

When we consider the emergence of the hedge school movement we cannot deny the traumatic reality in which it developed; the colonial politics of seventeenth-century Ireland made it necessary for such pedagogical movements to sustain cultural and economic survival. Without disregarding the often brutally authoritarian nature of the hedge school movement, the hedgeschoolproject was not an attempt to anthropologise that trauma, or to re-construct a romantic pre-lapsarian model of back-to-basics education, but rather to take from the name what traces of emancipatory affirmation that are left open by the movement in its relation to the present. In this sense the hedgeschoolproject is an attempt to re-signify the *idea* of the hedge school, as a unique moment of collective education, a *name* for future thinking rather than an 'object' of historiography.

This strategic reading of the historical moment relies on the redemptive conception of history posited by Walter Benjamin some years ago in his thesis on the concept of history.

Throughout the 18 meditations that make up 'The concept of history' (1940), Benjamin criticises the judgements made by traditional historians, by rejecting the hermeneutical school of interpretation, which suggests that in order to *know* the past it is necessary to suspend our knowledge of the present, and grasp historical events in their own terms as they really occurred. Secondly it rejects the notion that we can see the past only through the present, that the past is merely a series of competing interpretations, with no way of choosing between them. For Benjamin these two approaches, although they might appear to be opposed, are in fact the same. In Benjamin's analysis, such interpretive models cannot help but relativise the past by the present, and in response to this he puts forward the notion that in the proper conception of history, it is not the past but the present that is relativised. For Benjamin the true aim of historical interpretation then is to appropriate the past in itself in so far as it is 'open', in so far as 'the yearning for redemption' is still at work within it. How could it be possible to know the past 'in itself', but only in so far as it is 'open'? What does it mean when Benjamin speaks of a certain 'yearning for redemption' in the past?

In a seminal text on the ethics of evental thought *Miracles Happen: Benjamin, Rosenzweig, Freud and the Matter of the Neighbour'*, Eric Santner draws a genealogical outline of the relation between *history* and *event*. Beginning with the German–Jewish work of Franz Rosenzweig and Walter Benjamin, and ending with the work of Alain Badiou and Slavoj Zizek, Santer suggests that each of these thinkers has arrived via significantly different routes at the same particular truth of our era, that if we are going to understand and engage with the possibility of radical shifts in the values and the direction of our lives then it will 'require a notion of interpellation beyond ideological interpellation' (Santner 2005). Catherine Ryther has arrived at a similar proposal through a pedagogical reading of the work of Jacques Ranciere, calling for a re-opening of debate on the future of radical education through the notion of *anachronistic possibility*. Anachronisitc possibility points radical education away from a critical pedagogy of the present, towards an iterative process of exploration into

transformative events in the past which our present leads us to believe are no longer possible (Ryther 2008).

The hedgeschoolproject

Influenced by developments in the contemporary art world towards an appropriation of architectural form as performative site, the hedgeschoolproject was initially proposed in 2005 as a 'constructivist' school for process-based methodologies engaging with the idea of architecture as activism. Each of the processes in which the spaces were produced was informed by prior research with the co-participating individuals; this research then informed the pedagogical and art processes throughout the duration of the project. As

the designs of the school spaces were developed, there was an intense engagement with the public, workers and groups most involved with the project. It was envisioned that the process of constructing the spaces would be performatively pedagogical in various dimensions such as the technical, the historical and the political.

Subtracting education from its normative context (state schooling), the projects further subtracted the standard pedagogical tools of 'curriculum' and the 'test'. In response to the 'motivational deficit' or 'void' left by this subtraction, these processes were motivated by an 'axiom of equality'. The 'axiom of equality' proposes that pedagogical practice affirms that 'equality' exists at the *beginning* of a pedagogical process, rather than as a goal to be achieved *through* a pedagogical process. As Joseph Jacotot has said:

> Equality is not a goal to be attained but a point of departure, a supposition to be maintained in all circumstances (Ranciere 1991).

The following is an outline of the key themes motivating the hedgeschoolproject. In an attempt to fully illustrate the type of *praxis* developed in the project, this outline is structured by three inter-related elements, which are The Theoretical, The Practical and The Pedagogical. In the context of the research, The Theoretical conceptualises the connections between ideas of power, knowledge and representation. In terms of The Practical, we consider the openness of experimentation and the risks inherent in such processes. And through The Pedagogical, we articulate the links between both theory and practice, challenging the prescriptions of Theory, and interrogating the un-thought in Practice. As can be expected there is little room to give a full account of the intensity of experience and the pedagogical labour involved in each project, and without either disavowing this labour or glorifying event management, this outline is simply a prelude to a larger project that will take place over the next two years.

The first iteration

The first iteration of the project began in 2005 in a small rural village in Co. Carlow called Leighlinbridge. A proposal was made to the local council to construct a temporary structure that would provide a site for the exploration of pedagogical/art processes. An initial research period was set up to enquire into three fields of interest specific to the site and the proposed construction. They were:

- *The Historical*: produced the name for the project, a link to the politics of the site and an ethos of pedagogical experimentation;

- *The Technical*: developed the form of the space, the process of co-construction and the pedagogical link between the construction of the space and the politics of its name;

- *The Pedagogical*: developed the themes and process of engagement, informed by the construction of the space and the politics of its name.

Alongside this research, there was a lot of practical negotiation at work with the local community around the risks inherent to a project of this nature. After this period of research, it was decided that the space would be constructed out of straw-bales, which were donated by a local farmer, on a contentious site that was donated by a local priest, with a group of early school leavers, who were considered anti-social. The design of the space allowed for it to be constructed over a four-day weekend, with the support of local volunteers who were involved in all aspects of the build. From the construction it was proposed that the artist/educator would work in the space alongside volunteers, with a small group between the ages of 15 and 18. Due to the rise in anti-social behaviour against new communities that had arrived in the village, the theme of the project became 'the neighbour', which in turn was motivated by the axiomatic statement, 'Whoever is living here is from here' (Badiou in Bosteels 2005). The axiom is realised through the initial processes of investigation; it provides the minimum amount of prescription necessary to begin a series of enquiries through a series of artistic processes. It functions decisively and through an open and reflexive practice that does not totalise the process of enquiry.

The methodologies performed in the project were developed over a six-week period and resulted in an exhibition of artworks; in this case, a series of video dialogues titled The Neighbour, The Neighbourhood and Politics. The themes of these video works were written and developed by the group and expressed local scenarios of disagreement between neighbours around issues relating to migration, anti-social behaviour and local politics. The exhibition was held in the hedge school space, with a village BBQ in the field, where local councillors and the mayor were invited to publicly respond to the project. This process in turn created a dialogue with the young people and the community workers around the need for spaces of social engagement that might provide a supplement to the problem of anti-social behaviour. Finally the hedgeschool space was dismantled and the straw bales were returned to the farmer, the space on which it was constructed was considered for development as a community space, snooker hall and tennis courts, rather than residential developments, as had been previously proposed. This development is still in process.

Praxis
The theoretical: in terms of theoretical conceptualisation the theme of the *neighbour* provided a challenge to multi-cultural pedagogies of tolerance and respect that rely on the figure of the 'other'. This was manifested in two ways, first by problematising

the 'other' as banal and generic, an issue of proximity rather than an issue of identity. Secondly, by constructing an engagement around the ethics of the neighbour, the group was unable to rely on habitual resistances that had been developed in response to previous interventions with new communities.

The practical: beginning the project with a practical construction provided a substantial key to the formation of the group, the experimental and tactile construction of the straw bale space provided authorship and ownership, which in turn prescribed a sense of trust and openness in the pedagogical process. The space literally motivated the group to produce more work, and provided a historical context to give that work meaning.

The pedagogical: this drew together the various themes and processes, translating those links through material processes into a consistent set of enquires that allowed for the group to author its own research, contest the original axiomatic declaration and re-invent that declaration with a new set of concerns, expressed publicly alongside the construction of the space and the politics of its placing.

The first phase of the hedgeschoolproject was designed as a stand-alone project; there was no intention on the part of the artist to extend these explorations beyond the scope of the initial project. In this context, the second iteration of the hedgeschoolproject was the most significant outcome of the first, to continue the explorations due to what had been successful and also what had been lacking within the first project. A key element of success in the first project was the generative dialogue that developed through the complex relationship between the constructed space, its historical background and its political implications.

Beginning the process with an axiomatic enquiry into issues of power and difference proved fruitful. By supplementing the standard pedagogical tools of curriculum and test, with the axiom of equality the discussion began with disagreement, and this line of dialogue followed through to a creative expression of critique around key issues in the public realm.

What was lacking in the first iteration of the hedgeschoolproject or what was considered worthy of further investigation was a more ambitious timescale, an exploration of adult education through the politics of self-education as opposed to the critical pedagogical models of leadership, a focus on the problems of literacy with those most excluded and at risk from low literacy and a more challenging engagement with the politics of parliamentary democracy.

Literacy house

Phase two of the hedgeschoolproject began as a series of discussions and proposals on the possibility of developing a similar project with the traveller community. Initially developed on several different sites in the Wicklow area south of Dublin, the first research

phase of the project was stalled and eventually put on hold due to unstable conditions at the designated sites. Due largely to the commitment of the community to realise the project, alternative sites were proposed for the north Dublin area of Priorswood. From within this site there was a further extensive period of significant research with the traveller community, traveller teachers and community workers. Informed by this research it was decided with the community workers that the project would be developed across four different traveller sites over a period of ten months and would involve the reconstruction of a used mobile home into a mobile literacy space. The aim of the project was to engage the participants in the self-actualisation of the space, through a process of self-education. This process would be recorded in a series of hand-made books fabricated out of the materials of the old space as it was transformed, and these books would be used as resources for developing a literacy/research project around ideas of democracy, inclusion and belonging.

Building on the success of the first iteration of the hedgeschoolproject, a decision was made to replace the motivating structure of the curriculum with the appropriation of the performative statement: *all intelligences are equal.* This axiomatic beginning then led to the thematic methodology or non-methodolgy – *how to teach what you do not know.* Through further discussions, it was proposed that each member of the group would record their interpretation of the activities involved in this process with the aim of teaching those experiences to the next group. At the same time, it was suggested that statements from the discussions taking place would be recorded and used in the design of the space.

As stated previously it would be impossible to describe in detail what followed on from the early phases of the second project. For many different reasons it was a project that began with risk and ended the same way; often when it seemed like those risks were not worth taking, the participants asserted how the *risks* were driving the project.

After being evicted from the initial site, the trailer moved to a halting site where it was operative for about eight months, after which it moved on to an illegal site where it was in operation for about one year, before its final eviction. The project was in operation for almost two years, and it worked on three different sites, with four different families, until it was evicted a second time and moved in the middle of the night. Although the project was extremely precarious, it was nevertheless successful in addressing a material and pedagogical need through the construction of the literacy space. In each of the sites there were real processes involving technical literacy for democratic participation, and a sense of authorship that resulted from the collective teaching process *how to teach what you do not know.* This literacy programme produced a series of eloquent individual books, recording the discussions and enquiries that took place.

Finally, the recorded teaching sessions that were produced by each individual at the end of the process articulated an informed disagreement with the politics of the democratic state, and each individual's relation to it. These recordings were exhibited in an exhibition organised by the traveller organisation involved in facilitating the project, Blue Drum, in Co. Donegal in 2010[1].

Praxis

The theoretical: Initially the actualisation of a methodology around the non-methodology of *how to teach what you do not know* proved to be extremely challenging as it seemed to represent a problematic similarity with the practice of doing nothing. This was a paradox that had to be performed in the slow withdrawal of the authority of the educator through the assertion of the group dynamic. Eventually this idea began to make sense and proved to be instrumental in generating a group dynamic around discussions of power and authority in society. As the project developed and responded to the challenges of the process, the axioms and themes that initially drove the project began to recede and became replaced by new themes and new statements.

The practical: construction of the project was both motivating and exciting, yet it was also frustrating and significantly slowed down by the implementation of a self-education process. Further complications in locating the trailer after eviction produced unexpected developments in the final site, where it became active as an artistic/pedagogical space and a space for primary healthcare, literacy, community meetings, legal meetings, prayer meetings and after school projects.

The pedagogical: through the collective education with the groups involved in the process, and through the pedagogical links between sites, a unique exploration of the power relations between teacher/student both informed and changed the direction of the project. Significantly towards the end of the project, those processes were translated into an exploration of the politics of authority in relation to democracy/voting, from which the families felt excluded as they had no fixed address. This was the most successful outcome of a pedagogical process that did not begin with the politics of democratic inclusion and belonging, but rather with the politics of separation between teacher/student.

Precariat academy

The success of all the hedgeschoolprojects has been due largely to the time and energy of individuals whose belief and trust in the projects cannot be understated. And although there may not be enough space to name all those involved, one key figure in promoting, supporting and sometimes funding the hedgeschoolproject process was curator Ed Carroll who has written on the hedgeschoolproject. (Carroll 2010).

As head of curating at the Kaunas Biennale in 2009, Ed Carroll invited the artist to make a proposal based on previous projects for the Biennale. Developed over an extensive eight-month period of research and email contact with activists and artists living in Lithuania, the core theme of the discussions became 'labour'. The Textile Biennale is a national showcase for the highly skilled and highly aestheticised tradition of textile art in Lithuania. Yet, there remain significant contradictions and oppressive conditions for

workers in textile factories. Through dialogue with workers in those factories, a project was developed to re-construct a generic shipping container into a space for a pedagogical process around the politics of precarious labour. After the initial development of the project the container would be shipped back to an urban garden site in Dublin, where a second phase of engagement would be developed with the Lithuanian community living in Ireland. The project was named the Precariat Academy. The word 'precariat' is a hybridisation of the words precarious and proletariat, and it relates to an activist/academic discourse that analyses and protests against the ongoing restructuring of labour practices through short-term contracts, flexibility, creativity, mobility and cognitive labour.

The shipping container was delivered in late September, and sited outside the Biennale gallery on the main road going into the commercial centre. Working with local activists, graffiti artists and volunteers, the container was transformed inside and outside, through a series of discussions, screenings, research initiatives and other social engagements. A key problematic that needed to be addressed in the beginning of the project was the differences in language. To resolve this issue and facilitate a proper discussion, a small room was constructed at the back of the container, which was fronted by a large transparent acrylic screen. This screen was then whitewashed for each session, and used to inscribe drawings and text, allowing for translation, interpretation and intervention into discussions as they took place. Finally, these invisible inscriptions were recorded with a video camera, capturing the process as a live animation that would be projected onto whitewashed windows in abandoned shop fronts, in the commercial centre of Lithuania.

Within the project, a process of analysis began to take on momentum, looking at the different policies around labour rights and how they were unable to account for and protect the precariousness of labour in the textile factories. These analyses were informed by a series of film screenings by workers in the factories and unions working to support them.

As the space became continually transformed over the four-week period the idea of an axiom was replaced with the question 'What is a good life'? This question was installed on the top of the container and was accompanied by a series of blank poster boards mounted on the sides of the container allowing for public responses.

The first four weeks of the project ended on the opening day of the Biennale; all of the research material that had been developed over the four weeks was exhibited along with the pedagogical animation, which played on a loop on the Plexiglas structure. One of the strongest outcomes of the research process was a statement painted up on the inside of the space two days prior to the exhibition. This statement highlighted how the national poverty level was higher than the minimum wage: it was a very clear and simple statement and yet surprisingly powerful. The majority of people who read the statement were unaware of the contradictory and absurd nature of its claim. After the Biennale opening, the group most involved in the project continued to work in the space for another four weeks, running lectures on non-institutional spaces and poetry readings and other research processes. There were efforts made to fund the project so that it may return to Ireland, but they were unsuccessful.

Praxis

The theoretical: having developed an initial schematic for the project, on arrival these themes and axioms did not seem quite so relevant and were replaced by a focus on the Precariat discourse, prompting the question: what is a good life? The Precariat discourse proved to be problematic in the beginning as it is a discourse that responds to post-fordist labour conditions, whereas the conditions in the textile factories were still fordist. Yet the activists involved in the project were a younger generation whose experiences of the labour market were through internships, short-term contracts and indefinable high-tech jobs.

The question 'What is a good life'? worked well for the public discussions, and provided an interesting contrast to the often negative content of the research process. Finally, the impact of the animation and the statement regarding the minimum wage drew a lot of attention and provided a critical debate on labour laws.

The practical: the challenges faced by the temporality and displacement of the project were significant. Technically the physical transformation of the space took an enormous amount of labour from volunteers; yet again, it was key to forming a committed group of researchers and activists around a focused set of concerns. The space was used consistently for about ten hours a day, developing a reputation as an active space between the public and the private realm. Finally, the spatial aesthetics formalised the nuances of the project through its tension between heavy and delicate material, mobility and labour, description and prescription.

The pedagogical: the pedagogical process was challenged by the difficulty of translating from English to Lithuanian. This problem was creatively tackled by the construction of the Plexiglas screen that operated both instrumentally and aesthetically to motivate and provoke the pedagogical process. The only other real challenge to the pedagogical process was the social nature of the space. At times, it was necessary to censure the social desire for the space, in order to frame a proper engagement with the issues that were driving the process. This was successful in maintaining a critical engagement with the research into policy issues that produced both the animation and the declarative statement on the minimum wage, which were neither prescribed nor predictable.

Final note

Each of the processes in the hedgeschoolproject included within their structure a reflexive/discursive dimension that would be considered normal practice in informal education settings, whereby the artist/educator and the group would reflect on what is working and what is not, in relation to the process. Similarly this would also happen with the workers and volunteers involved in each of the sessions. In most cases, a note would be made of this reflective evaluation, to aid the next session. Yet, what needs to be emphasised is the

inter-subjective level at which these sessions were experienced. The economy that drives such projects and their processes is an economy of intensity and solidarity; this builds up through the various dimensions of commitment, problem solving, ambition, success and failure.

Finally, as each of the schools is evaluated they inform and motivate the next iteration of the project. It is in this sense that they are auto-reflexive and auto-didactic. In the current phase, the project is in the planning stages of a large-scale multifaceted series of installations, comprising constructed freight containers in a large city centre farm in Dublin.

An eventless or an evental education?

In a recent series of publications, artist, educator and writer Jan Jagodzinski has drawn out the links between the libidinal object of designer capitalism and its implications for the pedagogical process. Utilising a Lacanian framework, Jagodzinski asserts the relation between creativity and the 'real', in the face of its appropriation by educational policy via the innovation turn.

> Creativity, which cannot be *counted*, is therefore continually squeezed out of schooling with its over-emphasis on accountability and evaluation. The gap between art and design is eroding as design begins to strangle creativity by appropriating the same rhetoric of creativity, freedom and self-determination to further the innovation of products for industry (Jagodzinski 2010, p. 190).

For Stewart Martin, the confusion of *counting* creativity is symptomatic of a broader erosion of the terms and reference points traditionally defining artistic and pedagogical discourse (autonomy, creativity, self-determination) by *capital's* ability to domesticate its antagonisms. This ambivalence has brought about a crisis in progressive education, where post-fordism's appetite for creative self-directed activity has taken on a bio-capitalist currency that is

> standing at the centre of political–philosophical disputes over the commodification of human beings. Rather than the capitalisation of education, it has come to indicate the educationalisation of capital. These developments have led to a crisis of ideas of emancipatory education. Not merely because they have become embattled, but due to their appropriation and instrumentalisation (Martin 2008).

Similarly, Joseph Dunne suggests that the intrinsic relation between education and economy has reached such an impasse that our ability to think alternatively is limited at best, and apathetic at its worst.

The relationship between education and the economy has become a reciprocal one, with dependency running in both directions. On the one hand, the productiveness of the economy depends on the educational system for the supply of a skilled workforce (what is increasingly called 'human capital'). On the other hand, the educational system depends on a productive economy for funding on the scale which is required by a modern democratic system of schooling… This interlocking of education with the productive and economic sphere circumscribes the autonomy of education (2005).

With the increasing loss of educational autonomy via the state's relation to economic restructuring, it is no surprise then that there has been a significant re-thinking of historical pedagogical movements that might cultivate new thinking for what is possible in the current impasse. In the last eight to ten years there has been an increase of such activities within the artistic community towards the re-imagining of the emancipatory traditions of radical education in such projects as 'Chto Delat', 'The Radical Education Project', 'Edu-Factory', 'Copenhagen Free University', United Nations Plaza, Former West, 16 Beaver and many more. In a 2003 article titled 'A pedagogical turn: brief notes on education as art', Kristina Lee Podevsa from the Copenhagen Free University suggests that artworks that articulate *education as form*, 'choose to sidestep the closures of institutional critique which narrowly focus on institutional failures, offering instead to open up the academy through reinvention'.

After defining a historical lineage for this shift moving from the Russian avant-garde theories of Art into Life to Josesph Beuys social sculptures, Podevsa (2007) attempts to highlight the key objectives that have structured the more contemporary engagements.

- A school structure that operates as a social medium.

- A dependence on collaborative production.

- A tendency toward process (versus object) based production.

- An aleatory or open nature.

- An ongoing and potentially endless temporality.

- A free space for learning.

- A post-hierarchical learning environment where there are no teachers, just co-participants.

- A preference for exploratory, experimental, and multi-disciplinary approaches to knowledge production.

- An awareness of the instrumentalization of the academy.

It would be all too easy to affect an academic indifference to the emergence of these practices given the seemingly unquantifiable nature of their structures, but within these practices are ambitions to invent new forms of pedagogical engagement that fall neither into the formal nor the informal definitions of education. Following this line of thought, we could also suggest that to think these aesthetic pedagogical explorations as 'evental', we would need to move the limits of their operations from the relational to the extensional. Such a move would allow for an understanding of these practices as heterogeneous, forming a disjunctive synthesis with other sequences. This type of shift has been working itself out for a number of years through network theories such as trans-modernity, transversality, trans-locality and the precariat. It is also a shift that is particular to the 'banal infinity' of evental thought.

In *The Force of Law*, Jaques Derrida describes the *event* as the foundational moment that gives way to the present laws of the institution. These laws produce the norms of institutional existence. For the context of our discussion, Human Capital Theory would be understood as the *Derridean event* in the field of education in the late twentieth century. It would be logical in this sense to consider another type of *event* in relation to the institution of such laws, the *event* as rupture, as a critique of the totalising desire of the institution from within the institution. Yet, this is not the concept of the *event* that we have been working through in thinking the co-ordinates of an evental education. If our concept of evental education asserts that a process begins with the *subtraction* of education from the *state of the situation*, and yet simultaneously produces and affirms the construction of a new space in the *evental site*, then it is not caught in the binary logic of institution/rupture, but

> surpasses the romantic opposition of punctual event and static institution by conceiving of a mobile instituting force that takes place through local enquiries into the texture of a situation from the standpoint of the event. This is not the same operation as the institutionalization of an event, understood as its integration and domestication within an already existing set of institutions. Rather, the counter-state is always posterior to an event, and its consistency is continually renewed through a series of micro-decisions concerning the belonging of the event to the situation (Clemens 2008).

Inevitably, this logic of subtraction will be charged with the crimes of negation and reduction, given the close proximity to the twentieth century's historical violence of purging? How are we to imagine such a process of subtraction as anything other than a passive withdrawal, self-alienation or worse?

In terms of our thinking an 'evental education' that is both subtractive and affirmative, we could begin by looking back to the activism of Rosa Parks whose impact on desegregation for African Americans was due in no small part to the fact that she had been home

schooled (subtraction), before attending the *eventual site* of the Civil Rights education, The Highlander Folk School (affirmation). We could also include in this line of enquiry the MST (Movimentos Sem Terra) landless movement that has become recognised as the largest and most successful populist movement in the late twentieth century (UNESCO). The MST operates at a principled distance from the State (subtraction), and yet manages to prescribe the equal distribution of land by the State (affirmation). At the heart of the MST, movements are the constructed 'itinerant schools'; these schools are usually built on the move, out of the materials available in whichever site the movement pauses. These make-shift tents are sometimes transformed into fully functioning universities. The significant influence of the itinerant schools can be witnessed in the mixed responses they have often produced. In February 2009, authorities in the state of Rio Grande do Sul, Brazil, prompted the closure of seven schools for the MST Landless Workers Movement, claiming that they are being used by the MST to 'develop a revolutionary ideology'. Yet the MST in Rio Grande do Sul was also considered a pioneer 13 years ago for implementing a Brazilian law that supported schools in the countryside, becoming a model for the rest of the country. UNICEF Brazil has awarded the educational work developed by the MST as a model for education among children in vulnerable socioeconomic conditions.

Similarly, we could consider the Mondragon experiment, which is one of the longest running cooperative movements of the twentieth century, an impressive example of worker's self-management and democracy. The first cooperative of the Mondragón group was the product of a school built with the labour and the capital of a community desperate for social justice and economic security. The community of now 100,000 workers has its roots in a school that began with 12 pupils. Five of these pupils went on to start Ulgor, the first cooperative of the Mondragón movement. Thus, this cooperative movement was created out of a subtractive informal educational movement.

The long history of popular education is littered with similar examples; in Ireland, it was the hedgeschools, in Lithuania, there were the 'Misery schools' and in Australia there is the Aboriginal Tent Embassy camped out on the lawn of the parliament building. None of these movements is by any means perfect; there are critical lessons to be learned from all of them, yet what they all tend to have mobilised with some consistency is the assertion of a new space of political organisation, via a formal subtraction. In this classical sense, they represent the eternal struggle and significance of 'squatter sovereignty', the filling in of void spaces left open by the miscount of the State; Tahrir Square in Egypt, Pearl Square in Bahrain, Green Square in Lybia and many more to come. This is not at all to fetishise the camp, or to assert the camp as an ontological expression of Bare Life, 'we are all refugees', but rather the opposite, to consider in such forms of subtractive/ affirmation, the production of something other than the discourse of postmodern critique, something beyond fetishised nihilism of bio-political power.

To connect these large-scale movements with small-scale pedagogical explorations in the artistic community may seem like an absurd task, with cultural relativism and class disavowal lurking around every corner. We need to remain critical of such possibilities,

but not use their possibility as a form of retreatism. As Slavoj Zizek has suggested, the difference between our situation today and the earlier 20th century is that 'we do not know what we have to do, but we have to act now, because the consequences of non-action could be disastrous' (Zizek 2010). As educators and artists, our role may not only be in analysing the desubjectivising ideology of Human Capital Theory, but in understanding the limits of our own critique in doing so, by engaging with the *possibility of new possibilities*, no matter how seemingly futile they may seem. In this sense an *evental education* would attempt to cultivate the heterogeneity and force of these movements, and to re-imagine the *live thought* of praxis at a critical distance from the state, unsubordinated by the omnipresence of power, but rather motivated by it to create the coming *truths* of our times, the *new*.

References

Badiou, A. (2001) *Ethics: An Essay on the Understanding of Evil* (trans. P. Hallward) London & NewYork: Verso p. 43.

Benjamin, W. (1940) *On the Concept of History* in. Selected Writings Vol. 2. (eds.) H. Eiland, M.W. Jennings, and G. Smith Boston; Harvard University Press1 (1999).

Bosteels, B. (2005) Can change be thought? A dialogue with Alain Badiou in *Alain Badiou: Philosophy and Its Conditions* Gabriel Riera (ed.) Albany: SUNY Press p. 254.

Carroll, E. (2010) *Life Art-Experiences of Being Public* http://www.artandeducation.net/paper/lifeart-experiences-of-being-public/.

Cho, D. (2009) *Psychopedagogy, Freud Lacan and the Psychoanalytic Theory of Education.* London: Palgrave Macmillan.

Clemens, J. (2008) *The Romanticism of Contemporary Theory. Institutions, Aesthetics, Nihilsm* Aldershot: Ashgate Publishing.

DenHeyer, .K. (ed.) (2010) *Thinking Education Through Alain Badiou. Philosophy of Education Society Australasia, and Theory.* Chichester: Blackwell Publishing.

Dunne, J. (2005) What's the good of education? in W. Carr (ed.) *The RoutledgeFalmer Reader in Philosophy of Education* Oxford & NewYork: Routledge pp. 145–160.

Fernández-Suárez, Y. (2006) An Essential Picture in a Sketch-Book of Ireland: The Last Hedge Schools *Estudios Irlandeses*, No 1 pp. 45-57.

Feltham, O. (2008) *Alain Badiou: Live Theory* London & NewYork: Continuum.

Jagodzinski, J. (2010) *Badiou's Challenge to Art and Its Education—Or, 'Art Cannot be Taught—but It Can Educate'* in DenHeyer, .K. (ed.) (2010) *Thinking Education Through Alain Badiou. Philosophy of Education Society Australasia, and Theory.* Chichester: Blackwell Publishing.

Marx and Engels (1971) *On Ireland.* Moscow: Progress Publishers.

Martin, S. (2008) Pedagogy of Human Capital, *Mute Magazine* http://www.metamute.org/en/Pedagogy-of-Human-Capital.

Podevsa, L.K. (2007) A pedagogical turn: brief notes on education as art *Fillip* 6 http://fillip.ca/content/a-pedagogical-turn.

Ryther, C. (2008) *'The Possibility of Living Another Life': Reimagining Possibility in Radical Pedagogy Through Rancière* Stockholm University, Sweden PESGB Conference.

Ranciere, J. (1991) *The Ignorant Schoolmaster: Five Essays in Intellectual Emancipation.* Stanford: Stanford University Press.

Santner, E. (2005) Miracles Happen: Benjamin, Rosenzweig, Freud and the Matter of the Neighbour in *The Neighbour. Three Enquiries in Political Theology* Chicago: University of Chicago Press.

Zizek, S. (2010) *The Permanent Economic Emergency* New Left Review. 64, July-August 2010 http://newleftreview.org/?view=2853.

Note

1. The National Traveller's Retrospective, a spectrum of participatory.

Chapter 10

Making a Show of Ourselves: Art, Community and the Pedagogics of Identity

John Mulloy

In the end, the glorification of the splendid underdogs is nothing other than the glorification of the splendid system that makes them so.

<div align="right">Adorno, Minima Moralia, Aphorism 7.</div>

Ireland's National Campaign for the Arts, established in September 2009, aimed to protect Local Authority arts funding because of 'its essential role' in maintaining the cultural diversity, social cohesion and identity of communities and regions (National Campaign for the Arts 2010). The Arts Council 'always' advocates for the arts 'from a conviction about the intrinsic value of the arts, their singular contribution to Irish identity, and their importance for social and economic well-being' (Arts Council 2010b, p. 4). They also claim that artists 'interpret our past, define who we are today, and imagine our future' (Arts Council 2010c).

Are some of these positions mutually contradictory? Are the arts in Ireland, particularly at a rural community level, a normative force, part of the state's civilising mission? Are some of the claims made on behalf of the arts in Ireland actually unreasonable? A fraught battleground for these questions is the practice of community-based arts development, including projects organised through the Per Cent for Art Scheme.[1]

Community-based arts development has its historical roots in the broader new social movements of the 'counter-culture' of the 1960s and 1970s, linking it to a general desire to 'heal the world' (Becker 1994; Cockroft et al. 1998; Frye Burnham and Durland 1998; Kelly 1984; Lacy 1995). This was reflected in avant-garde movements such as Fluxus and Conceptualism, which in turn led to the 'reconstructive postmodernism' of the late 1980s and 1990s. This sought to redefine art in terms of social relatedness and ecological healing through collaboration, participation and a sense of place (Bourriaud 2002; Gablik 1991; Lippard 1997). The Irish community arts movement rapidly expanded in both quantity and sophistication in the 1980s, and by the late 1990s became part of a hugely increased state investment in, and control of, arts and culture, together with an increased focus on cultural citizenship. At least partly in response to this, Irish community arts activity divided into two strands: an instrumental strand, often known as arts-based community development, supported by the Community Development Projects, a wide variety of statutory agencies and the voluntary sector, with a focus on art as a tool of social change; and a more 'aesthetic' strand, community-based arts development, supported

by the Arts Council, the cultural institutions and the Local Authorities, which focuses on 'extending the boundaries, relevance and reach of art' (Murphy 2000, p. 38). The instrumentalist position is seen as being outside the remit of the Arts Council, and it is the latter, 'aesthetic' strand that is the focus here.

Art, community and the state

Community organisation is based on the production of symbols and the construction of identity in order to provide security and facilitate collective action (Bauman 2001, pp. 144–150; see also Appiah 2005; Della Porta & Diani 1999; Goodwin and Jasper 2009). Although the concept of community can be seen as fundamentally exclusive, constituted in opposition to an 'outside', it is generally regarded as fluid and dynamic, conjuring up images of trust and cohesion. Within any community, there is an exchange of liberty for security, a search for safety in collectivism at odds with the individualism of consumer capitalism. The liberal state is based on this search for collective security, predicated as it is on the autonomous individual (the citizen), engaging freely in a political 'community' (the State), swapping some freedom for the safety of democracy. Only those qualified to take part – the legal citizens – can enter fully into this exchange, which is therefore mediated through laws – but also through money. 'When all the members of a community are independent of or indifferent to each other, the co-operation of each of them can be obtained only by paying for it: this infinitely multiplies the purposes to which wealth may be applied and increases its value' (De Tocqueville 1998 (1831), p. 309).

Although democracy evolved as a system of checks on the market in order to protect the interests of the bourgeoisie and the working classes, neo-liberal successes over recent decades have given the markets dominance in a manner that is 'profoundly anti-democratic' (Harvey 2005, p. 205). This is especially obvious in Ireland, where there has been a recent weakening of both the democratic institutions and popular sovereignty, accompanied by a decline in social justice.[2] Held's model of 'legal democracy' demonstrates that neo-liberalism eroded many protections for the vulnerable, removing fundamental debates about redistribution from political discourse as all parties sought to placate the markets (Held 2006, pp. 205–208). As the need to develop categories of recognition is part of the state's justification for its policies of redistribution, issues of identity and community have become central themes in politics, education and governance (Goldberg 2002). These issues led Fraser to suggest a 'normative distinction between injustices of distribution and injustices of recognition' (Fraser 2008, p. 58). Contemporary ideas, policies and practices of community-based work have therefore been reshaped 'in line with the general policy orientations of the transition to neoliberalism, and they do so at the expense of building opposition through local organizing' (DeFilippis et al. 2010, p. 123). It is deeply ironic that whereas the language of the market exalts individualism,

those whom the market has failed and who are therefore socially excluded are 'prescribed "community"' (Taylor 2003, p. 79).

In the Irish Republic, politics is about the creation of a solidaristic whole, where the state's job is to embody and implement this collective solidarity in a communitarian vision based on ethnic and cultural identity. Ireland is often presented as a modern liberal state, but this misrepresents a polity constructed as a 'working model of a Catholic state' (Blacam 1921, p. xvi). Indeed, according to Arthur Griffith, 'the right of the Irish to political independence never was, is not, and never can be dependent upon the admission of equal right in all other peoples' (Mitchel 1913 *Preface*,). This ideology formed part of the basis of the newly independent state, entrenched in the hands of the descendents of the 'strong farmer' and rural shopkeeper class, with an insistence on private property and the family farm as the basis of prosperity (Commins , 1986, pp. 47–67; Nic Ghiolla Phadraig 1995, pp. 593–617). This can be seen in the reaction to the proposed appointment in 1930 of Laetitia Dunbar Harrison to the post of Mayo County Librarian in 1930, when a local councillor described her (Protestant) background as being 'not the culture of the Gael; rather it is poison gas to the kindly Celtic people' (Morahan 1931). Despite this, however, the basis of citizenship in the new State was by right of birth on the island – Jus Soli.

Although the 'special relationship' between the Catholic Church and the Irish State was removed from the Constitution in 1973, echoes remain in the Preamble's sectarian invocation of 'all our obligations to our Divine Lord, Jesus Christ, Who sustained our fathers through centuries of trial'. On the formal level, a state is secular that 'guarantees individual and corporate freedom of religion, deals with the individual as a citizen irrespective of his religion, is not constitutionally connected to a particular religion, nor seeks either to promote or interfere with religion' (Smith 1998, p. 178). The continued religious control over education in Ireland, the inadequacy of the State response to clerical child abuse, the failure to legislate on abortion and the constitutional requirement that newly appointed judges in Ireland must, in open court, ask God to 'direct and sustain' them (Article 34.5.1) are all evidence that there has been no substantive secularization in Ireland. It is therefore clear that the Irish State has failed to achieve one of the core requirements of Weberian modernity; hence, depictions of the Irish Republic as a fully modern liberal state are perhaps wide off the mark.

This has major implications for art in Ireland, as it questions some assumptions about art and modernity. 'Modern art is a product of the Enlightenment, and of enlightened atheism and humanism' (Groys 2008, p. 2). Groys argues that the disenchanted world is based on a regulatory belief in the balance of power, and that 'modern art favors anything that establishes or maintains the balance of power and tends to exclude or try to outweigh anything that distorts this balance'. A core part of modern art's historical struggle was the struggle for aesthetic equality between all visual forms and media, what he terms 'equal aesthetic rights'. It is through criticism of the social, cultural, political or economic hierarchies of value that art then 'affirms aesthetic equality as a guarantee of its true autonomy' (Groys 2008, p.16). As we have seen, in recent decades this avant-garde

history has produced new forms of practice, based on the art of 'encounter' or 'social engagement'. Beech suggests that Bourriaud's relational aesthetics, Kester's dialogic aesthetics and Bishop's antagonistic practice form a new social ontology of art linked to the death of both the art object and viewer, where now there is only the artist and participant, engaged often in a pedagogic encounter (Beech 2010, pp. 49–51). The core issue here is whether these pedagogic practices are linked to new forms of reactionary modernism, sponsored by the Irish State.

Identity, unreason and reactionary modernity

In discussing its own history, the claim is made on the *Circa* (Ireland's leading art magazine) website that 'Very roughly speaking, the 2000–2010 [*sic*] has seen the rise of the artist–critic–curator amalgam, a trend reflected not only in the writing but also in the art written about, where a reflexive relativism is now taken for granted'. This is thought to represent 'a drift from some sort of essentialist approach to art in Ireland to issues-based art to a postmodernist relativism and globalism' (*Circa* 2010). The questions here are how coherent such a position might be and the effects it might have, especially with regard to art and community.

The first issue is in relation to various forms of relativism and identity. The suggestion that art has developed a new social ontology can be seen as related to Searle's overall theory of social ontology, where collective intentionality is expressed in a 'status-function declaration' (Searle 2010, pp. 11–15, 25–60). Searle avoids postulating different ontological realms and maintains epistemological objectivity even in discussing realities that are ontologically subjective. Boghossian argues further that fact-constructivism fails on grounds of causation, conceptual competence and disagreement, and that relativistic constructivism either falls into an infinite regress or is not actually relativist (Boghossian 2006, pp. 38–41, 56).[3] Epistemic relativism often arises out of cultural relativism, however. For human rights, 'cultural relativism may be defined as the position according to which local cultural traditions (including religious, political and legal practices) properly determine the existence and scope of civil and political rights enjoyed by individuals in a given society' (Tenson 2001, p. 380). This has been used to justify a wide range of practices in authoritarian regimes, from female genital mutilation to flogging, in the name of 'culture' and 'group rights'.[4] Nanda and Malik both argue that the pluralist 'injunction to prefer cultural authenticity over truth, or at least to consider authenticity as a determinant of truth, plays into the hands of religious and cultural nationalists who are sowing the seeds of reactionary modernity' (Malik 2008; Nanda 2003, p. 127). This is affected through an epistemological and cultural relativism that resorts to canonical texts and cultural tradition for authority, a new cultural essentialism. This results in what Appiah terms the 'Medusa Syndrome', whereby acts of recognition 'ossify the identities that are their object' (Appiah 2005, p. 110). Postmodern self-conscious traditionalism

aims to preserve traditions as a social, political and moral good, as social cohesion is only possible 'if both the individual and the culture remain authentic' (Malik 2008, p. 175). 'In order for a culture to be lost… it must be separable from one's actual behaviour, and in order for it to be separable from one's actual behaviour it must be anchorable in race' (or some other 'authentic' essence) (Benn Michaels, 1995, p. 123). Thus, diversity 'has become the bridge between the cultural and the biological and between the liberal left and the reactionary right' (Malik 2008, p. 264).

With regard to reflexivity, Benhabib argues that in a

> disenchanted universe, to limit reflexivity is an indication of a rationality deficit. That is to say, only a moral point of view which can radically question all procedures of justification, including its own, can create the conditions for a moral conversation which is open and rational enough to include other points of view, including those which will withdraw from the conversation at some point (Benhabib 1992, p. 43).

The point here is that communicative ethics, although marking a shift from a substantialist to a discursive concept of rationality and being pluralistic and tolerant, is not relativist, remaining deontologically committed and non-neutral in regard to competing ways of life, hence the characterization of it as a form of 'pragmatic universalism'. Equally, Barrett, discussing the agonistic pluralism of Mouffe and Laclau, whereby they place antagonism at the core of the political, argues that in their description of ideology they avoid epistemic relativism, and that such relativism is not 'indexically linked to privileging the discursive' (Barrett 1994, p. 259). Thus, at the very least, there is no need to combine relativism with reflexivity. However, perhaps the

> deeper reason for today's easy acceptance of judgmental relativism is that, in practice, it absolves us from ever having to prove our open-mindedness, as relativism demands nothing more from our affections than bare tolerance – just as it involves nothing more from another culture. If we are prohibited from converting the natives, they must likewise respect the integrity of our own practices, however vile ours may appear to them (Fuller 2000, p. 20).

Reactionary modernism has been defined as 'the embrace of modern technology' by those 'who reject Enlightenment reason' (Herf 1984, p. 1). This includes combining information technology and science with various forms of re-enchanted 'holism', including process theology and panentheism (the belief that God not only interpenetrates every part of the created universe but timelessly extends beyond as well, as distinct from pantheism, which views the creation as synonymous with God), New Age mysticism, deep ecology, strong pluralism and anti-humanism. In holism, the whole determines the character and behaviour of the parts that constitute the entity or system, existence is hierarchical and causation flows downwards, from the system to the elements, putting the claims of

the community before the rights of individuals (Nanda 2003, pp. 96–97).[5] Therefore, as Nanda argues, 'It is simply not the case that holist ways of knowing are always and everywhere progressive or emancipatory. On the contrary, modern liberties – feminism included – became possible in the West only with a separation of the natural and moral orders' (Nanda 2003, p. 150). Holism has also been widely used to bolster the cultural essentialism that drives various forms of nationalism.

A major problem for all nationalisms is the struggle to find the nation's 'essential' characteristics. This leads to what Leerssen calls 'auto-exoticism': 'looking for one's identity in the unusual, the extraordinary, the exotic aspects of experience' – in Irish terms, the 'un-English' aspects of culture, trying to find 'our' Irishness in 'our' Otherness (Leerssen 1996, p. 225). At issue here is the ascription of some kind of 'essential' identity to an already existing group. As Appiah has shown, we 'often treat cultural differences as if they give rise to collective identities', although in practice culture provides content to an already existing group identity, and in reality 'the Other may not be very other at all' (Appiah 2005, p. 64). The process of shaping the national identity is central to the bureaucratic process of governance, as categories of entitlement are built up within the nation state through a process of recognition. One of the key motors for this is culture, with the Irish cultural institutions describing themselves as 'shapers of the national discourse on identity' (CNCI 2010).

Schiller linked aesthetic education to the practice of politics, arguing that the State, because it cannot make contact with their 'feelings', must remain forever a stranger to its citizens:

> Forced to resort to classification in order to cope with the variety of its citizens, and never to get an impression of humanity except through representation at second hand, the governing section ends up by losing sight of them altogether, confusing their concrete reality with a mere construct of the intellect; while the governed cannot but receive with indifference laws which are scarcely, if at all, directed to them as persons (Schiller 2000 (1795), p. 800).

The solution lay in a restoration of unity with nature, lost through the triumph of the rationality of the state, which now needed to be tempered by feeling. This was to be achieved through aesthetic education, through which 'man' would, 'out of every dependent condition be able to wing his way towards autonomy and freedom: then we must see to it that he is in no single moment of his life a mere individual, and merely subservient to the laws of nature' (Schiller, 2000 (1795), p. 803). Thus art, although remaining autonomous, had now a deeper purpose, to shape society according to the dictates of Beauty and Nature, in the process educating the nation's citizens about the true essence of their identity, the source of the 'organic unity' of the State.

There is a long history of teaching identity in Ireland, most notably during the period of cultural nationalism in the late nineteenth–early twentieth centuries. The divide between art and propaganda was firmly bridged, and Pearse 'rehearsed the insurrection by writing a play about it' (Townshend 2005, p. 15). In recent times, such education has tended to be state funded and representative of an 'official' view, seeking to naturalize 'the nation'. It has become dominated at a local level by the Local Authority Arts Offices, especially since the publication of the guidelines for the Per Cent for Art Scheme in 2004. An example is the 2006 Mayo County Council Per Cent for Art project *The Silver* by Martina Coyle, a four screen video installation and sound piece 'drawn from the actual and historical aspects of the Mullet peninsula, the Inish Kea islands and its inhabitants' in which the 'reflective mood is enhanced by a soundtrack of voices from the community, oral recordings using the Irish language as testimony of distinctive speech rhythms and place names particular to the locale' (publicart.ie 2010). With its echoes of Paul Henry's aesthetics, Coyle 'aims to capture the psyche of place and of the people through generations attuned to the minute changes [...] a feeling of time passing and of the inextricable continuity of life in this exposed and isolated peninsula'. This notion of continuity over generations is a familiar trope in nationalist iconography, and 'in Ireland as elsewhere, this iconography depends for its power on projecting a sense of distinctive national landscapes as timeless and unchanging' (Reid 2009, p. 46). There is an added irony in that just over 20 miles from An Fál Mór, a bitter struggle over the landscape was in full swing as the State and Shell sought to construct a pipeline against strenuous local opposition, opposition that regularly appealed to the very values extolled in Coyle's piece (Siggins 2010).

Cultural diversity, integration and arts policy

With the increase of immigration into Ireland from the late 1990s, the issue of citizenship took on an added edge, moving the imagined borders of the nation back to roots, blood and soil imagery. The cultural imperative of creating and maintaining a national identity was to take centre stage:

> The value which we place on the realisation of the creative potential of all our citizens is what will ensure that our sense of ourselves, and our distinctive voice in the world, is sustained into the future... The arts are central to our definition of ourselves as a society. This is a message to the world, as well to ourselves (Arts Council 1999).

There followed the City Arts Centre's 'Civil Arts Inquiry' – 'a two year review of the City Arts Centre's conceptual and organisational basis' (City Arts Centre 2004). This, even though it coincided with the Citizenship Referendum (which in 2004 shifted the basis of citizenship of the Irish Republic from the *demos* (people) under Jus Soli – birth

on the island – to an *ethnos* (nation) under Jus Sanguinis – the existing legal status of one's parents) was 'specifically focussed on the idea of civil culture, meaning a culture belonging to citizens, and its implications'. This failure to recognise the problems of non-citizens resulted in a situation in 2009 where, when

> minority-led organisations have developed an arts policy as part of a broader policy initiative, the explorations of arts and culture are, for the most part, described exclusively in terms of community development goals. This instrumental approach to the arts makes this practice ineligible for Arts Council funding (Jewesbury et al. 2009, p. 40).

The Arts Council's emphasis on the 'intrinsic' value of the arts and their autonomy has meant that the first of the core principles underpinning its approach to cultural diversity is that it 'recognises the potential enrichment of the arts sector in Ireland through intercultural interaction, equality of opportunity, understanding, respect and integration (as opposed to assimilation)' (Arts Council 2010a, p. 6). This notion of cultural diversity revitalizing the Irish arts echoes 'primitivist modernism', 'in which cultural difference is incorporated formally' (Lemke 2003, p. 410) – as such, Foster argues, the dominant arts culture 'escapes the radical interrogation' it would otherwise face (Foster 2003, p. 384). The provision of equal opportunity is central to the idea of integration, which 'connotes a mandatory social cohesion and act of living together with harmoniously worked out differences' (Jewesbury et al. 2009, p. 36). The definition of inter-culturalism offered in the *Cultural Diversity and the Arts Research Project* report is the 'development of strategy, policy and practice that promotes interaction, understanding, respect and integration between different cultures and ethnic groups on the basis that cultural diversity is a strength that can enrich society, without glossing over issues such as racism' (Jewesbury et al. 2009, p. 32). However, this definition elides the tensions between celebrating diversity and mandatory social cohesion, noted by the report's own description of the arts' celebration of the 'dissident, transgressive, hybrid and subversive... in distinct contrast to the agenda of integration' (Jewesbury et al. 2009, p. 36). How are commitments to cultural diversity, inter-culturalism and integration compatible with the normative claim that artists 'interpret our past, define who we are today, and imagine our future'? (Arts Council 2010c)

Identity and aesthetic education

'Social partnership' formed the basis of the Programme for National Recovery, 1987–1990, the first of a series of negotiated plans for economic and social governance. This created a kind of 'institutional isomorphism', whereby interest groups shaped themselves to take part in a debate structured by institutional needs, allowing bureaucratic classifications to structure the parameters of the debate (Healy 1998, pp.

59–78). In the context of participatory decision-making processes, '"Local people are used for justifying the agenda for rural development" rather than setting the agenda' (Macken-Walshe 2009, p. 16). DeFilippis et al. identify three elements in this capture of oppositional social movements by the State: (1) When community organizations become dependent on government funding, their capacity to challenge the government is compromised. (2) The organizations are then placed in the position of arguing for funding for services which they themselves provide – making such arguments appears to be mere self-interest. (3) As a provider of services, community organizations' own capacity for community mobilization becomes limited, as members of the community now interact with the organization from a position of dependence (De Filippis et al. 2010, pp. 92–93). Eventually, with increasing professionalization, oppositionality to the mainstream becomes a burden: 'Community arts placing itself as an oppositional practice and process to contemporary arts practice is hugely unhelpful' (Murphy 2005). However, Beech argues that we 'must be very suspicious of the turn to pedagogy within contemporary art as a set of techniques for reinforcing and underlining art's enjoyment and requirement of cultural capital, its complicity with managerialism and its investment in the cult of expertise' (Beech 2010, p. 60).

The process of institutional isomorphism has led to the development of much theorizing about the rural as a site of resistance through the generation of a new paradigm of rural development. 'New rural development perspectives seek to tap into broader rural economic opportunities by focusing on "the indigenisation of the local economy" and the "championing of local distinctiveness" so as to encourage high value-added production' – including the culture economy (Macken-Walshe 2009, p. 36). Cutaya suggests that the rural is a 'privileged site of action' for 'the representation of land and identity as a spectacle', and promotes the art of encounter (Cutaya 2009, p. 34). This returns us to the familiar conundrum in art theory of the tension between art's autonomy, based on its universality, and its historical contextualization. This debate ranges from Adorno's insistence on autonomy as an escape from commodification, through Bürger's description of the avant-garde negation of art's autonomy in order to reconnect 'art' with 'life', to Groys' argument that the contemporary sacrifice of autonomy through participation 'ultimately benefits the artist by liberating his or her work from the cold eye of the uninvolved viewer's judgment' (Groys 2010, p. 49).

Although trying to solve the impasse between artistic autonomy and social engagement may be 'questions of such pretentious magnitude' that we cannot answer them, 'we can, however, take a good look at the xenophiliac fervor that fuels and complexifies them' (Zolghadr 2010). In an Irish rural context, this takes the form of auto-exoticism whereby locals perform their nativeness to outside artists and authorities, indigenizing themselves in a process documented in many 'public' artworks. Certainly much of the language used to discuss various projects echoes themes already raised here. For example, Coyle's approach to creating *The Silver* was 'holistic, with consideration of location, history, language (being a Gaeltacht region) and integration with the local community, all being

paramount in the process to ensure a site sensitive artwork' (publicart.ie, 2010). The description of Michael Fortune's *Following the Whitethorn* (2009), although avoiding relativism, patronizingly reifies community by allowing 'the viewer into the shared imaginary space which exists within the psyche of a community, as they recount similar superstitious activities and rituals involving everyday life' (Fortune 2010).[6] Other recent projects explore the concept of art as a form of knowledge production, such as the *Lovely Weather* project in Donegal, which made art through accessing 'ongoing scientific studies alongside generations of local knowledge' (donegalpublicart.ie 2010) or the various walking projects that have taken place – for example, Emma Houlihan's *Aughty Walk: Rural Futures* (Houlihan 2010). However,

> [a]rt as knowledge production runs the risk of becoming an aestheticised epistemicism when portrayed solely as the production of a 'good'(non)knowledge which, due to its alleged negative and and/or rhizomatic character, supposedly outperforms the 'bad' modes of knowledge production operating in the realm of the cultural and creative industries (Holert and Wilson 2010, pp. 322–23).

The process of auto-exoticism apparent in many community-based art projects is the antithesis of the alienation effect of Brechtian theatre and, rather than converting the natives, teaches them how different they are, in works that become 'embodied allegories of inequality' (Ranciere 2009, p. 12) as they are led through the hoops of 'engaged citizenship'.

Conclusion

'Art cannot merely be the expression of a particularity (be it ethnic or personal). Art is the impersonal production of a truth that is addressed to everyone' (Badiou 2003). This, the second of Badiou's 15 Theses, explores the contradiction between capitalistic universality and the self of the community. He argues for 'a new universality against the forced universality of globalization', suggesting that 'art is always a proposition about a new universality'. This new universality is not much in evidence in some recent Irish community-based art, and perhaps by definition cannot be. The emphasis on identity, the valorisation of the local and the view of art as a form of knowledge production reflect public art's having been turned into a service provided through the local authorities. As a result, communities become ossified, and internal disputes and dissent are hidden from view. The supposed neutrality of the 'reflexive relativism' of the arts in Ireland assists in eliminating such antagonisms, which are the core of the political. Perhaps central to all this is Groys' perception that the contemporary sacrifice of autonomy through participation 'ultimately benefits the artist by liberating his or her work from the cold eye of the uninvolved viewer's judgment' (Groys 2010, p. 49). Could it be that some artists are embarrassed by their proximity to reactionary modernism and the new

essentialisms, and are using this strategy as a refuge at the end of art? If so, this may signify the unreasonableness of these art practices, as 'a mode of behavior is rational for a given person if this person feels comfortable with it, and is not embarrassed by it, even when it is analyzed for him' (Gilboa 2010, p. 6). Perhaps it is time for us all to stop making a show of ourselves.

References

Appiah, K.A. (2005) *The Ethics of Identity* Princeton: Princeton University Press.

Arts Council (1999) *Arts Plan 1999–2001* Dublin: Arts Council.

Arts Council (2010a) *Cultural Diversity and the Arts: Policy and Strategy* Dublin: Arts Council.

Arts Council (2010b) *Developing the Arts in Ireland: Arts Council Strategic Overview 2011–2013* Dublin: Arts Council.

Arts Council (2010c), *Take a Bow!* (advertising campaign) Dublin: Arts Council.

Badiou, A. (2003) Fifteen theses on contemporary art in *Lacanian Ink* Vol. 23 http://www.lacan.com/frameXXIII7.htm Accessed Nov 20, 2010.

Barrett, M. (1994). Ideology, politics, hegemony: from Gramsci to Laclau and Mouffe in S. Zizek (Ed.) *Mapping Ideology* London: Verso.

Bauman, Z. (2001) *Community: Seeking Safety in an Insecure World* Cambridge: Polity.

Becker, C. (Ed.) (1994) *The Subversive Imagination: Artists, Society, and Social Responsibility* New York/London: Routledge.

Beech, D. (2010) Weberian lessons: art, pedagogy and managerialism in P. O'Neill and M. Wilson (Eds), *Curating and the Educational Turn* London/Amsterdam: Open Editions/de Appel.

Benhabib, S. (1992) *Situating the Self: Gender, Community and Postmodernism in Contemporary Ethics* Cambridge: Polity Press.

Benn Michaels, W. (1995) *Our America: Nationalism, Modernism and Pluralism* Durham (NC): Duke University Press.

Blacam, Aodh de (1921) *What Sinn Fein Stands For* Dublin: Mellifont Press.

Boghossian, P. (2006) *Fear of Knowledge: Against Relativism and Constructivism* Oxford: Clarendon Press.

Bourriaud, N. (2002 (1998)) *Relational Aesthetics* Paris: Presses du reel.

Circa (2010) http://www.recirca.com/about/ Accessed Jan 4, 2011.

City Arts Centre (2004) Civil arts inquiry (2002–2004) http://www.cityarts.ie/memory/civilartsinqu.html Accessed November 12, 2010.

Clayton, P. (2006) Conceptual foundations of emergence theory in Clayton, P. and Davies, P. (eds), *The Re-Emergence of Emergence: The Emergentist Hypothesis from Science to Religion* Oxford: Oxford University Press.

CNCI (2010) http://www.cnci.ie/news-events/whose_culture/index.html Accessed Dec 31, 2010.

Cockroft, E., Weber, J.P. and Cockroft, J. (1998) *Towards a People's Art: The Contemporary Mural Movement* (2nd ed.) Albuquerque: University of New Mexico Press.

Commins, P. (1986) Rural social change in P. Clancy, S. Drudy, K. Lynch andL. O'Dowd (Eds) *Ireland: A Sociological Profile* Dublin: Institute of Public Administration.

Cutaya, M. (2009)., Situating art for a rural context in *Circa* Vol. 126.

DeFilippis, J., Fisher, R. and Shragge, E. (2010) *Contesting Community: The Limits and Potential of Local Organizing* New Brunswick/London: Rutgers University Press.

Della Porta, D. and Diani, M. (1999) *Social Movements: An Introduction* Oxford: Blackwell.

Department of Arts, Sports and Tourism (2004) *Public Art: Per Cent for Art Scheme— General National Guidelines* Dublin: Department of Arts, Sports and Tourism.

De Tocqueville, A. (1998 (1831) *Democracy in America* (trans. Henry Reeve) London: Wordsworth Classics.

donegalpublicart.ie (2010) http://www.donegalpublicart.ie/biogs/info-58.pdf Accessed Nov 10, 2010.

Fortune, M. (2010) http://www.michaelfortune.ie/Following_the_Whitethorn_1.html Accessed Jan 3, 2011.

Foster, H. (2003) The 'Primitive' Unconscious of Modern Art in J. Flam and M. Deutch (Eds) *Primitivism and Twentieth-Century Art: A Documentary History* Berkeley/ Los Angeles/London: University of California Press.

Fraser, N. (2008) Heterosexism, misrecognition, and capitalism: a response to Judith Butler in K. Olson(Ed.), *Adding Insult to Injury: Nancy Fraser Debates Her Critics* London/New York: Verso.

Frye Burnham, L. and Durland, S. (Eds) (1998), *The Citizen Artist: 20 Years of Art in the Public Arena* New York: Critical Press.

Fuller, S. (2000) *Thomas Kuhn: A Philosophical History for Our Times* Chicago: University of Chicago Press.

Gablik, S. (1991) *The Reenchantment of Art* London: Thames and Hudson.

Gilboa, I. (2010) *Rational Choice* Cambridge (Mass.): MIT Press.

Goldberg, D.T. (2002) *The Racial State* Oxford: Blackwell.

Goodwin, J. and Jasper, J.M. (Eds) (2009), *The Social Movements Reader: Cases and Concepts* (2nd ed.) Oxford: Wiley-Blackwell.

Groys, B. (2008) *Art Power* Cambridge (Mass): MIT Press.

Groys, B. (2010) *Going Public* Berlin: Sternberg Press.

Harvey, D. (2005) *A Brief History of Neoliberalism* Oxford: Oxford University Press.

Healy, K. (1998) The new institutionalism and Irish society in S. Healy and B. Reynolds (Eds), *Social Policy in Ireland: Principles, Practices and Problems* Dublin: Oak Tree Press.

Held, D. (2006) *Models of Democracy* (3rd ed.) Cambridge: Polity Press.

Henning, B.G. (2005) *The Ethics of Creativity: Beauty Morality and Nature in a Processive Cosmos* Pittsburgh: University of Pittsburgh Press.

Herf, J. (1984) *Reactionary Modernism:Technology, Culture and Politics in Weimar and the Third Reich* Cambridge: Cambridge University Press.

Holert, T. and Wilson, M. (2010) Latent essentialisms: an email exchange on art, research and education in P. O'Neill and M. Wilson (Eds), *Curating and the Educational Turn* London/Amsterdam: Open Editions/de Appel.

Houlihan, E. (2010) http://aughtywalk.blogspot.com/ Accessed Nov 20, 2010.

Jewesbury, D., Singh, J. and Tuck, S. (2009) *Cultural Diversity and the Arts Research Project: Towards the development of an Arts Council Policy and Action Plan:Final Report*, Dublin: Create.

Kelly, O. (1984) *Community, Art and the State: Storming the Citadels* London: Comedia.

Kusch, M. (2010) Epistemic replacement relativism defended in M. Suárez, M. Dorato, and M. Rédei (Eds.) EPSA Epistemology and Methodology of Science Heidelberg: Springer

Lacy, S. (Ed.) (1995) *Mapping the Terrain: New Genre Public Art* Seattle: Bay Press.

Leerssen, J. (1996) *Remembrance and Imagination: Patterns in the Historical and Literary Representation of Ireland in the Nineteenth Century* Cork: Cork University Press/Field Day.

Lemke, S. (2003) Extract from *Primitivist Modernism: Black Culture and the Origins of Transatlantic Modernism* Oxford: Oxford University Press (1998) in J. Flam and M. Deutch(Eds), *Primitivism and Twentieth-Century Art: A Documentary History* Berkeley/Los Angeles/London: University of California Press.

Lippard, L.R. (1997) *The Lure of the Local: Senses of Place in a Multicentered Society* New York/London: The New Press.

Mac Farlane, J. (2008) Boghossian, Bellarmine and Bayes in *Philosphical Studies* Vol. 141, pp 391–398.

Macken-Walshe, A. (2009) *Barriers to Change: A Sociological Study of Rural Development in Ireland* Athenry: Teagasc Rural Economy Research Centre.

Malik, K. (2008) *Strange Fruit: Why Both Sides Are Wrong in the Race Debate* Oxford: One World.

McGoldrick, D. (2007) Culture, cultures, and cultural rights in M.A. Baderin, and R. McCorquodale (Eds), *Economic, Social and Cultural Rights in Action* Oxford: Oxford University Press.

Mitchel, J. (1982 (1913)) *Jail Journal* Dublin: University Press of Ireland.

Morahan, J.T. (1931) *The Connaught Telegraph* Jan 3.

Murphy, A. (2000) People, place and the promise of art in L. Spillane-Doherty (Ed.) *Drawing a Balance: A Journey in Art, Education and Community* Buncrana: Artlink.

Murphy, A. (2005) Personal Interview 20 January.

Nanda, M. (2003) *Prophets Facing Backward—Postmodern Critiques of Science and Hindu Nationalism in India* New Brunswick/London: Rutgers University Press.

National Campaign for the Arts (2010) http://www.ncfa.ie/index.php/page/about/ Accessed Nov 20, 2010.

Nic Ghiolla Phadraig, M. (1995) The power of the Catholic Church in Ireland in P. Clancy, S. Drudy, K. Lynch and L. O'Dowd (eds) *Irish Society: Sociological Perspectives* Dublin: Institute of Public Administration.

Peacocke, A. (2004) Articulating God's presence in and to the world in P. Clayton and A. Peacocke (Eds) *In Whom We Live and Move and Have Our Being* Grand Rapids (MI): William B. Erdmans.

publicart.ie (2010) http://www.publicart.ie/main/public-art-directory/directory/view/the-silver/b047e5f0df/ Accessed Feb 3, 2010.

Ranciere, J. (2009) *The Emancipated Spectator* (trans. Gregory Elliot), London: Verso.

Reid, B. (2009) The territory of art and the territory underfoot – a reading of three artworks from Leitrim *Circa* Vol. 127.

Scally, D. (2011) Ireland among OECD's worst for social justice *The Irish Times*, Jan 4, 2011.

Schiller, F. (2000 (1795)) *On the Aesthetic Education of Man in a Series of Letters*, excerpted in Harrison, C., Wood, P. and Gaiger, J. *Art in Theory 1648–1815: An Anthology of Changing Ideas* Oxford: Blackwell.

Searle, J.R. (2010) *Making the Social World: The Structure of Human Civilization* Oxford: Oxford University Press.

Siggins, L. (2010) *Once Upon a Time in the West: The Corrib Gas Controversy* Dublin: Transworld Ireland.

Smith, D. (1998) India as a secular state in Bhargava, R. (Ed.) *Secularism and Its Critics* Oxford: Oxford University Press.

Taylor, M. (2003) *Public Policy in the Community* Basingstoke: Palgrave Macmillan.

Tenson, F.R. (2001) International human rights and cultural relativism in P. Hayden (Ed.) *The Philosophy of Human Rights* St. Paul (MN): Paragon.

Townshend, C. (2005) *Easter 1916: The Irish Rebellion* London: Penguin.

Zolghadr, T. (2010) Kitchen party – revisiting class hegemony, ethnic marketing and the unp casa refugio online at http://www.unitednationsplaza.org/video/101/ Accessed Nov 26, 2010.

Notes

1. 'In 1978 the Office of Public Works (OPW) established a scheme based on the principles of Per Cent for Art. In 1986 the Department of the Environment established a similar scheme titled the Artistic Embellishment Scheme. A decision in 1994 to review both schemes led to the publication of the *Public Art Research Project—Steering Group Report to Government* (PART Report). In 1997, on the basis of the recommendations of the PART Report, the Government approved the revision and extension of the existing Schemes to all Government Departments with construction budgets. Since that time the Scheme has been implemented in varying degrees by Government Department and public bodies' (Department of Art, Sports and Tourism 2004, p. 15.)
2. For examples, see the collapse of 'economic sovereignty' and the delay in holding by elections in 2010, the socializing of private debt from 2008 on, the role of the Gardai and Naval Service in the Corrib Gas dispute and many more. A recent study ranked Ireland 27th out of 31 OECD countries for social justice (Scally 2011).
3. Although the intricacies of the debate over epistemic relativism and constructivism are beyond the scope of this essay, for responses to Boghossian, see Kusch (2010) and Mac Farlane (2008).

4. Article 20(2) of the 2005 UNESCO Convention on the Protection and Promotion of the Diversity of Cultural Expressions expressly stipulates that the Convention is consistent with existing international human rights, reasserting their universality (McGoldrick 2007, p. 472).
5. Henning 2005, links process philosophy to aesthetics through his concept of the 'kalogenic universe'. For the emergence of compexity in hierarchies, see Peacocke 2004, pp. 137–142, and for downward causation see Clayton 2006, pp. 2–8.
6. *Following the Whitethorn* is a body of video work from 2008 to 2009, commissioned by Mayo County Council and funded by the Department of the Environment, Heritage and Local Government under the Percent for Art Scheme.

Chapter 11

Art, Artists and the Public: Pedagogical Models for Public
Engagement with Art and Artists in a Museum Context

Helen O'Donoghue

Introduction

> The pieces got the children thinking and they understood that their opinions mattered and it wasn't a case of being right or wrong. They were involved in creative thinking, language, analysis: why did the artists make this? Projecting themselves into the artists' mind, what was the artist feeling? Thinking? I saw the children really thinking in a way that is rarely seen in school.
>
> (Teacher, cited in Campbell and Gallagher 2002, p. 49)

Historically, gallery education has its roots in the nineteenth-century belief in the power of art and culture to improve society. In their early formulation, art museums and galleries were in themselves understood to be educational establishments whose function was to enable individuals to educate and thereby 'improve' themselves (Hooper-Greenhill 1994). Contemporary art, however, is predominantly conceptual and made in a much more 'contested' world than that of the period of the Enlightenment.

> Conceptual art is concerned with intellectual speculation and with the everyday. Conceptual art asks questions, not only of the art object; why is this art? Who is the artist? What is the context? But also of the person who looks at it or reads about it: who are you? What do you represent? It draws viewers' attention to themselves (Pringle 2006a, p. 7).

This model of art practice forces museum education departments to question traditional education practices. It challenges the assumptions that museums are 'tried-and-true sources of understandable information, places one can trust to provide reliable, authentic and comprehensible presentations of... objects and ideas' (Falk and Dierking 2000). The models of gallery education, which Pringle (2006b) explores, question many of these assumptions, including 'truth', 'authenticity' and 'reliability'.

The Irish Museum of Modern Art (IMMA)[1] has been part of this international wave of self-reflective practice, and in the last two decades it has experimented with and delivered on a range of projects and programmes that question the traditional and engage with the ambiguity that is a hallmark of art education in a postmodern era.

Establishing the education and community programme—a new model of engagement

From the start, IMMA aimed to create sustained access to both art and creativity for every sector of society. The museum placed the exchange between the public and the artist at the centre of its work in general and at the heart of the education and community programmes in particular. It offered a meeting point in a cultural context, which could be a common space that was inclusive of all: a space where practitioners and non-practitioners from a cross-section of professions and experience could come together in dialogue.

IMMA adopted the model of 'museum as forum' (Cameron 1972; Duncan 1995) and introduced a pedagogical practice that was informed by progressive education (Dewey, Hein) and critical pedagogy (Giroux) and set out to move arts practices with non-art practitioners from the periphery to the centre. An aim was also to explore the twinning of professionals from different disciplines, and to create opportunities for artists to work alongside other professionals, be they youth workers, carers or teachers and for them to cohabit the working relationship and space with the participants in the workshop environment.

Prior to the opening of IMMA, there was no permanent national cultural institution in Ireland dedicated to housing a collection or display exhibitions of contemporary art and there was no national framework with respect to policy on access to cultural institutions.

The residential area surrounding IMMA was a well-established community of mixed housing, including both private and a large conurbation of social housing. Recognising the challenge of its site/place, the founding director, Declan McGonagle (1991), placed this challenge at the centre of the new museum's policy on access and proposed to focus on its locality first and foremost. Although IMMA placed a particular focus on working with the communities located in its physical proximity, it simultaneously addressed its national remit, across all sectors including formal arts education at primary, post primary and third level. It also kept abreast of policy developments at the Arts Council, education and access provision in galleries and museums nationally and internationally and practices of the community arts movement and emerging artists.

In the wider arts field in an Irish context, issues of access to the arts had been on the Arts Council's agenda since the late 1970s. Under the directorship of Colm O'Briain, a number of reports and pilot projects were commissioned throughout this decade to address the broad principle of access and engagement with all art forms. Ciarán Benson was a seminal thinker in this respect.

In his essay *Art and the Ordinary*, Benson (1989) explored some ways of thinking about cultural institutions as instruments deliberately crafted for the creation of experiences, and asked how we might understand this. He suggested a distinction between policies aimed at making artworks, and policies aimed at making artworks work. He attacked the idea that there is some identifiable essence to art, as static and historically questionable.

Instead, he suggested that a more dynamic and helpful way of thinking about art is to ask what it does, how it functions and how it is always developing because human ways of living are always changing. He argued that policy makers should attend to the type and quality of functions of art, as well as to the quality of particular types of art forms. He called for an opening up to ways of thinking and understanding of what skilled community artists and arts educators are trying to do and sought directions for ways in which the qualities of this work and its standards could be monitored and evaluated. The values of participation and principles of critical pedagogy and democratic access to culture, as outlined by Benson, informed much of the thinking behind IMMA education and community practice.

The rest of this chapter describes and discusses the education practice of IMMA in terms of the engagement with artists, with adults including older people and with children and young people.

Working with artists

A significant starting point in 1991 was the openness of artists to explore and extend their practice to include a museum and to challenge the parameters on access. This is exemplified by the project *Unspoken Truths* that emerged as a result of a proposal by the artist Ailbhe Murphy. The principles of the project were to explore the potential of collaboration between 32 women, their community development projects, an artist and the Irish Museum of Modern Art.

This evolved over a five-year period into a framework of collaboration and partnership, between IMMA's Education and Community Programme and two women's groups from Dublin's south and north inner city; The Family Resource Centre, St. Michael's Estate in Inchicore and Lourdes Youth & Community Services, in Sean McDermott Street. The women engaged with artists and artwork shown at IMMA, and in art making in collaboration with Murphy, the process resulted in an exhibition of work made by the group at the museum. The process also included an exhibition tour to arts centres throughout Ireland, the women's participation of the group in national and international conferences, and finally, a publication in print and video format of the process and the individual participant's stories. When the work went into the public domain, the women personally mediated it and their stories to the public. In her analysis of the process and project, community development advocate and university lecturer Anastatia Crickley commented 'through this process the museum edges towards becoming a real forum where the debate can be 'with' rather than 'about'... the people participating in its programmes (1996, pp. 80–81.) An important element of the project was an ongoing evaluative process where each stage was carefully considered from the first engagement with the artist to the exhibition at IMMA, through to the women mediating their own work to the public in the gallery. This was validated in an independent evaluation carried

out by Martin Drury who stated, 'at all stages the work seems to have been interrogated. Apart from this allowing progress to be made, it built consciously and unconsciously a reservoir of shared values both spoken and unspoken. In short while art was the occasion of their work, their selves was the true subject matter' (1996, pp. 82–83).

The project with the highest profile that emerged from this period was the *Once Is Too Much* exhibition (1997–2004), also developed with the Family Resource Centre, St. Michael's Estate. The project was conceived to support community development work on the issue of violence against women and progressed from an initial workshop programme in 1995 with IMMA artist-in-residence, Rochelle Rubinstein, to three artist collaborative projects, with Rhona Henderson, Joe Lee and Ailbhe Murphy (some on a long term and others shorter) to the realisation of the exhibition, in 1997. The exhibition was significant in IMMA's history as it was programmed to run simultaneously with two significant mainstream exhibitions: one of work by Kiki Smith and the other, of work by Andy Warhol. *Once Is Too Much* occupied the galleries on the landing and West Wing, therefore physically linked the other two shows.

This process also led to an acquisition for the IMMA's collection of the artwork – *Open Season,* made by the women's group in collaboration with the artist/film-maker Joe Lee. The project was an issue-based project that aimed to raise awareness of the central theme but it was interwoven into artists' pedagogies and explored wider contexts looking at artists' work. It revealed to the participants either through direct engagement with artists in a workshop context or through the study of other arts practices such as Barbara Kruger and Tony Oursler how art and artists engage with social issues and how artwork can create a metaphor for meaning. This was apparent when the exhibition toured, where in one case the receiving venue misinterpreted the work as advocacy work solely and did not share the same understanding of why the work was conceived as it was. Tension arose when the receiving venue challenged the authenticity of the need to provide fresh flowers for one of the artworks that was integral to the meaning of this piece and suggested artificial flowers as a replacement. The participants in the process had the courage of their convictions to argue their position, explaining the difference between the role of the *work as artworks* and a media campaign that might select other means of articulation. They fully understood how art was central to the expression of the issue and could not take second place in its manifestation. The women who participated in the process mediated the exhibition through a specially designed public education programme, informed by the national organisation, Women's Aid, to target special interest groups and the general public. In addition to showing at IMMA, the women then toured with the exhibition to nine venues throughout Ireland, over an eight-year period. The process developed and deepened throughout the years of touring, with local community networks coordinating training for the listeners/mediators and facilitators of the exhibition. This training was provided by teams of professionals and non-professionals, which included representatives from family support agencies, violence

against women campaigners and the Garda Siochána (O'Donoghue 2005, pp. 113–16). This tour was facilitated by the IMMA's National Programme.[2]

An example of another Education and Community programming intervention working in an integrated way with the local community was with the network of youth groups across the local area based partnership in the Canals Communities. This project, which was titled *Mapping*, grew from a small-scale pilot project in 1997 with the St. Michael's youth project in Inchicore, and the Bluebell 'after-school' programme, to a large-scale project, which ran until 2005. Between 1991 and 1995, St. Michael's ran a number of programmes to enable young people to engage with artists and artwork at IMMA. The concept for *Mapping* grew from the desire of the youth workers, Brian Healy and Gwen Doyle, to explore the horizons of young people in the area to chart new territories and to travel beyond their local environment to see what other communities were like and how others live. Wet Paint had previously located the 'Tribal Project' both in the grounds at IMMA and in Youth Projects.[3] *Mapping* took some of the learning from this experience and added the extra dimension of a centralised gallery/studio construct with encountering artworks as a central dimension. The aforementioned youth projects from across the partnership area plus Rialto and the recently formed local arts agency Common Ground from within the Canals area joined the process and a major integrated project was undertaken. The project also moved from the initial summer months to an after schools programme facilitated though the youth projects, which ran throughout the year.

Employing the principle of partnership; a matrix was formed, with children at the centre of the two-way dialogue/s. Artists working with IMMA partnered with youth workers, and between them they created a myriad of possibilities for the children to engage with the core aims of the project through a series of initiatives that intersected with IMMA's resources and programmes. The shared understanding was that the museum espoused the belief that there are reciprocal learning opportunities that can arise from a partnership process. In this project, the museum would respond to and listen to the voice of its users and witness the children (the users in this instance) making sense of the museum on their own terms. As in previous models outlined in this paper, an evaluative structure was developed and all aspects of the project was documented and archived. A final publication written by Charlie O'Neill was published in 2006.

Although at times this long-term project placed stress on many aspects of the project and the principle of the partnership was difficult to maintain in an ongoing way due to the ambition in its scale and duration, the commitment to inclusion of multiple voices and points of view revealed that

[i]n the right moment, a museum of modern art can learn as much from an eight year old child as it can from a world renowned artist. A Youth Project can access, discuss and participate in the museum's programmes but it can also offer its unique expertise to influence policy and programme (O'Neill 2006, p.81)

The final evaluation report states that 'the model worked. Both practices contributed to that model. Personal development indicators like improved judgement, openness to new ideas, use of metaphor to explain feelings and ideas, self confidence… come more easily from an in-depth engagement in a creative or cultural process – in this instance in visual art. An appreciation of, or true participation in, a creative process like visual art is immeasurably assisted by a parallel process of questioning, seeing differently and the generating of original ideas and concepts' (O'Neill 2006, p. 133).[4]

Working with adults

An ongoing programme for adults outside those represented in community development programmes was designed and continues to date. This programme grew out of the engagement with St. Michael's Active Retirement Association in the inaugural exhibition and was structured in the years 1991–2005 on a project-by-project basis and engaged artists as facilitators.

Each project aimed to address specific learning objectives relating to arts education and wider issues relating to access to IMMA as an institution for older people. The objectives of the programme were to work with a small number of older people in order to inform the wider policy of engagement with the community in general and with older people in particular. And to break down existing barriers to the involvement of older people in contemporary visual arts, by involving them in as many ways as possible including the influencing of museum policy, thus acknowledging the role that older people have to play in contemporary culture.

This programme was structured to involve three elements of art education: making art, meeting artists and discussing with them the conceptual basis of their work (this involves contact with visiting international artists exhibiting at the museum, artists on the museum's studio programme and longer-term contact programmes with both Irish and international artists living and working in Dublin) and looking at art in the museum's temporary exhibitions and collection. The weekly programme set up in 1991 introduced basic art making skills initially, using a broad range of art processes and also introduced the older people to a cross-section of younger artists. The programme is student centred and different modes of cognition and communication are catered for and encouraged: making, painting, listening, looking, talking and welcoming others to the museum. Multiple intelligences are called on, built upon and strengthened: the visual/spatial and the bodily/kinaesthetic intelligences are involved in creating and responding to artworks and in the skilled manipulation of materials, media and tools; the personal, interpersonal and intrapersonal intelligences are used in interacting with others and in understanding and exploring the self. Musical and linguistic abilities within the group have also been drawn on in the workshops (Fleming and Gallagher (2000).

After experiencing the *Unspoken Truths* exhibition in 1992, meeting the women from that group and experiencing the stories as told by each woman, the work of the older people changed significantly. The first autobiographical works emerged a year later, in 1993, in *Ribbons of Life,* each ribbon depicting the story of its maker's life. This was developed into a longer-term process over the following years exploring the meaning of place and of how it changes over time; *A Sense of Place* (1996), *Points of Entry* (2001), and culminated in a final group exhibition *Equivalence* (2003). This final exhibition was an intergeneration exhibition, which explored spiritual and life-long belief systems through the metaphor of dreams and aspirations. The work was displayed alongside the work of children from Ireland's first Muslim school who were simultaneously working in collaboration with artist Terry O'Farrell.

Alongside art making, they engaged in curatorial processes and curated an exhibition in 1999 titled ' come to the edge' from IMMA's collection. From 1991 to 2004, the work was exhibited annually at IMMA and in other venues as part of a national arts festival celebrating creativity in older age, *Bealtaine,* developed to highlight the involvement of older people in contemporary arts. Members of the group acted as hosts for their peers and for younger visitors to these exhibitions. In 1999, an evaluation process created a three-way dialogue among the museum staff, the evaluators and the participants and thus enabled the participants to have a significant and informed input into the ongoing planning process. The wider learning from the evaluation of the Older People's programme was to distinguish the pedagogical framework of adult learning that was in action.

Working with young people

As described in the examples of practice earlier, the same critical pedagogy and enquiry-based learning methodologies were applied to working with the formal education sector as was applied to working with the community sector.

A learning framework for the primary school programme was initially developed in partnership with teachers and children in local schools and in collaboration with artists from the Artists' Team. Later, a focus group of teachers from a broad cross-section of schools in Ireland, who were attending in-career development courses carried out and evaluated exploratory projects in their classrooms. This resulted in a publication that stated the principles of practice and outlined IMMA's approach to engaging with artworks and the National Curriculum, *A Space to Grow,* in 1999. The timing of this publication was aligned with the introduction of a revised National Curriculum at primary level. A subsequent research project (1997–2004) resulted in a publication titled *Red Lines Between the Fingers.*

Both of these periods of development took on challenging circumstances; the former engaged teachers who were largely self-selected and who wished to engage in open-ended learning that connected the national curriculum with a museum of modern art.

The latter aimed to embed the learning from the former into the primary school system in a context of a national experiment – the introduction of a government plan to address disadvantage at primary school level.[5]

The latter project proved to be more challenging as it challenged the system from within a school, which, although led by an very open-minded principal, was subject to the difficulties of multiple expectations, ranging from the Department of Education and Skills to the teachers themselves. It uncovered the dearth of art education that teachers had previously experienced in their own formation both at school and in colleges of education. The project when it worked was highly innovative and the structure set up between school and museum worked well but the constraints of competing demands from overloaded curricula and the time constraints that made travel to and from the school to the museum for the teachers proved an ongoing challenge. However, the process articulated IMMA's pedagogical approach for school groups engaging with artworks. The child was at the centre of the learning process and support for teachers aimed to unlock ways to fully engage teacher and child and artist in a co-constructive model of learning. This approach was called 'the accepting framework'.

B surprised all the adults today by her response to the rice and lights exhibit.[6] While the work stimulated many amazing responses, hers astounded us all, as it was so imaginative and true. She thought it looked like a hand up to the sun because the sun makes red lines between the fingers. The group was using the framework of the three questions to think about the art instead of just dismissing it. Again the complete confidence of the children when responding was great, the fear of being wrong wasn't there. All responses were accepted, none were dismissed (Campbell and Gallagher 2002, p. 51).

During this period, a similar framework was applied to second-level schools and youth projects and links were made with accreditation bodies and third-level colleges.[7]

A series of action-research projects based in the gallery spaces was also put in place, in the mid-1990s, assessing initially how children were accessing the artworks, both in the context of school visits and with their families, and the family programme that is run every weekend is an outcome of this research.

Reflection

IMMA's programme for adults has been described as being developmental in the sense that it fosters connected self-reliance and provides an opportunity to deal with developmental tasks related to identity. 'Adult education is about forging connections, and seeing more than two polarities; it is about moving away from dualistic thinking to more connected and holistic modes of learning and action. The programme is a powerful

introduction to new ways of thinking, perceiving, acting and interacting' (Fleming and Gallagher 2000, p. 63). If, as John Dewey (1934), an advocate for museum education, said, learning begins with experience, we have to ask, in relation to the experiences that museums offer, what is happening in the faultline that museum educators occupy between the artwork and the viewer?

> [T]he meaning of art lies somewhere in the space between the work and the viewer and is to be negotiated in that space; and the business of an institution like a museum of modern art which is an expert presenting/mediating organisation is to make that space explicit; to protect that space; and to support the visible and invisible interactions that occur within it (Drury 1999).

The ongoing challenge to IMMA and similar institutions is to negotiate this space.

Encountering art in the faultline between the artists' intention and the audience reception is the space that presents this ongoing challenge – drawing on Frederic Jameson's theory, Anna Colford says

> [a]rt, in the museum context, is therefore a simultaneous experience as something both within the individual, in the space of its negotiation, but also in relation to its outside, its representational inadequacy (Colford 2007 p. 18).

For success there has to be a willingness to stake out some vacant territory for negotiating meaning, which allows leeway among creator, teacher (artist) and respondents (Sekules 2003).

Making knowledge meaningful is central to the theory of 'constructive' learning, a theory for learning in museums developed by the educator, George Hein. Referring to Dewey's theories on progressive education and its significance for museums, Hein (2006) says that the central argument is a moral one.

On reflecting through this essay on international discourse, there are parallels with IMMA's practice. Methodologies for the specific projects named here were devised by the artists leading them in association with the participants and co-collaborators, i.e. teachers, youth workers, care workers and community development workers, and findings articulated by evaluation processes that facilitated self-reflective learning by all involved. Methods of working were negotiated throughout the process of long-term projects and a 'dialogical' framework was employed adopting different discourses through the application of theories of critical pedagogy as defined by Henry Giroux (1994; Giroux and Mc Laren 1994) and Paulo Freire (1977). In projects where the museum partners with other organisations or agencies the museum respects the expertise of the group mentor/leader such as in the case of people with intellectual disabilities as reflected upon by their facilitator.

If the initiation of an idea or theory involves people, especially vulnerable people, it is incumbent on the 'theorist' to take on the responsibility associated with such a task. It was my pleasure to accept this responsibility and lead the trainees on their journey of discovery (Finnigan 2010, p. 437).

This learning strategy is a paradigm that reflects the challenge of a participant-centred learning environment in a contemporary arts context dealing with the ambiguity that is inherent in contemporary arts practices and with the multiplicity of learner's needs, experiences and styles.[8]

Dialogue is central, as it provides opportunities for learners to share and question knowledge and then take risks and change. In this model the teacher (artist) functions less as an 'expert' and more as a 'co-learner', instigating dialogues and voicing and re-ordering their own knowledge in collaboration with the learners. Learning develops from the learner's existing experience and knowledge (as per construction model), is driven by the learner's intentions and choices and is accomplished through a process of building and sharing knowledge and experiences with others. This embodies the belief that meaning and value reside in the individual, that art is a catalyst, which can unlock that meaning, which reflects the founding policies of the museum (McGonagle, 1996).

IMMA's models are developing in the context of a rapidly changing landscape of artists' practices both nationally and internationally, and Irish artists working at IMMA are part of this global movement, which is defining the postmodern critique of artists' pedagogy. IMMA promotes public engagement as, in Hein's words, 'fully educative'- promoting inquiry-based methodologies, encouraging critical thinking, strengthening democracy and addressing controversial issues.

Artists who have engaged in the projects that I have selected to illustrate have defined their practice in the context of contemporary cultural theory. They offer common and distinctive readings of this evolving pedagogy. Thus, Ailbhe Murphy (2004) has referenced the socially engaged collaborative artists' practices and the 'dialogical aesthetics' of Grant Kester, whereas Rhona Henderson (*Once Is too Much*) – also cites bell hooks alongside Kester and talks about the relevance and importance attached to the emotional connection with the group. She also cites laughter as being important (2004 p. 165), which both Gallagher and Fleming refer to in their evaluation:

laughter and humour play an important part in the groups' experience. The power of humour to break through barriers of fear, anxiety and tension is well recognised. It is part of well-being. Their laughter is a way of diffusing the discomfort, the anxiety of confronting images and artworks that may be embarrassing... in the workshops laughter releases creativity (p. 56).

Christine Mackey (who also spent a period in the residency programme) adopts a more open-ended stance when she says, 'I consider the artist's role in society as one

of interrelation, contingent on audience participation; in essence, an extensive social practice' (2006, p. 35). Terry O'Farrell (*Equivalence* 2003, 2001, *Wiseways* 2010), who has worked both with children and older people, combines a practice that is concurrently socially engaged and collaborative, inhabiting the role of cultural archivist, and seeing the role of a contemporary artist crossing boundaries of traditional disciplines.[9]

Another form of social archiving emerges from an interview with artist Joe Lee, talking about the motivation behind his work with community groups in St. Michael's Estate:

> Perhaps because Lee's work with the community of St Michael's occurred at such a time of change many of its outcomes, spectacular and intimate, are commemorative. At a time of change, it is important that we tell and retell our stories so that we can imagine our way into the future. And, as Michael D. Higgins has said on many occasions 'Every story has the right to be told'. Lee suggests that there is something about visual art that enables people to make or mark a memorial, to re-member their story and ask that it be given attention. Society tends to be rather selective regarding who gets commemorated and what is remembered, Lee's engagement with St Michael's and the memorials it generated remember a valiant and brutalised community, and articulates what they want to re-member' (Hanrahan 2003).

Collaborative practices are challenging and IMMA had to be cognisant of this and at times act as mediator between artist and community group thus ensuring that all voices were heard. In an interview following his residency in 1994, at IMMA, the American artist John Ahearn recounted his engagement with a local men's group:

> the men's center was set up with the idea of group decisions. If someone suggested something, they'd say, 'Let's wait until all the guys come tomorrow and then we will sit and talk about it', they regarded themselves as a collective and thought that individual efforts without the support of the group were divisive. I did play devil's advocate, encouraging individual men to work with me after class. I told them they had twenty-four-hour access because I was living over the workshop. But I felt constrained by the dynamic within the men's group (Finkelpearl 2000, pp. 94–95).

IMMA facilitated a second project for Ahearn, which resulted in the creation of an artwork that is now in IMMA's Collection, *Francis Street Boys*, 1994.

What IMMA achieved in its first 20 years was to bring about change in expectations both from within and outside of the museum worlds – its policies on access as tested through models of engagement led by artists and in collaboration with key partners illustrated and proved that museums can be flexible, fun and interesting places to learn in, from and about. Reciprocal learning can take place when both parties are invested in a shared learning contract (co-construction model). A broadly inclusive approach to public access and engagement with art and artists was built into the founding policy. We

have now come to expect a more multifaceted approach to the visitor experience in our museums than we would have accepted some 20 years ago. We no longer 'wait' to be led, in a guided tour, by a museum professional and to listen and not debate what is being said to us. We expect to have 'fun', we are more open to ambiguity, we have more context to draw upon with the explosion of the World Wide Web and its freely accessible bank of knowledge.

Irish museums and galleries have opened their doors to a wider scope of its potential audience. Children are encouraged to inhabit these public spaces as their own. Teenagers are welcome to hang out there, adults right through to old age are encouraged to spend time and lots of it, in our galleries, in public lectures and workshops and with artists who they may find in residence at any of our institutions. What IMMA did in the early part of the 1990s was a challenge to the status quo, and liberated both the museum educator and the public in relation to what we have come to expect of our national cultural institutions. But although practice has challenged the status quo, policies on access and public learning can be misunderstood by even the most ardent supporters in public life. When the cultural offer is one of 'cultural tourism' and entertainment; education programmes can suffer under false expectations and become annexed between the 'audience development' strand of visitor services and the education potential of meaningful learning – thus internationally, the term 'edutainment' has been coined.

When an institution is breaking new ground, it has freedoms that can evaporate once it has proven its success. The public, once they identify a 'good experience', will demand that that experience be on offer indefinitely. Often the programming strategy in a museum has to balance on the one hand, public expectation of tried and tested programmes as in previous seasons, with, on the other hand, the invitation to experiment with one's expectations.

Many contemporary museums currently have ring fenced a 'research unit' or strand of programming in order to give permission for this type of experiment. IMMA in the current phase has adopted this approach and has been reviewing the role of its work with (freelance) artists and is undertaking an action-research project to renegotiate the terms on which the public engage with contemporary art. The concept of a postmodern pedagogy (or even pedagogies) is, according to Milbrandt, one that celebrates the interconnectedness of knowledge, learning experience, international communities and life experience and that presents 'models of the artist–collaborator rather than the artist as solitary maverick or hero' (1998, p. 52).

Museums are at a crossroad of public expectations. If we believe that museums are for all citizens and we adopt a more democratic approach that is truly inclusive then museums will engage with, and be informed by, the interconnectedness of knowledge and life experience. The political debates that inform how we citizens perceive our public institutions need to be opened up again and perhaps a contemporary wave of enlightenment may emerge.

References

Benson, C. (1989) *Art and the Ordinary, the ACE* Report Dublin: The Arts Council/An Chomhairle Ealaíon.

Cameron, D. (1972) The museum: a temple or the forum *Journal of World History* Vol. 14, No. 1 pp. 197-201.

Campbell, E. and Gallagher, A. (2002) *Red Lines Between the Fingers: A Review of the IMMA/Breaking the Cycle Project* Dublin: Irish Museum of Modern Art.

Colford, A. (2007) Making space explicit *Conference Report on IMMA Access All Areas* (8 to 10 November 2006) Visual Artists Ireland http://www.visualartists.ie/sfr_back_issue.html.

Crickley, A. (1996) Community development analysis in R. Fagan, , M. Downey, A. Murphy, . and H. O'Donoghue (Eds) *Unspoken Truths* Dublin: Irish Museum of Modern Art IMMA pp. 80–81.

Dewey, J. (1934, 1980)) *Art as Experience* New York: Perigee Books .

Drury, M. (1996) Unspoken truths: a cultural analysis in R. Fagan, , M. Downey, A. Murphy, and H. O'Donoghue, . (Eds) *Unspoken Truths* Dublin: Irish Museum of Modern Art IMMA pp. 82–83.

Drury, M. (1999) A critical response to *A Space to Grow* Dublin, Text delivered on Tuesday May 4, 1999.

Duncan, C. (1995) *Civilizing Rituals: Inside Public Museums* London & New York: Routledge.

Falk, J.H. and Dierking, L.D. (2000) *Learning from Museums: Visitor Experiences and the Making of Meaning* Walnut Creek, CA: Altamira.

Fagan, R., Downey, M., Murphy, A. and O'Donoghue, H. (eds) (1996) *Unspoken Truths* Dublin: Irish Museum of Modern Art IMMA.

Finkelpearl, T. (2000) *Dialogues in Public Art, USA* Boston: Massachusetts Institute of Technology.

Finnigan, N. (2010) From One Heart to Another *The Undergraduate Journal of Ireland & Northern Ireland,* Vol. 2, pp. 431 – 438.

Fitzgerald, S. (Ed.) (2004) *An Outburst of Frankness, Community Arts in Ireland—A Reader* Tasc/New Island: Ireland.

Fleming, T. and Gallagher, A. (2000) *Even Her Nudes Were Lovely: Toward Connected Self-Reliance at the Irish Museum of Modern Art* Dublin: Irish Museum of Modern Art.

Freire, P. (1977) *Cultural Action for Freedom* Middlesex, England: Penguin.

Giroux, H.A. (1994) Travelling pedagogies – interview with Lech Witkowski in H. A. Giroux (Ed.) *Disturbing Pleasures: Learning Popular Culture* New York: Routledge pp. 153–171.

Giroux, H.A. and Mc Laren, P. (Eds) (1994) *Between Borders, Pedagogy and the Politics of Cultural Studies* New York, London: Routledge.

Hanrahan, S. (2003) In memoriam: a text about the *Out of Place* project http://www. joelee.ieAccessed Jun 22, 2007.

Hein, G.E. (1991) The museum and the needs of people; CECA (International Committee of Museum Educators) Conference Jerusalem Israel Oct 15–22, 1991 Institute for Inquiry http://www.exploratorium.edu/ifi/resources/constructivistlearning.html Accessed Jun 22, 2007.

Hein, G.E. (1998) *Learning in the Museum* London & New York: Routledge.

Hein G.E. (2006) John Dewey's 'Wholly Original Philosophy' and its significance for Museums in *Curator: The Museum Journal* Vol. 49, No. 2 pp. 181-204.

Hein, G.E. and Alexander, M. (1998) *Museums: Places of Learning* Washington DC: American Association of Museums Education Committee.

Henderson, R. (2004) Community arts as socially engaged art in S. Fitzgerald (Ed.) *An Outburst of Frankness, Community Arts in Ireland—A Reader* Dublin: Tasc/ New Island, pp. 159–178.

Hooper-Greenhill, E. (1994) *The Educational Role of the Museum* London & New York: Routledge.

Mackey, C. (2006) Rethinking the museum as a 'Way Station' in L. Moran (Ed.) *IMMA Artists' Panel* Dublin: Irish Museum of Modern Art pp. 35–36.

McGonagle, D. (1991) The necessary museum *Irish Arts Review Yearbook* Dublin: Eton Enterprises pp. 61–64.

McGonagle, D. (1996) Foreword in A. Davern and H. O'Donoghue *Intersections: Testing a World View* Dublin: Irish Museum of Modern Art p. 7.

Milbrandt, M. (1998) Postmodernism in art education, content for life *Studies in Art Education* Vol. 51, No. 6 pp.47-53.

Murphy, A. (2004) The fine art of floating horses in S. Fitzgerald (Ed.) *An Outburst of Frankness, Community Arts in Ireland–A Reader* Dublin: Tasc/New Island, pp. 159–178.

O'Donoghue, H. Pelan, R. and Hayes, A. (Eds) (2005) *Women Emerging* Galway: Women's Study Centre pp.113 – 116.

O'Neill, C. and Moran, L. (2006) *Mapping Lives Exploring Futures, The Mapping Arts Project* Dublin: Irish Museum of Modern Art.

Pringle, E. (2006a) *Learning in the Gallery: Context, Process, Outcomes* London: Arts Council of England.

Pringle, E. (2006b) Researching gallery education, recognising complexity and exploring collaboration in *Learning in the Gallery: Context, Process, Outcomes* London Engage 18 Winter 2006 pp. 29–35.

Sekules, V. (2003) The celebrity performer and the creative facilitator: the artist, the school and the art museum in M. Xanthoudaki, L. Tickle, and V. Sekules (Eds) *Researching Visual Arts Education in Museums and Galleries* London: Kluwer Academic Publishers pp. 77–89.

Notes

1. The Irish Museum of Modern Art (IMMA), established in 1991, is housed in the Royal Hospital Kilmainham, a 17th-century building that lies west of the city centre of Dublin. It is Ireland's leading national institution for the collection and presentation of modern and contemporary art. The museum presents a wide variety of art in a programme of temporary exhibitions by

international and Irish artists, which regularly includes bodies of work from its own collection. It also creates more widespread access to art and artists through its Artists' Residency Programme, Artists' Panel and countrywide through exhibitions and projects devised by The National Programme. Opportunities to gain access to and engagement with art and artists at the Irish Museum of Modern Art are created through projects and programmes designed by the Education and Community Department both on site at IMMA and throughout Ireland.

2. The National Programme is based in IMMA's Collections department and works in collaboration with partners throughout Ireland to create exhibitions and projects using works from the collection as the central focus.

3. Wet Paint was a youth arts organisation working in theatre and street pageants in the 1990s.

4. A small group of young people who were central to *Mapping* now are part of the arts collective 'What's the Story' with artist Fiona Whelan; see website www.section8.ie.

5. 'Breaking the Cycle of Disadvantage' (BTC) was initiated in 1996 by the Minister for Education, Niamh Breathnach, an action to tackle disadvantage in a cohort of schools in rural and urban areas and was planned to run for five years.

6. Neon Rice Field (1993) by Vong Phaophanit.

7. National College of Art and Design Education faculty run an undergraduate and post graduate 'museums' module' and the national accreditation body, FETAC, offers a Visual Arts module for trainees on Youthreach and Community Training programmes.

8. The term *Construction* is applied when learning is individual sense making and *Co-construction* when learning is building knowledge as part of doing something with others. This model is founded on the belief that knowledge is socially constructed and learning is identified as a collaborative, social process (Hein 1991; Hein and Alexander 1998; Pringle 2006b).

9. Pringle (2006b) articulates this in referring to research into the nature of artists' engagement with participants in learning scenarios,, finding that artists take on a number of different roles - educator, collaborator, role model, social activist and researcher - requiring a broad understanding of the term 'educator' (p. 13).

Chapter 12

Holistic Art Education: Can the Learning Be the Learner?

Alastair Herron

I only went out for a walk, and finally concluded to stay out till sundown, for going out, I found, was really going in.

(Muire 1913 in Ehrlich 2000, p. 9)

Nature is also a place… but we will come back to its truth through our own inadequacy, if nothing else. Primal law demands it… *Nature undefined* [my emphasis] is what I know in myself.

(Hay in Halpern and Frank 2001, p. 8)

The quest for a right relation to the natural world is also the quest to understand our own nature. This connection was recognised by the pre-Socratic thinker Heraclitus, who also identified a few signposts for that quest. Two seem particularly worth noting; the trail will be trackless and it will yield the unexpected.

(Halpern and Frank 2001, p. x)

Truth is a pathless land.

(Krishnamurti 1929/1996, p. 1)

Over the past decade and more, I have facilitated a number of educational programmes attempting to directly engage creative art enquiry and nature. These workshops have involved a variety of learners including university undergraduates, postgraduates and lecturers from the University of Ulster and children from many parts of Europe (Herron 2000; 2010). The basic framework underpinning this ongoing enquiry involves exploring areas of facilitating creativity *and* consciousness. My university lecturing and research of some 20 years have been primarily in art media practice and to a lesser extent theory, although I feel in many respects practice is an applied form of theory. This long period of art education involvement has afforded

origination and development towards a range of holistic teaching and learning strategies, what could be termed suggestions for visual enquiry. These enablements have come to engage natural environment, sustainability and creative origination with a strong emphasis on learning one's nature in nature.

There are several related areas of questioning arising from such facilitation that interlink the two sections in this chapter. The first section explores areas of art and creativity reviewing relevant literature and addressing the broad area of natural environment as a source of pedagogy. The second section describes one of a series of nature engagements exploring art and creativity as a new form of suggested visual enquiry. Implications for art education as an ongoing personal and shared questioning implicitly underpin the whole chapter.

Art, creativity and environment

The process of urbanisation in Ireland is part of a global phenomenon. Since 2008 most of the world's population has been urbanised. Current demographic predictions suggest that by the middle of this century, 69.6% of the total human population will be residing in cities and large areas of conurbation (United Nations Statistics 2007). Some of these cities will have populations many times the current population of Ireland. The social, health, economic and cultural implications will, in terms of our planet and its resources, present incredible challenges that education, in its broadest sense, will need to address.

In the last few hundred years, there has been an extraordinary disengagement of humans from the natural environment. This is mostly due to the enormous shift of people away from rural areas into cities… Already, some research has shown that too much artificial stimulation and an existence spent in purely human environments may cause exhaustion and produce a loss of vitality and health… Modern society, by its very essence, insulates people from outdoor environmental stimuli and regular contact with nature… Some believe humans may not be fully adapted to an urban existence (Maller et al. 2005, p. 46).

If as some recent findings suggest we are not exactly suited to highly concentrated urban environments and their attendant cultural and economic problems, are there alternative findings that may provide clues to a more sustainable future? Moreover, if such emergent environments create unrecognised stress and disorder in individuals, are there any forms of competent solution? Parsons suggests the psychological benefits of relationship with natural landscape in that people's negative identification (sympathetic arousal) can be significantly reduced by direct rural environmental contact and there is

psychophysical evidence that nature transactions reduce sympathetic arousal associated with stressful and other negative emotional states (Parsons 2007, p. 762).

Such observations and research have arisen from a growing number of informing studies mainly from North America over the last two decades (see for example Greenway 1995; Kaplan and Kaplan 2006; Ulrich 2002). These empirical investigations provide data to reveal the advantages of human beings learning and sensing about themselves through nature. The emphasis of many of these findings demonstrates a commonality of people's response to nature. In examining the research, certain positive results unfold that could indirectly be useful to art education enquiry in general and self-learning in particular. It is worth developing and emphasising this questioning why direct human contact with nature may help facilitate creativity and learning.

Taken together, the healthy attributes of natural environments to people have been recognised and clearly identified by a range of empirical research (Parsons 2007; Ulrich et al. 1991). It must be clearly understood and emphasised that these benefits are realised not just in terms of human *physical* activities (although this is an important connection) through walking, running, climbing, swimming and so forth but these initial findings demonstrate *deep psychological benefit* to people in their seeing and mental engagement within natural environments. By such holistic association, it seems that creativity can also be optimised and encouraged through contact with nature.

Among these aforementioned studies, there are two specific but interrelated areas of research: one into the distinctly medically related benefits of nature (Ulrich; 2002; Ulrich et al. 1991) and the other into the findings of nature in relation to restoring a less fatigued (and for art educators) visually orientated perspective (Kaplan and Kaplan 2006). Consider Rachel and Stephen Kaplan summarising their findings on the power of nature in relationship to popular culture:

The source of much mental distress, is overuse of 'directed attention'… To escape the discomforts of mental fatigue, people often turn to activities that 'capture' their attention… Watching TV, for instance, requires little willpower: the programs do the work, and the brain follows along… activities like watching TV or sporting events as 'hard fascination'. The stimuli are loud, bright, and commanding. The activities are engaging and fun, but they don't allow for mental rest. Soft fascination, on the other hand, is the kind of stimulation one finds on, say, a stroll along the beach or in the woods. Nothing overwhelms the attention and the beauty provides pleasure that complements the gentle stimulation. The brain can soak up pleasing images, but it can also wander, reflect, and recuperate (Kaplan and Kaplan 2006).

The integrative psychological and physical restorative qualities of nature provision for individuals recuperating from sickness have also been documented. Roger Ulrich's findings demonstrate a long history that

plants and gardens are beneficial for patients in healthcare environments is more than one thousand years old, and appears prominently in Asian and Western cultures (Ulrich and Parsons 1992). During the Middle Ages in Europe, for example, monasteries created elaborate gardens to bring pleasant, soothing distraction to the ill (Gierlach-Spriggs et al. 1998). European and American hospitals in the 1800s commonly contained gardens and plants as prominent features. [Ulrich 2002, p. 2]

The importance of being close to nature has yielded important restorative evidence but likewise the proximity of nature, even if not physically engaged, has fairly recently been proven to be beneficial (Kaplan and Kaplan 1989). Furthermore, certain natural environments have been carefully preferenced with particular natural form noted. It appears in more detailed research that flowing water has a strong predilection for humans. People are also seemingly drawn to large elderly trees and unbroken vegetation. This has also apparently been found to cross national and cultural groupings (Maller et al. 2005). The specifics of the beneficial aspects of nature seem to reveal a human connection that provides deep psychological, restorative and creative properties. The importance of physiological alertness in rural settings of such soft fascination leads Kaplan and Kaplan (2006; 2008) to designate this as *effortless attention*. This alertness with nature is one that resonates with an alert relaxed form of perception, ameliorating fatigue while potentially rejuvenating and redefining the psyche (Kaplan and Kaplan 2008) for creative art.

The reaction to Kaplans' effortless attention and passive activity has been explored in a slightly different manner by the neurophysiologist Laura Sewell (Sewell 1999) on the ecopsychology of perception. Sewell notes that neurological arousal can become a more conditioned encounter than previously imagined but her findings lead to what could be viewed as a similar though more constructivist conclusion than that of the Kaplans (Kaplan and Kaplan 1989).

Our attentional focus both internally and externally influences and creates subjective reality by facilitating the perception of some objects, relations and events to the exclusion of others… Edward Hall an anthropologist philosopher put this more simply 'Man learns while he sees and what he learns influences what he sees'… Our habitual way of looking at the world is iterative – in effect, it accumulates our worldview. This is how our perceptual habits, conscious or unconscious, become our reality… unless we consciously choose to attend to what we haven't yet seen, to notice the unexpected elements of the world. Ultimately attention is the true power of vision. It is the capacity to join inner and outer landscapes (Sewell 1999, pp. 110–111).

Unexpected dialogical relationships occur with an open alertness to ambiguity and mystery evidenced through the ever-changing qualities that nature exhibits, similar in creative manner and diversity to the creation of art. This holistic unknowingness helps provide an important link to the character of art making and education in particular. Consider also Torrance's test of creativity (Torrance 1974) that includes an openness to ambiguity as a central precursor to nurturing human ingenuity and original learning in the unfolding of meaning.

Research indicates that seeing nature (even as photographic imagery [Kaplan and Kaplan 1989]) can not only help re-establish a degree of human focus, it can also improve efficiency. Nature appears to provide a deeply restorative environment for awareness to unfold. It is worthwhile looking at the creating and creative potential of passive awareness and alert sensing contained in attentional restoration hypothesis:

> Attention restoration theory (ART) contends that attention plays a key role in why mental fatigue occurs and in how restorative environments can foster recovery. Mental fatigue is the result of declining capacity to use directed attention. Recovering from it calls on the other kind of attention, attention to activities that are fascinating and compelling. Attention restoration theory posits that time spent in such effortless pursuits and contexts is an important factor in the recovery from mental fatigue. In other words, restoration involves activities and settings that are compelling and allow directed attention to rest. Tending to our attentional needs is central for achieving clear headedness. There is a substantial empirical literature, drawing on ART that documents the important role the natural environment can play in recovering attentional capacities... (Kaplan and Kaplan 2006, pp. 827–828).

It is not only with nature that there are profound psychological and biological connections being proposed but also in creative areas of art pedagogy. Here a new kind of direct origination is being suggested as emerging not only from traditional areas of practice, such as art-as-therapy but art learning itself is proffered as directly and deeply animating human activity through a non-stressful and creatively holistic approach. Creativity, and by association art, is connected to the essence of what learning can be. To be alertly human can be to learn in a most profound, open and creative manner.

The term 'Palaeoanthropsycho' is Professor Ellen Dissanayake's description of what she sees as art making (Dissanayake 1988; 2008). Her empirical definition includes the complete canon of art history, pre- and post-historical cultures and the formal operation of art in itself as a uniquely human generative expression. Such a vast range of human activity she cites as arising in and coming from a deep psychological drive. This perspective may seem to be an obvious finding for art educators especially when art is considered as a common heritage shared by all humans (McNiff 1998) and all human cultures (Spivey 2005). McNiff's understanding of the benefits of visual art has however evolved from a psychological positioning within an art therapy or art as (a less

clinical) therapeutic approach (Moon 2002). Artistic expression can also be perceived as a holistic element alongside human existence or at least an integral part of human cultural evolution (Spivey 2005). This view is similar to how other human phenomena like religion or social interaction may be viewed. Arnheim is closer to Dissanayake's theory and moreover he deepens art to creativity through an important analogy with nature:

> Much is known about what was going on in the minds of Leonardo Da Vinci or Einstein. But I do not intend to discuss any particular cases. Creativity concerns me as one aspect of the mind's general functions, especially its cognition. Even more broadly, one must look beyond human behaviour to the root causes of this activity. One must realise that one is dealing with one of the fundamental needs of the organism… The organism reaches the world of its functioning through the perceptual media of vision, touch, sound and others. The sensitivity of these media begins way below sensory consciousness. Take the example of a tree. A tree reaches for the height prescribed by its species. As its branches spread, they distribute their spaces. They make the best use of light. There is biological interaction of forces, but even without conscious awareness, it represents the solution of a vital problem and what we experience as the beauty of a tree. The tree is acting creatively, not just metaphorically – *it is the real thing* (Arnheim 2001, p. 24) [my emphasis].

The thesis that nature not just seeks to be but actually *is* in a permanent state of creativity suggests that (at its most fitting) art aspires towards a condition of nature. Darwin observed that the planet's 'endless forms most beautiful and most wonderful have been and are evolving' (Darwin 1859/1996 p. 396). He also detailed the interconnectedness of 'the mutual relations of all' (p. 7). If nature is in a permanent and immediate state of evolving creativity, from which humans can receive mindful benefit, the psychological extension and transference of such condition into art and education would seem quite sensible and rational.

Dissanayake's findings (to some extent like those of the Kaplans, and Ulrich's on nature) suggest an empirical practice, an applied discovery that may be tested. Dissanayake's research on what she terms the human art of 'making special' is viewed as an innate movement of creativity that includes theoretical and problem-solving social theories:

> Influential organising principles of nineteenth- and twentieth-century intellectual discourse such as Marxian interpretation of history, Freudian psychoanalysis, Jungian archetypes, or structuralist mythographies can be reframed (or discarded) when one recognises that principles of human action arise fundamentally from an evolved human nature; different circumstances produce different responses in different individuals, but these individuals have the same underlying psychobiological needs (Dissanayake 2008, p. 242).

This suggests that art resides with instinctive psychological learning that places creativity as a deeper human attribute concomitant with sensing. Art then can be felt not as something quite apart and separating but rather more holistically inborn, more sensed as an innate human necessity in practical learning. Dissanayake concludes:

> Culture ('nurture') is not an alternative to but is part of biology ('nature'): every human is born with an unstoppable preparedness to become cultural (Dissanayake 2008, p. 245).

Spivey, in his aptly named 'How Art Made the World' (2005), documents the possible sociocultural 'magical' origins of art, and even touches on the psychological–religious by way of ritual and trance. A creativity that appears psychologically moved by deep personal, collective and, by a common human origin, shared expression. Dutton (2010) to some extent develops Dissanayake's discourse, although perhaps less critically. Expression as art, he suggests, is essential to being human and has been observed throughout all histories and cultures as a continuity of a psychological and by association somatic practice. There are a number of earnest features that Dutton suggests are present in any artwork. Although they may not all be collectively present at one time there is, he strongly argues, an underlying commonality of human learning achieved in benefitting from creating art. Moreover, and like Dissanayake's argument, he suggests that there is an instinctive psychological feeling in the appreciation and in the drive to make art. This innate urge to invent may demonstrate common ground, in the sense of a positive learning benefit concomitant in human encounters with nature such as the advantages suggested through different disciplines by Arnheim, Kaplan and Ulrich. Agreeing with Dutton (2010), Cambridge art educationalist Richard Hickman contends

> that aspects of behaviour which are associated with art-making might have a biological rather than a purely cultural foundation: all humans (to the best of my knowledge) have a strong interest in creating narratives and an enjoyment of problem solving; human beings also appreciate and value skilfully made objects. For educators, if we accept that young people have an 'art instinct', then it is incumbent upon us to ensure that this instinct is nurtured and developed. The idea that art might be something more than a cultural construct should not be dismissed by art educators (Hickman 2010, p. 350).

Does this help present the possibility of a unifying denominator between art and nature through a common sense of awareness and creativity? Art (as an intelligent creative enquiry) and nature may in such review require a newer attention not only as a mechanism of perception but as an active perceptual engagement (Sewell 1999), a healthy natural encounter (Dutton: 2010; Kaplan and Kaplan 1989; McGilderchrist 2009) and a choicelessly aware consciousness (Krishnamurti 2001). This (especially the latter) can

be a different highly charged form of meeting and dialogue that requires inward, and at the same instant outward attention, non-judgementally and naturally unfolding. What Kaplan calls 'soft attention' may be necessary for nourishing the psyche and restoring the neutrons in the brain (Sewell 1999). Jiddu Krishnamurti's perspective may require elucidation in relation to this potential application:

> That awareness begins with outward things, being aware, being in contact with nature. First there is awareness to things about one, being sensitive to objects, to nature, then to people, which means relationship; then there is awareness of ideas. This awareness, being sensitive to things, to nature, to people, to ideas is not made up of separate processes but is one unitary process... As awareness is not condemnatory, there is no accumulation... That awareness is from moment to moment and therefore it cannot be practiced (Krishnamurti 2001, p. 26).

Krishnmaurti's assurance that this moment to moment movement of awareness cannot be practised and is therefore beyond any result or training is surely a critical challenge to dominant discourses of scientific rationalist and economic determinism embedded in the language and orthodoxy of 'learning outcomes'.

In matters of the creative human psyche moreover such verification can really only be lived in (and as) a dynamic questioning in the moment of learning. This is what is being alluded to here; the urgent need for some educational focus on the ongoing relationship between inner nature (the deeply psychological) and outer nature (the learning environment) passively observed *as it happens*. Such holistic primacy is also a necessary concomitant to creativity and an openness to the truly new and unknown.

Description (as Magritte's image of a pipe so eloquently illustrates) is a secondary, unreal process. Necessary and important as such understanding is (i.e. in areas of mechanical analysis, rote learning and reflective practice as memory) it is no substitute for internal psychological learning and creating in *and as* action. Educators may pragmatically utilise description but actually feel and learn qualities that go beyond depiction and are immediately different, vaster and heartfelt. If there was opportunity for honest dialogue concerning the movement of ourselves in and as action, this, it is posited, could unfold a more integrated and intelligent sense of collective creative human enquiry (Krishnamurti 2001).

Each learning situation and each learner is really unique. But what if the vitality of nature, art and creativity are being denied or perhaps more appropriately misplaced or misunderstood because of the kind of 'hard fascination' choices Kaplan and Kaplan (2006) allude to? The relentless distraction of popular mass communications (Mander 1978; Postman 1988), now on a global scale, tends to suggest a challenging disengagement from an unmediated personal relationship with nature, worldwide. Is it possible that current pedagogy may also be faltering, at risk of becoming too focused on narrow outcomes to the detriment of deeper, more personally relevant learning?

The creative underpinning within art education offers the potential for individual learning insight that may be nourished and shared. However, there can be reluctance through ownership and scarcity in economically driven institutions for creativity to become heavily conditioned and reductively directed. A cautious protectionism can emerge, sometimes observed in social and personal practice and also within the humanities, arts and unfortunately in formal education (Gatto 1992; Robinson 2008). Samuel Clements reportedly did not let his schooling interfere with his education, viewing learning as lifelong and in this sense available to everyone. Learning in this manner can also be seen as similar to nature, in not being generally exclusive.

Nature (*natura*) is defined as vital, creative power, its origin being found along with *natal* and *nascent* in the Latin stem *nasci*, to be born. Origination is true of everything, in being formed. Nature in the aforementioned and general sense of the evolution of intelligence does unfold a highly complex, unexplained but *mutually related* movement all around us (Darwin 1859, p. 64). The structures that humans have made among themselves, especially the economic and social ones of the last 200 years – even with remarkable technological advancement – seem to permeate (or be accompanied by) an unhealthy kind of individualism based upon largely [unlearned] psychological fear and insecure protectionism with its attendant division and strain. This, it seems to me, is the source of many challenges our world, including education, faces. But at least it is one that we can begin to address holistically: meeting ourselves through nature and through creativity/art can present an opportunity for a new kind of attention-in-action to occur. This awareness seems relevant in these times of ecological and environmental crises. A healthy, fearless, sustainable site for learning alert facilitation may be required, one that sees one's nature *through* nature: a nature worth caring for while being explored. Exploration of this nature may mean a totally different reappraisal of what learning is. Utilising the aphorism of 'being the change one wants to see' suggests one's life, in all its detail, becoming the genius loci, spirit or sense of place, for educational focus. Such applied psychological exploration can go against the received approaches of much art education and practice:

> So here is the heresy:… creating oneself as an excellent person in all the activities of one's life and in one's being, is the real work of art (Gablik 1985, p. 18).

How might such challenge in *and of* relationship, this creating of personal awareness, be understood?

> You may say it is very difficult to be constantly aware. Of course it is very difficult – it is almost impossible. You cannot keep a mechanism working at full speed all the time; it would break up; it must slow down, have rest. Similarly, we cannot maintain total awareness all the time. How can we? To be aware from moment to moment is enough. If one is totally aware for a minute or two and then relaxes, and in that

relaxation spontaneously observes the operation of one's own mind, one will discover much more in that spontaneity than in the effort to watch continuously. You can observe yourself effortlessly, easily – when you are walking, talking, reading, – at every moment. Only then will you find out that the mind is capable of freeing itself from all the things it has known (Krishnamurti 2001, p. 19).

This challenge, or questioning in and as oneself may be more likely reciprocated in natural environments where nature is similarly changing not only in terms of day or season or mood but as a living and dying entity. The wide variety of local environment experienced in Ireland, for example that of bog, river, forest, mountain, seashore or drumlin reflects to a certain degree such diversity. Of course, it could be any natural area of the earth: sierra, desert or tundra. Natural landscape (the word comes from 'land shaping') can with quite a direct contact help shape and indeed heal the self (Greenway 1995; Ulrich 2002). But in what manner may such findings assist creative and artistic learning?

A new form of visual enquiry?

This chapter began with reflection on nature and the natural environment as a source of creative learning. Reviewing a broad sample of art, pedagogy and philosophical literature, I urge a reconsideration of integrative approaches to creativity as enquiry, skill and living. A short documentation of one of the learning enquiry workshops may provide a kind of flavour and character of informal but productive education. Many of these workshops occurred over periods of one or two weeks, quite a number were residential. For the purpose of this chapter, there will be a general review of a one-day workshop carried out in the late spring of 2010 involving a small group of lecturers and undergraduate students. This will concentrate not so much on the specifics or outcomes of study but more on introducing the overall intent, quality and character of what occurred.

This also helps locate some of the points explored in the previous review. As such, it is possible to explicate holistic links and additional connections concerning nature, art and learning in an applied practical and to some extent theoretical sense. Certain approaches to nature, art and consciousness can be encouraged through direct physical and psychologically aware engagement. The structuring of these workshops attempts to reveal the core relationship of nature and art to such potential learning.

The workshop description is laid out later. It was open to second-year undergraduate Fine Art and Photography students from the University of Ulster. The purpose of the programme was a consciously informal coming together primarily to enable individuals to self-understand themselves in action. In this relaxed context, it is important to allude to the challenges of what may be formally identified within educational establishments as evaluation, reflection and feedback. Within holistic education the learner is of prime

importance especially in the facilitation of understanding the precise psychological movement of their own unique learning in action and the quite personal obstacles, feeling and emotions that may impede insight.

Each person has a particularised way of thinking and can only really discover for and about themselves *as* themselves. In such questioning, no one else can do this understanding for them; such intrusion introduces authority that may disallow the necessary freedom to deeply learn. In many ways art education, with its traditional emphasis on individual creativity, can be the most useful starting point because each person is ordinarily creating their own unique form and as such the ground for individual enquiry can be already keenly felt. Finding out for and about oneself in a potentially creative environment, on one's own, is not therefore totally alien. Enquiry here is in the journey rather than the result.

There was a small group seminar situation involving eight people both staff and students in a secluded forest area close to Belfast (I have found it beneficial to work with small groups, numbering usually not more than ten). It was useful to get to know everyone and reasonably quickly establish a situation of mutual trust and relaxed but focused interest. This particular workshop was carried out in the late spring of 2010. A mixture of cloud and blue sky, but no rain, helped set the scene. The light was changing with the cloud and there was a refreshing stillness in the forest. The workshop began in mid-morning, and included a working break and a return in the afternoon for applied creative enquiry. All mobile phones, portable music devices, radio, mobile Internet had either been disengaged or left back at the forest educational centre where the group was based.

Within and among this relationship of art, nature and self there can emerge a commonality of feeling and the vehicle or mode for such feeling is *sensing*. After one cross sensing exercise, most of the students and staff reported an increase in visual perception. This enquiry commenced by pairing off, with one of the pair being totally blindfolded and carefully directed for over 20 minutes. An increase in ocular sense is perhaps to be expected. However there was also a stated appreciation and increase of hearing, touch and to a lesser extent smell. In one learner, a declared manifestation of low threshold synesthesia may have been evident.

The smell, touch and auditory experiencing was conducted in silence; haptic sensing was carefully and discretely carried out. The primacy of silence during creative enquiry (and from a number of workshops) is worth noting and something that may be greatly underestimated. Most of us today inhabit a world of noise. This is especially true for younger students. Some creative, silent environments can still be encountered in art colleges, diminishing though they are. For example, life drawing rooms, certain applied art ateliers and small workshops; here a shared silence can be most congenial to a feeling of personal and collective enquiry and active learning. This is sometimes also encountered and felt in old libraries, small schools. Silence and a quietude can be concomitant with rural environment, as Picard holistically and perceptively notes:

The things of nature are images of silence, exhibiting not themselves so much as the silence, like signs pointing to the place where silence is (Picard 1952 p. 137).

Developing on the potential educational and creative learning value of relaxed, natural silence, Angelo Caranfa also comments:

education based on silence teaches students not only to think logically or critically or rationally, but also to see and to feel the whole of things. The underlying principle is that students become more conscious of themselves in relation to the world of silence with which their lives become unified. By shifting the mode of learning from discourse (knowing) to silence (unknowing), students come to value things not for the purpose of exploitation, profitability, and utility, but for the spirit they contain (Caranfa 2004, p. 227).

In this nature workshop, for the opening ten minutes or so, there was silent, slow, deliberate stopping and walking and stopping again for one or two minutes to gently establish confidence and to develop a sense of ease among participants. As noted, individuals were partnered in pairs for a blindfold exercise. Ground was uneven but this helped underpin an emphasis on slowness and balance along with sensing the shape of the earth underfoot. Direction to trees, shrubbery, rocks, grass and earth was encouraged. Silence with movement assisted in focusing the senses. Learners were encouraged to be uninhibited to explore nature with not only their hands and arms but also (if they felt like it) their whole body, for example resting on the earth or embracing a tree.

Our willingness to be in the mud and rain can reflect our willingness to be in our internal mud and rain. To put oneself in mud and rain is more than a matter of tolerance; it is active participation (Harper 1995, p. 188).

Throughout this section of nature workshops, learners are asked to remain very much in the moment, participating with and as their senses open, slowly allowing learning from moment to moment to unfold. In such interaction, physically feeling relationship, and interface between textural qualities, haptic patterning of nature and the human senses can become most important, more holistic.

Some students requested what we call 'sensing focus' whereby specific directed auditory association (by means of quiet auditory suggestion) was introduced to try and enable learners to explore their inner senses more fully. This involved gently naming interconnecting parts of the learner's physical body (usually at rest on the dry earth, eyes closed) and gradually moving with the suggested passive observation to their psychological interior. Processing suggested feelings into sensing those feelings can be quite expanding while being extremely tranquil, relaxation being particularly apposite in a natural setting (Kaplan and Kaplan 1989). This allows for a number of points to be

iterated, not least that the emphasis is clearly placed with the learners in exploring their own senses from and about themselves in a calming manner.

The haptic (touching), aural (hearing) and olfaction (smelling) increase is in proportion (after the blindfold is removed) to the intensity of sight and accompanying increase of colour, tone, light and response to patterning and abstraction. But the inner sense focus, the overall feeling of underlying sensing in and of itself, must be emphasised. This passive remaining with a more holistic inner and outer sensing as it is happening presents an interesting enquiry into learning as the learners themselves. It raises an important question: is there a feeling of creatively finding out, of enquiry for and about itself, per se?

To re-emphasise: most learners in this (and other art nature workshops) reported an increase in their visual and quieter creative sense. They appreciated the natural environment as suitable to alertness and lack of stress, substantiating both Ulrich (2002) and Kaplans' (1989; 2008) findings. Holistic integration between natural form was likewise noted, detailing interconnectedness between features like tree and ground, the particular in relationship to the general.

Following from the sensing exercises came the largely silent undertaking of much creative activity. Utilising the ecological, sustainable concept of 'leave-no-trace' found natural forms such as cones, leaves, dead wood (and biodegradable thread) were utilised to create a series of personal 3D sculptural artefacts in the woodland. Digital photography was also used to support this suggested visual enquiry.

An adjunct was gently proffered in asking students how they might integrate their visual art within a shared learning environment. That is, could they create or indicate a conscious scheme of work, embed a learning reference in their artwork for foundation or pre-first-year art students. Considerations were asked as to how this might be communicated to others as part of the artwork. This was suggested in order to view artwork as dialogue not necessarily as an individually completed artefact on its own but rather as a learning work in progress that others could 'take' from or add to. Time constraints did not allow for significant applied response. This remains an interesting consideration however of artwork production to be further developed. That is not only viewing art making as an individually destined or finished sculpture or art form but also as a potentially holistic integration whereby one's work may also be a learning enablement for others to develop and share upon.

Overall, the concluded workshop and other nature learning (Herron 2010) attempted to place a different kind of communication deliberation on the artists in a sense of sharing embedding and communicating elements within their enquiry while observing their own senses in operation. This is what may be viewed as a creative dialogue (Bohm and Nichol 2003; Krishnamurti 1996).

In dialogue, alertness is placed not on outer or inner dichotomy but an overall unitary observation is established with no difference between teacher and taught, learner and teacher, learning and learner. This, if focused simply, can unfold learning as an unknowing, ongoing enquiry. It does not, in its origin, tap into memory but directly engages in a

moment to moment of awareness sensing in and of itself, greatly assisted by being in the natural environment. The artist's creative production may be seen to increase as a practical integrated learning most useful in describing *around* an activity but like Magritte's pipe (1954) not the object of the activity itself. This is similar to Korzybski's (1921/1950) observation that the map is not the territory or Krishnamurti's (1996) that the description is not the described, in that both suggest a living questioning in the moment.

So in a similar fashion nature learning is not static but requires living sense that only individuals (indivisible is the etymological root of this term) can directly enter into, of and significantly *as* themselves. Additionally there is a beauty in the understanding that no one else at a deep personal level can learn for another. There cannot in creative enquiry be one single model or framework for such learning, although careful enablement and facilitation is necessary and important.

There is a unique quality and challenge in any changing learning relationship. Like nature, this can be quite distinctive, differentiated and unique, but rarely from a traditional educational point of view is it considered as such. Being in a natural, constantly changing environment can help facilitate such changing learning relationships. In natural environments, one may feel a sense of holistic unitary manifestation. What is meant here is a moment-to-moment learning as an undivided whole.

All of this is not to undermine particular standardisation, facilitation and organisation of art or creative education but rather to locate disciplines, objectives and outcomes as supportive of, and secondary to, deeper integrated learning, living and understanding of self in action. That learning should be felt as lifelong and person centred can be easily forgotten in the scramble for fixed sets of certitudes in a world increasingly subservient to economy-led definitions, paradigms and educationally reductive considerations. Language, words and definitions serve a vital human function in classifying, distinguishing and abstracting phenomena. Such processes however can lead to a peculiar dominance whereby categories, statements and concepts can appear greater and more important than living itself (Bohm and Nichol 2003). Over identification with the idea, mistaking thinking for what is, can result in personal thoughts about a person becoming greater than the actuality of the person themselves (Krishnamurti: 1996).

Ideation may become rigid, amplified, reproduced from a non-holistic psyche into organisational structures that take precedence over the living potential of a pedagogical moment. Our descriptions and judgements can take on characteristics that seem more important than the actuality surrounding us, description being confused with the thing itself: *thinking* we understand instead of actually, creatively understanding. In the moment of non-temporal holistic life, is an education unfolding wherein the learner is no longer divided, separated from her or his learning? Can such art of learning, like unified nature herself, be something collectively shared and cherished in a carefully observed, alertly sensed, ongoing enquiry that meets the creativity of everyone? This questioning, in its limited literal sense, is but an attempt to introduce the possibility of opening up such a challenging enquiry.

References

Arnheim R. (2001) What it means to be Creative *The British Journal of Aesthetics* Vol.41, No.1, pp.24-25.

Bohm, D. and Nichol, L. (Eds) (2003) *The Essential David Bohm*: London: Routledge.

Caranfa, A. (2004) Silence as the foundation of learning *Educational Theory* Vol. 54, No. 2 pp. 211–230.

Darwin, C. (1859/1996) *The Origin of Species* London: Oxford University Press.

Dissanayake, E. (1988) *What Is Art for?* Seattle: University of Washington Press.

Dissanayake, E.(2008) The arts after Darwin; does art have an origin and adaptive function? in K. Zijlmans and W. van Damme *World Art Studies: Exploring Concepts and Approaches* Amsterdam: Valiz pp. 241–263.

Dutton, D. (2010) *The Art Instinct; Beauty, Pleasure and Human Evolution* New York: Bloomsbury Press.

Ehrlich, G. (2000) *John Muire: Nature's Visionary* Washington DC: National Geographic Press.

Frank, T. (2000) *One Market Under God* London: Secker and Weburg.

Gablik, S. (1985) *Has Modernism Failed?* London: Thames and Hudson.

Gatto, J.T. (1992) *Dumbing Us Down* Philadelphia: New Society Publishers

Gierlach-Spriggs, N. Kaufman, R. E., and S. B. Warner, Jr. (1998). *Restorative Garden: The Healing Landscape* New Haven: Yale University Press.

Greenway, R. (1995) The wilderness effect and ecopsychology in T. Roszak, M. E. Gomes, and A. D. Kanner (eds.) *Ecopsychology* San Francisco: Sierra Club Books.

Halpern, D. and Frank, D. (Eds) (2001) *Nature Reader* London: Picador.

Harper, S. (1995) The way of wilderness in T. Rozak *Ecopsychology* San Francisco: Sierra Club Books pp. 183–200.

Herron, A. (2000) An informal community of learning *The Link* No. 9 Autumn/Winter England: Krishnamurti Link International.

Herron, A. (2010) *Learning Nature: Sustainability and Art Education: Finland* Symposium 1. I.N.S.E.A. European Congress: University of Lapland.

Hickman, R. (2010) Review of The Art Instinct: Beauty, Pleasure, and Human Evolution by Dennis Dutton *International Journal of Art and Design Education* Vol. 29, No. 3 pp. 349–350.

Kaplan, R. and Kaplan, S. (1989) *The Experience of Nature: A Psychological Perspective* New York: Cambridge University Press.

Kaplan, R. and Kaplan, S. (2006) in Loy, J. *A Walk in the Woods Michigan Today* Vol. 35, No.1 University of Michigan: University of Michigan Electronic News Service.

Kaplan, R. and Kaplan, S. (2008) Bringing out the best in people: a psychological perspective *Conservation Biology* Vol. 22, No. 4 pp. 827–828.

Korzybski, A. (1921/1950) *Manhood of Humanity* Pennsylvania: Dutton & Co.

Krishnamurti, J. (1996) *Total Freedom* San Francisco: Harper Collins.

Krishnamurti, J. (2001) *Choiceless Awareness* California: KFA Publishing.

Maller, C. M. Townsend, A. Prior, P. Brown and L. St Leger (2005) Healthy nature, healthy people: 'contact with nature' as an upstream health promotion intervention for populations Health Promotion International Vol. 21, No. 1 pp. 45-54 Oxford: Oxford University Press.

Mander, J. (1978) *Four Arguments for the Elimination of Television* New York: Harper Collins.

McGilderchrist, I. (2009) *The Master and His Emissary* New York & London: Yale University Press.

McNiff, S. (1998) *Trust the Process: An Artistic Guide to Letting Go* Boston: Shambhala.

Moon, B. (2002) *Working with Images: The Art of Art Therapists* Illinois: Charles C Thomas Pub. Ltd.

Parsons, R.J. (2007) Environmental psychophysiology in J.T. Caciioppo L.G. Tassinary, G.G. Berntson (eds) *Handbook of Psychophysiology* 3rd ed. Cambridge: Cambridge University Press pp. 752–788.

Picard, M. (1952/1989) *World of Silence* Chicago: Regnery Press.

Postman, N. (1988) *Amusing Ourselves to Death* London: Fountana.

Robinson, K. (2008) RSA lecture http://comment.rsablogs.org.uk/2010/10/14/rsa-animate-changing-education-paradigms/.

Sewell, L. (1999) *Sight and Sensibility: The Ecopsychology of Perception* New York: Tarcher/Putnem.

Spivey, N. (2005) *How Art Made the World* London: B.B.C. Books.

Torrance, E.P. (1974). *Torrance Tests of Creative Thinking*: University of Georgia: Scholastic Testing Service, Inc.

Ulrich, R.S. (2002) Health benefits of gardens in hospitals Conference Paper, Plants for People International Exhibition, Florida.

Ulrich, R.S. RF Simons, BD Losito, E Fiorito, MA Miles, and M Zelson (1991) Stress recovery during exposure to natural and urban environments *Journal of Environmental Psychology* No.11 pp. 201–230.

Ulrich, R.S. and Parsons, R., 1992. Influences of passive experiences with plants on individual well-being and health. In: Relf, D. ed. *The role of horticulture in human well-being and social development: a national symposium*, 19-21 April 1990, Arlington, Virginia. Timber Press, Portland, 93-105.

United Nations (2007) World urbanisation prospects statistics http:// esa.un.org/ unup/ p2k0data.asp. 2010/10/14.

Chapter 13

Mainstream and Margins in Art and Design Education: Adult Learners and Part-Time Provision in the National College of Art and Design, Dublin

Nuala Hunt

T his chapter is concerned with developments in part-time adult and continuing education at the National College of Art and Design (NCAD) since the late 1990s. This period takes into account a decade of activity in higher education and changes in the nature of part-time provision. In particular, the implications of policy initiatives for part-time adult learners in art and design education and institutional responses are examined. The introduction contextualises adult and continuing education within higher education and at NCAD. The next section reports on the implications of research undertaken to inform the development of adult continuing education at the NCAD. The third section presents an overview of policy developments, implementation of curriculum change within continuing education and the implications for staff and students. The fourth and final section identifies challenges and opportunities arising for part-time and continuing art and design education in the future.

Introduction

NCAD is a recognised college of the National University of Ireland, and as such, is the only college of art and design within the Irish university sector. Since the late 1990s at NCAD, continuing education policy has focused on the formation of a coherent part-time provision to cater for mature students who want to participate in art and design education, develop skills, build confidence through practice and progress within higher education. However, the context has changed over the years. Adult and continuing education was previously on the margins; increasingly the current intention is to mainstream this provision within higher education. According to the most recent Higher Education Authority (HEA) position paper 'continuing education must be mainstreamed if it is to feed into main stream programmes and its priority in higher education programmes must be given due recognition' (OECD 2006, p. 8). Notwithstanding the intention to mainstream continuing education within Ireland, themes of widening participation, massification and greater accessibility within higher education remains a key policy initiative within Europe. The implications of the Bologna process and developments in technology have highlighted the need for increased flexibility of provision within higher education. Inevitably, the relationship between part-time, adult continuing education and higher education is changing. In some cases, institutions are slow to change, although the newer Institutes of Technology (IoT) are acknowledged as offering greater

flexibility in terms of provision (HEA 2010). Recent research indicates that there are low participation rates and limited progression routes available to part-time students in higher education (Darmody and Fleming 2009, p. 67; HEA 2009). Within art and design education in Ireland, there is only one dedicated part-time evening BA degree option offered through Institute of Art Design Technology (IADT) in Dun Laoghaire (though with no new intake of students since 2008, it is possible this programme will be phased out). Current developments within the IoT sector suggest art and design part-time provision will be addressed through modularised accumulation of credits. It is in this context that NCAD is undertaking significant curriculum reform and the role of part-time, continuing education is being repositioned within the college.

Throughout this chapter, the terms part-time, flexible and adult continuing education are used interchangeably. Though these terms are linked particularly under the umbrella of lifelong learning and share some common characteristics such as widening participation and inclusion, there are differences. 'Flexible learning' typically refers to modes of learning or to an approach to how learning is provided. However, concepts underpinning adult and continuing education traditionally relate to themes of empowerment, transformation and equity (Murphy and Fleming 1999). Issues of diversity and parity remain central to the discourse around increased participation of part-time students and integrating continuing, adult education within higher education (Schuetze and Slowey 2002, Davies 2000). Lifelong learning is an expansive concept; policy initiatives in this area are ambitious and often undeliverable, particularly when addressing social inclusion and meeting the needs of mature age, part-time students, and needs which have yet to be comprehensively attended to within higher education (Darmody and Fleming 2009, p. 68; Skilbeck and Connell 2000, p. 39). Experiences at NCAD suggest that mainstreaming continuing education is not straightforward or easily achieved.

The tradition of part-time education at NCAD is long established and can trace its development from the mid-nineteenth century. However, the introduction of formal state examination systems in the mid-1930s and the arrival of dedicated accredited programmes from the 1970s onwards resulted in full-time undergraduate diplomas being offered, which in turn were replaced by BA degree programmes in the 1980s. For a short time in the 1980s, the college offered a part-time degree route; however this option was discontinued having encountered some serious operational difficulties (Turpin 1995). Throughout most of the 1990s, NCAD concentrated on the development of these full-time undergraduate programmes in a range of art and design disciplines, including painting, sculpture, print-making, craft, industrial design, fashion, textiles and teacher education.

For many years, part-time education at NCAD was informed by traditional, instrumental and vocational perspectives of education. From the 1980s a wide-ranging programme of short continuing education courses evolved, offering primarily fine art, with some design, portfolio preparation and art history classes in the evening. An autonomous

unit, Continuing Education and Education Research (CEER) was established, separate from the academic faculties of NCAD. This unit catered for a mature student audience mostly attending evening classes. These part-time courses were non-accredited and this provision fitted within a hobbyist and extra-mural format. As the provision was structurally separate from other NCAD departments and faculties, CEER was outside mainstream, full-time programming.

By the late 1990s, policy developments at national and European levels signalled change for higher education generally and for adult and continuing education in particular. Key policy developments included the Universities Act (1997) Qualifications – Education and Training – Act (1999) and the Bologna Declaration (1999). Seminal government policy papers pertaining to adult and continuing education were issued, including the Green Paper *Adult Education in an Era of Lifelong Learning* (DES 1998) and the subsequent White Paper *Learning for Life* (DES 2000). Additional policy initiatives were undertaken by the HEA to promote access, equity, modularisation and an outcomes-based approach to teaching and learning within higher education (HEA 2002. As a consequence of legislation, new validating agencies emerged within the higher education and further education sectors: Higher Education and Training Awards Council (HETAC) and Further Education Training Awards Council (FETAC). The establishment in 2001 of the National Qualification Authority of Ireland (NQAI) and the arrival of the National Framework of Qualifications (NFQ) introduced a framework whereby all qualifications could be mapped onto a single entity and also could be linked to European and international qualifications. Furthermore quality assurance units were established in most third-level colleges and in 2002 the university sector established an overarching body, the Irish University Quality Board, (IUQB). Issues of accountability and transparency are increasingly important for higher education (DES 2011; IUQB/ IUA 2007; Skilbeck 2001).

Since the 1970s, the university sector had developed a range of approaches to adult and continuing education, including adult education as catch up, second chance, catering for returners, disadvantaged students, and also as continuing professional development, personal development and enrichment. Adult education by definition is not confined to formal education; it is often associated with basic education. Also, it can inform social change through community development and further education initiatives. Within higher education, the inclusion of continuing education had tended to cater for mature students, providing opportunities for adults to return to or to access education where previously no option existed, or providing programmes accessible in remote areas. The range of adult and continuing education provision was impressive in its intentions to widen participation amongst non-traditional learners through outreach, access and extra-mural certification initiatives.

Although the diversity of programmes and localised responses on offer to students was extensive, by the late 1980s what had emerged was a two-tier arrangement. Often extra-mural qualifications existed outside the walls of institutions, and did not translate into

a pathway for part-time adult learners, resulting in an 'accreditation cul de sac' creating problems where progression and parity was concerned (Kelly 1994, p. 107). Critically at this time, the more expansive concept of lifelong learning anticipated a change in direction for higher education in respect of earlier approaches to adult and continuing education (DES 1998). By the late 1990s, lifelong learning policy increasingly was moving towards notions of integration, learning for and throughout life, employability and ensuring that adult learners could progress within higher education. In future it would no longer be a case of where adult education fitted within higher education, rather how higher education could respond to the challenges of moving from an elite to a mass system of higher education, diversity within the student body, and increasing post-graduate numbers. Part-time, flexible and modularised learning created increased learning opportunities and different modes of learning. Moreover, the space occupied by continuing education within higher education needed to be revised in terms of the concept and practices informing the provision. The importance of mainstreaming adult and continuing education within higher education has intensified in recent years as policy makers have emphasised the need for the full integration of continuing education 'into institutional life rather than being often regarded as a separate and distinct operation employing different staff' (OECD p. 55). However, the pace of change within higher education can be incremental; research conducted at NCAD in 2000 revealed a fragmented continuing education provision existing on the margins of the college (Hunt 2000).

'Other narratives and histories'

As the wider context of higher education anticipated or responded to change, inevitably established policies and practices within NCAD were challenged. The appointment of a new Head of Faculty of Education and a researcher/coordinator for continuing education in the late 1990s instigated a period of review and change. Continuing education was repatriated to the Faculty of Education; as a result, it was now placed within a broader conceptual approach, inclusive of lifelong learning. The researcher initiated an internal survey of staff and students and conducted interviews with management. In tandem with the internal investigation, a series of interviews was scheduled with heads of adult and continuing education in other third-level colleges and universities. The researcher's intention was to capture an in-depth view of the internal NCAD context and to use data gathered from external models and approaches to inform a report, which offered a way forward for continuing education in art and design education (Hunt 2000, p. 3).

The questions informing the internal research aimed to establish what senior staff considered the primary benefits and strengths of continuing education, the weaknesses and challenges. It also explored possible accredited programme options including a route to a part-time degree and how changes within continuing education should be managed and provision organised within college structures in the future. This survey looked to

establish a profile of the student body, identify their motivation for returning to part-time art and design education, factors impacting on their choice of courses, quality of learning and teaching experience and level of interest in certification. Finally, the implications of relevant policy developments nationally were a factor in the development of the research report.

Responses from senior academic staff and management varied in respect of their understanding of continuing education. Although there was some positive feedback on continuing education as a promotional opportunity for NCAD, for others continuing education had limited credibility (Hunt 2000, p. 16). The research revealed that although the part-time programme was popular with students, it was not guided by an academic rationale. Accordingly, the then director described the programme as 'very popular however it has developed in a haphazard and ad hoc manner' (Hunt 2000, p. 52). Furthermore and pointedly, he said 'provision did not come into place in the context of a policy... If continuing education is to develop then other narratives and histories need to be told' (Sheridan, cited in Hunt 2000, p. 53). The programme had grown expeditiously but there was no progression route for students, no entry requirements for courses, or certification options. Several full-time staff who contributed to the research had a view of continuing education as a hobbyist provision, which generated a profile for the college but did not offer access or provide links to full-time provision. The programme was conventional and not regulated by college standards. Continuing education existed on the margins of the college, competing with full-time provision for space and facilities and was not integrated within college structures.

In contrast, the student survey revealed a committed cohort who commented positively on their learning experience, citing facilities as poor but teaching as excellent or very good. Furthermore when asked if they had an option to take certification and assessment, the response was overwhelmingly affirmative.

In summary, CEER at that time lacked credibility internally, there was no vision guiding it, its aims were unclear and not articulated. Furthermore, there were limited resources, and with no indication of change in government policy, there was no state funding forthcoming for part-time education. Adult education was under-resourced and continued to be self-financed. Compounding the situation was the limited visibility of CEER within the college. Accordingly, CEER students were described as 'invisible to the day (students), they are transitory like ghosts' (Hunt 2000, p. 33). The issues of visibility and integration are not unique to art and design education. Indeed there is evidence (Darmody and Fleming 2009, p. 67) to indicate that part-time students within Irish higher education are not a priority and have a low status, despite the advent of accreditation.

The report, which emerged from the research phase, signalled change as a feature for future development and invited key stakeholders to contribute to the process. The director summarised the situation when he stated that 'change is needed to animate the process of revitalising CEER' (Hunt 2000, p. 53). Accordingly, six key areas of activity were identified for future development

- part-time provision offering increased participation

- accredited progression options to a part-time degree route

- staff development teaching and learning

- access initiative

- outreach

- continuing professional development.

The plan for implementing change commenced with a change of name from CEER to Continuing Education in Art and Design (CEAD), the development of an undergraduate certificate awarded by the National University of Ireland (NUI) and the introduction of a postgraduate community arts education diploma programme. These initial steps were followed by the appointment of an access officer and development of a dedicated access initiative targeting disadvantaged schools and students with a disability.

Over several years, the process of planning and implementing change within CEAD accelerated. The initial phase of development was characterised by the movement away from classes towards the construction of programmes that provided a coherent learning experience and were linked to existing undergraduate provision. The part-time evening programme was developed into accredited options and non-accredited courses, the latter consisted of introductory, and intermediate courses offering preparation, orientation and progression for students with limited prior experience of art and design. Teaching and learning workshops were organised for part-time continuing education staff as well as full-time teaching staff. From 2005 onwards, the development of the continuing education programme moved towards consolidation, including increased certification, diploma options and greater modular flexibility within programmes.

As the configuration of part-time programmes changed, the profile of students gradually altered over the years. Originally the non-accredited programme of courses had attracted mature students, a portion of these were 'returners', that is individuals who were taking a different course within the discipline or in some cases repeating the same courses. Analysis of the part-time student body in 2000 indicated that 53% of those participating in part-time classes had been coming for three or more years. There were more women that men attending, mostly the student population was Dublin based and more than half of the respondents to the survey were over 40 years of age (Hunt 2000, p. 19).

However, the advent of certification created opportunities for those individuals who wanted to develop a professional practice and or progress within art and design education. Also, entry requirements, standard application processes and assessment were introduced within accredited programmes. Non-accredited courses were defined

in terms of introductory, or intermediate/advanced. The profile of adult learners participating in continuing art and design education has consolidated in response to the structural changes. In 2003 examination of the profile of CEAD evening students indicated that just under half of the population were over 45 years of age (NCAD 2003). By 2009 as part of quality assurance review of continuing education (NCAD 2009), analysis of the profile of students participating indicated an increase in the number of students under 40 years of age. At this stage, CEAD had developed certificate and diploma options including a flexible multi-modular programme. Interestingly the multi-modular programme, which facilitates large numbers of students to take modules and gain credits incrementally over a three-year period has an older profile, with 58% of students over 40 years of age while the one-year certificates and diploma has approximately 45% over 40. Similarly the non-accredited courses witnessed a reduction in older students with 43% over 40 (NCAD 2009, p. 7). Further analysis of the part-time continuing education student population indicates that the majority are working either full-time or part-time.

Full-time study was not an option for many mature students and NCAD had no modular or part-time accredited options in 2000. The potential development of part-time accredited programmes and providing part-time students with progression routes that were linked to full-time was given a boost by the arrival of the NFQ.

Bologna, the NFQ and part-time education

The Bologna Declaration (1999) proposed the introduction of a European Area of Higher Education by 2010. This proposal included the introduction of three cycles (bachelors, masters, doctoral) of higher education, each within a common credit system and quality assurance mechanisms. Generally, the thrust of Bologna intends to encourage transparency and comparability of qualifications, as well as improving transfer and employment opportunities for learners across the European Union. The arrival of Bologna accelerated the process of modularisation and hastened the introduction of an outcomes-led approach to teaching and learning in higher education in Ireland. The Bologna process has had a significant impact on the structure of qualifications, how students learn, how programmes are designed and delivered.

The Qualifications Act led to the establishment of the NQAI. The arrival of the NFQ in 2003 – amongst other things – provided a means of constructing progression routes and transfer options for learners. Similarly, NUI published a set of proposals in *An NUI Qualifications Framework for Lifelong Learning* (NUI 1999). This document provided a set of guidelines for the university sector to support the inclusion of part-time and continuing education within the burgeoning framework of qualifications.

Since the setting up of NQAI, the implementation of the NFQ has gathered momentum within higher education. However, the framework presents some interesting challenges and

dilemmas while constructing and aligning minor awards to major awards. The positioning of awards within the framework is contentious, it can prove complicated, particularly where minor awards such as undergraduate certificates or diplomas offer progression and transfer options. The difficulty rests with ensuring that existing undergraduate awards for full-time students have established intended learning outcomes at various levels within programmes, and that they are aligned to levels within the framework. NQAI proposes that for major awards at least 60 credits are at the programme award level, yet the practice of writing learning outcomes at lower levels such as 6 and 7 is not consistently observed across higher education (NQAI 2006). Where programmes are not comparable, problems emerge when students attempt to transfer within or across higher education (Skilbeck and Connell 2000, p. 38).

The lessons of Bologna and modularisation for part-time mature students in higher education are unclear. Generally, research indicates that modularization and Bologna encourage flexibility, increase choices within the curriculum and offer opportunities for transfer for students (Healey 1991). However, critics have argued that curriculum coherency and student progression has been undermined as a result of modularisation and outcomes-led curricula design. Whether the lessons emerging from full-time undergraduate higher education in a post-Bologna context extend to part-time and mature student cohorts is unclear as research in this area is limited.

The Bologna process poses particular issues for higher art and design education, including the possibility of a shorter undergraduate qualification and the development of progression options at post-graduate level from masters to Ph.D.

There are 13 providers of art and design education within the state, most being schools within an IoT. NCAD, as a recognised college of NUI, is the only art and design college situated within the university sector. Generally, the majority of BA programmes in art and design are at Level 8; typically, they are four-year full-time programmes amounting to 240 credits on completion. Structured taught masters programmes in art and design are a more recent initiative in Irish higher education. The development of Level 10 (doctoral level) programmes has been a contentious area, particularly where it pertains to practice-based research, though the Graduate School of Creative Arts and Media (GradCAM) strategic initiative proved a viable option, with several art and design colleges (Dublin Institute of Technology, IADT, NCAD, Ulster University) collaborating to develop a PhD track in creative arts and media, including art and design.

On a less positive note, part-time art and design progression routes at undergraduate level are limited. Currently three Irish colleges (GMIT, LIT and IADT) offer part-time routes to BA awards, though the duration of these programmes differs substantially. Also, two of these options are for part-time day study, where students take modules alongside full-time cohorts, accumulating credits over a longer time frame. In this instance, there is no dedicated programme constructed in response to the learning needs of a particular cohort of students; rather it is a flexible version of a full-time course, based on modularised accumulation of credits. At NCAD the development of part-time

progression routes has concentrated at sub-degree level with a range of certificates and diplomas currently on offer. Generally Irish higher education has a poor record in respect of part-time provision with limited flexibility and low levels of participation: 'only 12 percent of undergraduate students are enrolled on part-time courses and the majority of these are enrolled on Level 6 and 7 courses in institutes of technology' (HEA 2009, p. 4). Evidence from the UK and Ireland (HEA 2010; Osborne 2004) indicates the university sector has been slow to evolve flexible options and respond to the needs of adult learners who want to participate in higher education but may not want to undertake full-time options. These issues concerning institutional flexibility and lack of choice have been highlighted in a recent policy paper where it was noted, 'one of the major bottlenecks for Irish adults wishing to engage with higher education is the very limited provision and the choice of part-time, flexible learning opportunities at undergraduate level' (HEA 2009, p. 4). Evidently, the introduction of modularization and qualification frameworks alone have not brought about increased flexibility within undergraduate provision in some parts of Irish higher education.

As the implementation of the Bologna process continues, so too does the debate around the implications for undergraduate art and design programmes, and whether this will lead to shorter courses and/or programmes that include interdisciplinary and multidisciplinary choices. Art and design education is usually studio located, involving experiential learning that is process based, with students engaged in a range of teaching and learning activities including problem solving, project based work, ideas generation, conceptualising, making, doing, critical thinking, evaluation and displaying artefacts. For some teachers, modularisation presents particular challenges: it can be seen as reductive, limiting experimentation, eroding discipline boundaries and leading to increased assessment. However, there are examples of capstone modules and integrated approaches that have been adapted successfully to an art and design context (Lo et al 2010). At NCAD, it has been decided (NCAD 2011 p. 4) to adopt the 3+2+3 (bachelors, masters, doctoral degree) cycle and curriculum change remains on the agenda.

Curriculum change does not occur in a vacuum. It is undertaken in response to external drivers such as the Bologna process, modularisation or quality assurance, or internal college initiatives arising from a commitment to critically reflective practice amongst teachers. Brookfield notes that 'curricula arise out of conflicts of interests' and they can also be 'dismantled and reframed by teachers and students' (Brookfield 1995, p. 40). At NCAD, implementing curriculum change and undertaking programme design within continuing education has proved contentious. A combination of research, using quality assurance mechanisms to inform planning, and providing teaching and learning workshops to support change has proved useful in achieving goals.

Since 2000, a period of review and research has resulted in the reconfiguration of the provision of continuing education. All part-time provision in the early years of the new millennium was based on personal interest only. In 2001 a process of curriculum reform was initiated, the purpose of which was to provide students with a coherent learning

experience, to develop accredited progression routes and to provide flexible modes of delivery for 'non-traditional' mature learners. This process signalled a move away from part-time classes towards courses that were linked to contemporary practice. In CEAD, curriculum development involved examining existing part-time and full-time courses, considering approaches to teaching and learning, gathering information on the student profile, including their motivation for returning to learning, analysing programme content, sequence of learning and modes of delivery and considering how new courses might be linked to existing full-time undergraduate provision in order to provide for progression.

Introducing new part-time undergraduate programmes

Initially new one-year certificate programmes in Drawing Visual Investigation (DVI) and Photography and Digital Imaging (PDI) were introduced to address critical developments in visual art practice that were absent from the provision. These one-year programmes were minor awards within the NFQ, requiring students to attend a minimum of two nights per week contact time. These studio-based programmes combine conceptual, theoretical and practical modules in an integrated manner.

In 2006, a second wave of curriculum design was embarked upon with a view to establishing an extensive range of modules that would offer mature, part-time students a means of accumulating credit towards certificates over a longer period of time, taking into account students' capacity to balance course workload and other commitments. Furthermore, the intention was to provide teaching staff with opportunities to work in pairs, to become familiar with outcomes-based education, and to design and deliver modules that were linked to the full-time undergraduate curriculum.

Using the existing non-credit courses as a starting point, a multi-modular certificate programme was developed. This minor award within the NFQ contains 11 modules, offering choice across a range of subjects. The programme is delivered in the evening and students progress at a pace to suit their circumstances. The modules are described as Audit-Credit (AC), that is, students can audit without undergoing assessment or they choose to take assessment and gain credits. This certificate, known as Visual Art Practice (VAP), consists of four categories: Drawing and Research, Materials and Media, Discipline Experience and Visual Culture. Students navigate their own route across the programme taking modules in whatever sequence they wish, the only limitation being to select a module from each category. Although the programme is flexible, it is also structured, combining conceptual, theoretical and practical skills and knowledge. This programme contrasts with other part-time and full-time art and design undergraduate courses where there is less flexibility in programme design and choice of modules.

Knight (2001) has criticised outcomes-led curriculum planning and highlights the negative impact of modularisation, which can lead to fragmentation within curricula, interrupt progression and undermine coherency. At NCAD, introducing learning

outcomes was prioritised when modularisation was being rolled out across colleges. Teachers were supported in writing learning outcomes through workshops and resource documents, which addressed issues relating to art and design disciplines and outcomes-based education. The multi-modular part-time programme at NCAD has proven popular and students are progressing, though the possibility of taking modules incrementally, gaining credit and increased choice has been key to the success of the programme. Interestingly where mature students' choice of modules is tracked over time, the evidence indicates that students make their initial selection based on pre-existing knowledge of media and materials. It is possible where mature students are returning to higher education after a gap, often their conception of fine art or design or their prior knowledge of the discipline influences their initial choice of module or programme. The tendency is for students to choose a subject such as painting, jewellery design or textile design to start with rather than drawing and visual research methods.

One regular feature emerging from curriculum change in CEAD at NCAD is the importance of communicating outcomes-based education and explaining the language of art and design to mature students. As part of curriculum development within another university, McMahon and Riordan (2006) noted that including students in the change process yielded positive outcomes However, communicating modular, flexible, outcomes-based art and design curricula to new part-time students can be challenging. It requires making the programme transparent, stating intended learning outcomes, establishing clear progression routes and explaining the process of accumulating credits. The preparation of explicit course material, the use of visual diagrams, on-line materials and open days assist this process. However, where mainstreaming continuing education is involved, the issue of supports and access to resources for part-time students in higher education will have to be addressed in a manner that is comparable to full-time cohorts.

In 2008 and 2009, course evaluations (NCAD 2009) were undertaken in CEAD as part of a quality assurance review. This researcher and an external consultant developed student surveys jointly, though the compilation and analysis of data was undertaken externally. Each questionnaire used pre-coded answers and all of the rating questions employed a Likert scaling whereby the answers were assigned an order of numerical value (NCAD 2009). The survey group was small and the findings are particular to the local context though there are noticeable similarities with research data on part-time students in higher education in the wider Irish context. In particular, the material provides insights into student profiles, their motivation for returning to learning and their experience within part-time art and design education. Nonetheless, it would be difficult to argue that these findings might be generalised or applied beyond the immediate cohort.

The surveys were distributed to students participating on accredited and non-accredited evening courses. However, the figures cited here relate to accredited programmes only. The surveys were constructed in three parts: (1) establishing a profile of the student

population and motivation for returning to learning; (2) evaluation of the teaching and learning experience; and (3) future educational plans and additional comments. The data referenced below relate to two cohorts of students, the first group taking AC modules and the second group taking other accredited programmes such as: DVI, PDI and diploma (these students are referred to as 'others'). The profile of students indicates that more women (AC: 76%, others: 71%) than men participate in the accredited programmes (NCAD 2009, p. 7). The majority are mature (23 years of age) students and there were significant numbers of European and non-nationals participating in programmes at the time the survey was carried out in 2009. The majority of students were employed either full-time or part-time. Interestingly those students taking AC modules were more likely to be employed full time (60%) whereas the numbers employed full time on the courses requiring more weekly contact hours were slightly less (53%). Many of the cohorts had an existing undergraduate qualification (AC: 66%, 'others': 50%) and a quarter had post-graduate qualifications. Their motivation to return to higher education was driven largely by an interest in the subject, attending in the evening, and is undertaken for personal development reasons; 85% of audit credit students were motivated by personal development, slightly less, that is, 67% of students taking other certificate and diploma courses cited personal development. Notably, 58% of this second group indicated professional development was important in their reason for taking the course compared to 34% of AC students. Additional factors identified as very important in their choice of programme include: the subject, the flexible nature of the programme and the academic challenge it provided for students. In contrast, programme costs and accreditation were identified as only 'somewhat important' (NCAD 2009, p. 11).

Progression routes and institutional flexibility within NCAD

Currently the part-time programme at NCAD offers in excess of 300 places on certificate and diploma programmes and as many non-accredited places; though the progression route to a part-time BA degree is in the process of being constructed, it is contingent on college wide curriculum reform. At NCAD, the introduction of a part-time degree has been in development for some time. Factors impeding progress include established college structures, negotiating management and ownership of the new part-time programme, establishing how the programme will be resourced, accessing facilities for part-time students, reviewing the structure and format of programme content, ensuring discipline identity, while facilitating modular choice and flexibility within a part-time degree without impairing the learning experience.

The challenges of mainstreaming continuing education cannot be underestimated. While addressing issues of inclusion within higher education Merrill stated that 'changing institutions… is not straightforward' (Fleming et al. 1999, p. 52). The existing college structures have been in place since the 1970s and include four faculties and multiple departments within the college (Fine Art, Design, Education, Visual Culture), which inform disciplinary structures and provide a means of managing programmes. Similarly,

existing curricula have evolved over two decades. The BA undergraduate programme is not a single disciplinary entity, as all full-time students enter into a common core or first year, at the end of which they choose a disciplinary programme within Design, Teacher Education or Fine Art. As core year exists separately in terms of structure and curriculum planning, achieving curriculum coherence and sequencing of learning across the college structures can be a challenge. The introduction of modularization has improved curriculum transparency, though the move towards outcomes-based education in art and design and ensuring constructive alignment within programmes in higher education is a goal yet to be achieved. Currently CEAD is a centre within the Faculty of Education: the process of full integration of continuing education within college structures features as part of quality improvement plans for the college in the next few years.

Conclusion

Traditionally Irish higher education has offered full-time programmes, catering primarily for school leavers. Through a range of policy initiatives there is increased diversity within the full-time student cohorts and greater flexibility in accessing learning opportunities. Unfortunately, the issue of part-timers in higher education remains problematic. Critics argue that the status of part-time education n Ireland 'has been undermined by the absence of coherent policy or resources to develop structured provision for part-time learners' (Darmody and Fleming 2009, p. 67). There has been limited research into part-time and flexible learning modes in higher education, and the implications for learners attempting to juggle work, life and study commitments. This lack of research presents a challenge for policy makers and providers alike, as the barriers to participation, progression and implications of sustaining part-time flexible provision have not been fully explored. Furthermore, there is no change in approach to state funding for part-time adult education; therefore the status quo can be difficult to shift.

This chapter has examined policy developments and their impact on higher part-time education with particular reference to the art and design sector. The research focused on the process of changing curricula at undergraduate level within NCAD and the lessons emerging for curriculum planning for part-time students in the future. As the implementation of the Bologna process gathers momentum, the interest in curriculum change and concepts underpinning curricula increases nationally. The experience at NCAD suggests that knowledge of policy and current discourse in teaching and learning can assist when addressing curriculum change. With this in mind and where part-time, mature students are concerned, education developers and teachers might take into account a number of factors when undertaking curriculum design and planning in the future. These include the profile of learners, the workload spread across the duration of a programme, different modes of learning, greater accessibility of programmes and supports available to students and training for teaching staff.

Often within mainstream higher education there is a struggle to conceptualize part-time provision, insofar as there is a temptation to repackage full-time programmes into a part-time mode, without adequate attention being given to the profile of students, analysis of learners' needs, approaches to teaching or supports required for part-time mature students. If mainstreaming continuing education is to be achieved and more part-time flexible options are to be provided, then reform of curricula, institutional structures and funding mechanisms is required.

References

Brookfield, S.D. (1995) *Becoming a Critically Reflective Teacher* San Francisco: Jossey Bass.

Darmody, M. and Fleming, B. (2009) The balancing act – Irish part-time undergraduate students in higher education *Irish Educational Studies* Vol. 28, No. 1 pp. 67–83.

Davies, P. (2000) Lifelong learning a European perspective in *Learners Credit and the Learning Age, A Colloquium* Dublin: Irish Youthwork Press.

DES (1998): *Adult Education in an Era of Lifelong Learning* (Green paper) Dublin: The Stationery Office.

DES (2000) *Learning for Life* (White paper on Adult education) Dublin: The Stationery Office.

DES (2011) *National Strategy for Higher Education 2030, Report of the Strategy Group* Department of Education and Skills Dublin.

Fleming, T., Collins, T. and Coolahan, J. (eds) (1999) *Higher Education, the Challenge of Lifelong Learning,* Maynooth: Centre for Education Policy Studies.

HEA (2002) *Creating and Sustaining the Innovation Society* Dublin: Higher Education Authority.

HEA (2009) *Open and Flexible Learning,* HEA Position Paper http://www.hea.ie/en/ Publications/Flexible Learning.

HEA (2010) *A Study of Progression in Irish Higher Education* Dublin.: HEA.

Healey, M. (1991) Modularisation and geography: some reflections *Journal of Geography in Higher Education* Vol. 15, No. 2, pp 215-16.

Hunt, N. (2000) 'Other narratives and histories need to be told' A report on NCAD Continuing Education, unpublished internal research report.

IUQB (2007) *A Framework for Quality in Irish Universities: concerted action for institutional improvement* Dublin: Irish Universities Quality Board/ Irish Universities Association.

Kelly, M.B. (1994) *Can you credit it? Implications of accreditation for learners and groups in the community sector* Combat Poverty Agency Dublin.

Knight, P. (2001) Complexity and curriculum: a process approach to curriculum making *Teaching in Higher education* Vol. 6, No. 3 pp. 369–81.

Lo, A., Chan,V., Hung, F., Lee, A., Ma, H., Chan, R. and Tso, M. (2010) Assessment of Programme Outcomes, Capstone Project, School of Design, Hong Kong Polytechnic University, unpublished paper.

McMahon, T. and O'Riordan, D. (2006) Introducing constructive alignment into a curriculum: some preliminary results from a pilot study *Journal of Higher Education and Lifelong Learning* Vol. 14. pp. 11-20.

Murphy, M. and Fleming, T. (1999). Higher education and lifelong learning: The experience of adults at college. In T. Fleming, T. Collins & J. Coolahan (Eds.), *Higher education: The challenge of lifelong learning.* Maynooth: Centre for Education Policy Studies.

NCAD (2003) Survey of adult participants in CEAD classes, unpublished report.

NCAD (2009) *CEAD Quality Assurance Report,* http://www.ncad.ie/about/qareports. shtml accessed 06/06/2011.

NCAD (2011) *Undergraduate Prospectus 2012-13* Dublin: NCAD.

NQAI (2006) *Towards the completion of Framework implementation in the universities – a discussion paper* http://www.nqai.ie/docs/publications/28.doc.

OECD (2006) *Higher Education in Ireland* Paris: OECD.

Osborne, M. (2004) Adults in British higher education in R. Mark, M. Pouget and E.M Thomas (Eds) *Learning from Experience in the New Europe, Adults in Higher Education* Bern: Peter Lang.

Schuetze, H.G. and Slowey, M. (2002) Participation and exclusion. A comparative analysis of non-traditional students and lifelong learners in higher education *Higher Education* Vol. 44 pp. 309–327.

Skilbeck, M. and Connell, H. (2000) *Access and Equity in Higher Education: An International Perspective on issues and Strategies* Dublin: HEA.

Skilbeck, M. (2001) *The University Challenged* HEA/CHIU.

Turpin, J. (1995) *A School of Art in Dublin since the Eighteen Century, A History of the National College of Art and Design* Dublin; Gill and Macmillan.

Chapter 14

Emergent Outcomes: Inquiry, Qualitative Reasoning and the Aesthetics of Care

Richard Siegesmund

In the fall of 2010, I had the privilege of serving as a Fulbright scholar in the Faculty of Education at the National College of Art and Design, Dublin. My task in this chapter is to provide an assessment of Irish art education from this outsider perspective. This is a somewhat daunting task. Three months in residence in Ireland is only enough time to scratch the surface of a different culture. It provides an opportunity to have some introductory conversations, get a vague sense of the landscape and frustratingly realise what might be possible to learn, analyse and contribute if there was only more time. Consequently, I offer these remarks with trepidation and the hope that a beginning learner will have the opportunity to return to this remarkable country to explore these issues in greater depth.

This essay unfolds in three sections. First, I consider the context of Irish art education and contrast this with the American model. This highlights the formalist roots of British art education and the cognitive roots of American curriculum. Second, I consider how this cognitive tradition applies to contemporary visual art practice, and how one could consider learning in the visual arts. Third, I close with a section on how these cognitive traditions might apply to assessment of student learning.

The context of Irish art education

All societies have formal or informal systems of arts education for culture reproduction. Every culture has a method for transmittal of its values. This appears particularly intense in Ireland. Culture is a point of national pride. The arts are serious business. Cultural identity clearly links to music, dance, literature and the performative word as exemplified in·the nation's traditions in theatre and story telling. In this context, visual arts, separate from Ireland's international reputation in film, might initially appear to be the poor cousin in this group. Nevertheless, the richness of visual art education within Ireland, and the public exhibitions that arise from it, is striking (even if music, dance and theatre might be the first things mentioned in the tourist guides).

As a cultural outsider to Irish art education, my initial reaction – particularly to manifestations at the primary, junior and senior levels – is that philosophy matters. Historic British–Irish ideas about thinking and beauty manifest themselves in contemporary Irish curriculum. This might not be readily apparent to a discipline with a curriculum that seems structured around the technical training of connecting the eye to the hand and the mastery

of cultural literacy. Nevertheless, there is a sense that Irish art education is deeply informed by British empiricism: the philosophies of John Locke, George Berkeley and David Hume that held that all knowledge is grounded in sensory perception (Markie 2008). I would argue that there are links to the British concern for taste, which precedes the German project of aesthetics (Beardsley 1975). Judgements of taste and the connoisseurship of beauty drive early British art education. As the Oxford English Dictionary attests, well into the nineteenth century British art educators disdained the philosophical implications of German aesthetics – how we think through our senses. Finally, British formalism, as articulated by Bloomsbury group member Clive Bell (1913) and later by Sir Herbert Read (1958), retains a strong imprint on the character of the curriculum.

In contrast: the American/German model of art education

Understanding how art education in the United States and Canada differs from the Irish model can be instructive to understanding the Irish perspective. Aesthetics as articulated within German Idealism significantly influences art education in the United States and Canada. The philosophies of Immanuel Kant, Friedrich Schiller and Friedrich Schelling – in direct response to the British empiricists – suggested that an aesthetic imagination mediated perception (Bowie 2003). The difference between the German and the British models continues to inform curriculum.

The British and German traditions both valued the training of the eye. Both held that perception is an achievement of mind. However, there are important differences. The British tradition supports art education for its ability to analyse and produce knowledge of the world and the production of beauty, whereas the German tradition supports art education as an entryway into thinking itself, or what the current art education literature now calls habits of mind. More concerned with the sublime than beauty, the German tradition saw aesthetics as a space within which reason resided.

These two traditions continue to influence contemporary instruction. The British tradition, perhaps best articulated in modern practice by Sir Herbert Read (1958), makes art, in its formal visual structures, a critical ancillary or accelerant to learning in all subject areas. The German tradition, articulated in modern practice by Viktor Lowenfeld (1947), holds that art provides its own deep insights into individual learning and personal transformation.

The German art education tradition in America: personal growth

Arguably, the field of art education, as distinct from artistic education (the training of the artists), is concerned with the educational benefits of the study of visual arts for all

students, not just a small minority that wishes to pursue a professional career in the visual arts. Friedrich Schiller (1795/2004) first made this theoretical justification for art education in *The Aesthetic Education of Man*. Johann Pestalozzi (1801/1977), working with orphans from the Napoleonic Wars, is the first to propose a specific educational curriculum around Schiller's principles. Pestalozzi introduced specific lessons for the visual training of youth that would bring them to a state of consciousness (*Anschauung*), which would prepare them for literacy and numeracy education.

In the wake of the Napoleonic Wars, Pestalozzi's ideas were adapted by the Prussian public education system as a means of creating a common national cultural consciousness (Efland, 1990). Pestalozzi's student, Friedrich Froebel (1826/1911) furthered the educational conceptual foundation for pre-linguistic learning that undergirds core learning through his curriculum innovation of the Kindergarten – the garden of children.

These German ideas arrived in America in two ways. First, the American intellectual communities surrounding Boston Massachusetts embraced Transcendentalism, which had explicit roots in German Idealism. For example, Bronson Alcott developed a private school curriculum based on Schiller's aesthetic ideas. American Transcendentalists Mary Peabody and Horace Mann reinforced this connection in 1834 when they travelled to Prussia to explicitly see the practical application of Pestalozzi's methods in schools. They returned to the United States advocating the adaptation of Pestalozzi art education in American public schools. In the second half of the nineteenth century, Mary Peabody's sister, Elizabeth, successfully established the acceptance of Froebel's kindergarten as a structural part of public education (Wygant 1983).

The second way in which German Idealism became part of the structure of American education was through immigration. In a 100-year span beginning around 1820, 6 million Germans arrived in the United States. These immigrants settled in close-knit German communities where they sustained their cultural expectations. These included an insistence that the schools in their new American communities adopt aspects of the Prussian public school curriculum. This can be seen in Cincinnati (a major centre for German immigration) being the first school district in the United States to mandate specific instruction in art in primary grades (Efland 1990).

These German ideas were revitalised in the twentieth century through Victor Lowenfeld's *Creative and Mental Growth* (1947), which brought the ideas of Sigmund Freud (1930/1961) into the curriculum. Arguably, Freud's theory of an unconscious that controls rational thought is itself an extension of the aesthetic theory of German Idealism. Just as Pestalozzi and Froebel proposed an aesthetic dimension of thinking before literacy and numeracy instruction can begin, so too, Lowenfeld proposed that art provided an avenue of expression for the unconscious that would set the stage of accelerated numeracy and literacy education. Freud's concept of an unconscious continues to influence contemporary art education in the United States particularly through the psychoanalytic work of Jacques Lacan (Tavin, 2010).

The American philosopher John Dewey (1934/1989) also contributed to the resurgence of German Idealism through *Art as Experience*. Ironically, the practical impact of Dewey's aesthetics came from his high regard as a curriculum scholar. His proposals for teaching art were not well understood. The specific curricular ideas that Dewey argued for did not begin to have an actual impact on curriculum until after his death. Dewey's ideas of inquiry-driven curriculum structured by habits of mind have direct influence on the contributions of both Howard Gardner (1983) and Elliot Eisner (2002) to contemporary practice.[1]

The British art education tradition: applied design

The British art education system focused on art academies whose objective was the production of designers and craftspeople. Similar to Mary Peabody and Horace Mann's trip to Prussia in 1834, the Normal School in London, in 1837, authorised William Dyce to view the German art education system in practice. However, where Peabody and Mann saw a system for the education of all children, Dyce saw a system for the earlier identification of talented designers and artisans. The British art curriculum thus became utilitarian in concept (Macdonald 1970).

The United States flirted with the British model during the 1880s. The Boston public school system brought Walter Smith from England to institute a design programme in European textile design education so that the mills of Massachusetts could compete in the international fashion market. The Massachusetts government mandated the implementation of Smith's curriculum in schools through the state. However, just as quickly as this art education reform took hold, social class issues undermined it. In particular, citizens of Irish heritage pointed out that their children were far more likely to be tracked into the Smith's design curriculum than children of Anglo heritage, who tended to be tracked into college-preparatory studies. This political protest ended Massachusetts' brief foray into art education as preparation for professional practice (Bolin 1995). Nevertheless, the British system was highly influential on the curriculum in art academies in the United States. It influenced schools such as the Pratt Institute in Brooklyn, New York and the Maryland Institute, College of Art, Baltimore, Maryland.

At the beginning of the twentieth century, the ideas of the Arts and Crafts Movement, with their emphasis on the hand shaping materials for utilitarian purposes, still appeared to hold sway in the British system. Resistance continued to the American system that continued to be open to new German ideas surrounding the merits of personal expression in children's art. Although British psychologists recognised the schematic development in child art, this did not carry over into the art education curriculum. British learning outcomes conformed to the strict definitions of form as articulated in the academies or through the Arts and Crafts movement. Children's art was deficit expression: something to be overcome, not something to be celebrated as evidence of learning (Macdonald 1970).

In 1941, Sir Herbert Read championed children's art as a legitimate form of expression. With growing interest in art curriculum reforms as advocated by Marion Richardson, the British system began to align more with the American system. Art education was a subject to benefit all students, not simply a talent identification programme.

Nonetheless, the legacy of the British system, particularly its emphasis on formal visual qualities to produce beautiful objects, appears to exert a strong hold on the Irish primary and secondary system. For example, at the 2010 annual meeting of the Irish Art Teacher Association, the morning session presentations were devoted to contemporary practices that emphasised student self-expression. In response, one art teacher pointed out that contemporary practice was a subset of modern art, which in turn, is a subset of the general practice of art. From the murmurs of agreement in the room, I concluded that a number of other teachers supported this description. It appeared to be a moment of the classic British system reasserting itself: art is form in the service of beauty. The Greeks and the Italians wrote the rulebook. The role of art educators is the transmittal of these European cultural values. In this view, the current accepted narrative of the art of the past 150 years – what we call modernism and post-modernism – is simply a somewhat curious cul-de-sac within the context of a much larger, and enduring, grand narrative of art.

Implications on practice

There are important practical outcomes from the British philosophical legacy in Irish art education. First, Ireland takes art education seriously. Both the junior and senior levels have formal curricula and Junior and Leaving Certification exams. This is not the case in the United States where visual art evokes scholarly suspicion. Often its utility within the secondary school curriculum stems from serving as a useful place to park students who are not capable of applying themselves to real academics.

The Leaving Certificate is a double-edged sword. A formal national test applies status to a curriculum. However, national tests and standardised assessments also drive curriculum. Secondary art teachers, with whom I talked, found the goals of Leaving Certificate worthy; however, the scope and sequence of materials covered by the exam are so overwhelming that senior cycle is a headlong rush with students racing from one project to another along with striving to master the art history of the world. There simply was no time for exploration, reflection and genuine inquiry.

In the United States, Arthur Efland (1976) coined the phrase the *school art style*. He argued that we have cultural expectations for what children's art should look like. We want children's art to demonstrate particular visual characteristics. Kindergarten[2] painting epitomises the school art style through its thick, fat bristle brushes and opaque tempera paint. What a child can produce with these tools is very predictable, and we expect the production of such abstract works as tangible outcomes of childhood learning.

Irish secondary art education has its own school art style, articulated through the Leaving Certificate, which becomes a self-sufficient educational reason d'être. There is much to admire in the Leaving Certificate. For example, the marking scheme in the area of Craftwork awards points for Sketches, Design Suitability and Design Development. However, three quarters of the total score cover technique and formal properties. Formalist criteria comprise all the scoring for the Life Sketching sections.

Such marking systems are coherent. They provide teachers with clear directions on how to teach, and students with clear expectations for what they will be expected to know and to do for their final examinations. These are all indicators of a robust, well-designed curriculum. However, consider the entrance requirements into the National College of Art and Design (NCAD 2011). Here, another set of skills is valued: creativity, flexible thinking and the ability to visually iterate ideas. In the brief for the 2011 admissions portfolio, NCAD asks students to submit four different mind maps. With each mind map, students demonstrate fluency in the articulation of many different ideas and the ability to construct a variety of associative meanings from this array. Students need to select and develop particularly significant elaborations and create a range of visual iterations. Thus, it appears that although the learning outcomes of the Irish secondary art education are well articulated, they do not align with what the national art school considers basic skills for admission to higher education.

This gap is even more evident in the first-year studies programme at the NCAD. An inquiry-based curriculum is immediately introduced. Students problem find, problem solve and work through visual inferential reasoning. Not until late in the first term is skills training introduced. This is a radically different way of thinking of art making from what students have experienced at the secondary level. Students often struggle with this transition.

Thus, the Irish currently have a disconnect in their art education sequence where secondary school art education is not keeping up with the remarkable innovations that are occurring in college level instruction. Does this gap have to be so wide? Could secondary art education begin to incorporate an inquiry-based approach into its work?

The challenge to any change in secondary classroom practice is the Leaving Certificate. Revising the Leaving Certificate appears like a daunting task. However, a serious reappraisal of the learning outcomes articulated within the Leaving Certificate appears to be long overdue. Therefore, there may be some reason to hope that this issue might be taken up in the not too distant future.

Furthermore, there is the opportunity for curriculum innovation within the Transition Year in Irish secondary education. Here, in an academic year devoted to self-guided study, there may be an opportunity to introduce forms of inquiry-driven visual art practice. Currently, there may be greater potential within the Transition Year for the introduction of new forms of exploratory arts-based curriculum.

Towards inquiry-based visual practice

A move into a more inquiry-based visual arts practice could well meet another form of philosophical resistance from traditional Irish education. Analytic philosophy is a lingering educational legacy. Championed by British thinkers like Bertrand Russell and G.E. Moore, analytic philosophy pushed formal logic to rigorous extremes: thinking is mathematical (Rey 2008). A thought is a mathematical expression. Although such disciplined thinking led to breakthroughs in the construction of computer language, it also diminished the cognitive value of arts activities. Indeed, activities built on metaphor and the shaping of materials through the hands could not even be categorised as thought (Phillips 1987). Over the past 20 years, cognitive science has consistently challenged analytic philosophy's conceptual framework of mind. Indeed, the tables are now turned where it is now openly questioned if rigorous mathematical manipulation could even be called thinking (Damasio 2003; Lakoff and Johnson 1999).

In this new age, our sense of how the arts can contribute to knowledge has expanded both through changing practice within social science and changing arts practice. For example, recent research in the social sciences such as anthropology, sociology, nursing and geography have begun to turn to the visual arts as a method of recording and presenting data. Some quantitative methodologists, like the statistician Edward Tufte (1990), argue that visual representations are more meaningful representations of the comparative relations of quantities – as reflected in the context of time and space – than numerical matrices. Artists are attempting to move out of the privileged state of disinterest, what Dewey (1934/1989) derisively referred to as the 'beauty parlour of civilisation', and find art forms that critically engage communities in social dialogues.

Our knowledge systems are in transition from a linguistic model to a visual semiotic model of communication. Understanding visual images is increasingly complex. This complexity suggests new ways to think about the visual. These ways encapsulate past art education practice, but suggest new ways of thinking about the future.

Simultaneously, as social science moves to the visual, as society increasingly communicates in the visual, fine arts visual practice moves towards research and social communication. To lay a foundation for bringing these new trends into Irish secondary art education, it is helpful to approach the visual from a cognitive, rather than a cultural, point of view.

Three forms of the visual: a foundation of art as research

New methods of thinking about the visual require new conceptual frameworks. Inquiry-based visual arts practice, rooted in the social sciences, can conceptualise the visual image in at least three different forms: the objective, formative and generative. These three distinctive forms represent a linear, yet non-hierarchical, spectrum of approaches to image and object.

Here, a definition of visual images is appropriate. Visual images are mental representations achieved through sensory perception. Perception includes sight, sound, smell, touch and the somatic experience of our bodies moving through space, as well as the unfolding of sensory perception in time. In short, the visual is a sensory achievement of mind. It is not limited to what the eye sees. That the visual is not limited to vision is demonstrated by how individuals who have never been able to see, can describe the visual images they create in their minds.

The *objective* image seeks to frame an image of the world as it appears. The *formative* image uses disruptions – building on twentieth-century art practice of montage (the repetition or appropriation of film and photographic imagery), collage (the disruption and juxtaposition of commercial imagery and text) and bricolage (the appropriation and resignifying of everyday objects) – as a space to expand meanings or allow for new combinations of metaphor. The *generative* image is a performative exploration of the visual, utilising raw media, in a space that may precede language and formal symbolic conceptualisation.

These divisions – the objective, formative and generative – are permeable. Inquiry-based arts practice may cut across all three dimensions. Here, the work of individuals who are professionally trained and self-identify as artists can readily cross the line into research. They potentially change the way we might consider the learning outcomes of art education.

The objective image
The famous photographic time-lapse studies by Eadweard Muybridge revealed a world that was too ephemeral for the unaided eye to grasp – and was the proof necessary to settle a legendary wager. Photographic evidence benchmarked a 'fixed' reality. Later photographic evidence showing how a culture might have changed over time became evidence for the deterioration of an 'authentic' culture (Banks 2001).

However, we now appreciate the intricate connections that support the creation of a visual image. These connections include the relationship of persons and objects framed in an image to the individual controlling the framing. The connections include the affordances and constraints of the technical equipment and selection of media chosen to render the image. By altering and adjusting this web of connections, we can alter the outcome of the image. In this way, our appreciation grows for how we may use the visual in different ways to different ends.

Consider the social documentary work of the American photographer Lewis Hine, whose pictures of children, alone and working heavy machinery in textile mills, were critical to forming the political will to change child labour laws in the United States at the beginning of the twentieth century. Here is a case of photography showing us a world we may not have seen, but a world nevertheless as it is. In research into art education, photography can document the life of a classroom and provide visual evidence to the scope and sequence of an instruction.

No longer is the camera regarded as a neutral object that records reality. Attention has shifted to how we construct images. In looking at an image, we now ask how researchers actively, or passively, manipulate and stage a scene – often with the collusion of the participants. A famous example of the constructed objective photo is Dorothea Lange's iconic portrait of *The Migrant Mother* (Dunn 2002).

The formative image

Disruption is critical to the formative image. The most significant art forms of the twentieth century – montage, collage and bricolage – opened the door to participants selecting, altering and reordering personally significant images into new forms of constructed meaning. Such research extends to the visual signs that mark the everyday. Montage is the repetition of the image. Collage is the ripping and juxtaposition of images. Bricolage is the recombination of objects.

In the fine arts, Jim Goldberg (1995) has participants write their responses to their photographs in the margins of the image. Thereby, he captures explicitly the co-conspiracy of participants to deceive the 'objective' lens. He invites the participants with whom he works, to alter, rearrange and reinterpret the photographs that he has taken so that new meanings emerge.

In her educational research into the visual arts secondary curriculum in Singapore, Koon Hwee Kan (2007) manipulated conventional snap shot photographs to generate a deeper aesthetic understanding of goals and purposes of schools. These manipulations facilitated the analysis of her data. The images are not stand-alone works of arts that an observer can 'read'.

The generative image

In the third form of visual research, the generative, the researcher or the research participants viscerally create visual objects or experiences from previously unformed materials in the process of data collection or data analysis. The generative image is more than a record of a place or an event. The generative image, as Dewey (1934/1989) reminds us, distills experience through compression. It conveys more than semiotic meaning, it has the potential – through the skilful manipulation of visual media – to bring the viewer and the maker into a felt (sensory and emotional) space. Most importantly, it opens research to the manipulation of raw sensory materials.

Lisa Lajevic (Powell & LaJevic, 2011), provides an example from a junior level school art education classroom. She discussed a knitting project that began as a filler activity for a one-day gap in the standard curriculum. It spontaneously spread to a school-wide participatory public art installation. The knitting assignment propelled students to explore the ignored environment of their school through the perception of colour and physical touch. In this case, the artwork did not demonstrate traditional standards of form, but was an exercise in marking a place to make it special.

These three different approaches to visual research have implications for creating, documenting and analysing data. Although these methods are broadly democratic, they still require students to participate in guided praxis. They fulfil art education's quest (within the German legacy) for core cognitive skills worthy of development. These forms of visual learning are general educational outcomes for all students regardless of individual 'talent'. At the same time, each presents the opportunity for specialised training and developing expertise within either disciplinary or cross-disciplinary contexts.

This change, where arts educators are speaking to social scientists and not simply artists, requires a new vocabulary for art education. As social science is willing to embrace the visual arts, the visual arts in turn have to re-examine ways of characterising practice that may have intentionally excluded art from the discourse of disciplined inquiry.

In this reshaping of the vocabulary, consider the term 'intuition'. Traditionally, the arts have used this concept as a means of expressing its embrace of non-linear thinking. In the past, these imaginative leaps allegedly place art outside rationality. However, postmodern thinking demonstrates that raw rationality, at its most inventive, is not linear. It is rhizomatic (Deleuze and Guattari 1987) and metaphoric (Lakoff and Johnson 1980). Thus, aesthetics concepts like *freischwebend* (1992) – literally, to hover freely – enter a critical realm of the analysis of complex data. Knowing requires not knowing – a state of being lost in order to find. We should be epistemologically humble by assuming we may not know what we think we know. In this manner, searching that seeks new metaphors is a rigorous form of reflexive practice – a practice that forces researchers to change the conceptual lenses through which we experience phenomena. Through disciplined praxis, research can create a disorientation and openness that leads to the artistic concept of intuition.

Critical to this openness is the experience of thought that John Dewey claimed existed outside of semiotics (1934/1989). This, according to Dewey, was the ability to construct meaning though visual qualitative relationships. Sensitivity to these felt qualities – not simply semiotic referencing – distinguishes an additional dimension of meaning in the visual arts.

Consequently, theoretically skilful reflexive researchers can form a kind of hermeneutic circle with visually acute artists not trained in theorising yet capable of creating works beyond their own powers of descriptions. Whereas the reflexive researcher may be able to contextualise the work of artists in words, the work of artists can lead the reflexive research to new levels of perception.

Through reflexive practice, the visual researcher gains insight into the potential of the visual. We do not find data; we construct them.

Assessment

To conceptualise the visual as representing the objective, formative and assessment leads to questions of assessment in each of these three areas of image making. Assessment-

driven curricula, shaped by standards, privilege the objective visual image. Even if such images are abstract or non-representational, standards create clear expectations for an image, as it should be. Thus, there is a legitimate question as to whether any system of assessment can deal with formative and generative image making.

Eisner (2002) reminds us of Dewey's distinction between standards and criteria. Standards are tools for measurement; criteria are conditions for making judgements. Comparison of qualities of experience – qualitative reasoning – is the basis of judgement. Thus, for Dewey, artistic inquiry emerges from a developed sense of criteria for making fine-grained selections. Eisner suggests that criteria provide tools for 'a fuller reading of the work that will be useful to students and teachers alike for knowing what to do next' (2002, p. 170). Criteria provide points of entry to the teacher of how to analyse thinking with the purpose of making the students' work stronger. Standards only provide guidelines for appraisal.

To move from an assessment system built on criteria to one built on standards would require letting go of formal standards of excellence and privileging instances of student decision making. Rather than scoring student outcomes on the basis of composition, form or tone, students would be evaluated on the source and diversity of their reference materials, their ability to select and focus from variety and their justification for one approach over another in the service of expanding an idea.

Here the difference between formal qualities and learning to think through a medium is a subtle but critical difference. It requires changing assessment from works of art that demonstrate formal qualities, to an assessment of qualitative reasoning as demonstrated through a work of art.

Qualitative reasoning

The late-twentieth-century view of cognition limits thinking to the manipulation of verbal and mathematical symbols. It is true that artists do not generally draft extended written outlines of what they are about to do, or confine their work to the execution of mathematical formulas. Therefore, one could argue – if one wants to hold on to this recent, although increasingly antiquated, view of cognition – that what the artist achieves in the isolation of the studio is 'uncognised, unanalysed and unthought' (Elkins 2001, p. 108). In such a view of thinking, all art instruction could legitimately claim to do is the transfer of skills and techniques.

John Dewey, in *Art as Experience*, disagreed with such a limited notion of cognition. He suggested that thinking is more robust. Besides the manipulation of symbols, thinking also includes constructions of meaning through the relationships of qualities.

To think effectively in terms of relations of qualities is as severe a demand upon thought as to think in terms of symbols, verbal and mathematical. Indeed, since words

are easily manipulated in mechanical ways, the production of a work of genuine art probably demands more intelligence than does most of the so-called thinking that goes on among those who pride themselves on being 'intellectuals' (1934/1989, p. 52).

According to Dewey, the manipulation of relationships of qualities requires sophisticated intelligence. There is more to intelligence than the analytic manipulation of symbol systems.

But what exactly is a quality? A quality might be the solidity of a mass, the intensity of hue in a colour, the repetition of a line. In short, a quality is what we call an element of art. Mass, colour and line have no significance in themselves, but *relationships of qualities* of mass, colour and line communicate feeling and emotion. They communicate nonverbally through the flesh. We feel them. Pattern, balance, emphasis and unity are relationships of qualities. We call these principles of design.

I believe that it is no coincidence that our elements of art and principles of design (Dow, 1899) emerged in the same historical zeitgeist as Dewey's proposal for purposive communication through the structured relationships of qualities. These two intellectual traditions are intimately related. Dewey reframes the intellectual visual traditions, which we now casually characterise as formalism. The elements and principles are not a formula for making pictures 'look good'. They are grammatical tools used in the process of nonverbal visual thinking and communication.

In contemporary art education theory, Elliot Eisner (1994) staked out this realm of teaching qualitative reasoning by advocating the recognition of how artists use *forms of representation*. These are relationships of visual qualities, produced through the affordances and constraints of visual materials, to communicate felt, emotional and somatic forms of knowing distinct from the manipulation of symbols. Continuing to follow Dewey, Eisner cites the need for reflective and reflexive discourse around art for understanding how forms of representation contribute to meaning within works of art. Through explicit instruction, students gain mastery over applying forms of representation in their own art making.

Attention to qualitative reasoning is something that could be given added attention within the existing structure of the Irish Leaving Certificate in Art. This does not represent additional content to be covered. It is a question of values within the existing curriculum.

Aesthetics as a philosophy of care

Assessment should reflect the teaching outcomes that art educators value. When teachers talk to me about magical moments in their classroom, when they want to talk about learning that reaffirmed their commitment to be an educator, they do not talk about how a student mastered composition, or tone, or manipulated a tertiary colour. Teachers

want to talk about moments of personal transformation: when a child made a deeply profound connection to learning. These are moments when education becomes a place 'to recreate oneself' (Eisner 2002). They are moments when art is more than the teaching of art.

Ireland, like all industrialised countries is in the thrall of high-stakes standardised testing. However, there have been calls for alternative conceptions of schools that were more holistic and nurturing to the child. Nel Noddings (1984) advocated infusing education with an ethic of care. Instead of incessantly emphasising memorisation and recall, Noddings called for, and continues to advocate, instruction that is both intra- and interpersonal: a relational curriculum focusing on the student's own sense of self and awareness of connections to others.

Care giving and caring-for are acts of interpersonal relationship. Care of self is intrapersonal. It develops through one's ability to recognise one's felt interior life as real and worthy (Foucault 1988; Noddings 1995). Foucault (1997) called for the transformation of art from the perception of static objects external to ourselves, to understanding the shaping of one's own self as aesthetic engagement. By conceptualising the origins of aesthetics as an intrapersonal care of self, care expands to relational forms engaged with animate and inanimate objects, with persons and things. Like widening ripples in a pond, the circles of care expand from family and friends, to a classroom and school, and on to a larger community.

To understand these intricate webs of relationship is to become human (Feldman 1970). Arguably, these are the ends of aesthetics as originally conceived within the German Idealist tradition. To teach students to care is instruction in aesthetics (Siegesmund 2010).

Noddings has observed that 'the greatest structural obstacle... may simply be legitimising the inclusion of themes of care in the curriculum' (1995, p. 678). For most academic disciplines, care is a dimension of pedagogy through which curriculum is mediated, but it is not a part of the curriculum itself. This is not the case in art. Aesthetics is a legitimate part of the discipline. It is part of the content of what we teach.

In the United States, the new Georgia Performance Standards for the Visual Arts (Georgia Department of Education 2009) put forth a vision of art education as dealing with five areas of care: (1) the care of materials; (2) the care of self as demonstrated by one's own art work; (3) the care of others in the class; (4) the care of the school; and the (5) the care of community. These five areas of care represent critical aspects of visual art practice. They speak to the values of art teachers. Finding a way to build our assessments to honour these dimensions of care is a way to move beyond an exclusive attention to formalist skills development. These new standards allow art educators in Georgia to openly address essential learning outcomes that are core to their practice. Aesthetics is revitalised as dealing directly with the aims of public education: preparing individuals for responsible participatory citizenship.

Concluding thoughts

In this essay, I have attempted to address three major areas. First, the philosophical differences that distinguish Irish art education from art education in the United States and Canada. Second, I have put forward a framework for beginning to think of visual practice as a form of inquiry as opposed to the formal construction of objects. Finally, I have put forward ideas in the assessment of student learning that could be adapted into the existing Irish system.

Nevertheless, as Eisner reminds us, not everything can be taught; no one can learn everything. Choices must be made. Curriculum is a mind-altering device.

The current Irish national curriculum proves a strong foundation in technical skills. This is not insignificant. Furthermore, Irish art education enjoys curriculum legitimacy as a subject covered by the Leaving Certificate. Within the Leaving Certificate reading and constructing visual meaning is valued. These are all good things.

However, the system does not align well with the exciting new directions in inquiry-based studio practice that have been introduced at the college level. The existing forms of assessments may not provide adequate attention to the personal transformative outcomes of art education.

A formal reappraisal and revision of the Leaving Certificate in Art is long overdue. The ability to officially re-enter and revise state curriculum in the arts often lags behind the opportunities to revise and update curriculum in 'core' subject areas. It took 20 years for the State of Georgia to revise its official arts curriculum. However, when the opportunity arose, art teachers embraced the political process with enthusiasm and helped draft a document that offered a significant new vision of art instruction.

It is reasonable to expect that in the near future, Irish art educators will have a similar opportunity to better align the national curriculum to contemporary learning outcomes in the visual arts. When the opportunity arises, art educators will need to be ready to seize it. This will require research into these dimensions of curriculum: visual arts practice as inquiry, development of qualitative reasoning through forms of representation and aesthetic learning outcomes that address dimensions of care. Research needs to inform and give voice to innovative practice. Secondary art teachers need space to explore new possibilities of teaching. National curriculum needs to incorporate articulated best practice.

In the progressive curriculum that has been implemented at the college level, and new curricular ideas in pre-service and in-service art teacher education programmes, the tools are present for a robust renewal of Irish art education. Through a cycle of research, classroom implementation of new curricular theory and formal revision to national curricular outcomes, Irish art education will stay abreast of contemporary ideas in the visual arts.

References

Banks, M. (2001) *Visual Methods in Social Research* London and Thousand Oaks, CA: Sage.

Beardsley, M.C. (1975) *Aesthetics from Classical Greece to the Present* Tuscaloosa, AL: University of Alabama Press.

Bell, C. (1913) *Art* New York: Frederick A. Stokes.

Bolin, P.E. (1995) Overlooked and obscured through history: the legislative bill proposed to amend the Massachusetts Drawing Act of 1870 *Studies in Art Education* Vol. 37 No. 1 pp. 55–64.

Bowie, A. (2003) *Aesthetics and Subjectivity: From Kant to Nietzsche* (2nd ed.) Manchester, UK and New York: Manchester University Press.

Damasio, A.R. (2003). *Looking for Spinoza : Joy, Sorrow, and the Feeling Brain* (1st ed.) Orlando, FL: Harcourt.

Deleuze, G. and Guattari, F. (1987) *A Thousand Plateaus: Capitalism and Schizophrenia* Minneapolis: University of Minnesota Press.

Dewey, J. (1989) Art as experience in J. Boydston (Ed.) *John Dewey: The Later Works, 1925–1953* (Vol. 10: 1934, pp. 1–400) Carbondale, IL: Southern Illinois University Press (Original work published 1934).

Dow, A.W. (1899) *Composition: A Series of Exercises Selected from a New System of Art Education* Boston: J.M. Bowles.

Dunn, G. (2002) Photographic license. *New Times: San Luis Obispo* http://web.archive.org/web/20020602103656/http://www.newtimes-slo.com/archives/cov_stories_2002/cov_01172002.html#top Accessed Jan 9, 2011.

Efland, A. (1976) The school art style: A functional analysis. *Studies in Art Education* Vol. 17, No. 2 pp. 37–44.

Efland, A. (1990) *A History of Art Education: Intellectual and Social Currents in Teaching the Visual Arts* New York: Teachers College Press.

Eisner, E.W. (1994) *Cognition and Curriculum Reconsidered* (2nd ed.) New York: Teachers College Press.

Eisner, E.W. (2002) *The Arts and the Creation of Mind* New Haven, CT: Yale University Press.

Elkins, J. (2001) *Why Art Cannot be Taught: A Handbook for Art Students* Urbana, IL: University of Illinois Press.

Feldman, E. B. (1970) *Becoming Human Through Art: Aesthetic Experience in the School* Englewood Cliffs, NJ: Prentice-Hall.

Foucault, M. (1988) *The History of Sexuality: Volume 3, the Care of the Self* (R. Hurley, trans.) New York: Vintage.

Foucault, M. (1997). On the genealogy of ethics: Overview of a work in progress in P. Rabinow (ed.) *Ethics: Subjectivity and Truth* New York: New Press pp. 253–280.

Freud, S. (1961) *Civilization and Its Discontents* (J. Strachey, trans.) New York: Norton (Original work published 1930).

Froebel, F. (1911) *The Education of Man* (W.N. Hailmann, trans.) New York: D. Appleton and Company (Original work published 1826).

Gardner, H. (1983) *Frames of Mind: The Theory of Multiple Intelligences* New York: Basic Books.

Georgia Department of Education (2009). *Georgia Performance Standards: Visual Arts* https://www.georgiastandards.org/Standards/Pages/BrowseStandards/FineArts. aspx Accessed Sept 15, 2010.

Goldberg, J. (1995) *Raised by Wolves*. Zurich and New York: Scalo.

Kan, K.H. (2007) A story told visually: The Singapore secondary art style *Arts & Learning Research Journal* Vol. 23 No. 1 pp. 135–156.

Lakoff, G. and Johnson, M. (1980) *Metaphors We Live By* Chicago: University of Chicago Press.

Lakoff, G. and Johnson, M. (1999) *Philosophy in the Flesh* New York: Basic Books.

Lowenfeld, V. (1947) *Creative and Mental Growth* New York: Macmillan.

Macdonald, S. (1970) *The History and Philosophy of Art Education* London: University of London Press.

Markie, P. (2008) Rationalism vs. empiricism in E. N. Zalta (Ed.) *Stanford Encyclopedia of Philosophy* Stanford, CA: Stanford University http://plato.stanford.edu/entries/rationalism-empiricism/ Accessed Jan 9, 2011.

National College of Art and Design (2011) *Portfolio Submission Brief* http://www.ncad.ie/portfolio/ Accessed Jan 9, 2011.

Noddings, N. (1984) *Caring, a Feminine Approach to Ethics and Moral Education* Berkeley: University of California Press.

Noddings, N. (1995) Teaching themes of care. *Phi Delta Kappan* Vol. 76, No. 9 pp. 675–79.

Pestalozzi, J.H. (1977) How Gertrude teaches her children in D. N. Robinson (Ed.) *Significant Contributions to the History of Psychology 1750–1920, Series B Psychometrics and Educational Psychology, Vol. II, J.H. Pestalozzi* L. E. Holland and F. C. Turner (trans.)) Washington, DC: University Publications of America (Original work published 1801) pp. 1–391.

Phillips, D.C. (1987) *Philosophy, Science, and Social Inquiry: Contemporary Methodological Controversies in Social Science and Related Applied Fields of Research* Oxford: Pergamon Press.

Powell, K., & LaJevic, L. (2011). Emergent places in pre-service art teaching: Lived curriculum, relationality, and embodied knowledge. *Studies in Art Education*, Vol. 53, No.1, pp. 35-52.

Read, H. (1958) *Education Through Art*. New York: Pantheon Books.

Rey, G. (2008) The analytic/synthetic distinction in E. N. Zalta (Ed.) *The Stanford Encyclopedia of Philosophy* Stanford, CA: Stanford University http://plato.stanford.edu/entries/analytic-synthetic/ Accessed Jan 9, 2011.

Schiller, F. (2004) *On the Aesthetic Education of Man* R. Snell (trans.) Mineola, NY: Dover (Original work published 1795).

Siegesmund, R. (2010) Aesthetics as a curriculum of care and responsible choice in T. Costantino & B. White (eds) *Essays on Aesthetic Education for the 21st Century* Rotterdam, The Netherlands: Sense pp. 81–92.

Steiner, R. (1998). The sense organs and aesthetic experience in M. Howard (Ed.) *Art as Spiritual Activity: Rudolf Steiner's Contribution to the Visual Arts* C. E. Creeger (trans.) Hudson, NY: Anthroposophic Press pp. 176–194.

Tavin, K. (2010). Six acts of miscognition: Implications for art education *Studies in Art Education*, Vol. 52, No. 1 pp. 55–68.

Tufte, E.R. (1990) *Envisioning Information* Cheshire, CT: Graphics Press.

Wygant, F. (1983) *Art in American Schools of the Nineteenth Century*. Cincinnati: Interwood Press.

Notes

1. In Ireland, aesthetic ideas based on German Idealism have an educational presence through schools based on Rudolf Steiner's Waldorf curriculum (Steiner 1998).
2. In the United States, kindergarten is for children aged 5–6 and is the first formal year of instruction in most state curriculum guides.

Notes on Contributors

Michael Flannery lectures at Coláiste Mhuire, Marino Institute of Education (MIE) in Dublin. He works as a Senior Lecturer in Education (Visual Arts – Primary Education). He heads the Arts and Religious Education Department at Marino. Previously, he worked as a primary school teacher. He is a PhD graduate of NCAD; his research explored Irish primary teachers' perspectives regarding the 1999 visual arts curriculum. He also completed a Higher Diploma in Community Arts Education at NCAD and has since coordinated community based visual arts orientated programmes between MIE and local DEIS primary schools. He is also interested in and has designed online CPD summer courses for practising primary teachers who wish to develop further confidence, connoisseurship and teaching competence to enable them facilitate art appreciation and appraisal with children.

Gary Granville is Professor of Education at the National College of Art and Design, Dublin. He was formerly Assistant Chief Executive of the National Council for Curriculum and Assessment (NCCA) and is currently a member of the NCCA Senior Cycle committee and chairman of its Board of Studies for Arts and Humanities. He has acted as evaluator and advisor to national and international agencies in the field of education and training. A former member of the Higher Education Authority, he is founding Chairman of the Forum for Heads of Teacher Education in Ireland. His research interests and publications are in the fields of art and design education, curriculum and assessment policy and educational evaluation.

Alastair Herron has lectured for 20 years in the practice and theory of communication arts at the University of Ulster (Belfast). His PhD from NCAD enquired into more holistic pedagogical approaches. During the last decade this work continued exploring relationships of creativity, nature and consciousness to learning. He has extensive experience supervising and examining PhDs, validating and examining degree

programmes throughout the UK and Ireland. He has also traveled widely giving workshops and talks mainly in Europe, primarily Switzerland, but also in the United States, Canada, and China. Currently lecturing in Fine Art and Photography he is planning a compilation of his learning-nature enquiry through cross-media platforms.

Nuala Hunt is Head of Continuing Education at NCAD since 2002. Nuala completed an MA in architectural history and worked as a tutor in art history in several third level colleges in Ireland. An interest in community arts led her to work as a project manager in the arts and as a training co-ordinator of EU/ESF funded training for trainers project and subsequently as an accreditation advisor with the Youthcert project with the National Youth Federation of Ireland in the 1990s. Completing a second masters in education and training management, she then returned to work at third level as a researcher and subsequently as Head of Continuing Education at NCAD. Nuala is responsible for reconfiguring the part-time programme, changing it from an interest-only provision to include accredited progression routes for mature students returning to higher education. Research interests include adult and continuing education, socially engaged arts practice, and teaching and learning within higher education.

Dervil Jordan is a senior lecturer in art and design education at the Faculty of Education in the National College of Art and Design in Dublin, where she co-ordinates the Professional Diploma in Education (Art and Design) and supervises postgraduate students in the Masters in Visual Arts. She has acted as external examiner for Initial Art Teacher Education in Northern Ireland Scotland and Ireland. She is currently undertaking a Doctorate in Education in St Patrick's College, in Dublin where her research interest is in Art and Citizenship. She has recently completed a research project with six European partners called 'Images and Identity' which explored European citizenship through digital art within second level schools. In particular she has an interest in exploring issues of national identity within initial art teacher education in the North and South of Ireland as a means of developing issue based art curricula across the island.

Jackie Lambe is a Lecturer in Education at the University of Ulster. She is Coordinator for all Post-primary Post Graduate Certificate in Education Programmes and is Course Director for Post-primary PGCE Art and Design with further responsibility for developing Special Needs and Inclusion Education provision across all post-primary PGCE programmes. Her research interests relate to pre-service education and issues around Special Needs Education and inclusion, the pedagogical use of ICT, and Art and Design Education. She has acted as External Examiner to the NCAD Faculty of Education and is currently engaged in a collaborative research project with the Faculty, funded by the cross-border Standing Committee of Teacher Education, North and South (SCoTENS).

Glenn Loughran is an artist and educator. A fine art graduate of NCAD, he was one of the first scholars to be awarded funding through the Graduate School of Creative Arts and Media (GradCAM) in Dublin. He teaches The Politics of Participation, on the NCAD MA programme, Art in the Contemporary World. He is currently completing a PhD on 'Evental Education' in the Faculty of Education, NCAD. This research is developed through the Hedgeschoolproject which takes the idea of the hedge school as a model of non-state education (for more information, see http://eventaleducation.tumblr.com/).

Tom McGuirk is currently Senior Lecturer in Art Theory/Critical Theory at the University of Chester, UK. He was Research Fellow in Fine Art at Nottingham Trent University, UK from 2008 to 2009. He has also worked as lecturer and course coordinator at KEA – Copenhagen School of Design & Technology (2005-08). He holds a PhD by thesis, in art and design education from the Faculty of Education at NCAD. Dublin (2003). Tom was a lecturer and course coordinator at NCAD in the period 1990 to 2003 including five years as Lecturer in Painting in the Faculty of Education. Tom's research interests include the epistemology of drawing and related questions regarding the contested epistemic status of art production and practice-based research within higher education.

John Mulloy worked for many years as a community artist in a wide variety of settings. Increasing discomfort with the negative impacts of state policy on marginalised groups led him to research a 2006 PhD with the NCAD's Faculty of Education on 'community arts'. Recent work includes 'Wild Country, Community, Art and the Rural', Blue Drum, Dublin, 2009 (online), 'The Unreasonableness of Art Interventions in Public' a presentation with Ed Carroll in 2010, and 'Anything - as long as it's not a sculpture!' in Verge, Galway, 2010. He teaches History of Art, Critical Theory and Rural Arts in the Galway-Mayo Institute of Technology, and is currently jointly curating an exhibition exploring print culture and ideas in the West of Ireland.

Ailbhe Murphy is an artist and researcher whose collaborative practice has been based primarily within the community development sector in Dublin. Recent research focuses on critical co-ordinates for collaborative arts practice within the spatial politics of urban regeneration. She was external examiner for the Graduate Diploma in Community/ Arts/Education, NCAD (2007 – 2011). In 2007 she co-founded *Vagabond Reviews* with independent writer and researcher Dr Ciaran Smyth. *Vagabond Reviews* combines art interventions and research processes towards developing interdisciplinary trajectories of critical inquiry into a range of socially situated arenas. Projects include international research on public art, community-based research exploring principles of practice for arts-based pedagogy in youth and community development and a participatory public art commission in Galway.

Máire Ní Bhroin, currently working on her PhD in NCAD, lectures in art education in St Patrick's College, Drumcondra, a college of Dublin City University (DCU). She has extensive and varied experience of teaching in various settings ranging from primary to third level over many years. Her research interests include assessment in art education, meanings in childrens' art making, inservice education for teachers and theory and practice in primary art education. Her art practice includes book cover design, illustration and painting and her publications to date focus on children's art making. Her PhD studies examine how formative assessment works in art education at primary level.

Donal O'Donoghue is Associate Professor at the University of British Columbia (UBC), Vancouver, Canada, where he serves as Chair of Art Education. His research interests are in art education, arts-based research methodologies, curriculum theory, and masculinities. He received the 2010 Manuel Barkan Memorial Award from the National Art Education Association (United States) for his scholarly writing. Currently editor of The Canadian Review of Art Education, he is an elected member of many national and international art education associations and editorial boards. Previously, he served as the Honorary Secretary of the Educational Studies Association of Ireland, and Secretary of the Arts Based Educational Research SIG of the American Educational Research Association (AERA). A former lecturer at the University of Limerick, Mary Immaculate College, Ireland, he was the first PhD student to graduate from the Faculty of Education NCAD in 2000.

Helen O'Donoghue is Senior Curator and Head of Education & Community Programmes, Irish Museum of Modern Art. She has worked on trans-European funded research programmes exploring digital learning and on a national project exploring links between the visual arts and literature. An honours graduate of Fine Art at the National College of Art and Design, Dublin (1979) she was awarded a MLitt in 2007 from the Faculty of Education NCAD, and is currently a guest lecturer there. Current research includes essays on participatory arts and arts education in the twentieth century (for the Royal Irish Academy). Recent publications- Foreword: In the Works/Vu de l'intérieur monograph on artists Cleary & Connolly, Gandon Editions, 2011.

Richard Siegesmund is Associate Professor of Art Education at the School of Art, Northern Illinois University. In 2010, he served as a Fulbright scholar in the NCAD Faculty of Education at the National College of Art and Design. His research focuses on qualitative reasoning, aesthetic theory and arts-based research. His most recent publication is the book chapter, *Aesthetics as a curriculum of care and responsible choice,* in *Essays on aesthetic education for the 21st century* (Sense). He is also the past-president of Integrative Teaching International (integrativeteaching.org), a non-profit organisation that critically re-examines the first-year training of art and design college/university students as visual and social practices increasingly intersect.

Hazel Stapleton was Examinations and Assessment Manager at the State Examinations Commission (SEC) until her retirement in 2011. She was formerly an Art Inspector at the Department of Education and Skills, and prior to that, a teacher of Art at post-primary level and in the areas of special education and further education. Her main interest is in the assessment of visual art in state examinations, which was the subject of her PhD research in NCAD.

Art Education and Contemporary Culture:
Irish Experiences, International Perspectives